sounds
of silence | breaking

sounds
of silence | breaking

A Book Series of Curriculum Studies

William F. Pinar
General Editor

VOLUME 1

PETER LANG
New York • Washington, D.C./Baltimore • Bern
Frankfurt am Main • Berlin • Brussels • Vienna • Oxford

janet l. miller

<table>
<tr><td>sounds
of silence</td><td>breaking</td></tr>
</table>

women,
autobiography,
curriculum

PETER LANG
New York • Washington, D.C./Baltimore • Bern
Frankfurt am Main • Berlin • Brussels • Vienna • Oxford

Library of Congress Cataloging-in-Publication Data

Miller, Janet L.
Sounds of silence breaking: women, autobiography,
curriculum / Janet L. Miller.
p. cm. — (Complicated conversation; v. 1)
Includes bibliographical references and index.
1. Curriculum planning—Philosophy. 2. Education—
Curricula—Philosophy. 3. Feminism and education.
4. Women—Education—Philosophy. I. Title. II. Series.
LB2806.15.M47 375'.001—dc22 2003019418
ISBN 0-8204-6157-1
ISSN 1534-2816

Bibliographic information published by **Die Deutsche Bibliothek**.
Die Deutsche Bibliothek lists this publication in the "Deutsche
Nationalbibliografie"; detailed bibliographic data is available
on the Internet at http://dnb.ddb.de/.

Cover art by Denny Camino: "Remembering Carol Camino"
Oil on paper, 2004, Privincetown, MA

Painting in background of author photo by Johniene Papandreas,
Provincetown, MA

Cover design by Lisa Barfield

Painting in author photo by Johniene Papandreas, Provincetown, MA

The paper in this book meets the guidelines for permanence and durability
of the Committee on Production Guidelines for Book Longevity
of the Council of Library Resources.

*In memory of
my mother & Mimi*

CONTENTS

PREFACE
What Should Be and What Might Be

William F. Pinar

> *The sound of silence breaking is harsh, resonant, soft, battering, small, chaotic, furious, terrified, triumphant.*—Janet L. Miller

Janet and I go back a long way. It has been more than thirty years since we met on the campus of the University of Rochester. Our friendship—and our professional partnership—took root in the snows of upstate New York, and grew (yes, rhizomatically) in Ohio, Virginia, Louisiana and in New York. There is a "worldliness" to our friendship, grounded as it is in shared commitments to and lived experience of the academic field of curriculum studies, commitments first enacted and experienced perhaps most intensely during the field's reconceptualization, a decade-long event that was simultaneously intellectual, political, and personal, as this collection testifies (see chapter 4, Pinar et al., 1995).

Winter 1978 found me in Berkeley, California, where I was a visiting scholar and a visiting Dad. In Columbus, Janet was working at Battelle Memorial Institute, in the Center for Innovative Education. We spent hours on the telephone, planning the new journal and the conference its editors would sponsor: *JCT* and what would later become known as "Bergamo." In those conversations we imagined together "what should be and what might be." These imaginings were never fixed, always in motion, and they ranged from the theoretical to the practical, the professional to the personal. As Janet points out,

> one big reason why the conferences sponsored by *JCT* over the years drew a loyal following was that the reconceptualization was itself about understanding curriculum as *intersections* of the political, the historical, the autobiographical.

It seemed we were always at intersections, junctions (*JCT* as the road-signs signal) where diverse ideas met, sometimes clashed, sometimes conjoined and created something new.

Janet and I were together often in those years, and not only over telephone, but at conferences, at Paul Klohr's house on Walhalla, at Janet's place on North High Street (and, later, on South Lazelle Street in German Village) all in Columbus, in Norfolk, Virginia, on Long Island, in Manhattan, in Baton Rouge. And during the late 70s and early 80s, we danced and danced. We were in sync on the dance floor.

And off. Not that we were fused, of course; we spoke, as Janet notes about herself, "through multiple and changing autobiographical voices." The work of reconceptualization was "sometimes noisy, sometimes quiet work," but, as Janet underscores, the intellectual and organizational work also spoke "to the daily need of reinventing our selves through and in these processes." These were simultaneously subjective and social processes, as we rejected the bureaucratic roles fashioned for us by the past. As Janet acknowledges, our generation declined "to pass on its 'received heritage'—a heritage that framed curriculum as an administrative designation."

Solitary and in solidarity with others, Janet remembers her participation in the field reinventing itself. "My memories here," she writes, "attempt to honor the connectedness that informs and impels my own work as well as the work of others long involved in this project called reconceptualization." As she will suggest about school reform, this "memory text" (as Marla Morris might characterize it) is very much situated: "[T]he brief history I've reviewed here speaks of, as well as constantly questions, my partiality in terms of remembering, interpretation, and attachment." Acknowledging, then, the situatedness of memory, interpretation, and its social relationality, Janet declines to "generalize from my middle-class, white woman enactment of US curriculum theory professor." She speaks her situated singularity and, in so doing, calls us to ours.

Janet may not generalize from that situated singularity, but she is hardly hermetically sealed within it. From the outset, Janet always

> struggl[ed] to create spaces within reconceptualized versions of curriculum theorizing that could enable me to explore, for example, "the personal" and "the political" not as a binary but rather as reciprocal, interactive, constantly changing and (re)constructing influences on my own and other teachers' conceptions of curriculum, pedagogy, and research.

These "spaces" were simultaneously subjective, social, and political: imbricated, interwoven, in-between.

Such spaces were discernible in the work of Maxine Greene. "I first read some of Maxine Greene's writing when I was studying for my master's degree at the University of Rochester in 1973 and 1974," Janet remembers. "I immediately was drawn to Maxine Greene's compelling philosophical and political analyses of curriculum as project—and to her uses of literature as means of engaging in such analyses." At Ohio State with her mentors (and mine)—Paul Klohr and Donald

R. Bateman—Janet wrote her Ph.D. dissertation on the significance of Maxine Greene's philosophy of education for the fields of curriculum theory and English education.

That work held specific significance for Janet as a feminist theorist. Janet attends to a chapter of Maxine's (Greene, 1995a) on "the shapes of childhood recalled," precisely "because it evokes provocative tensions in the doing of educational autobiography that resists closure or paralysis around issues of identity and agency." Maxine Greene provides, Janet observes,

> glimpses of contradictions, disjunctures, and ambivalences, the "incompleteness" that she experiences within and toward her "self" as a woman who desires both to "merge and to be outside" as an academic who dares to do educational philosophy in unconventional ways, and as a scholar who reads imaginative literature as one way of disrupting and questioning any one final version of her self and world. (The quoted passages within Janet's sentence are Maxine's.)

At the same time, Janet continues, "Maxine gestures toward possibilities of taking action against unjust and inhumane conditions even as individuals face the 'incompleteness' and 'unfinished whole' of their actions, their knowledge, their 'selves,' and their lives." In this convergence of subjective meaning and social significance resides the project of reconceptualized curriculum theory.

In disciplinary terms, it is a convergence of literary and social theory, of literature and politics. In the spaces in-between those apparently disparate disciplines Janet locates autobiography as one key form of educational inquiry. It is not to be regarded as literature, per se, but she does wonder "what might happen to the forms and purposes of autobiography in education if they assumed the potentials of imaginative literature to disrupt rather than reinforce static and essentialized versions of our 'selves' and our work as educators." Janet quotes Maxine Greene to show how such "defamiliarization" and "revising" can enlarge our capacities "to invent visions of what should be and what might be in our deficient society, on the streets where we live, in our schools." "In fact," Janet concludes, "this may be the only reason to use autobiography as a form of educational inquiry . . . [to] call into question both the notion of one "true," stable and coherent self and cultural scripts for that self." Such calling into question occurs constantly in this collection.

Autobiography

[A]n educator who conceives of autobiography as a queer curriculum practice doesn't look into the mirror of self-reflection and see a reinscription of her already familiar, identifiable self. She finds herself not mirrored—but in difference.—Janet L. Miller

In Janet's autobiographical voice we can hear the "sound of silence breaking." It is that courageous voice that names "heretofore unspoken connections among gender, sexuality, and curriculum" that, in the late 1970s, were then just "emerging as central issues within the field of education, in general, and curriculum studies, in particular." As Janet understood: "Curriculum and feminist theories have moved into areas of inquiry that may break that unnatural silence." It would be through

Janet's autobiographical voice that the social terrain of gender and sexuality would be redrawn, where she would see herself, and where I would see myself, not mirrored, but in difference.

It was during a session at the Bergamo Conference that Janet found herself writing, not for the first time, on legal yellow writing paper. She entitled the piece she wrote for the session "Yellow Paper," and in it she described the writing, in the mid-1970s, of her dissertation in longhand, on the same type of legal yellow writing paper that she had grabbed that afternoon. In the last part of "Yellow Paper," Janet spoke of breaking a silence, of "my desiring to share those words with the woman I love." Janet explains,

> My ongoing work in autobiography thus provided an incentive and a reason, in the conference session, to tell how my life, my "identities," and my love exceeded the very academic and social normative discourses and frameworks that tried to contain them. My long-term autobiographical work also provided a backdrop against which, at that point in my life, I could queer both the subject and the forms that autobiography typically took in educational settings. I was interested not only in pointing to the "undesignatable field of differences" within identity categories of lesbian, woman, teacher, and researcher, for example. I was also interested in exploring uses of autobiography that addressed and even exemplified Butler's (1990, 1993) concept of performativity, the power of discourse to produce, through reiteration, an "I" that is always coming into being through social and cultural constructions of gender identity and, simultaneously, failing to cohere.

In this paragraph—you are able to read the entire essay in this collection—Janet is working several tensions. Ted Aoki would suggest, I think, that the paragraph discloses Janet's dwelling in a "generative tensionality" (see Pinar & Irwin, in press).

First, Janet is working the tension between and the subjective meaning and social significance of her professional persona and scholarly work. Janet is participating in a public event where her long-term study of autobiography is well known, as is her key role in the reconceptualization of the field. This present—simultaneously a social fact and a subjective reality—provides a passage to a future where she acknowledges, in public, her love for Liz. That public acknowledgment of a private relationship would revise many participants' perceptions of Janet's professional persona and of her work. I suspect it did so for Janet as well; she was exceeding the discourses and the voices those discourses expressed and contained, creating new space and finding new voice.

For me, this "performance" of autobiographical voice and professional identity reveals how working the past autobiographically enables one to "midwife" the future and, in so doing, reconstruct the public space in which identity is reiterated. That future—itself a convergence of subjective meaning and social significance—is a shared and public space, a kind of civic square. It is, as well, a room of one's own. As an established scholar, Janet created herself and was created by others by the time of the conference event she is describing. Interpellated, then, in social terms as autobiographical and feminist curriculum theorist, Janet's public

persona no longer coincides with her private reality. Janet exceeds that public identity through its discursive rewriting. It is as "text"—writing on a yellow writing pad—that Janet moves from 1970s Ph.D. student, studying the existential-political philosophy of education Maxine Greene had formulated, onto her present as autobiographical and feminist curriculum theorist, into a conference session (a classroom for colleagues), where she queers autobiographical curriculum practice and, in the process, her professional persona as well.

While the social and the subjective are inextricable, the two can, sometimes must (when in tension), be worked separately, as that paragraph illustrates. It is through working the past, in this instance recalling the 1970s work, evoked through the artifact (the yellow writing pad), that Janet's subjective space—the room of her own—exceeds the public space and becomes disjunctive with it. Subjectively "larger" than the persona interpellated (however understandably) by her fellow conference-goers, Janet dwells in the disjunction between private and public self. No longer identical with the interpellated self, one is able to reconstruct that public space through discursive means, in this case, by reading and writing aloud the private reality. By working the tension between the autobiographical and the social, Janet reconstructs both.

In that Bergamo session, Janet not only queers autobiography thematically, she also queers it structurally, in her rewriting of and dis-identification with herself: "[W]hen autobiography is conceptualized as a queer curriculum practice, it can help us to dis-identify with ourselves and others." Such a practice creates a disjunction between the self that is and the self that might be; one finds oneself "not mirrored—but in difference." Such practice challenges those "humanist educational research and practices that normalize the drive to sum up one's self, one's learning, and the other as directly, developmentally, and inclusively knowable, identifiable, 'natural.'" Reconstructing the public sphere in curriculum and teaching requires reconstructing the private sphere as well.

Such reconstruction—"*strategically* producing a difference out of what was once familiar or the same about what it means to 'be' a teacher or student or researcher or woman," as Janet succinctly puts it—cannot occur if "telling my story" reinscribes the "self" already hailed into existence by others. Nor can strategically producing a difference occur if such difference is understood as only—here Janet quotes Maxine—"binary and oppositional rather than nuanced, plural, and proximate." To democratize the subjective sphere—in Janet's words "addressing 'self' as what Butler calls a 'site of permanent openness and resignifiability'—requires "*queering* autobiography, speaking and writing into existence denaturalized ways of being that are obscured or simply unthinkable when one centered, self-knowing story is substituted for another." It is the structure as well as thematic contents of the "self" that are reconfigured in queer autobiographical practice.

Such subjective labor cannot be conducted effortlessly, nor without troubling a life carefully composed and socially stable. In all likelihood, there will be discomfort in "strategically producing a difference" between the self that is and the self that might be. "Autobiography as a queer curriculum practice," Janet points

out (after Britzman), "compels us to consider 'tangles of implication,' how we are implicated in our desires for an enactment of, as well as in our fears and revulsions toward, those identities and practices that exceed the 'norm.'" Again, this work is hardly self-enclosed: such subjective reconstruction creates what Butler argues for: *more space for and recognition of the various actions and 'selves' performed daily in a social landscape blinded and hostile to variety.* Too many schools are indeed "blinded and hostile to variety." After thirty years of right-wing school deform, schools are *required* to be blinded and hostile to variety.

Schools are the specific social landscape Janet has in mind, wondering if the queer character of the first wave of autobiographical work (during the 1970s) disappeared because it "invited too many denaturalized stories." These were stories that "many educators could not or would not want to hear," in part because "official school knowledge, identities, and visions of revolutionary educational practice were exceeded by heretofore unimagined or at least unarticulated constructions of students, teachers, and curricula." As L.L. Langness and Gelya Frank (1981, p. 93) have observed, "[a]utobiography can be a revolutionary act."

Not only taken-for-granted conceptions of school are challenged by the queerness of autobiographical practice, Janet suggests; so too are "developmental and incremental notions of both learning and autobiography." Indeed, "queered versions of autobiographical practice" threaten those dominant and taken-for-granted developmental narratives "in which one, through linear learning of official and predetermined curricula, passes from ignorance to knowledge about both 'self' and 'other.'" As we know from Bernadette Baker's careful and groundbreaking work, the very concept of developmentalism is historically continent, appearing "in the vicinity of such fears [of racial amalgamation in the late nineteenth century]" (2001, p. 463). It was also, as I suggest and as Janet suspected, queer (see Pinar, 2001, chapter 6).

Feminist Educator

Curriculum and feminist theories have moved into areas of inquiry that may break that unnatural silence.—Janet L. Miller

As teachers we are both subjective and social creatures, conceived by others, struggling to create ourselves, inviting our students—through study—to do the same. We are burdened by the psycho-political history of our profession; as Janet points out, "US educators throughout the nineteenth and into the twentieth century internalized the notion of subordination as a primary framework for behavior within the classroom." This is, as Janet suggests, a gendered notion of social control, in which our "subordination" is a gendered subordination. Because the profession is imagined as female, mostly male legislators and administrators have assumed they are entitled, indeed obligated, to direct it. The subordination of US educators is a form of what Southern Baptists imagine as the biblically ordained "gracious submission" of wives to husbands.

Such submission becomes, as Janet knows, internalized; there is no firewall between "teacher" as social identity and "teacher" as subjectively lived. Janet

knows this fact from her own lived experience: "I had, without thinking, and without questioning, transferred an expectation of myself as a woman, which largely was a societal creation as well as perhaps a psychologically based developmental need, to my professional role." Because she understands that interpellation—her professional role—is simultaneously subjective and social, "I encourage my students, men and women who themselves teach, to explore underlying assumptions and expectations that frame their conceptions of themselves as teachers." Such "underlying assumptions and expectations" comprise social sedimentation in which the self is submerged, and from which it can separate. As Ewa Plonowska Ziarek (2001, p. 39) points out:

> Yet, it is the tear, or the separation of the self from its sedimented identity, that enables a redefinition of becoming and freedom from its sedimented identity, that enables a redefinition of becoming and freedom from the liberation of identity to the continuous "surpassing" of oneself.

The exploration Janet encourages, then, enables students to separate from others' expectations of them, especially as these have been internalized, turned into psychic sediment.

Janet performs this self-reflexive self-separating labor herself, remembering that "in the summer between fifth and sixth grade, I spent a lot of time hoping that I would get Mr. Brucker as my sixth-grade teacher." That hope may have been structured by the power of patriarchy, but such abstractions fail to convey its subjective meaning:

> To have a man as a teacher, in that last year of elementary schooling that still sanctioned childhood play even as it prepared us for the grown-up demands of junior high school, supposedly guaranteed our rites of passage into the rules, content, and structure of the disciplines.

In psychoanalytic terms, the male subject here functions as a transitional object, and not only for the transition from "play" to "work," but from childhood to adolescence, from the projects and interest centers of elementary school to the disciplinary vocationalism of secondary school.

It turns out Mr. Brucker also functioned as a transitional object from traditional to more contemporary conceptions of femininity and womanhood. "[I]n our unit on careers," Janet remembers,

> Mr. Brucker [discussed] possible jobs that we girls might want to consider. He didn't assume that we or our mothers would want—or be financially able—to stay at home. . . . He challenged us girls to move beyond stereotypical images of ourselves that we reinforced every recess in our jump rope and hopscotch play, for example, by insisting that we be part of the class kickball team.

Mr. Brucker demonstrated that teachers are inevitably agents of reproduction. Perhaps it is "giving back" to teachers past that inspired Janet to "spend a portion of my time in the schools, working directly with other teachers and students." Such work is hardly unproblematic, Janet understands, "for, as a woman teaching

in the university, I still feel the pull of internalized expectations for myself either as distanced 'expert' and 'conveyor of knowledge' *or* as nurturer and caretaker of my students' needs and interests." Thinking of teaching young children, Janet is acutely aware that "such work is historically grounded in social expectations and school structures that rely on women's accustomed roles as subservient, genteel, and docile reinforcers of the status quo." That problematic becomes concretely clear in her narratives of Katherine (a pseudonym chosen by Georgette Vosseler, who claims her "real" name in chapter ten of this collection), one of the teachers with whom Janet worked collaboratively for six years (the first three years of which Janet reports in *Creating Spaces and Finding Voices:* see Miller, 1990a).

"Our Work Together"

> *Memoir, like autobiography, must recognize its own social construction and cultural conditioning.*—Janet L. Miller

Perhaps more than any other autobiographical curriculum theorist, Janet Miller has focused upon "our work together." In mid-summer of 1986, Janet tells us, "I joined five graduate students in a picnic lunch to celebrate the end of our course-work together." But, it turns out, this picnic was not to be the end of it, but, rather, another beginning: "By the close of the afternoon . . . we agreed to continue our conversations in an informal and unofficial way." And not for a few weeks, or even months: "At present, we have been meeting and talking together on a regularly scheduled basis for six years." This remarkable, probably unprecedented, fact testifies to the power of "our work together." What became increasingly clear was that, despite the collective commitment to collaboration,

> willing participants could [not] easily avoid the circulations of power that attend any human interactions, or could [not] "progress" in seamless and transparent ways, with all participants moving as a collective through the collaborative work in similar ways and at identical times.

Georgette was a case in point. In the collaboration with Georgette [Katherine was her pseudonym in the book *Creating Spaces and Finding Voices*], Janet focused on how "stereotypic and essentialized notions of women teachers as only caretakers and nurturers" can foreclose opportunities for becoming "creators and examiners of our own as well as others' constructions of knowledges and practices." Through her work with Janet and other members of the group, Georgette described "her journey through our collaborative attempts thus far as one of 'becoming vocal.'" A first-grade teacher, Georgette became clear about the "ways in which historical and social constructions of teaching as 'women's work' have framed and constrained her own expectations for herself as early childhood educator."

While such work is solitary, it did not occur in isolation. Supported and, no doubt, inspired by others' self-reflexive labor, Georgette's work inspired others in the group, including Janet: "Georgette's struggles have provided me with incentives for parallel analyses of my own expectations and internalizations of caretaker

and responsible leader roles within and without our research group." And not only Georgette inspired Janet to examine her interpellation as group leader; so did Beth, who asked: "What are we going to do?"

Beth's question, Janet tells us, was only "the first of countless questions that have emerged throughout our ongoing collaboration," questions concerning the "tangled intersections of theory and practice," abstractions expressing "the permeable boundaries of their—and our—relations with and to one another." Janet notes: "It is our daily challenge, our daily work." It is work that positioned Janet not only as "leader" but as "student" as well:

> As we continue our meetings, discussions, and individual as well as dialogical journal writing, I am acutely aware of just how much I have been influenced in my teaching, research, and curriculum theorizing efforts, by our interactions, reflections, and confrontations with one another.

For me, this is the subject position prerequisite to study (see McClintock, 1971).

Studying the gender of teaching (as "women's work"), including participants' internalized expectations and assumptions of that work, led to study of "our 'selves' as white Western women who are trying to raise questions about how we 'perform' ourselves as women teachers, how we might address the provisional and political nature of identity construction." Such identity is no simple or obvious matter of empirical representation, it exists in the social imagination. School "reform" of the last thirty-five years positions teachers as "wives" in "gracious submission." Despite the gendered (and racialized: see Pinar, 2004) politics of school "reform," Janet and her colleagues proceeded with their groundbreaking collaborative work:

> We take heart in knowing that we *can* analyze, critique, and work to change our habitual responses to static and limiting constructions of our work and our educational identities. . . . It's a form of local and contingent "emancipatory" work, if you will, and it's *what we can do* to continue the slow but crucial work to understand and, if necessary, change the nature of our own and perhaps our students' and colleagues' educational experiences. . . . As we continue to meet on back porches and living rooms, juggling coffee mugs, bagels, and conversations, we still ponder discrepancies in our expectations as collaborative group members as well as members of various educational communities.

That is the power of working from within, together. As Georgette testified: "I know I have changed as a result of our work together, changed from an accepting, docile teacher, to a questioning, challenging person." Such transformation is not exactly what politicians have in mind when they demand "school reform."

School Reform

The longer I engaged in these reform studies, the more I worried about large-scale attempts to implement versions of whole-school "reform." —Janet L. Miller

Noting, with understatement, that "some school reformers during the past decade have assumed that particular conceptions of school reform could be implemented in similar ways across diverse classrooms in the United States," Janet discovered that many teachers declined to position themselves in "gracious submission." Indeed, Janet found that

> [m]any of the teachers I have observed and interviewed responded in ways that disrupted, called into question, subverted, divided, or re-formed what had been presented or agreed upon as "the ways" to proceed in their school reform projects. As a researcher of these reform efforts, I also responded in ways that sometimes disrupted the generalizing intentions and design of the research projects in which I was participating.

Despite the fact that "students' raised achievement scores would be *the* criterion used to measure 'successful' reform efforts," there were teachers, Janet confirmed, who exhibited a more subtle and sophisticated sense of "reform."

Informed by her experience and understanding of "our work together," Janet formulates a concept of "situated school reform" that "disrupts any essential or generalized notion of school restructuring processes or goals." Indeed, situated school reform "draws attention to how these processes and goals constantly are re-written within specific school cultures and by particular individuals." School reform is not raising test scores to establish bragging rights for politicians; it is the subjective labor of self-understanding:

> A notion of situated school reform and research thus refocuses my work so that I might look for ways that particular situations might enable both teachers and myself to re-write and re-work any discourses of reform and educational research that would generalize, universalize, standardize and reify teacher or researcher identities.

This is, I submit, the subjective labor of self-reconstruction, labor enabling the reconstruction of the public sphere in curriculum and teaching.

Acknowledging that "some school reform movements *do* encourage administrators, teachers, students and parents to consider carefully their particular schools' organizational and social cultures as they arrive at their own interpretations of school improvement tenets," Janet appreciates that school reform is local, singular, situated:

> I believe that a focus on teachers' actual responses to and engagements with school reform efforts might point toward "more lucid understandings" of the need for school reform conceptualizations that take into account the constantly changing nature of teaching and learning within particular classrooms and school settings.

Situated school reform is, then, lived. It engages the processes of self-formation, especially as these are structured through study, through the juxtapositions of lived and embodied ideas, juxtapositions producing "excessive moments."

Juxtaposition and Excessive Moments

The strategy of juxtaposition is one that invites inconsistencies, ambiguities, ambivalence, and it emphasizes the fact that there will always be "unspoken themes" that cannot or will not be interrogated. —Mimi Orner, Janet L. Miller and Elizabeth Ellsworth

Excess is a symptom of histories of repression and of the interests associated with those histories. —Mimi Orner, Janet L. Miller and Elizabeth Ellsworth

The concept of "excess" enables Janet—in collaboration with Mimi Orner and Elizabeth Ellsworth—"to call attention to the relation between particular educational discourses and repression." What is "contained" by an educational discourse and "what becomes excess or excessive to it" is, they suggest, "no accident." Indeed: "Excess is a symptom of histories of repression and of the interests associated with those histories." Excessive moments are like epiphanies, enabling she or he who experiences them to discern the repression of which they are symptomatic.

It is a significant contribution to our understanding of educational experience to appreciate that such moments are *related* to repression, that they represent, in a sense, shifts in the plates of repression, versions of psychic earthquakes. Like earthquakes, they occur without prediction, precipitated by pressures building from the contradictions of lived experience and our self-reflexive study of it. Unlike earthquakes, they can be encouraged pedagogically. Mimi, Janet, and Liz suggest a strategy for producing such "excessive moments" by deliberately shifting or juxtaposing the "plates" of understanding. As they read their sections to each other in preparation for presentation at the Bergamo Conference, "the more the juxtaposing of educational discourses not intended to be read together created for us meanings that exceeded the norms of the discourses that informed our separate texts." Repetition produced difference; juxtaposition produced excess.

Mimi, Janet, and Liz's individually composed sections were not written, then, "to engage each other directly or linearly." The "fault line" (in my analogy) is "the relation we construct among moments, narratives, and authorial voices," and it is one of "*juxtaposition*." It is this "strategy" the three theorists employ as a means "of foregrounding and negotiating the fact that there are no simple, linear, cause-effect relations between official forms of educational representation and the moments in theory and practice that exceed them." Mimi, Janet, and Liz explain:

> Juxtaposition, as an aesthetic device in postmodern art and as rhetorical device in postmodern theory and writing, provokes viewers and readers to make associations across categorical, discursive, historical and stylistic boundaries—associations never intended or sanctioned by the interests that construct and require such boundaries.

Their formulation precedes my own employment of the practice in *The Gender of Racial Politics and Violence in America* (2001), in *What Is Curriculum Theory?* (2004), and in "The Synoptic Text Today" (in press-a).

In those studies I juxtapose paraphrased works of others; in Mimi, Janet, and Liz's practice of the concept, the emphasis is on the disruption of repression and the "eruption" of "excessive moments." The juxtaposition of sections in their conference presentation, now a chapter, "invites readers to explore the notion of performance and the performative across various moments of education research, writing, and teaching." The three scholars suggest that "juxtapositioning also invites readers to allow what happens in one of the three texts to spur images from that text to the others, and on to the reader's own contexts and practices." This example speaks to what is for me the very definition of educational experience, namely the intertextual reverberations of ideas from one text to other texts, including scholarly as well as subjective and social texts, experienced by the embodied, self-reflexive, historical individual.

"Working Difference"

We use "working difference" to refer to the possibility of engaging with and responding to the fluidity and malleability of identities and difference, of refusing fixed and static categories of sameness or permanent otherness. —Janet L. Miller and Elizabeth Ellsworth

For at least two decades, Janet and Liz point out, several disciplines have devoted themselves to "thinking through relations among subjectivity, power, and difference." The two scholars invoke the notion of "working difference" to refer to "the possibility of engaging with and responding to the fluidity and malleability of identities and difference, of refusing fixed and static categories of sameness or permanent otherness." While not discussed in this same chapter, it seems to me that it is, in part, this tendency toward categories of sameness discernible in many autobiographical curriculum studies that compels Janet's commitment to "working difference." As she points out, too many such studies—the evocation of "teachers' stories"—tend to

> offer unproblematized recounting of what is taken to be the transparent, linear and authoritative "reality" of those teachers' "experience." And their "teacher identities" in these stories often are crafted as unitary, fully conscious, universal, and non-contradictory.

"Working difference" cracks the surface of "experience," exposing those genealogical and sedimented layers of repression interpellation necessitated.

It is, of course, hardly the replacement of one static identity with another that "working difference" effects. Janet and Liz emphasize that "working difference" foregrounds the possibility and significance of reading and performance difference as "work-in-progress." Nowhere is that more pointed than in Janet's discussion of Toni Morrison's (1992) *Playing in the Dark.* That "powerful work compels us," Janet writes, "to work with our students to identify what Morrison (1992, p. 18) calls a 'willful critical blindness'—those 'habits, manners and political agenda' that have contributed to an objectified Africanist persona as 'reined-in, bound, suppressed, and repressed darkness' (pp. 38–39)." Specifically addressing English teachers and English educators, Janet calls us to monitor our classrooms and the

literature we teach for "willful critical blindness." That work cannot proceed unless we are also "aware of the places where our own pedagogical imaginations may have been sabotaged as well as sabotage, may have been polluted and pollute our visions of what it could mean to read and write, teach and learn across social and cultural difference." Such pedagogical action requires autobiographical study.

Sedimented subjectively, "willful critical blindness" also follows, as Janet observes, from the "external presses for standardization and accountability that currently characterize the teaching of English/language arts and the field of education, writ large." Likewise, Linda McNeil (2000, p. 7) has pointed out: "The conservative transformation of American public education [has occurred] through the use of technicist forms of power." Still thinking of the teaching of English but speaking to all educators, Janet notes:

> [I]n the press for standards, accountability, and standardization of curriculum and teaching, we easily may lose sight of ways in which reading and writing in the English classroom and teacher education sites can challenge static and stereotypic constructions of "literary whiteness" and "literary blackness," for example.

I suggest that "accountability" is a racialized and gendered form of power in which teachers are reduced to positions of "gracious submission" to mostly white male politicians (see Pinar, 2004).

Such positions of submission smash teachers and students onto the social surface, but despite this shattering of "our multiply inflected and constructed identities as gendered, raced, classed selves" (as Janet appreciates), self-reflexive educators remain torn by conflicting demands. Smashed onto "sites of disunity and conflict, unfinished and incomplete," we teachers are torn "in part because we must respond to differing and disunited contexts, individuals, and historical moments at the same time that we often are required to respond to normative demands for similar and 'acceptable' performances of our students' and our own selves." Behind enemy lines we still signal to others that this (standardized) world is not *the* world. "We are," Janet reminds us, "in-the-making."

"Education in-the-Making"

I use autobiography as also in-the-making, as one means of grappling with multiple versions and questions about various constructions of my identities "as" English teacher, teacher-educator, researcher, curriculum theorist, writer, partner, feminist, woman who struggles to not close down, in the press for standardization, around "certainty." —Janet L. Miller

Not unlike Ted Aoki's concept of "improvisation," Janet's notion of "in-the-making" emphasizes our "incompleteness—the open question, perhaps—that summons us to the tasks of knowledge and action" (Greene, 1995a, p. 74). So summoned, we—teachers and teacher-educators—must attend to issues of "risk and safety" in our "constructions and deconstructions of meanings and identities in classrooms," as we are implicated in the very discursive structuration of knowledge as action. Attending specifically to English education in-the-making, Janet notes that teaching "calls attention to those very constructions of meaning as

always situated in language that unwittingly writes us" (Felman, 1993, p. 157). Such situatedness also calls attention to understanding curriculum as autobiographical text, to autobiography as a textual pedagogical practice.

In "autobiography in-the-making," Janet tells us, "I push my students to tell situated and multiple stories of our educational experiences of teaching, learning, and research." Informed, in part, by the work of Madeleine Grumet and Jo Anne Pagano, Janet further extends and complicates our understanding of autobiographical practice by emphasizing the disjunction among internalized and discursive as well as cultural and historical constitutions of the "self." Always attentive to interpellation as simultaneously subjective and social, Janet advises:

> So, even if we do write multiple and situated stories of ourselves as educators and immediately call those into question, rather than try to create just one summarizing "true" autobiographical rendering, we also must wrestle with those still normative meanings and identities that society, history, cultural conditioning and discourses have constructed for us as well as those that we have constructed or perhaps unconsciously assumed.

Embedded in language, constituted by history, how do I create subjective spaces—Janet characterizes them as "cracks" in the official curriculum—in which I can act, informed by that self-reflexive knowledge and ethical conviction autobiography "in-the-making" enables? (see Wang, 2004). How can we teach such conviction in a postmodern age? (see Slattery & Rapp, 2002).

These are vexing questions, closed down by disingenuous demands for "accountability," by "willful critical blindness," by repression, simultaneously political and psychic. Through study, one summons oneself to question, to become "in-the-making," to take action in the public world that is the classroom understood as civic square. Autobiography becomes the practice, oneself the provocation, and the classroom the site to reconstruct the private and public spheres in curriculum and teaching. Janet calls us to undertake such pedagogical action:

> Autobiography in-the-making, then, includes multiple tellings, multiple questionings of those tellings, and multiple angles on representations of "self" that give strategic leverage on two central questions that frame a notion of English education in-the-making: (1) As a teacher, as a teacher educator, how *will* I respond to students' and colleagues' identities and responses that deviate from the "norm," or that are different from "mine"? And (2) how *will* I respond to educational discourses and practices that function to position some as permanently "other," knowing that, at the same time, I am always caught up in and by the very languages and resulting practices that I wish to challenge?

Too sophisticated to be seduced by social engineering, Janet replaces ends-means calculations with ethical questions requiring pedagogical action. Such action is "performed" with the humility that accompanies the realization that, as Janet notes, "the teacher or researcher can never fully know her 'self' nor her students nor what she teaches or researches, and can never fully control or predict what is learned." She quotes Liz to emphasize her point: "At the heart of teaching

about and across social and cultural difference is the impossibility of designating precisely what actions, selves, or knowledges are 'correct' or 'needed'" (Ellsworth, 1997, p. 17).

This frank acknowledgment of uncertainty is coupled with the recognition that educational experience is not always observable and measurable. Despite the teacher scapegoating tactics of those who insist it is (see, for instance, Hirsch, 1999), Janet points out that

> There may be no achievement score raised, no journal entry written, no homework assignment or worksheet completed, no behavioral objective met, no Regent exam passed, no "excellent student" certified as a result of a particular teaching and learning experience. And yet something of value has happened in that classroom.

Indeed, the observable and the measurable are often the trivial.

Educational experience that is subjectively meaningful and socially significant does not occur readily through curriculum connected to standardized examinations. Especially in the nightmare that is the present, "the 'sweaty fight for meaning and response-ability' is an always-new struggle. . . . It's difficult, challenging, exhilarating, discouraging, numbing, mandatory and exciting work—daily work that's always in-the-making." This is the everyday subjective labor of enabling our students to reconstruct the classroom as civic square *and* as a room of one's own.

Cracks in the Curriculum

Thank goodness there were cracks in the official curriculum and predetermined objectives through which my students and I could connect words that we were studying . . . to our selves, to one another, and to the world around us. —Janet L. Miller

"As a beginning high-school English teacher," Janet remembers, "I felt constrained to teach for the test, to cover the curriculum, to fill in the blanks—in short, to prepare my students for what was coming next rather than to respond to what was happening in our classroom." This is a succinct statement of teachers' subjugation in the regime of "accountability." Without academic—intellectual—freedom to influence what and how they teach, without the discretion to choose how to assess student study, teachers are disabled from practicing their profession: "Confronted by this officially mandated, test-driven, and dissected approach to teaching English, I tried to justify my distancing from my own passions for learning in order to sustain a curriculum and pedagogy that kept students from theirs." Teachers *and* students have been forced into positions estranged from their lived experience of intellectual work.

Janet remembers that the present nightmare—in which teachers have lost control of the curriculum they teach and the means by which they assess students' study of it—began after Sputnik, first with the 1959 Woods Hole Conference, followed by the Kennedy Administration's national curriculum reform movement. Despite the Dartmouth conference and others like it, politicians intensified their scapegoating and control of teachers' professional practice. Despite

these outrageous conditions, many in the profession proceeded, insisting, in our time, on "best practices" that are often at odds with the right-wing agenda of cultural authoritarianism. Janet remembers that her own sense of being an English teacher was formed in a time before Sputnik:

> My own perceptions of the potential for engaging students in the work of the English classroom were fueled by my love of reading and by my senior-year high school English teacher, Miss Biedle, who engaged us in student-and-response-centered activities before they ever were deemed "best practices."

Left to their own devices, individual teachers have often devised "best practices" according to the specificity of their school situations.

And, of course, the specificity of schools, and of classes within schools, stymie our efforts to devise such practices. Superb teachers are not superb in every setting, on every day, with every group. Nor are they superb in the same way. Teaching is context specific, as Janet remembers. Among her assignments was a class of mostly working-class students, insensitively labeled 12D. "D is for 'dumb,' one student announced to me on my first day in that class," Janet recalls. With such administered self-defeat, what is a student, what is a teacher, to do?

> I was stymied by the relational and experiential tensions between the plant managers' kids who lived on Mortgage Hill and who were students in my modern literature classes, and the plant workers' kids who lived at the bottom of that hill, or on the Mohawk Indian Reservation six miles down the road, who were my students in English 12D.

First a student of literature, Janet had to face the effect of such classification schemes on her sense of herself as a teacher. "So, daily," Janet recalls, "between sixth and seventh periods, in the momentary lull that signaled the modern literature students' departure and the English 12D students' entrance in to my classroom, I had to face the bifurcated English teacher I denied I could ever become."

Despite the odds against us, despite class conflict and "willful critical blindness," despite the gendered and racialized politics of school deform, we teachers still find ways to practice our profession: "Yet, in some ways I taught within and between the cracks of mandated . . . expectations." Such "cracks" become discernible from certain "subject positions," certain shared and situated terrain: "But I was able to pry open those cracks more readily for the students with whom I shared social, cultural, and academic backgrounds." This is, of course, no argument for cultural homogeneity, but a frank and welcomed acknowledgment that the practice of teaching is situated in culture, in race, in gender, in class, in historical moment: it is no surgical incision that can be practiced on everyone everywhere always the same. Is not the fascination—obsession—with the educational potential of "technology" the fantasy that computers can somehow clean up the mess left by history, culture, and politics without ever having to work *through* culture, history, and politics? Is not technology fantasized as education's surgery?

"What's Left in the Field?"

If conceived and enacted as a recurrent and yet always changing project,
curriculum studies would entail both recognizing and welcoming the need
to constantly un-make and re-make the field. —Janet L. Miller

Janet subtitles her American Educational Research Association (AERA) vice-pres-
idential address "a memoir." Like this collection itself, this "memoir makes no
pretense of replicating a whole life." A memoir is a collection of self-reflexive
"musings," Janet explains, "on themes or puzzles" that have run through one's
life, musings on one's narrative reconstructions of that life. She quotes Judith
Barrington's (1997, p. 88) characterization of memoir: it is a "track of a person's
thoughts struggling to achieve some understanding of a problem." In this sense, a
memoir is a recasting of one's "theoretical relationship" with oneself, a Marxian
idea of interest to Louis Althusser (1993, pp. 169–170): "I was greatly struck and
still am by something Marx said to the effect that the philosopher expressed in
his concepts (in his conception of philosophy, that is) his 'theoretical relationship
with himself.'" That "theoretical relationship" with oneself can be explored and
recast through autobiographical reflection:

> My first thoughts about linking those readings [of the phrase "what's left in the
> field"] to a "curriculum memoir" segment focused on tracing my feminist com-
> mitments to autobiographical explorations of connection, collaboration, and cur-
> riculum that call into question any seamless, unmediated, power-neutral, static
> version of "self," content, relationship—or curriculum field.

In that succinct statement we glimpse how far and how fast the field traveled
from Tyler's Rationale.

But not everyone took the journey, and even those who did, did not travel in
the same way or to the same destination. At the outset of *Understanding
Curriculum*, Bill Reynolds, Patrick Slattery, Peter Taubman and I acknowledged
this fact (with an auditory rather than spatial image) in our likening of the con-
temporary field to "a cacophony of individuals' voices . . . [a] complicated sym-
phony . . . what will sound to some as excessively contrapuntal" (1995, p. 5). Janet
lived through the collective composition of that "symphony," those sounds of
silence breaking. What her "nerves and skin remember," she tells us, is framed by
what Maxine Greene wrote in the *Educational Researcher* just after her election as
President of AERA. "There ought to be controversy among us," Maxine (1981, p.
6) pointed out, "open debate, an ongoing conversation." Maxine was clear that
we work in a field that needs reminding.

The post-reconceptualization period—the last twenty years—have been
framed, on the "outside," by an ever-increasing savagery from the political right,
scapegoating and political subjugation disguised as calls for "accountability" (what
Janet rightly terms "the technocratic and prescriptive versions of curriculum
work") and, on the inside, by continuing complaints by those still at the station,
those who still see something of value in Tyler's Rationale, those who still insist
that it's our job to tell teachers what to do. "Maxine Greene's visions for educa-

tional research remain unfulfilled," Janet rues. "I could surmise that there's nothing in the field but posturing, fiefdoms, and self-interest. Perhaps there's nothing ethically left in the field." Who has not felt such a moment of discouragement?

Integrating the relative speed and complexity of the reconceptualization would be arduous enough, even if the public world around us were not antagonistic. The combination of the two, I worry, has "shut down" some in our generation, even though many of us are still a decade or more from retirement, even though the historical moment requires that we mobilize, create infrastructure (such as the American Association for the Advancement of Curriculum Studies, of which Janet is president). Despite the speed, despite the complexity, despite the fatigue, physical and emotional, we must mobilize to continue the intellectual advancement of the field of curriculum studies.

There is second sense of "what's left in the field." This second sense conveys what Janet suggests "is departed, what is no longer present, in our work in curriculum studies." What is missing are the teachers. They have not been permitted to travel with us on the journey of reconceptualization. Rather than an occasion for impotent and misdirected rage, Janet finds this fact an occasion for mourning:

> Katherine, the first-grade teacher, decided at the last minute not to attend the [Bergamo] conference. She told us she had to withdraw because she felt torn apart by the active questioning and discussion at Bergamo. . . . There was too great a discrepancy, she said, between the kinds of curriculum studies represented at the conference and the passive, submissive atmosphere and pre-determined content that was mandated in the elementary school where she taught.

The scapegoating of teachers, their increasing subjugation by legislation (such as *Leave No Child Behind*) that disables them from practicing their profession, has left us looking at each other from a distance.

Caught in a world not of our own making, we are under assault from circumstances both exterior and interior to the field. We have not chosen the balcony; we prefer the dance floor, from which we have been barred. Given these facts, the "build it and they will come" fantasy that has, in part, inspired the curriculum and pedagogy movement requires, like the movie with which the phrase is associated, a taste for magical realism (see Pinar, in press-b). "[W]e remain," Janet concludes, sadly, sagely,

> in a crisis of identity precipitated by . . . the reconceptualization. . . . Perhaps what's left in the field is the work that it will take to address one another, not to merely mend or to make the field whole, but to engage one another with "openness with regard to the social consequences of what we do" (Greene 1981, p. 6).

As Janet appreciates, the future of the field depends on our capacity for such engagement.

First Reconceptualization, Now Internationalization

What new disciplinary, interdisciplinary, and transnational pedagogical and curricular practices and discourses might infuse and bring fresh life to what some see as a bifurcated and balkanized American curriculum field? —Janet L. Miller

Janet's question is mine as well. One of my motives in asking Janet and others to participate in the internationalization of US curriculum studies—in part through joining me in founding the International Association of Curriculum Studies and its US affiliate, the American Association for the Advancement of Curriculum Studies—was my hope that by focusing outward we might be enabled to reconfigure the field internally. Such a moment of consolidation has not yet occurred. While hardly limited to the academic field of curriculum studies, interrupting American narcissism is proving (as of this writing, in January 2004) even more difficult than I feared.

Janet and I share a second and much more important motive for internationalization, a motive Janet has articulated more eloquently, more profoundly, than have I. That motive concerns what we see as the curricular imperative to attend, as Janet phrases it, to "the worldliness of American curriculum studies." From the essay so entitled, it is clear that Janet is thinking of September 11, 2001 (which, living in New York City, she experienced in a direct way those of us outside New York cannot fully imagine). Janet is also thinking of the Bush Administration, of high-stakes testing, curricular standardization, and of "accountability." In one succinct statement, Janet synthesizes the multiple motives for attending to the "outside" of the US field:

> If we conceive of the US curriculum field as text, . . . then one major obligation is to also work the tension to which [Edward] Said alludes: how might we construct a field of American curriculum studies that does not leave it a hermetically sealed cosmos with no connection to the world, but which also avoids reducing that text to its worldly circumstances?

It is a field in-between, occupying what Hongyu Wang (2004) theorizes as space in-between: intercultural, intrasubjective, dialogic. Janet describes this space as "intertextual," as "working in and with this tension."

The field is not in that space now. It remains sealed—if divided—within the borders of an "imagined community." Like the nation, US curriculum studies seems even more withdrawn, more self-absorbed, as if still in shock, uncertain, with the future in doubt. Like the nation, the field risks reacting to external assault and internal complexity by its own version of right-wing reactionary politics, by the denial of diversity, by nostalgia for a past that never was. Janet understands that such a reaction represents a flight from worldliness:

> One danger for our field, I believe, is that the tragic events of September 11, 2001, the most recent war against Iraq, and further re-shapings of the world through effects of globalization, ecological instability, bioethics debates, instant and constant interconnection through the Internet, and new waves of immigrants and refugees could compel those of us engaged in American curriculum studies to

focus more exclusively than ever on a narrow, standards-centric version of our worldly circumstances. These same events and situations could persuade us to retreat into what seems to be our field's version of a hermetically sealed cosmos that encapsulates endless, often contentious and decidedly un-worldly debates about functions, purposes, and the varying discourses used to frame conceptions of our work in American curriculum studies.

The difficulty of the present makes the difficult decade of reconceptualization seem, in retrospect, effortless.

"The US curriculum field," Janet is clear, "especially given these most recent world events, necessarily must . . . confront the implications of curriculum as international and global text." Such text is, she underscores, simultaneously local and global, as each is embedded in the other. "To understand curriculum studies globally," she writes, "means to understand our work as potentially embedded in multiple local contexts of use, not only *around* the world but also *in* the world." Employing Deleuzian language, Janet sets the agenda for the next decade of internationalization:

> We must work to understand how we are implicated in that worldliness—implicated not only in the sense of our vested interests but also in how American curriculum studies folds in, on, and around other cultures, knowledges, and identities, and how those, in turn, now enfold American curriculum content and practices. To address such implications requires proliferating, in multi-variant ways—not constraining in a hermetically sealed cosmos—the discourses and practices that comprise our work in curriculum studies. Thus, I propose that we now ask, in light of the pressing social, cultural, and historical conditions that necessarily frame our work: . . . [h]ow will we rethink curriculum studies, yet again, as text that is fully implicated in its unavoidable worldly circumstances?

It is a question we must ask and answer individually and collectively.

We can make opportunities to do this work. The establishment of new professional associations provides infrastructure acutely needed in this nightmare time, providing (a relative) refuge from political assaults from the outside, creating safe—in-between—spaces of diversity within. Social reconstruction requires subjective mobilization. With Liz, Janet elaborates:

> [C]onstructing and disrupting fixed meanings of difference is profoundly situational, and often tedious. It is also personal and social at the same time, risky, never predictable, and requires imagination and courage of the intellect as well as of the heart. . . . And, as [Patricia] Williams reminds us, working difference is life work. "Nothing is simple. Each day is a new labor" (1991, p. 130).

In a footnote, Janet and Liz emphasize: "[W]e argue for a politics that is responsible to rather than repressive of difference."

Socially and subjectively we might undertake such responsibility by becoming internationalists, a concept once influential on the left. As Michael Hardt and Antoni Negri (2000, p. 49) remind us: "There was a time, not so long ago, when internationalism was a key component of proletarian struggles and progressive

politics in general." May it become so again. With Janet's participation and leadership, reconceptualization will be followed by internationalization.

Guernica

[T]he force of my response to one particular painting eventually would point to my efforts to understand some possible connections among curriculum, the arts, my work as an academic, and my life. —Janet L. Miller

Internationalism was at its most fervent during the 1930s, a terrible decade of economic depression, the rise of fascism, the outbreak of war, most devastatingly World War II on September 1, 1939 but, earlier, the bloody Spanish Civil War. Picasso painted a depiction of that savagery, a powerful painting he entitled *Guernica* after that city was bombed by fascists on April 26, 1937. "My nerves and skin remember a work of art," Janet tells us,

> a curriculum if you will, that was created where it was needed, within and because of massive and horrific social, political, and cultural disjunctures and tensions. That work of art, Picasso's *Guernica*, influenced and ultimately impelled me to consider the possibilities inherent in conceiving of both curriculum and teaching as human projects, where "ongoing conversation" and "new stories can root." . . . And that viewing inspired in me a conception of curriculum as a never-ending and, at the same time, potentially transformative human project.

It was an "excessive moment."

Janet first saw Picasso's *Guernica* when she was on a high school class trip to New York City. "I felt frozen by this painting," she remembers, "unable to speak even after I had backed away from the canvas, in retreat from the pain that emanated from Picasso's vision of the wanton destruction of war." It was as if "all the color had been drained from the world." Janet remembers speaking about the powerful experience of confronting the painting with Miss Biedle and her classmates, and about her reactions to *Guernica*. (This was the same Miss Biedle Janet remembers as she teaches high school English, wondering "how Miss Biedle had found the room in her curriculum to even mention the connections she saw among music, art, and the literature we were studying at the time.")

That wasn't the end of it. Janet was haunted by the painting. She read more about the Spanish Civil War and tried to figure out Picasso's political stance by studying more about the historical and political circumstances in which Picasso painted *Guernica*. Such study did not contain the experience of encountering the painting. Nor did it render the experience less compelling: "[U]ltimately, *Guernica* shattered my learned and limited ways of seeing, forced me to consider new ways of looking at life and death, demanded that I encounter, confront, and, most importantly, respond to and take action in and on competing visions of the world." It is this imprinting educational experience that informs Janet's wise counsel:

> While the "controversies among us" in the curriculum field are *not* in any way analogous to the inhumanity that provoked Picasso's shattering images, our con-

troversies may necessitate and ignite creative and imaginative acts of curriculum construction and reconstruction—visions of what "should be and what might be" in the curriculum field as well as in our schools. Intractable humanness and always-changing circumstances, with their accompanying potentials for "acts of imagination" and new beginnings, provoke us to engage one another.

Let our civil wars conclude and new coalitions assemble in that in-between space where, against the odds, complicated conversation continues.

Just as *JCT* and Bergamo—a journal and conference in which Janet Miller obviously played key roles—provided necessary infrastructure for the reconceptualization, the American Association for the Advancement of Curriculum Studies—a comprehensive and inclusive professional association, a conference, and a journal in which Janet Miller is also playing key roles—provides key infrastructure for this contemporary moment, a time of consolidation and internationalization, in which the latter engenders the former and the former animates the latter. "We haven't done it right the first time," Janet acknowledges. "We will need to do it again. What's left in the field is the need to remake our work, and our selves, again and again. And that we have the opportunity to do so is both the challenge and the gift." The balkanization and fragmentation of contemporary curriculum studies are not end-states, she is admonishing us to remember, but, rather, a "challenge" and "a gift." "What's left in the field," Janet reminds us,

> are people with nerves and skin, whose memories, representations, and connections with one another are full of "system error, of holes that connect like a tangle of underground streams." Thus we must work our relationships to one another if we are to construct and reconstruct the curriculum field as an ongoing and human project, incapable of closure yet dedicated to taking action in order to create "what should be and what might be."

Let us begin our work together, again, now.

Janet, your work has been and continues to be a challenge and a gift. Challenging us intellectually, ethically, and subjectively, your gift commemorates the past, complicates the present, and commands us to reimagine our future. Like *Guernica*, your work's power and beauty, framed in this collection, will engage those who see it. May many be moved, as I have been, by what you have painted.

ACKNOWLEDGMENTS

My interest and work in the American curriculum field began in discussions with Bill Pinar many years ago. Bill, I am grateful for the many conversations that we have shared, for opportunities to work with you on projects dear to our hearts, for your intricate framing of this collection, and for the invitation to join yet again in the complicated conversation that this book series represents.

Voices of valued colleagues, students, friends and loved ones echo throughout these selected writings. The essays gathered here especially signify my connections to and deep respect for many with whom I've collaborated, debated, researched, performed and interpreted various versions of curriculum theorizing. In particular, I thank Maxine Greene, whose friendship, scholarship, and passionate commitments to education and educators inspire me daily. I thank Paul R. Klohr and Donald R. Bateman for their unwavering friendship and accomplished mentoring that supported my first and ongoing curriculum theorizing efforts. Jean Anyon and Craig Kridel have offered insightful comments on this and every other curriculum and interdisciplinary project in which I have been involved over the years, and I am grateful.

Special thanks to En-Shu Robin Liao, who lent her incredible organizational and research support skills to this entire collection. Thanks also to other students at Teachers College, including Naoko Akai, Tan-ching Chen, Jungah Kim, Joseph Lewis, Pamela Murphy, Sophia Sarigianides and Mary Sefranek who, along with Robin, daily string together challenging and inspiring questions and insights. I'm thankful as well for stimulating conversations about this project with Chinelo Ejueyitchie, Ray Pultinas, Leigh Jonaitis, Andrew Ratner, Laurie Rice, Martha Witt and Antoinette Quarshie. Mit Allenby's administrative commitment to this project was invaluable, as was the supportive work of Nicole Kozlowski and Lena Tuck. And I very much appreciate the encouragement of colleagues at Teachers

College, including Greg Hamilton, James Albright, Mikki Shaw, Judith Burton, Nancy Lesko, Graeme Sullivan and Ruth Vinz.

The unwavering commitment of Christopher Myers, Managing Director at Peter Lang, bolstered the elongated process of conceptualizing and crafting this collection. As well, I thank Lisa Dillon, Bernadette Shade and Ace Blair for their knowledgeable production assistance.

Heartfelt thanks to Denny Camino for the art that graces the cover of this book.

To my family, my deepest thanks for your constant love and sustained interest in this project. And to Liz—for every shape of the day.

INTRODUCTION

The process of rereading one's work and situating it in historical and biographical contexts
reveals old story lines, many of which may not have been articulated. Voicing them offers the
opportunity to rewrite them, to renarrativize one's life. —Laurel Richardson,
Fields of Play: Constructing an Academic Life

In this book, I gather up old story lines that have composed thirty years of my writings as a woman working in an academic field called curriculum. These story lines sound the depths of systematic, accidental, or unconscious silences that form subtexts of the daily work of teachers and curriculum developers, theorists, and researchers. Sounding these writings again, in new contexts and times, I hope to articulate some story lines in fresh ways or perhaps even for the first time. I offer these writings as a continuation of the work of creating languages, ideas, and analyses that are capable of breaking silences or using them strategically.

And, at the same time, this collection is filled with silences. You won't be deafened with any roar of silence breaking here. And in spaces between and among silences, you won't hear one voice, one story. Rather, these gathered story lines twist and turn, collapse, and circle back on themselves—spinning out murmurs, queries, and a few shouts along the way. What you might hear, then, are some temporary and sometimes-strategic coherences as well as non-linear associational relations among stories I re-tell of becoming and refusing to become.

I talk back and across interwoven strands of my work in order to complicate, even as I attempt to articulate, my thirty years of lived curriculum theorizing and research practices. Although I'm unable to fully represent, deconstruct or perform those theorizing efforts and practices, my multivalent voices still testify to ways in which my work has been shaped in great part by—and in turn has helped to shape—the US curriculum movement known as the reconceptualization.

I had no idea what reconceptual curriculum theorizing *was* when I started to study for my master's degree at the University of Rochester in January of 1973. It took me a while to grasp what my academic advisor, William Pinar, meant when he talked in class about the need to reconceptualize the curriculum field. (I still sometimes stutter when people ask me what the reconceptualization *is/was* because, of course, it functioned more as a movement in and through particular and changing times, tensions, institutions and conditions in US curriculum history than as a "thing" that could be pinned down in any definitive way).

As an undergraduate English major and then as a high school English teacher for seven years, I felt grounded in my chosen discipline as I began my graduate studies at Rochester. But I only had experienced school curriculum as "content" squeezed into textbooks that I had to "cover" so that my eleventh-grade students could pass the New York State Regents exams and my seniors could graduate. I hadn't understood or experienced curriculum as a field of study in and of itself.

It didn't take me long to become absorbed in the work to reconceptualize the US curriculum field, however, given my classroom teacher's distaste for notions of mandated curriculum and standardized tests that were supposed to measure my students' knowledge of "English." I was eager to participate in that reconceptualization with a then-small group of individuals, scholars whose work I first encountered in my Rochester studies. From my fledgling perspective in the field, it initially appeared that these curriculum academics were united in their attempts to move the field from an administrative emphasis on behavioral objectives, design, development and evaluation to a more humanities-based emphasis on understanding educational experience, particularly in its cultural, social, political, historical and gender dimensions.

I learned though that these scholars worked from a variety of often-conflicting theoretical perspectives. In particular, I felt that early on in the reconceptualization, there existed almost a standoff between those who focused on what I'll here simply call "the personal" or "the political" in curriculum work. The prelude and Chapter 1 in Part I of this book provide background and conceptual details that point to difficulties caused by positioning as a binary those two early prominent theoretical positions that impelled the reconceptualization.

Drawn to autobiography conceptualized as a form of political work, especially because of my growing affiliation with feminist concerns in education, I struggled to figure out how I might variously voice contributions to the "complicated conversation" that now constitutes contemporary curriculum studies and that this book series represents. Early in my academic career, I conducted a number of autobiographical and collaborative studies that explored effects of silences on constructions of my "self" and others as woman teachers. In particular, I was interested in links between my sense of fragmentation as a woman teacher-academic and the structuring absences of female perspectives in the discipline of education and the field of curriculum studies, as well as women's exclusion from the production of educational culture and curriculum.

In order to pursue those interests, I worked autobiographically, initially from phenomenological orientations, in order to examine sources of—and silences sur-

rounding—my own sense of fragmentation as a woman teacher. At the same time, I shared many feminists' concerns about political agency. I was interested, as many feminists were and continue to be, in constructing modes of inquiry that not only position women as having a say but also interrogate those very ways of saying in order not to replicate patriarchal discourses and educational practices. For indeed, "one can talk about silence in ways that ask for access to a hierarchy that already exists" (DeVault, 1999, p. 183).

In 1993, Magda Lewis published her work to formulate "a conceptual understanding of women's silence not, as has been traditionally the case, as a lack that concretely reaffirms women's nonexistence, but rather as the source of an active transformational practice" (p. 3). So, in my continuing attempts to address both "the personal" and "the political" in my curriculum theorizing, I also struggled within tensions to which the work of Magda Lewis as well as bell hooks (1989) and Alice Walker (1989), for example, alluded: how, if, and when to pedagogically and conceptually address women's silences not always as absences, deficits, or essentialized attributes but rather as political acts, as forms of strategic subversive feminist agency:

> Our reclaiming of the right to name, challenge and theorize silence is a political and personal activity emerging from the (self)consciousness of our stories. We speak and write out of our collective experiences of silence, at the same time acknowledging the insights and experiences of women who have informed and who will be informed by our work. . . . Breaking silence means bursting through the surface of the other's hearing, fleshing what is resisted, cloistered. . . . [T]he implications of breaking anything can be profound and immutable. (Davies, Dormer, Honan, McAllister, O'Reilly, Rocco & Walker, 1997, p. 75)

Concurrently, I wanted to explore implications of "examining how speaking and silence, and the production of language itself, become objects of regulation" (Walkerdine, 1990, p. 31). Engaging in such debates and explorations during the early 1990s meant that I also had to consider how it might be easier for me, a white, middle-class woman who had benefited from privileges associated with those subject positions, than for women who do not benefit from such subject positions, to consider conceptions of women's silences as potentially constituting a form of political action.

So, I continued much of my feminist work within autobiographical analyses, wanting that research and writing to address questions, conceptions, manifestations and contradictions of silence and speaking through and in my own representations of "self" as teacher and academic. At the same time, I investigated, from a variety of perspectives and angles, ways to use autobiography as a form of political inquiry that could interrogate both silence and speaking as "objects of regulation." Autobiography utilized for these purposes perhaps could be one means "to make sense of everyday life and to make sense of questions of gender and of power and powerlessness" (Davies, 2000, p. 130). I wanted to engage in such forms of autobiographical research not only in relation to my constructed "selves" and to investigations of the language used in such constructions but also

in relation to and with women teachers whose background and experiences were not in any way similar to my own.

A bit later in my career, I also found incentive for pursuing feminists' wide variations on "the personal is political" in what Patti Lather posed as critical appropriations of postmodernism. In Pinar and Reynolds' edited collection (1992), Patti speaks of her poststructural work and states that it is the "intersection of postmodernism and the politics of emancipation that I put at the center of my exploration of what it might mean to generate ways of knowing that can take us beyond ourselves" (p. 257). Jane Flax's succinct question and reply gesture toward such critical appropriations of poststructural thought: "Can there be forms of subjectivity that are simultaneously fluid, multicentered, and effective in the 'outer' worlds of political life and social relations? . . . Only multiple subjects can invent ways to struggle against domination that will not merely recreate it" (Flax, 1993, p. 92–93).

The declared political work of many feminist poststructural theorists is to challenge, deconstruct, and pry open the "already known" of fixed and static identity categories and ways of knowing. This work still remains, for many, in tension with feminist standpoint theorists' quests for political agency derived from an *achieved* collective identity, such as the category "women," for example. But as Davies (2000) points out,

> Agency is spoken into existence at any one moment. It is fragmented, transitory, a discursive position that can be occupied within one discourse simultaneously with its nonoccupation in another. Within current ways of speaking it is a readily attainable positioning for some and an almost inaccessible positioning for others. . . . The language that embeds . . . dualisms needs breaking up. The dualisms that constitute the lived reality of those who are placed on the negative side need uncoupling, respeaking. Words need reworking. (p. 68)

Further, the construct of gender itself has necessarily been reworked as "what is put on, invariably, under constraint, daily and incessantly, with anxiety and pleasure," but at the same time *not* "mistaken for a natural or linguistic given" (Butler, 2003, p. 426). I agree that fluid and constructed social locations and identities (and any oppressions attached to static conceptions of these) intersect in different ways and mean differently for different groups, and that critical interrogations "of the exclusionary operations by which 'positions' are established" (Butler & Scott, 1992, p. xiv) are imperative. I continue to attempt to conceive of and enact non-essentializing *and* non-compliant configurations of "woman" in relation to my work in autobiography and curriculum. In particular, I autobiographically attend to examples of speaking and silence and their regulations as one means by which to examine how "positions are established."

This book, then, should not be read as a transparent and linear description of my cohesive curriculum theorizing and research practices, or as a definitive account of the reconceptualization. I have interrupted here and there any strict chronological arrangement of this book's selections so that they *cannot* be read collectively as a declaration, as a life history of a "US woman curriculum theorist"

who has reconciled tensions between enactments of political agency and discursively produced conceptions of changing, shifting, and contingent identities, for example.

Rather, I offer these selections as forms of autobiographical narration that provide "occasions for negotiating the past, reflecting on identity, and critiquing cultural norms and narratives" (Smith & Watson, 2002, p. 9). The specifics of such negotiations, reflections, and critiques change as I teach, research, and write across a thirty-year span of time and diverse educational contexts as well as through a slice of US reconceptual curriculum history. These selected writings whisper, buzz, warble and clank against one another as I attempt to write and re-write my selves and my inquiries, even as they too are written by and through specific events, ideas, theories, discourses, conceptualizations, moments and individuals within and beyond the reconceptualization of the US curriculum field.

I have selected writings that re-present work from my early years in academe through the present. But these are not harmonious renderings. There are no flowing compositions of my and others' work within the movement to reconceptualize the US curriculum field, no crescendos that signal culminations or completions. Instead, this collection resounds with echoes of my work alongside a number of curriculum theorists who worked, disagreed with one another, and even rejected the movement still known as the reconceptualization. It details my qualitative research and curriculum theorizing efforts as they emerged alongside inquiries with classroom teachers, students, academic colleagues, dear friends and my life partner. It reverberates with contrapuntal attempts to address, break, and reconfigure oppressive silences—silences especially surrounding women and our work in education.

But this book, centered on issues of "women, autobiography, and curriculum" certainly does not announce that all silences surrounding women's work, in education in general and in the field of curriculum in particular, have been broken. Or that all women's "authentic" voices, women's autobiographical stories and experiences can now be "discovered," recovered, and heard in all educational arenas. Or that there's even such a thing as "a woman's voice," or any singular, unitary version of "woman," "experience," or a genre or method called "autobiography," for that matter. Or even that breaking silences and being "heard" are enough to challenge gender, class, race, sexual orientation, disability or age oppressions, for example. Or that silences, once shattered, remain so.

Rather, *Sounds of Silence Breaking* attempts to articulate effects of exclusions, absences, stereotypes, disruptions, reconfigurations and generalizations within the very processes of curriculum theorizing as well as within the very categories and constructions of "woman," "voice," "experience," "identity" and "curriculum." It does not do so in any linear, chronological, developmental, or complete way. Nor do I mean to say that I automatically consider silence as that which must always be shattered. There are politically and personally charged silences—strategic silences—here too.

What I do hope is that, if read together, these essays resonate with other educators who wish to engage in the difficult work of conceiving "curriculum,"

"selves," "identity" and "gender," for example, as works-in-progress. This collection points to teaching, researching, writing and collaborating as the necessary daily effort of critiquing institutional and social-cultural spaces that would standardize, delimit, normalize or devalue our selves and our practices. And it also points to the daily need of reinventing our selves through and in these processes. This every day, always-in-the-making labor is sometimes noisy, sometimes quiet work.

.

I initially arranged this book's contents, for the most part, in the order in which the individual pieces were written. But as I re-read and "renarrativized" the work represented in this collection, I became more intrigued with juxtaposing more recent pieces with earlier ones, by either placing them next to one another or, in a few cases, actually enfolding segments of one into another. I did so, finally, because I wanted to highlight particular events or ideas or theories that continue to inform or challenge one other. I intend that these juxtaposed essays "open out upon adjoining essays as a means of exploring the conjunctures between some arguments and disjunctures among others" (Visweswaren, 1994, p. 12).

For example, the prelude and Chapter 1 in Part I: Curriculum, Autobiography offer several versions of my initial involvements with the reconceptualization, versions separated by time and interpretations of a past that, of course, is never totally recoverable. As well, these chapters present juxtaposed accounts of that curriculum movement, stories infused with particular relationships and interests and written at different moments within and after the reconceptualization. The last selection in Part I, springing from my study of Maxine Greene's scholarship, points to my more current conceptions of autobiographical inquiry in education and, at the same time, indicates ways in which autobiographical theorizing is always in-the-making. That essay, like one other in this section, juxtaposes excerpts from another piece and, at the same time, foreshadows themes, concepts, ideas and individuals whose work and influence reverberate throughout this collection.

Part II: Women, Autobiography contains work that represents the beginnings of my writing of a "voice," a feminist curriculum theorizing voice that grappled with what I then, in the late 1970s and early 1980s, tended to describe as the dichotomous or fragmented parts of my educator "self." At that time, I worked within liberal feminists' conceptions of woman, voice, and gender. I'm no longer comfortable with many of those particular essentialist, universal, and unitary assumptions that frame these early pieces. This is because I've been persuaded by poststructural feminist claims that subjects and "voices" are irreducibly multiple. Thus I am challenged to write autobiographically without essentializing my "selves" by the very categories that I have constructed or that have been constructed for me to talk about those selves. I now consider fragmentation as suggestive of openings, crossings, and spaces in and through which to disrupt notions of authoritative and "finalized" discourses or identity constructions. At the same

time, I'm compelled by postmodern concerns with the desire for a space for agency without granting "that identity space the standing of an essence" (Sedgwick, 2003, p. 64).

Although such postmodern challenges inform my more current work, the early feminist pieces located in Part II do demonstrate some uses of hermeneutical and existential phenomenology as philosophical frameworks for describing, in relation to education, structures of "experience" as they present themselves to consciousness. For example, during my initial scholarly efforts in the 1970s and early to mid-1980s, I particularly focused on my work *as* a woman teacher. I tried to suspend my presuppositions about my fragmented "self" in order to enter into my female academic life-world and to study the specific phenomenon of the gendered nature of my teaching.

Early on in this work, then, I struggled with the phenomenological notion of "bracketing" my teaching experiences, to engage in Husserl's phenomenological reduction so as to describe the intentionality of my teaching and theorizing practices. But instead, Heidegger's emphasis on making manifest what is hidden in ordinary, everyday experience and Merleau-Ponty's denial of the possibility of bracketing existence encouraged me to begin to focus on methods of interpretation, on ways that "understanding" moves from originary experience through language as an expression of the bodily experience of the world and back again. Such versions of phenomenology seemed to me, at the time, to support calls for studies in curriculum that examined the "self" in relation to social, cultural, and political contexts—in relation, for example, to the "hidden curriculum" and language of ordinary, everyday classrooms and ways in which they gendered educational experience.

Part II thus also contains writing that attempts to complicate and multiply the sound of my singular "voice" and to explore some situated examples of gender relations in education. Several essays offer differing examples of those attempts. In one, I engage the work of one researcher, Cinthia Gannett, and her inquiries into relationships of gender to writing practices in the university. In several others, I attempt to disrupt academic writing practices that require me to adopt the all-knowing, authoritative voice of the academy. I do so in one selection, for example, not by studying my students' and my own writing practices, as did Gannett, but rather by writing a citation-less inquiry into my sixth-grade teacher's pedagogy and the gendered nature of my responses to his teaching practices. That essay performs, as do some others in this collection, aspects of what Bill Pinar (1994) calls the regressive phase of his autobiographical method of *currere*—a reentry into the past and its conscious reincorporation into the present.

My interests in examining gendered constructions of myself *as* teacher as well as my focus on issues of representation and interpretation have continued in a variety of research and curriculum theorizing forms throughout my professional career, even as I eventually re-focused my feminist explorations to include poststructuralist conceptions of and concerns about language, subjectivity, identity, difference, power and human agency. That re-focusing was one response to my moving away from what were my initial individual explorations of myself as

woman, student, and teacher. I moved instead into forms of collaboration that challenged any unitary representation of myself or of collaborative efforts.

In particular, the essays in Part III focus on a series of long-term collaborative research projects with other teachers. In those projects I struggled with issues of representation, power relations, agency, volatile and shifting identity constructions, performativity and multicentered subjectivities as well as with ways in which those issues still required me to consider insidious effects of gendered conceptions of teaching, researching, and collaborating. Two of the pieces elaborate on aspects of my six-year collaboration with five other teacher-researchers, aspects that I initially described (in relation to copious responses from the five other participants) in *Creating Spaces and Finding Voices: Teachers Collaborating for Empowerment* (1990a). But even vast amounts of input from "research participants" can never finally signal complete and stable "reciprocal and equitable" research relations or identities—or so I've learned through this and other collaborative ventures.

Two selections in Part III take up similar issues of power, representation, voice and identity in relation to my participation as a member of a large research team engaged in an intensive three-year qualitative research study of school change across the United States. Those issues also frame my five-year collaboration with five teachers in an elementary school located on a rural edge of Madison, Wisconsin.

In the essays in Part III: Teachers, Difference, Collaboration, I still am working tensions between "authorized" academic forms of writing and autobiographical writing as a form of curriculum theorizing. I extend my initial autobiographical inquiries about my "self" as woman student, teacher, and academic into my local professional relations with other teachers, curriculum colleagues, students and researchers. While attempting to investigate uses of autobiography and feminist curriculum theorizing with teachers in the field, especially, I again had to consider ways in which my desires for a "whole" self were a reflection of Enlightenment discourses and social structures, particularly in US education, that promised such unity. By engaging in such analysis within the contexts of my work with other teachers and curriculum theorists, I began to consider and to examine my gendered "selves" as both constructing and constructed by normative discourses and practices in education. And my interests turned to the relations between and among other educators as well as to constructions of my various academic woman teacher researcher selves that those normative discourses and practices made both possible and impossible.

And the first and last essays in this section on Teachers, Difference, Collaboration are examples of collaborative, experimental, and cross-disciplinary thinking and writing with Mimi Orner and Elizabeth Ellsworth. They especially complicate and re-sound our "voices" through interactive, synergistic, and juxtaposed moments in our teaching, researching, and writing. Most important to me is that these first and last selections in Part III particularly portray a way of conducting and performing my academic life—in relation to and with people I admire and deeply love—toward which I continually aspire.

In Part IV: Autobiography, Curriculum, I continue to interrogate difference in relation to autobiographical representations of my "identities" as constructed through gender and sexual orientation categories as well as in relation to my home discipline of English education and to a reconceptualized (and some would argue now deeply fragmented and balkanized) US curriculum field. Part IV opens with my juxtaposed readings of "what's left in the field" as a response to a recurring press for standardization of purpose for US curriculum studies. I choose "memoir" as a vehicle for positing, across a span of time, various perspectives on debates in the curriculum field about what counts as curriculum research and theorizing as well as what counts as the field's relationship to practice. Memoir segments, contiguous with my diverse analyses of "what's left in the field," draw attention to incomplete and always interminable processes of conceptualizing a self as well as a field. These segments also point to the intractable humanness of education that requires us to engage one another, regardless of differing discourses, ideologies, historical, social and cultural situations, needs or desires. My hope is that myriad readings of "what's left in the field" compel conceptualizations of curriculum studies as always differing human projects, never fully realized, yet obligated everyday to reinvent themselves.

That obligation everyday to reinvent our selves and our fields is a theme that especially reverberates throughout this section. In particular, that obligation frames a brief concluding chapter in Part IV in which I gesture toward what I, along with many others, perceive as the now necessary participation of the US curriculum field in the internationalization of curriculum studies.

In the Coda, I describe work-in-progress, work that reinforces, affirms, and returns me yet again to my interest in the work and life of Maxine Greene. In engaging in research and relational processes that could result in what we variously are calling a "collaborative, double-voiced, recursive auto/biography," I hear sounds of my work in autobiography, gender, and curriculum studies rumbling and colliding in new and challenging ways. And yet there will be silences in this work-in-progress too, perhaps strategic as well as unintended, unconscious, unchallenged or unequal silences. The sound of silence breaking is never predictable, never welcomed on all fronts, never guaranteed, never uniform in its ascribed or intended or unintended meanings. And neither are we.

.

For this collection, I primarily have chosen previously published book chapters as well as journal articles that have not been reprinted in books. All published selections, although in revised form, appear with their original publication dates noted. This book also contains unpublished writing, including the Interludes between certain selections. These Interludes, written in the vein of Laurel Richardson's (1997) "writing stories," allow me, as Richardson suggests, to explore and highlight the situated nature of knowledge making that the process of rereading one's work compels. So I do use these Interludes as historical and biographical "contexts and pretexts" (Richardson, 1997, p. 1) for this book's particular selections.

But I also use them to *work* my ambivalence about this very collection. In them, I tell a bit more about what and who influenced me to write a particular piece, and about the times and situations in which I wrote. But of course, I composed the Interludes from memories and remnants—of letters, copies of old Bergamo and AERA conference programs, photographs, conversations. Every time I reread and renarrativized the published work contained here, and every time I composed an Interlude, I wanted to add a different detail, elaborate on a half-formed idea, revise any hint of a solidified, finished self. At the same time, I sometimes welcomed a notion of the same old me, still afraid that my colleagues and students would not consider versions of an incomplete, often unknowing and in-the-making self as "academic enough"—as authoritative, knowing, knowledgeable, certain.

Ah, still caught up in the very discourses, assumptions, and tensions with which I struggle throughout this collection—or so my theoretical preferences would shout. But one commitment that murmurs throughout this book does feel right in its constancy: to question meanings of silence in every arrived-at definition of women, autobiography, curriculum.

Permissions

I gratefully acknowledge the following journals and publishers for permission to reprint:

(1978). Curriculum theory: A recent history. *The Journal of Curriculum Theorizing*, 1(1), 28–43. Corporation for Curriculum Research, Rochester, NY.

(1981). The sound of silence breaking: Feminist pedagogy and curriculum theory. *The Journal of Curriculum Theorizing*, 4(1), 5–11. Corporation for Curriculum Research, Rochester, NY.

(1983). The resistance of women academics: An autobiographical account. *Journal of Educational Equity and Leadership*, 3(2), 101–109.

(1992). Shifting the boundaries: Teachers challenge contemporary curriculum thought. Reprinted with permission from *Theory Into Practice*, 31(3), 245–251. Copyright 1992 by the College of Education, The Ohio State University. All rights reserved.

(1992). Teachers, autobiography, and curriculum: Critical and feminist perspectives. Reprinted by permission of the publisher from S. Kessler & B. B. Swadener (Eds.), *Reconceptualizing early childhood education* (pp. 103–122). New York: Teachers College Press. Copyright 1992 by Teachers College, Columbia University. All rights reserved.

(1993). Solitary spaces: Women, teaching and curriculum. Reprinted by permission from *The center of the web: Women and solitude* by D. Wear (Ed.), The State University of New York Press. Copyright 1993 State University of New York. All rights reserved.

(1994). "The surprise of a recognizable person" as troubling presence in educational research and writing. *Curriculum Inquiry*, 24(4), 503–512.

(1995). Women and education: In what ways does gender affect the educational process? In J. L. Kincheloe & S. R. Steinberg (Eds.), *Thirteen questions: Reframing education's conversation*, 2nd Edition (pp. 149–156). New York: Peter Lang Publishing.

(1996). Curriculum and the reconceptualization: Another brief history. *JCT: Journal of Curriculum Theorizing*, 12(1), 6–8. Corporation for Curriculum Research, Rochester, NY.

(1996). Excessive moments and educational discourses that try to contain them. With Mimi Orner and Elizabeth Ellsworth. *Educational Theory*, 46(1), 71–91. Copyright by *Educational Theory* and The University of Illinois Board of Trustees.

(1996). Teachers, researchers and situated school reform: Circulations of power. Reprinted with permission from *Theory Into Practice*, 35(2), 86–92. Copyright 1996 by the College of Education, The Ohio State University. All rights reserved.

(1996). The human histories: Hermeneutical portraits and Janet Miller's Bergamo Presentations. *JCT: Journal of Curriculum Theorizing*, 12(4), 41–43. Corporation for Curriculum Research, Rochester, NY.

(1996). Working difference in education. With Elizabeth Ellsworth. *Curriculum Inquiry*, 26(3), 245–264.

(1998). Autobiography and the necessary incompleteness of teachers' stories. Reprinted by permission of the publisher from W. C. Ayers & J. L. Miller (Eds.), *A light in dark times: Maxine Greene and the unfinished conversation* (pp. 145–154). New York: Teachers College Press. Copyright 1998 by Teachers College, Columbia University. All rights reserved.

(1998). Autobiography as a queer curriculum practice. In W. F. Pinar (Ed.), *Queer theory in education* (pp. 365–373). Mahwah, NJ: Lawrence Erlbaum, Publishers.

(1998). Biography, education and questions of the private voice. In C. Kridel (Ed.), *Writing educational biography: Explorations in qualitative research* (pp. 225–234). New York: Garland Publishing, Inc. Reproduced by permission of Routledge, Taylor & Francis Books, Inc.

(1999). Curriculum reconceptualized: A personal and partial history. In W. F. Pinar (Ed.), *Contemporary curriculum discourses: Twenty years of JCT* (pp. 498–508). New York: Peter Lang Publishing.

(2000). English education in-the-making. *English Education*, 33(1), 34–50. Copyright 2000 by the National Council of Teachers of English.

(2000). What's left in the field . . . A curriculum memoir. *Journal of Curriculum Studies*, 32(2), 253–266. (http://www.tandf.co.uk)

CURRICULUM, AUTOBIOGRAPHY

The life narrator selectively engages aspects of her lived experience through modes of personal "storytelling"—narratively, imagistically, in performance. That is, situated in a specific time and place, the autobiographical subject is in dialogue with her own processes and archives of memory. The past is not a static repository of experience but always engaged from a present moment, itself ever-changing.—Sedonie Smith and Julia Watson, *Interfaces: Women/Autobiography/Image/Performance*

INTERLUDE 1

In 1996, Craig Kridel established and began serving as editor of "Hermeneutical Portraits," a section that appeared regularly in *JCT: The Journal of Curriculum Theorizing*. Craig concluded his editorship of that section, devoted to providing a historical glance at curriculum theory, in the latter part of 2003. By then, he had established a "tradition" of periodically requesting a Bergamo Conference participant to review a list of her or his Bergamo presentations and to discuss any thoughts and reflections stimulated by that list. The "Bergamo Conferences," as they are now collectively and colloquially known[1], are the ones started in 1973 at the University of Rochester by Bill Pinar, the ones eventually sponsored by *JCT*, the journal that Bill founded in 1978 and the one for which I served as managing editor from 1978 through 1998.

Craig invited me to compose the "inaugural" Bergamo reminiscence for "Hermeneutical Portraits." That informal reflection and its accompanying listings of my Bergamo presentations appear here, in updated form, as a prelude to this collection. This prelude contextualizes, to some extent anyway, themes, interests, struggles and obsessions that sound throughout this book. And it provides glimpses of the people, ideas, places and events that have greatly influenced my work and life.

Craig's invitation of course has a history. Craig, as curator of the Museum of Education at the University of South Carolina, already had archived, tabulated, and contributed important conceptual analyses of materials from a number of curriculum scholars, in particular, and of educators, in general. And in 1995, I was sitting in the audience when he presented to a large Bergamo audience his conceptual analyses and tabulations of presentations (work aided by Bill Schubert, Russell Long, and Virginia Richards) at US curriculum theory conferences. I wasn't the only one in the packed conference room who loved Craig's summation

and analysis of presenters' themes, his slide show of various participants over the years, and the juxtaposing of "histories" represented at those conferences. Then, in 1997 in Bloomington, Indiana, at the 19th Annual Conference on Curriculum Theory and Classroom Practice (the "official" Bergamo Conference title), Bill Schubert and I responded to Craig's bountiful collection of slides as platform for our collective discussion of curriculum theory conferences from 1973 onward and their influences on the American curriculum field. Our Bergamo Conference session was entitled "Reflections on *JCT* Conference 'Histories'—A Twenty-Five Year (or so) Retrospective."

I would guess that, in particular, the lively audience reception to his inspired 1995 presentation bolstered Craig's resolve to introduce "Bergamo" reminiscences into "Hermeneutic Portraits." But I should ask him: Craig and I have known each other since 1974, when we both were at the very beginnings of our doctoral studies at The Ohio State University. Thirty years later, we still talk with one another about the field of curriculum (among many other topics), and we wonder together about its future.

Note

1. Throughout this collection, I will refer to *JCT*'s collective conferences as "Bergamo." Here, I follow Craig Kridel's (1996) lead:

 > After considerable discussion on the matter of an appropriate "working title" for the *JCT* Conference on Curriculum Theory and Classroom Practice, I have decided to use the term "Bergamo" to represent all avant-garde curriculum theory conferences that have been held in the autumn since 1974. The term offers as much (and as little) clarity as such titles as "Baroque" and "Renaissance" offer their respective eras, and using a common term is easier than trying to distinguish Airlie, Bergamo, DuBose, [Four Winds] or Banff Conferences. (p. 41)

 For an elaborated discussion of these conferences, see also Kridel (1999).

HERMENEUTICAL PORTRAITS
The Human Histories

I am experimenting with examining my life . . . with giving my work purpose and direction, through remembering where I have been.—Louise DeSalvo, *Vertigo*

I can't remember what I wrote about for my first academic talk that heads the listing of my "Bergamo Conference" presentations. [The list appears at the end of this chapter.] On the program, it's listed as "Round Table Discussion #4," one of several roundtables scheduled at the 1975 curriculum theory conference held at the University of Virginia. That's the conference where I drove from Columbus to Charlottesville with Bob Bullough, both of us doctoral students at The Ohio State University. The one where I still called myself Janet Fassett, just divorced and not quite ready to reclaim my maiden name. The one where I secretly hoped no one would attend Roundtable #4, because what could I, as a second-year doctoral student, possibly say about curriculum when people could hear Maxine Greene and James Macdonald speak?

I had first heard Maxine and Jim, as well as Dwayne Huebner, Donald Bateman, and Paul Klohr, present or facilitate sessions at the 1973 curriculum theory conference at the University of Rochester, where Madeleine Grumet and I were master's degree students, studying with William Pinar. Bill, with great encouragement from Paul Klohr, his mentor in curriculum studies at Ohio State, had organized and served as Chair of that 1973 gathering, now identified as the first of the "reconceptual" curriculum theory conferences. Little did I know then that these individuals would become major influences in my personal and academic lives.

I officially was introduced to Maxine Greene in 1974 at the Xavier University curriculum theory conference in Cincinnati. I sat with Maxine and a few others at breakfast one morning and listened as she threaded together ideas from the latest novels and essays that she had read as well as from current theatrical and dance

performances and museum exhibitions in New York City that she had attended, and what all of these had to do with curriculum theorizing. In particular, she talked not only of her commitments to the arts, especially literature, as means of breaking with the taken-for-granted, but also of her increasing interest in the work of women in education, and of her desires to challenge gender-biased conceptions of curriculum and research. In that one breakfast conversation, Maxine touched on a number of my own just-developing academic pursuits. And she did so in ways that resounded with my English major and teacher background and experiences, even though I was too terrified to say so at the time.

In particular, at that beginning point in my academic career, I was interested in studying gender as a construct and the ways it permeated my understandings of myself as teacher. So, I was determined to hear more, to hear Maxine in her gravelly Brooklyn-bred voice talk about women and education as well as about Sartre, literature, the arts, imagination and *praxis*. Those determinations, sparked at both the 1973 and 1974 conferences, led to my dissertation at The Ohio State University on Maxine's scholarship and its relations to curriculum theorizing, even as she rejected any "reconceptual" designation of her own work.

One of the moments that I do recall vividly about that 1975 conference in Virginia was that I actually was able to finally speak with Maxine. In that conference setting, we began what has become an elongated conversation about our interests in literature, curriculum, teaching and issues of gender as they influence our roles as women academics. I remember, too, that, in a general session at the Virginia conference, Bill Pinar and Madeleine Grumet presented portions of their important work in autobiography that drew on existentialism and psychoanalysis and that soon thereafter would appear in *Toward a Poor Curriculum* (1976).

And I know that in fact I did write a paper for Roundtable #4, even if I can't retrieve the contents[1], because I can remember talking through it for weeks in Columbus with my friends Craig Kridel and Bob Bullough. In good weather, our discussions usually took place on the back porch of my North High Street second-floor, seventy-dollar-a-month apartment in Alhambra Court. It was the apartment that Paul Klohr, Bill Pinar's mentor first and then mine, had spotted during the weekend that Bill and I arrived in Columbus from Rochester to look for my graduate student housing. Craig, Bob, and I often discussed our work and our doctoral student lives as we scrunched together on my apartment's back-porch swing that creaked in swinging rhythm with our chatter.

Conversations with Craig and Bob as well as Leigh Chiarelott, Rick Lear, George Dixon and Jim DiGiambattista accelerated when we met with Paul in his North High Street, plant-filled office in Ramseyer Hall at Ohio State. Sometimes Paul Shaker, although further along in his doctoral studies, would join us. Our weekly doctoral seminar in curriculum theory focused not only on the upcoming 1975 curriculum theory conference, but also on the ways in which the "reconceptualist articles of faith" that our mentor had described at the 1974 Xavier conference (Klohr, 1974) might be enacted and enlarged upon at the 1975 meeting.

What I can trace, then, from that 1975 conference and even from that presentation that has no name and no recoverable content, are the people who influ-

enced my initial as well as subsequent work in the field of curriculum. The accompanying listing of my Bergamo Conference presentations certainly reflects my academic interests as well as particular events and theoretical orientations within and beyond the move to reconceptualize the field. But not so immediately evident from such a listing are the often complex and entangled yet undeniable relational histories that saturate my work and my life.

For example, I've served as managing editor of *JCT: The Journal of Curriculum Theorizing* since Bill Pinar established the journal in 1978. I served my first year as conference director in 1979, the year that I began my first academic appointment at Old Dominion University in Norfolk, Virginia. That was the first year of the *Journal's* official sponsorship of the conference associated with the reconceptualization. It was the year that Bill and I assembled the conference proposals into a program by literally sifting through papers strewn about on the living room floor of my apartment and arranging those accepted proposals into what we thought might be appropriate session groupings. And it was the year that I had to greet people as they straggled down the steps of the chartered bus that had transported them from Dulles Airport to the conference center—The Airlie House in Virginia, just outside Washington, D.C. As they gathered in a circle around me on Airlie's manicured front lawn, I had to inform those weary and bewildered travelers that some would have to double up on rooming assignments because the CIA—with whom we were sharing conference room space during that long weekend—had booked all the single rooms upon their arrival, thus bumping, so to speak, my months-ahead arrangements. It was an interesting twist on the relational aspects of curriculum theorizing (or so I tried to tell myself as I smiled brightly at the new roommates and conference attendees).

Of course, my interests in the relational in my academic work are not divorced from the conceptual, theoretical and methodological pursuits that are reflected in the listing of my Bergamo Conference presentations. I think one big reason why the conferences sponsored by *JCT* over the years drew a loyal following was that the reconceptualization itself was about understanding curriculum as *intersections* of the political, the historical, and the autobiographical. Thus, ideas presented and issues wrestled with at Bergamo did not just spew forth from ahistorical, de-contextualized talking heads, but rather emanated from actual persons working (differently) within particular historical moments in US education. Even as our theoretical perspectives differed, as did we ourselves, we seemed to share, at the minimum, a deep commitment to moving the curriculum field from a technical and prescriptive emphasis on content design and development to a focus on understanding the nature of educational experience, broadly defined.

My involvement in the curriculum field, as that field was being reconceptualized and as it continues to change and shift in its constructed emphases, primarily hinges on the interrelatedness of individuals and implications of that interrelatedness for constructions of curriculum, pedagogy, and research. My work is driven by the sharing of ideas, passions, and theoretical and personal commitments to teachers, students, and colleagues as well as to curriculum theorizing as an always changing yet potentially liberating practice.

Thus, I can't review any one of these listed conference presentations in isolation, either from one another or from particular individuals and the specific contexts and moments that memories of those individuals evoke. For example, my early feminist presentations at the curriculum conferences were not detached from the circumstances in which I wrote and taught or from the people with and about whom I studied. I had followed my initial interests in Maxine Greene's work as I worked toward and through my dissertation. And I began to explore a variety of feminist theories, theories at first liberal and then later more postmodern in orientation, not only because of my continuing involvement with Maxine's scholarship, but also because I was teaching about and living through, with equally committed friends and colleagues, a series of theoretical and activist waves especially generated by the Women's and Civil Rights movements in the US, as well as the war in Vietnam.

Those events of the 1960s framed an introductory course entitled "Women and Education" that I conceptualized in 1979 at Old Dominion University. That course, one of the first to introduce feminist perspectives into course offerings in the Darden School of Education at ODU, was supported more by the director of women's studies, Nancy Bazin, than it was by education faculty—my first encounter with certain segments of academic resistance to anything labeled "feminist."

Working through the discomfort created my initial feminist foray, and attempting to connect feminist and reconceptual ideas of autobiographical inquiry, I conducted a long-term interview study of a number of women teachers (Miller, 1986b) and their reasons for and questions about choosing a profession that had become associated in the US with "women's work." That interview study, conducted in the early years of my second academic appointment, at St. John's University in Queens, NY, began my concomitant academic focus on exploring questions of representation, especially in relation to issues of power, gender, and difference, that were being raised by those committed to the doing of qualitative research in post-foundational times. My interview study also was informed by work in which Bill Pinar and I had traced our interests in the growing emphasis on gender studies within the reconceptualization. In that effort, we chronicled a "recent history" of feminist theory and gender research in curriculum studies (Pinar & Miller, 1982) and then updated our "history" at a Bergamo presentation in 1989. That update eventually appeared as a large segment of chapter seven in Pinar, Reynolds, Slattery and Taubman's *Understanding Curriculum* (1995).

During the early years of the *JCT*-sponsored conferences, I also met and talked long hours at Bergamo with other feminists working in curriculum, including Patti Lather, Magda Lewis, Ann Berlak and Deborah Britzman, all friends whose work and commitments continue to inspire me. And Bergamo is where I met my amazing friend, Mimi Orner, who introduced me to her doctoral mentor at the University of Wisconsin-Madison, Liz Ellsworth—a meeting that has changed my life in innumerable and wondrous ways.

So, it wasn't just one curriculum theorist, or one academic event, or one feminist perspective that initiated or impelled the work reflected in this Bergamo Conference presentation listing. It was a compilation and confluence of historical moments in the field of curriculum and particular individuals who helped to create those moments that initially enabled me to explore connections among my interests, commitments, and academic lines of inquiry.

The list of my conference presentations indicates some of those connections. My English major background and seven years of high school English teaching experience provided context for my initial phenomenological curriculum theorizing that interrogated historical, psychological, and social-cultural influences on constructions of what I initially viewed as my own "woman teacher identities." As I continued to examine reasons why and ways in which I had internalized so deeply those identities that US educational and social discourses and histories had a major role in constructing, I also began working collaboratively with academic colleagues as well as K–12 classroom teachers. I did so perhaps as another way to disrupt and challenge what I heretofore had considered to be merely my isolated, individual and "personal" constructions of my "self." My subsequent work has focused, in part, on exploring effects of various discursive and psycho-social influences on what often are construed as "true," unitary and transparent autobiographical renderings of teachers' identities in relation to processes of school reform, professional development, and collaborative research among university and classroom teachers.

Postmodern critiques of and influences on conceptualizations of qualitative research, autobiography, and feminist theories in the field of curriculum strongly influenced, for example, my six years of collaborative work with five other teacher-researchers. That collaboration began during my tenure at St. John's University and continued through my fours years at Hofstra University on Long Island. *Creating Spaces and Finding Voices* (1990a) only details the first few years of that collaboration. Our group's presentations for several years in a row at Bergamo enabled us to draw larger, longer, and more nuanced portrayals of ever-changing and often conflicting agendas, issues, and identities constructed through and beyond educational discourses that framed our collaborative research. As well, Bergamo provided a recurring context for me both to ponder and to testify to the immense influence that this group of individuals has had on my educational commitments and understandings.

Three other long-term qualitative research and curriculum theorizing ventures have been influenced by that original and major collaborative research project. These too have provided focus for a number of my Bergamo presentations. So, in addition to the six-year teacher-researcher collaboration, I have engaged in long-term work as: (1) a collaborator with and consultant to elementary and secondary English/Language Arts teachers for nine years in one school district on Long Island while I taught at St. John's University from 1982 through 1988 and then at Hofstra University from 1988 through 1992; (2) a member of a large research team engaged, for three years in the mid-1990s, in a national study of "school reform" efforts in five high schools, located in differing geographical and

socio-economic contexts across the US; and (3) a researcher for five years in a collaborative study with five classroom teachers who worked in a multi-age, interdisciplinary program in an elementary school located just outside Madison, Wisconsin. This long-term study took place during the years I taught at National-Louis University, from 1992 through 2000.

Within all these elongated studies, unpredictable, complex, often changing and conflicted collaborative work called into question any seamless, transparent, and unitary version of "self," "identity," "experience," "voice" or "collaboration" in our educational enactments of autobiography, qualitative research, and curriculum theorizing.

So, whether presenting with my fellow teacher-researchers in a symposium session, or working with Mimi Orner and Liz Ellsworth as a stand-up comic collaborator in "Camp Theory" at the Bergamo Conference in Banff, or clapping in time with Patti Lather's accordion-playing introduction to a Bergamo symposium session, or joining with Bill Pinar to present the annual Macdonald Prize and Aoki Award, or engaging in conversations and dancing with my colleagues and collaborators in the main lounge of Bergamo Hall on a Saturday night—at the same time, I was working on and with the ideas, conceptualizations, and theories that infused our often rambunctious renderings. This list of my Bergamo presentations only begins to touch on the relations that continue to complicate, challenge, and enrich my work. This listing, however, has allowed me to honor those incomplete and yet vibrant memories of "where I have been" as evidence of that connectedness that informs and impels my work.

Note

1. Actually, during the course of revising and researching for this book, I came across the title of my 1975 presentation in a footnote on page 97 in Bill Pinar's 1994 collection, *Autobiography, Politics and Sexuality: Essays in Curriculum Theory 1972–1992* (New York: Peter Lang). The title of my 1975 "Roundtable #4" presentation was "Duality: Perspectives in Reconceptualization." I'm sure, now that I've "recovered" the title, that the general focus of that presentation included issues I discuss in the following chapter.

Janet L. Miller's Bergamo Conference Presentations

1975 "Round Table Discussion #4" (Janet Fassett)
1976 "Deceptive Arts in Pedagogy"
1977 "Curriculum Theory of Maxine Greene: A Reconceptualization of Foundations in English Education"
1978 "Feminism, Theology, and Teacher Education"
1979 Conference Director (no presentation)
1980 "The Sound of Silence Breaking: Feminist Pedagogy"
1981 "Feminism and Curriculum Theory"
1982 "Perspectives on Curriculum Theorizing"
1983 "Women as Teachers: Reflections and Rejections"

1984 "Marking Papers and Marking Time: Issues of Gender in Teachers' Self-Concepts"

1985 "Writing as Discovery: Teachers' Emerging Texts"

1986 (1) "Researching Teachers: The Problems and Potentials of Collaborative Studies"; (2) "Recognizing Images in Their Own Caves of Lascaux: Returning to Teachers' Writing, Journals, and Texts"

1987 (1) "Teachers as Researchers: Personal Reflections"; (2) "The Theory and Practice of Liberating Research and Pedagogy"

1988 "Expanding Contexts of Discovery: Teachers/Researchers' Reflections on Two Years of Collaborative Studies"

1989 (1) "The Arts as a Basis for Understanding Curriculum and Teaching"; (2) "Remembering Forward: Explorations in Educating for Peace"; (3) "A History of Feminist Theory and Gender Research in Curriculum Studies"; (4) "Creating Spaces and Finding Voices: Teachers/Researchers' Reflections on Collaborative Inquiry"; (5) "Concepts and Narratives: The 'Mother' Problem in Feminism and Education"

1990 (1) "Continuing Issues in Creating Spaces and Finding Voices"; (2) "Breaking Forms: (Re)Reading Power & Authority in Academic and Feminist Discourses"

1991 "Curriculum as Autobiographical and Biographical Text: Selected Issues"

1992 (1) "Conferencing: Doings and Undoings"; (2) "Curriculums of Works in Progress: Enactments and Engagements"; (3) "Turning and Facing the Repressed in Our Own Curriculums and Teaching Practices: A Performance Conversation"

1993 (1) "An Agenda for a Second Wave of Curriculum Reconceptualizing: A Response"; (2) "Troubling Research/Exceeding Dialogue: 'Hit It, Louise!'"; (3) "Rewriting Gender Equity in Teacher Research"

1994 (1) "The Color of Fear: A Response"; (2) "Stand Up Theory"; (3) "Working Difference in Education"

1995 (1) "Missing Autobiography: Disrupting 'Cheerful' Teachers' Stories"; (2) "Situated Pedagogy and School Reform: No Guarantees"

1996 "What is This Thing Called Self? Issues of Private Voice in Biography and Autobiography"

1997 (1) "Reading 'Ellen's' Coming Out as an Educational and Political Intervention"; (2) "Reflections on *JCT* Conference 'Histories': A Twenty-Five Year (or so) Retrospective"

1998 "Reflections on Twenty Years of Bergamo Conference Presentations"

2004 (The 25th Anniversary of Bergamo) (1) "A Conversation on 'A Second Wave of Curriculum Reconceptualization'"; (2) "Remembrances of Conferences Past: Airlie House and Bergamo from the 1970s and 1980s"; (3) "The Birth of Bergamo and *JCT*"

INTERLUDE 2

The following chapter enfolds three essays that represent my various and partial accounts of a "personal history" in relation to events and ideas that connected (but surely did not coalesce) a number of people who worked to reconceptualize the US field of curriculum studies. I've dropped small sections from work published in 1978 and in 1996 into this 1999 piece in order to elaborate, to clarify certain points, and to draw—from my situated perspectives—several extended portraits of both the movement and some of the individuals who contributed to the reconceptualization.

I want this piece, as a whole, to portray my local and contingent viewpoints on reconceptual history. I spend some time detailing theoretical and ideological tensions in order that readers never view the reconceptualization as a movement in which all participants agreed—or even liked each other, for that matter. At the same time, I hope to convey some sense of the excitement that accompanied my (and, I think, a number of others') participation in the start-up of *JCT* and the Bergamo Conferences especially. But I also would have to say now, in retrospect, that I probably elongated this 1999 version of my "personal history" in relation to the reconceptualization as one way of lingering over multiple memories of a formative, challenging, and yes, exhilarating time in my career and my life. This enfolded essay charts the trajectories of much of my subsequent academic interests, research, and writing—and alludes to personal relationships that still provide reason and momentum for my work.

CURRICULUM RECONCEPTUALIZED

A Personal and Partial History

With Segments from "Curriculum Theory: A Recent History" (1978)
& "Curriculum and the Reconceptualization: Another Brief History" (1996)

I have my own version of a "history" of the US curriculum theory movement known as the reconceptualization, and of *JCT: The Journal of Curriculum Theorizing*[1] and the annual conference it sponsors. It's a history spun from my work as managing editor of *JCT* from its inception in 1978 through 1998 and as conference director for many of those years. And it's a history inundated with fragmented memories of particular individuals, places and ideas as well as with my own interpretations of their intersecting and sometimes contradictory relationships. For this version, I embellish [and utilize segments of] my earlier chroniclings (1978; 1996a) of the reconceptualization through a focus on two primary influences on and manifestations of the movement—the journal and its conferences.

Of course, as I construct this version, I also must acknowledge that in all remembering, there is forgetting. Thus, this is a partial history—partial in terms of preference and commitments as well as gaps, warps, slants and silences.

To write about twenty-five years of what still is termed by many as "reconceptualist" work also compels me to acknowledge that there are those in the curriculum field who have little or no knowledge of this curriculum movement. There are those who do not know about, or who choose to ignore or marginalize work that *JCT* publishes and supports through its annual conference, colloquially known and referred to here as "Bergamo."[2]

At the same time, many curriculum scholars and practitioners have participated in the Bergamo Conferences or have contributed to work aligned with the spirit of the reconceptualization. That work takes the form of master's theses, doctoral dissertations, journal articles, books, workshops, and presentations and performances not only at Bergamo but also at annual meetings of the American Educational Research Association (AERA), among other education conferences. As well, the influence of the reconceptualization on the field of curriculum stud-

ies, both nationally and internationally, has been documented in a variety of synoptic curriculum texts, journal articles and conference presentations.[3]

Of course, as William Pinar has explained, there never has been any methodologically or ideologically unified "reconceptualist" point of view. Still the label "reconceptualist" persists, even as "the reconceptualization" of the curriculum field has been accomplished in terms of incorporating theory, history, and research orientations into what heretofore had been an exclusively practice-oriented endeavor (Pinar, 1988).

Thus, whether acknowledged in broad curriculum circles or not, many people associated with the reconceptualizing of the US curriculum field have worked for more than twenty-five years to move the field away from its long-standing managerial, technocratic, and positivist orientation, and toward multivocal, multiperspectival theorizings of curriculum. Contemporary curriculum theorists have moved from either neo-Marxist or phenomenological and existential orientations that characterized much of early reconceptualist inquiry into a riotous array of theoretical perspectives that point to expansive and complex conceptions of curriculum reconceptualized. At the same time, I suggest that those working in curriculum studies who still align with the spirit and original intentions of the reconceptualization are loosely united by a commitment to examine, within educational contexts, what Patricia Williams asserts: "That life is complicated is a fact of great analytic importance" (1991, p.10).

Early Markers of the Reconceptualization

From my perspective, a history of the US reconceptualization, of *JCT* and of Bergamo begins in the 1960s. Paul Klohr, in 1967, helped to organize a conference entitled "Curriculum Theory Frontiers" at The Ohio State University. Klohr presented a paper, as did Elsie Alberty, Kelly Duncan, Alexander Frazier, Jack Frymier, Charles Galloway, Dwayne Huebner and James Macdonald. This 1967 conference marked a gathering of individuals who were honoring the twentieth anniversary of the first US curriculum theory conference. That 1947 conference, held at University of Chicago, was entitled "Toward Improved Curriculum Theory," and participants included Hollis Caswell, Virgil Herrick, B. Othanel Smith and Ralph Tyler.

The work presented at the 1967 conference not only marked a break from the dominant technocratic emphases on curriculum design and development that had characterized the field, but also foreshadowed James Macdonald's essay, "Curriculum Theory" (1971). In that influential publication, Macdonald noted disagreement among US theorists about the purpose of curriculum theorizing. He identified three major camps: (1) those who see theory as a guiding framework for applied curriculum development and a tool for its evaluation; (2) those who are committed to a conventional concept of scientific theory and who see the purpose of theory as primarily conceptual in nature; and (3) those who see theory as a creative intellectual task that should be used neither as a basis for prescription nor as an empirically testable set of principles and relationships. Here I elaborate

on Macdonald's influential publication with a section from my 1978 piece, "Curriculum Theory: A Recent History":

> In speaking of those for whom curriculum theorizing is a creative intellectual task, Macdonald notes that such individuals may choose to criticize existing conceptual schema and/or to develop new means by which to view and to examine all that is named curriculum. The separate tasks of criticism and of creation later became important distinctions in the structural organization of William Pinar's edited book, *Curriculum Theorizing: The Reconceptualists* (1975a). Macdonald's initial naming of these tasks indeed influenced the conceptual framing of the reconceptualization. (pp. 31–32)

In the late 1960s, Bill Pinar began his doctoral studies in earnest at Ohio State, with Paul Klohr and Donald Bateman serving as his mentors in curriculum theory and English education, respectively. (During the time that he taught high school English on Long Island, Bill also studied with Dwayne Huebner at Teachers College, Columbia University). As Bill studied curriculum theory with Paul, their discussions necessarily included analyses of the 1947 and 1967 curriculum theory conferences, Macdonald's 1971 article, and their subsequent influences on the field.

The 1967 conference, Macdonald's delineation of varied perspectives on the purposes of curriculum theorizing, and Paul Klohr's encouragement and far-reaching visions for the field—all provided incentives and support for Bill as he began his first academic appointment at the University of Rochester. As an assistant professor, he organized and served as chair of a curriculum theory conference entitled "Heightened Consciousness, Cultural Revolution, and Curriculum Theory." Curriculum theorists who attended or presented papers at this conference at the University of Rochester, in May of 1973, were united only by their objections to the primarily managerial and prescriptive nature of the curriculum field in the US. These scholars included James Macdonald, Maxine Greene, Dwayne Huebner, Robert Starratt, Donald Bateman, Paul Klohr, William Pilder and William Pinar. The conference proceedings were published the following year; that collection represented the first nationwide indication of a move to reconceive not only the role of curriculum theorists but also the field itself (Pinar, 1974). Again I elaborate with a section from the 1978 piece (pp. 33–35):

> At the Rochester conference, a loosely felt collective need to examine educational experience in light of the radical changes in contemporary culture of North America during the 1960s and early 1970s, including the war in Vietnam as well as the Civil Rights and Women's movements, provided a shift in emphasis from the "social needs" orientation of the aforementioned 1947 Chicago Conference to "value gestalts," which included existentialism and phenomenology as philosophical bases. That collective need also provided impetus for attending to Macdonald's call for theory that encompassed social, human, and personal qualities. Further, because the "cultural revolution" in the US during the 1960s was viewed by many as a revolution of consciousness, theorists such as Pinar argued that those who were examining the nature of contemporary educational experience must focus upon the inner states of those who are involved in the process of

learning as well as upon actions that follow from those states. Intending the theme of the Rochester Conference to provide a possible point of synthesis at that historical juncture in US curriculum studies, Pinar commented on themes developed at the meeting:

> Huebner and Greene have worked persistently on questions of mean-ing and language, and both extended their positions in ways that raised interesting questions for practitioners and theorizers alike. My work, which has been exploring a phenomenological approach that draws heavily on psychoanalytic theory, offered a partial explanation of the conference theme. Bateman and Pilder offered political and cultural analyses. Bateman drew on the work of Freire to support his belief in the need to "demythologize" curriculum. By implication, Pilder makes a compelling case for the creation of intentional communities which might foster what he terms "mutual indwelling." These two theorists urge a fundamental reexamination of the relationship between curricu-lum, the school, and society. All papers attempt, in some fashion, to deal with internal experience. . . . While individual paths may differ markedly, ultimately we seek the same, and that has something to do with the cultivation of wisdom. This, finally . . . recalls the theme of consciousness and cultural revolution. (Pinar, 1974, pp. ix–x)

Discerning the shape of the future of curriculum theorizing as indicated by themes in the Rochester papers proved to be a difficult yet important task. Pinar identified primary areas of concern: reform of the curriculum field must be the-oretical, political, and psychological; it must invoke a reworking of language employed to all described phenomena linked to curriculum; it must involve a politically sensitive approach to schooling relationships as well as to analysis of curriculum materials; it must involve a shift in focus to one's inner states (Pinar, 1974, p. x). Macdonald's calls for social, human and personal qualities as bases for theorizing were beginning to be realized.

The atmosphere that prevailed at the 1973 conference must be noted as well. Many in attendance attribute much of what has evolved from that initial confer-ence to "reconceptualize" the field of curriculum, albeit characterized by ideo-logical polarities and resistance to labeling and categorization, to a shared quest for a "new grounding for the professional curriculum field" (Benham, 1976, p. 11). For example, Maxine Greene noted that the conference "escaped the usual convention spirit" (Benham, 1976, p. 15), and Paul Klohr described the potential he felt for building a new paradigm for curriculum theory:

> It is the kind of excitement I experienced during the very early days of A.S.C.D. [Association for Supervision and Curriculum Development] when a relatively small group came together to spearhead fresh devel-opments in the field of curriculum. This was before A.S.C.D. became so large and diverse in its aims that in order to survive it felt obliged to offer a bit of everything for everyone at all times and, consequently, became completely submerged in the so-called conventional wisdom. It is the kind of feeling rekindled one had at the pioneer Granville Conference on creativity that Ross Mooney sponsored before "creativ-

ity" became the password for every modish curriculum change, how-
ever trivial. (Klohr, 1974, p. 5)

That sense of excitement, of commitment, sustained the work of many of us
who have participated in the yearly conferences since 1973. However, to declare
that unity or alignment of perspective had occurred within the reconceptualiza-
tion would be incorrect.

Divergent Perspectives

For a further understanding of differing views, in the early 1970s, of the theoret-
ical and conceptual approaches and methodologies that "should" be utilized to
reconceptualize the curriculum field, consider Pinar's second edited book,
Curriculum Theorizing: The Reconceptualists (1975a). One basis for conflict emerged
from Pinar's organizational scheme of the collected papers, as well as from his
claims for that particular segment of thinking that he labeled "postcritical,"
aligned with what Macdonald had identified as "creating the new."

The book is divided into four sections: (1) the state of the field, (2) historical
criticism, (3) political and methodological criticism and (4) post-critical theoriz-
ing. Drawing from Macdonald's discussion of "three major camps" of curriculum
theorists, Pinar distinguished among what he termed traditionalists, conceptual-
empiricists, and reconceptualists. And among the reconceptualists, who attempt to
understand "self" and the nature of educational experience, Bill posited the work of
those he termed "postcritical" as shifting from criticism of the old to creation of
the new. Modes of inquiry were literary, historical, and philosophical, and Bill's
work, especially, demonstrated the strong influence of psychoanalytic theory.

But some, after the publication of the 1975 text, took issue with Bill's defini-
tion of "postcritical" as separate from and apparently—from the arrangement of
the book—of greater importance than reconceptual political and methodological
criticism of "the old," the traditionalists and the conceptual-empiricists. Again, a
section from my 1978 piece (p. 38):

> William Burton (1974), in a correspondence with Pinar in November of 1974,
> stated that Pinar's definition of postcritical—a concern with transcendence and
> consciousness, a moving away from the criticism of the old into a creation of the
> new—obscures and minimizes the importance and necessity for political criticism
> and action. Burton argued that the existential-phenomenological approach that
> characterized much of what Bill termed "postcritical" thinking was an evasion of
> the reality of political oppression that characterized US life in the 1970s.
> Reliance upon such existential-phenomenological philosophical perspectives,
> Burton asserted, mystified the issues and could only lead to yet another version of
> a moribund curriculum field. Bill's reply at the time (1974) was that all acts must
> begin with self, and that recognition of self and of one's place in the world could
> become ultimately political, for one is then free to act—once one has at least
> gained some measure of understanding of one's "self." One's experience may then
> be placed and acted upon within its political, cultural, and psycho-social dimen-
> sions.

These initial conflicts between what I here will reduce to the terms "the political" and "the personal" characterized the early years of the reconceptualization and its journal and conferences. In retrospect, these conflicts, initially situated in binary and oppositional terms, only begin to suggest the tensions among a multitude of perspectives and theoretical orientations and discourses, including historical, poststructural, hermeneutic, constructivist, neo-Marxist, feminist, psychoanalytic, cultural, queer and phenomenological, from which contemporary curriculum theorists work. At the same time, those initial "personal" and "political" orientations, and even the conflicts between them, hinted at the generative effects of what I argued in 1978 should become the necessarily interdisciplinary and intertextual bases for curriculum theorizing. Again, from the 1978 publication (pp. 39–40):

> The fact that much attention has been paid to the various "namings" of the divergent realms within which many curriculum theorists are working indicates, I believe, a positive phenomenon; the point is not that we must reach agreement or consensus about the named contexts or theoretical framings of our work, but rather that we are infusing life into the curriculum field by our very careful attentiveness to the specific limitations and possibilities of our various and often dichotomous perspectives.

> In reviewing, then, the recent history of curriculum theory, it seems to me that we *do* resemble one another in a larger sense in that we are committed to the importance of curriculum theory as a crucial arena of educational research and practice. Our diversity provides us with possibilities for evoking understanding as well as alterations of conceptual and theoretical representations of the realities that we construct. Thus, I argue that we must acknowledge our differences, and at the same time allow the framing of conflict to provide us a means for movement within a comprehensive commitment to the reconceptualization of the curriculum field, writ large. As Macdonald noted:

>> I do not believe that there is any fundamental contradiction in the long run between those theorists who advocate a personal change position and those who advocate a social change orientation in terms of changing consciousness toward a liberating praxis. . . . Neither approach need be exaggerated to the point of exclusion of the other. (1977, p. 10)

> Clearly, major issues that drive the work of curriculum theorizing are diverse. Thus, in some respects, concentration upon attempts to prove the correctness of one particular approach or stance threatens to stall movement and growth within the field. In order to create a living and vital field, we must acknowledge the varied dimensions that inform and constitute our work. Rather than become entrenched in one perspective, risking rigidity and immobility in the name of conviction, we must open our theorizing to the possibilities of examining the nature of educational experience within and among differing cultural, political, social, economic and biographic contexts. We must view our work as a means by which we may communicate our chosen concerns. At the same time, we need to listen to the voices of individuals and to consider possibilities as well as impossibilities of constructing a collective curriculum voice for change and social justice.

To accomplish this, we must not work in isolation. One point crystallizes as we pause to review curriculum theory's recent history: the calls for open exchange, for dialogue, for acknowledgment of the life-giving energies of a variety of perspectives appear as immediate and clear priorities.

Extending a Personal History of JCT and Its Conferences

There are reasons, of course, that I here incorporate segments of my earlier "histories" into this piece, and that I identify some of the beginnings of US curriculum reconceptual history with a conference organized by Paul Klohr at The Ohio State University. By the autumn of 1974, with my University of Rochester mentor Bill Pinar's encouragement, I was a doctoral student at Ohio State, studying curriculum theory with Paul and English education with Donald Bateman, just as Bill had done before me. And I began writing about the reconceptualization as part of my doctoral studies because I was able to participate in its initial organizational and conceptual endeavors.

For example, in my first year as a doctoral student, I traveled, as did my fellow doctoral students Bob Bullough, Craig Kridel, Leigh Chiarelott and Paul Shaker, to Xavier University in Cincinnati, Ohio, for the October 1974 Curriculum Theory Conference. That was where I heard Maxine Greene speak informally for the first time, at a breakfast punctuated by her wide-ranging analyses of curriculum in relation to the arts, especially. Others at the table had to carry the conversation with her; I was overwhelmed but enthralled. Again, from my 1978 piece (pp. 35–36):

> Timothy Riordan chaired the 1974 conference. Presenters included Maxine Greene, Dwayne Huebner, James Macdonald, William Pinar, William Burton, Paul Klohr, Ross Mooney, Tim Riordan, Francine Shuchat-Shaw and David Williams. The themes of the 1973 Rochester Conference, those of heightened consciousness and cultural revolution, were in evidence, and indeed, appeared bolder and in more specific language than before. Burton and Williams specifically pressed for political awareness. Pinar's paper, based on existential and psychoanalytic perspectives, dealt in depth with an evolving autobiographical method he called *currere;* Mooney's paper presented challenges to curriculum workers to conceptualize "curriculum for life." Both appeared at odds with the political concerns expressed by Burton, Williams, and several others at the conference.

> One way of understanding the apparent inevitability and perhaps even the necessity of tensions developing among these theorists is to note common threads that run through their work. In his careful assessment of the state of the field, Paul Klohr presented to those of us attending the Xavier Conference important guidelines for viewing the work of those within the third category of the Macdonald analysis: these people are engaging in fresh modes of inquiry in order to create the new. Conflicting ideas concerning ways and means of such creation are inevitable within such initial work. Klohr (1974, p. 5) identified a framework within which one could trace common elements that characterized the works-in-progress of those committed to a reconceptualization of the field:

1. A holistic, organic view is taken of man and his relation to nature.
2. The individual becomes the chief agent in the construction of knowledge; that is, he is a culture creator as well as a culture bearer.
3. The curriculum theorist draws heavily on his own experiential base as method.
4. Curriculum theorizing recognizes as major resources the preconscious realms of experience.
5. The foundation roots of their theorizing lie in existential philosophy, phenomenology, and radical psychoanalysis, also drawing on humanistic reconceptualizations of such cognate fields as sociology, anthropology, and political science.
6. Personal liberty and the attainment of higher levels of consciousness become central values in the curriculum process.
7. Diversity and pluralism are celebrated in both social ends and in the proposals projected to move toward these ends.
8. A reconceptualization of supporting political-social operations is basic.
9. New language forms are generated to translate fresh meanings— metaphors, for example.

Klohr's analysis emphasized the diversity of foci as well as of methodology employed by those working toward the reconceptualization. Certainly, these people do not work as a cohesive group, and yet binding elements emerge from a commitment to betterment of individual and collective educational experience.

Other conferences, organized by individuals associated with the reconceptualization, followed the one at Xavier University: 1975 at the University of Virginia, chaired by Charles Beegle; 1976 at University of Wisconsin-Milwaukee, co-chaired by Alex Molnar and John Zahorik; 1977 at Kent State, chaired by Richard Hawthorne, and 1978 at both Georgia State University, chaired by Wayne Urban and Dorothy Huenecke, and Rochester Institute of Technology, chaired by Ron Padgham. I attended all of these.

The Journal

Throughout Bill Pinar's graduate work and later, during my doctoral studies at Ohio State, Paul Klohr had been encouraging the establishment of a journal devoted to what Paul called "fresh" approaches to the conceptualization of curriculum studies and work. And what had become clear to many of us involved in the curriculum theory conferences from 1973 through 1978 was that there were few journals and fewer spots on the program at the annual meetings of the American Educational Research Association (AERA), at least in the mid and late 1970s, that were open to work that incorporated political or phenomenological-existential-autobiographical theorizing. Thus, in 1978, Bill Pinar, with the royalties from his 1975 edited book, *Curriculum Theorizing: The Reconceptualists*, established *The Journal of Curriculum Theorizing*, now known to most as *JCT*. He invited me to serve as managing editor, a position I held through 1998.

The journal declared a two-fold purpose: (1) to provide an open forum for curriculum theorists to explore various cultural, political, and psychological dimensions of the field, and (2) to acknowledge the variety of perspectives that characterize these various dimensions by printing criticism of such work.

During that first *JCT* organizing year of 1978, on an old manual typewriter, I haltingly composed letters to Maxine Greene, Dwayne Huebner, Paul Klohr and James Macdonald, among others, asking for their support in terms of serving on our editorial board or presenting at the conferences that the journal officially started to sponsor in 1979. Although Greene and Huebner declined board of editors membership, our original board included distinguished scholars as well as newer scholars in the field. This mix has continued to characterize the *JCT* board of editors, even as its membership has rotated and changed through the years under the editorship first of Bill Pinar, then Bill Reynolds, Jo Anne Pagano, co-editors Brent Davis and Dennis Sumara, Patrick Slattery [and, currently, Marla Morris].

Our first journal issues were produced on electric typewriters. In fact, our whole effort to establish the journal had a grassroots feel to it. For example, we initially rejected possibilities of journal publication under the aegis of a large publishing house so that we might retain our commitment to and decisions about the publishing of avant-garde work. So, for the first decade of *JCT*'s existence, we were attempting to publish a journal with international circulation without the benefits of desktop computer production.

In those early years, the *JCT* editors decided to purchase a "composer," a typewriter-styled machine that could produce typeset copy. First Bill, then Margaret Zaccone (whose organizational and managerial leadership continues to support *JCT* and the Corporation for Curriculum Research in substantial ways), and then Eileen Duffy, my program secretary at St. John's University, typed issues of the journal on the "composer." Not until the end of the 1980s were we finally able to enjoy the advantages of desktop publishing.

The first issues of *JCT* were 8½ by 11 sized, with plain white covers and black binding. But the simplicity of our journal design and production belied the excitement that Bill and I and the board of editors felt as we forged a new space in the curriculum field for what many still insist on calling, in diminishing ways, "alternative" voices, discourses, and perspectives.

As the journal moved into libraries and into graduate curriculum studies classrooms, we began to receive a substantial number of manuscripts submitted for consideration. Fully aware of the risks of establishing a new journal, I was elated by these submissions, for they indicated that curriculum scholars were viewing the journal as a viable publication arena as well as a welcoming venue for avant-garde work. The commitments of Paul Klohr and Bill Pinar to establishing a journal that would welcome "fresh" perspectives and forms of inquiries in the curriculum field were indeed visionary.

The Conferences

In 1979, *JCT* began to officially sponsor the reconceptual conferences. Still a relatively small group, we met at the Airlie Conference Center, outside Washington, D.C. from 1979 through 1982. I have vivid early Airlie memories: prior to our first "official" conference, Bill Pinar and I assembled the first program into what we hoped were viable session combinations from proposals strewn about on my living room floor in Norfolk, Virginia. Jim Macdonald sat with us at the Airlie Center and helped to distribute nametags to participants at the makeshift registration table. Bill and I paced Airlie's green manicured front lawn, waiting to greet all the conference participants arriving on the two buses that I had scheduled from Dulles Airport. I stood at the podium in Airlie's main meeting room and announced, just before each set of concurrent sessions, the room assignment for each participant. A masked Gail McCutcheon delivered her paper to the assembled Airlie crowd on Halloween night. Madeleine Grumet presented the first version of her influential "Conception, Contradiction, and Curriculum" paper, Bill Pinar elaborated his autobiographical method, *currere*, and Jacques Daignault and Clermont Gauthier introduced poststructuralism into our conferences as well as curriculum theory discourses—all at Airlie.

As the *JCT* conference grew both in numbers and reputation, we moved to the larger Bergamo Center, associated with the University of Dayton in Ohio. We made this move in order to avoid ideological conflicts not only over the plantation-with-slave-quarters origins of Airlie House but also with various groups that met simultaneously at Airlie, including the CIA.

During the initial Bergamo-site years (1983–1993), the *JCT* conference became known outside curriculum theory circles, and grew to include participants from a variety of fields in education. Presentation modes grew more diverse as participants began to include performance, exhibition, and media representations. The yearly conference was acknowledged as a major arena for curriculum theorizing, and served as a marker for many major events in the field, both theoretical and personal. For example, a profound moment at Bergamo occurred when many gathered to mourn the death of James B. Macdonald, and at the same time to celebrate and commemorate his vastly influential curriculum theorizing. One vivid image among many: Dwayne Huebner's hands grasping both sides of the podium as he struggled to complete his tribute to Jim.

I always will recall Bergamo as a dramatic as well as dizzying confluence of people and ideas. Those ideas (and people) were discussed with great intensity, not only in the daily multiple sessions but also each evening in the lounge area of Bergamo Hall. Given my particular academic interests, I especially recall Bergamo as the setting for the emergence of multiple and groundbreaking versions of feminist curriculum theorizing and methodologies.[4]

These perspectives and many others swirled into memorial moments, often elongated by informal and yet catalytic performances and discussions of ideas and theories professed in the more formal sessions. So I remember just as well Ron Padgham's humor that both lightened and informed any session he attended; Craig Kridel's fabulous slide shows and commentaries on curriculum scholars and

histories; Tom Kelly's "best titles of Bergamo" contest; Jesse Goodman, Bill Schubert, and Bill Ayers's symposia where they regularly featured their doctoral students; the presentations of the Macdonald Prize and the Aoki Award (I distinctly remember squeals of excitement from the audience as Bill and I announced Sue Stinson, University of North Carolina-Greensboro, as the recipient of *JCT*'s first annual Macdonald Prize). In all of this recounting, I remember selectively, influenced most dramatically by, and therefore naming here, those with whom I've worked most closely over the years.

Acknowledging the long-term support and participation of Canadian curriculum scholars at Bergamo, the editors agreed to sponsor the 1994 annual conference in Banff. Then, after many years of meeting at Bergamo, a reduction in that site's physical accommodations motivated the move for the 1995 and 1996 conference to the DuBose Center in Monteagle, Tennessee. The 1997 and 1998 conference locale was Four-Winds Conference Center just outside Bloomington, Indiana. In 1999, new lodging arrangements at the Bergamo Center allowed the return of the conference to its namesake site.

Situating Histories

In recalling the establishment and development of both the journal and its conferences, then, I return again and again to my multiple, intersecting, and conflated memories of those exciting first years of *JCT*'s existence. And I return to the conceptual and methodological perspectives and debates that framed our attempts to establish the journal and its annual conference as helping to create viable spaces in which to pursue work that, at the time, was considered very much outside the curriculum mainstream. Given that some in the field still regard much of this work as fringe, and given that technocratic, mechanistic, predetermined and linear constructions of curriculum still hold sway in elementary and secondary schools in the US, the commitments and goals described in 1979 in the very first published announcement of *JCT*'s existence seem pertinent still. That 1979 announcement claimed that the work of the reconceptualization was, in one essential sense,

> the work of developing alternatives. It is more ambitious however; we aspire to a fundamental reconceiving of current ideas of curriculum. . . . The journal will not be afraid to publish works of writers who are not well known, including work by graduate students. We are especially interested in work that is intellectually experimental. We are willing to take risks, publishing material more conservative journals would reject. Some of these articles will be controversial—at least we hope so.

> We intend to print pieces that speak to schoolteachers and administrators, to interested laymen, as well as to our colleagues in colleges and universities. On occasion, we will print articles written with the often-powerful simplicity of the autobiographical voice. At the same time, we remain conscious that the journal is responsible to the field as presently constituted. Our primary commitment is to assisting the field to take its "next step," but we recognize that such a step can

only finally be taken by us all, by traditionalists, and conceptual-empiricists as well as by reconceptualists. We want to minimize the rigidifying effect ("here I stand, there you stand") such categories often have. We want exchange, including criticism. (p. 1)

I have included these goals and commitments as part of my brief and partial history because I believe it is important to situate the original intentions of *JCT* and its conferences. My limited history, of course, provides only one lens through which to contextualize how and why initial reconceptualizing work erupted within a field that had been called moribund just a few years earlier (Huebner, 1976; Schwab, 1970). But to historically situate these beginnings, even in limited ways, is necessarily to call attention to particular aspects of the US field during the 1960s and 1970s as well as to their historical antecedents. It is to call attention to particular and various theoretical orientations that emerged in response to technocratic and controlling conceptions of curriculum. It is to note that curriculum conceived only as predetermined "content and facts" to be "covered and memorized" seemed, in light of the war in Vietnam and the Civil Rights and Women's movements as well as the proliferation of education's so-called Romantic critics such as Kozol, Dennison, and Holt, and the development of "alternative schools," for example, to be devoid of human "relevance," to use a word of the times.

At the same time, I urge ongoing social, historical, and cultural contextualization of current work represented in the journal and its conferences as well as in the general US curriculum field. Such situating can illuminate the continuing need to challenge managerial approaches to, and technocratic, ahistorical constructions of curriculum. In light of current mandates for standardized testing and "procedures" for accountability that are imposed on both K–12 schools and schools of education across the US, the challenges represented by the reconceptualization remain pertinent for teachers, students, and curriculum theorists alike.

Thus, to historically situate *JCT* and the Bergamo Conferences is also to call attention to the ways in which conceptualizations of curriculum as only predetermined "content and facts"—conceptions that ignited the establishment of the journal and its conferences and underlined the urgency of that "reconceptualist" work—still often attend in our classrooms, in our work with students, teachers, principals, and superintendents, parents and community members. Therefore, those of us who are still alarmed about mechanistic and behaviorally oriented manifestations of curriculum work in schools must continue to interrogate any and all curriculum constructions that deny aspects of the reconceptualization. Although the field itself has been reconceptualized (Pinar, 1988), I believe that our work to theorize, to question, to constantly rewrite our selves with, and in, curriculum "reconceptualized" is not finished.

I agree, then, that what identifies more than twenty-five years of US curriculum theorizing is not the term reconceptualist per se, but rather collective and diverse approaches to resisting technologies of education that try to separate content, pedagogy, and learning into discrete, measurable, and observable units of behavior and product. One ongoing characteristic of *JCT* and its conferences is a

commitment among its participants to reveal and to challenge traditional conceptions that insist on a static definition of curriculum as a predetermined, linear, depersonalized, apolitical, and discrete body of knowledge. Such a definition completely misses the analytic importance of those complications of life, including relations of power and discourses that construct both knowledge and identities, that cannot be predicted or controlled.

Many of us continue to grapple with such complications through and with the multiple discourses, experiences, concerns, and interpretations of students, teachers, parents and school administrators. For example, I argued, in "Curriculum and the Reconceptualization: Another Brief History" (1996a, p.7):

> that our theorizing as curriculum scholars, as curriculum workers, always has been and is performed in relation to particular situations and social-cultural contexts, and thus in relation with and to particular teachers, students, administrators and others in educational settings. Our work to theorize, to question, to constantly re-write ourselves and our work with and in such relations is part of a "reconceptualized" definition of curriculum.
>
> As such, this work then contradicts still predominant efforts in education to universalize and standardize curriculum conceived only as subject matter. Curriculum reconceptualized resists such effects because they sever the relationships that converge to enact and create teaching and learning situations and episodes. Reconceptualized curriculum theorizing challenges efforts to technologize pedagogies that accompany such standardizations and separations. It interrupts attempts to reify educational experiences of teaching and learning as transparent, replicable, and unitary.
>
> For many of us working within the spirit of the reconceptualization, our research and writing projects have taken as major concerns the daily lives, the lived curriculum of students and teachers, including our own teaching, researching, writing selves. We might be developing critical analyses that focus on unequal power relations and ways in which these replicate social structures and economies, or we might be developing autobiographical modes of inquiry and interaction with our students and teachers with whom we work that simultaneously call into question the selective and representational aspects of our own story telling. We might be developing collaborative approaches to school leadership that concurrently question the seductive and unifying aspects of collectivity in order to raise and wrestle with issues of difference. Whether we are working from neo-Marxist, phenomenological, feminist, psychoanalytic, poststructural, hermeneutic, or any other theoretical orientation, we are working within the spirit and commitments, if not the name, of the curriculum field's reconceptualization. That is, we are challenging traditional conceptions of curriculum as linear and sequentially organized fixed bodies of knowledge. And we are working to illuminate sources and effects of the multiple discourses that construct learning contexts, processes, experiences, and even identities of both students and teachers.

Versions of such challenging theorizing can be heard now, not just at Bergamo but also at AERA conference presentations and performances, in the pages of diverse education journals, and in the classrooms of those with and for

whom we work. Those of us who have participated and continue to participate in the scholarship that has become known as reconceptual in nature are necessarily grounding that work in our own daily educational practices because we recognize the implications of Patricia Williams's claim: "that . . . life is complicated is of great analytic importance." Further, the field of curriculum reconceptualized enables us to always question and always again theorize, from a variety of perspectives, "what it means to educate, what it means to be educated" (Pinar, Reynolds, Slattery & Taubman, 1995, p. 8).

My remembering, as well as my obvious commitments to the journal and its conferences, reflect, of course, my investments in the work and theorizing of all those associated with *JCT* and the reconceptualization. My memories here attempt to honor the connectedness that informs and impels my own work as well as the scholarship of others long involved in this project called the reconceptualization. At the same time, a curriculum field reconceptualized requires this final acknowledgement: the brief history I've reviewed here speaks of, as well as constantly questions, my partiality in terms of remembering, interpretation, and attachment.

Notes

1. The journal's original title was *The Journal of Curriculum Theorizing*. During Jo Anne Pagano's term as editor, the Board of Advising Editors voted to change the title to *JCT: An Interdisciplinary Journal of Curriculum Studies* to recognize the acceptance of *JCT* as an identifying acronym as well as the expanded dimensions of work appearing in the journal. During Brent Davis and Dennis Sumara's co-editorship, the title was changed once again to *JCT: Journal of Curriculum Theorizing* to acknowledge the journal's historical roots.

2. Throughout this article, I will refer to *JCT*'s collective conferences as "Bergamo." Here, I follow Craig Kridel's (1996) lead:

 > After considerable discussion on the matter of an appropriate "working title" for the *JCT* Conference on Curriculum Theory and Classroom Practice, I have decided to use the term "Bergamo" to represent all avant-garde curriculum theory conferences that have been held in the autumn since 1974. The term offers as much (and as little) clarity as such titles as "Baroque" and "Renaissance" offer their respective eras, and using a common term is easier than trying to distinguish Airlie, Bergamo, DuBose, [Four Winds] or Banff Conferences. (p. 41)

3. Space does not permit me to document the proliferation of references that address the reconceptualization. See Pinar, Reynolds, Slattery, & Taubman's 1995 text, *Understanding Curriculum*, as well as Kridel (1999) for extended documentation of these writings.

4. Patti Lather worked early versions of her important book, *Getting Smart* (1991a) at various Bergamo sessions; Ann Berlak (1994), Magda Lewis (1990), and Mimi Orner (1992) elaborated their influential ideas about feminist pedagogy; Liz Ellsworth presented her first version of the now widely cited and powerful critique of critical pedagogy, "Why Doesn't This Feel Empowering? Working through the Repressive Myths of Critical Pedagogy" (1989) in a Bergamo session; Flo Krall worked on her

poetic analyses of ecological issues in relation to curriculum (1988a); Jo Anne Pagano presented early excerpts of *Exiles and Communities* (1990); and Deborah Britzman (1992, 1993) brought her analyses of poststructuralism, multiculturalisms, and psychoanalytic theory to Bergamo sessions.

INTERLUDE 3

I wrote the following piece for the 1998 collection that Bill Ayers and I co-edited, *A Light in Dark Times: Maxine Greene and the Unfinished Conversation.* I crafted this piece primarily as rumination on ways that Maxine's scholarship has deeply influenced themes and issues in my own. That was the intent of the edited collection. In honoring her expressed desires for that book, Bill and I had asked contributors not to discuss or analyze Maxine's writings, per se, but rather to illustrate, describe, theorize ways in which particular themes and concepts within, or approaches to her unique and widely significant body of work had affected their own.

It was during a coffee and cookie break at a Bergamo Conference in the mid-1990s that Bill had asked me to consider the possibility of co-editing such a collection. I immediately agreed because I knew Bill Ayers shared my admiration and love for Maxine and her ardent commitments to teachers and students, to teaching for and about social justice, and to the arts as means of stimulating what Maxine calls "social imagination." But Bill and I came to our particular framing for the Maxine book, as we tended to call it, not because of our long-term individual relationships with Maxine but rather because she told us, in no uncertain terms, that she did not want to be positioned as an "icon." That was the major reason she gave for not attending any but the very early reconceptual curriculum theory conferences. She just didn't want to be talked about—or addressed—as if she were a figurehead, a fixed and completed abstraction instead of a real person who is always changing and becoming.

Maxine's insistence on framing her work and her life with an existential emphasis on the necessary yet stressful act of constantly choosing undergirds issues that I address in this piece. Specifically, placing this writing here in the collection introduces various tensions in the uses and forms of autobiography in education

with which I wrestle throughout this book. This particular work also gestures toward effects of solidified, reified gender constructions, especially of myself as "woman-teacher-academic," that occupy many of my investigations represented in this collection.

I situate this article here, then, not only as an elaboration of connections to Maxine that I delineated in the opening selections in Part I or as foreshadow of Coda, the last piece in this collection, but also as invitation to interrogate my work in autobiography, gender, and curriculum that follows. It certainly is not any definitive statement on autobiographical, gender, or curriculum inquiry in education. Rather, this essay—supplemented with excerpts from another piece published in 1998—highlights concerns I still ponder as I write and teach autobiography as both genre and method, as I explore current constructions of and debates about gender, and as I situate both autobiography and gender studies as vital yet contested terrains in curriculum theorizing and educational research.

AUTOBIOGRAPHY AND THE NECESSARY INCOMPLETENESS OF TEACHERS' STORIES

With Segments from "Biography and Questions of the Private Voice" (1998)

No one of us can see the whole or sing the whole. Since I was a little child, I have known that all perspectives are contingent, that no one's picture is complete. —Maxine Greene, "The Shapes of Childhood Recalled"

I first read some of Maxine Greene's writing when I was studying for my master's degree at the University of Rochester in 1973 and 1974. I was newly divorced, living alone in a strange, cold city, substituting instead of teaching English to high school juniors and seniors, as I had during the seven previous years. Disconnected from all that had been familiar to me, I clung to the recognizable processes of being a student. Unclear about where or how I would live, at least I knew that I could read and study.

I derived some comfort in knowing how to be a student, but was quickly immersed in new, unfamiliar, and disruptive work. I initially read Maxine's work within the context of what William Pinar, my academic advisor at Rochester, characterized as the emerging "reconceptualization" of the US curriculum field. That reconceptualization, at the outset, shifted emphasis in the curriculum field from the linear and sequential activities of designing and developing "content" to a focus on understanding curriculum as encompassing and examining personal and political dimensions of educational experience. But as both student and teacher, I only had conceptualized and worked with school curriculum in ways that Pinar characterized as "traditional" (Pinar, 1975b).

I first met Maxine and heard her present academic papers in 1973 and 1974 at early curriculum theory conferences identified with the reconceptualization. Dressed in New York black, leaning into the rhythm of her words, periodically gazing toward the ceiling as she spoke, Maxine articulated personal and political imperatives in conceptualizing curriculum as means by which to take "a stranger's vantage point on everyday reality" and to look "inquiringly and wonderingly on

the world in which one lives" (Greene, 1973, p. 267). Ah. Perhaps this was a way for me to begin to understand curriculum reconceptualized.

Such perspectives had informed my English-major undergraduate studies but had in no way influenced my scant and behaviorally oriented undergraduate teacher preparation or my full-time high school teaching experiences. There, I was pressured to present predetermined, sequential, skills-oriented and measurable versions of "English" to my students—hardly ways to encourage looking "inquiringly and wonderingly on the world."

Immediately I was drawn to Maxine Greene's compelling philosophical and political analyses of curriculum as project, as the existential concept of always "trying to bring into being" (Sartre, 1968, p. 91) a self in relation to knowledge, to the world. And I loved her uses of literature as means of engaging in such a project. When I taught high school English for those seven years, I had only a few colleagues who would discuss with me reasons why and how to side-step pressures to teach mechanics of grammar and even literature as fixed and immutable "bodies of knowledge" and to present that knowledge in detached, scripted, and officious ways. In Maxine's writing I found at last the theoretical, philosophical, and political imperatives for what had been considered among some of my colleagues as "subversive" attitudes and perspectives about teaching. Reading and hearing Maxine, I no longer felt apprehensive or even guilty about wanting my students to "look inquiringly and wonderingly" on their diverse worlds, knowing, at the same time, that "all perspectives are contingent, that no one's picture is complete" (Greene, 1995a, p. 82).

And I found comfort in the countless literary examples that illuminated Maxine's work. Since my childhood, literature had provided one means by which I could look "with a stranger's vantage point on everyday reality" of growing up in a mostly white, middle- and working-class, steel-industry-infused neighborhood in the south hills of Pittsburgh. Later, literature illuminated for me ways in which subsequent "everyday realities" of teaching in a small industrial town on the banks of the St. Lawrence River in upstate New York were influenced and even constructed by intertwined and contradictory economic, political, discursive, social and cultural contexts in which I lived and taught.

But when I first encountered Maxine and her work, I adhered to what had been familiar in my personal as well as teaching life. I had studied Camus's *The Plague* with my high school seniors, so I felt assured that I could make immediate associations with Maxine's insistence on "wide-awakeness" as a form of moral vigilance and action against the plagues of habit, passiveness, indifference, and alienation. I also had taught Ibsen's *A Doll's House*, and was reading Kate Chopin's *The Awakening* in one of my graduate classes—surely I could continue to consider what, in the early 1970s, these literary representations of women's lives had to do with my own.

My most immediate readings of Maxine Greene's work, then, reflected my own passions about imaginative literature and teaching and their capacities to move individuals to see and to act against habit and indifference. But as an existential phenomenologist, Maxine and her work also pushed me out of the famil-

iar and *toward* the world. Working to understand how encounters with the arts, especially encounters with literature, could open curriculum spaces for a multiplicity of realities, I wrote a dissertation at The Ohio State University on the relation of Maxine's work to the fields of curriculum theory and English education. Maxine distanced herself from any one categorization of her intentions and perspectives, and so I attempted to read and to situate her work contingently, and as exceeding the confines of the label "reconceptualist."

During the mid 1970s, I also began working autobiographically, simultaneously grappling with various feminist orientations to this particular mode of inquiry that contributed to "the reconceptualization" of the US curriculum field. I continued to be influenced by Pinar's (1975b) autobiographical method of *currere*, a method that enables one to study the relations between one's academic knowledge and life history, as well as by Pinar and Grumet's (1976) theorizing of autobiography.

But further, I was drawn to efforts in the US during the 1970s and early 1980s to theorize women's autobiography based on women's "experience" (Jelinek, 1980; Mason & Green, 1979). Based on early 1970s Second Wave feminism foundational tenets (Nicholson, 1997), I initially focused my autobiographical research on internalized patriarchal constructions of identity and gender, on questions of "being" and "becoming" a "woman" who teaches, researches, and theorizes in a male-dominated profession. Of course, these were issues that Maxine earlier had begun to address from her stance as an educational philosopher influenced by existential phenomenology. Her uses of historical analyses and imaginative literature to conceptualize and to interrogate "predicaments" as well as "the work" of women (1978, 1988) as evidence of one's project of "always becoming" provided impetus and challenge to me as I began my feminist explorations.

Later, I moved away from Second Wave feminism tenets that I, along with many others, found limiting and exclusionary. Those tenets (1) read women's lives as inextricably embedded in patriarchy—understood as a general, transcultural, and ahistorical system of social organization—and (2) asserted, unproblematically, the category of "woman" as well as a universal "we" in "women" (Smith & Watson, 1998). In rejecting those Second Wave tenets, I began to explore poststructuralist and queer theory orientations to autobiography as a historically situated and discursively inflected practice. Such a practice posits subjects as irreducibly multiple, calls attention to constructions of "identity" as produced and sustained by cultural norms, and points to the performativity—the political and provisional nature of identity formation (Butler, 1993).

Shaping of Selves

The essay, "Shapes of Childhood Recalled," in which Maxine Greene (1995a) "recovers" literary experiences that have been significant at various times in her life, certainly disrupts modernist notions of unified, rational, coherent, autonomous and "whole" individuals. At the same time, this work exemplifies ways in which the quest for agency, even in the face of provisional and changing

identity constructions, drives her disruptions. Further, in detailing her various responses to imaginative literature, Maxine also challenges normative, singular, and essentialist categories, such as "woman," on which versions of autobiography that supposedly tell "the one true story" rest. Maxine's work thus continues to inform my explorations of both tensions and potentials in the various uses and forms of autobiography as modes of feminist curriculum research and theorizing. In evoking "the shapes of childhood recalled," Maxine explores her sense of the resonance of various images from particular works of literature and what these images and stories "had to do with the patterns I was constructing as a child, the horizons toward which I was extending my hands" (p. 80).

Through her recollected responses to imaginative literature, Maxine also examines aspects of her "life story" as a woman and an academic by refusing any one definitive construction of that story. Maxine has not "spider like, . . . somehow spun a web solely from the stuff" of her own being, nor does she "claim to be free from the shaping influences of contexts" (p. 74). Rather, Maxine acknowledges the impossibility of constructing her life story outside "a whole variety of ideologies and discursive practices," including those related to gender, sibling and maternal relationships, and political and professional phenomena (p. 74). In so doing, she provides provocative challenges to any simplistic version of autobiography as a "memory game" (p. 77), or as a merely self-indulgent endeavor, or as a reinforcer of already known or predetermined constructions of "selves." And, as always in her work, there are political imperatives attached to her unique enactment of autobiography:

> If I can make present the shapes and structures of a perceived world, even though they have been layered over with many rational meanings over time, I believe my own past will appear in altered ways and that my presently lived life—and, I would like to say, teaching—will become more grounded, more pungent, and less susceptible to logical rationalization, not to speak of rational instrumentality. (1995a, pp. 77–78)

Further, Maxine contends that "the narratives we shape out of the materials of our lived lives must somehow take account of our original landscapes" where there is "a sense of consciousness being opened to the common" and where we might "recognize each other" (p. 75) in order to "take the kind of initiatives that relate perspectives into a more or less coherent, even if unfinished whole" (p. 74). I now struggle with possibilities of ever fully comprehending our "original landscapes," or relating different perspectives into such a "whole," but I do agree that it is "incompleteness . . . that summons us to the tasks of knowledge and action, . . . putting an explanation into words, fighting a plague, seeking homes for the homeless, restructuring inhumane schools" (p. 74).

Maxine, in imposing her own present-day order on the shapes of childhood recalled, provides glimpses of contradictions, disjunctures, and ambivalences—the "incompleteness" that she experiences within and toward her "self" as a woman who desires both to "merge and to be outside" (p. 84), as an academic who dares to do educational philosophy in unconventional ways, and as a scholar who

reads imaginative literature as one way of disrupting and questioning any one final version of her self or the world.

At the same time, Maxine gestures toward possibilities of taking action against unjust and inhumane conditions even as individuals face the "incompleteness" and "unfinished whole" of their actions, their knowledge, their "selves," and their lives. I take this to mean that, in recognizing that I have a responsibility to act in and against an unjust world, and in at least admitting the possibility that I might "recognize" another with whom to take such actions, I am not paralyzed by the limits or "incompleteness" of my "selves," or my commitments, or my inability to "see the whole or sing the whole" (1995, p. 82).

I particularly am drawn to Maxine's essay on "the shapes of childhood recalled," then, because it evokes provocative tensions in the doing of educational autobiography that resists closure or paralysis around issues of identity and agency. And, as always, I am drawn to Maxine's encounters with imaginative literature as means by which to break with the taken-for-grantedness of one's "self" or of one's world.

Autobiography and the Incomplete Self

My reading of Maxine's "shapes of childhood recalled" obviously reflects my ongoing interest in autobiography as both genre and method in educational research. Issues that now compel my attention are poststructuralist, psychoanalytic, postcolonial and queer theory challenges to the unity and coherence of the intact and fully conscious "self" of Western autobiographical practices and to the limits of its representation. Calling attention to discourse as a constitutive force, for example, Shoshana Felman (1993) notes, "We can neither simply 'write' our stories nor decide to write 'new' stories, . . . because the decision to 'rewrite' them is not simply external to the language that unwittingly writes us" (pp. 156–157). Here I elaborate a bit with a section from my 1998 piece, *Biography, Education, and Questions of the Private Voice* (pp. 229–230):

> Felman's point takes into account . . . issues of power, language, and subjectivity that circulate between and among biographer and subject, autobiographer and "self," the researcher and the researched. These perspectives take into account the postmodern moment as, in Marshall's (1992) words, "an awareness of being— within a way of thinking . . . of being—within, first, a language, and second, a particular historical, social, cultural framework" (p. 3). These perspectives thus call attention to language as constituting factor in the artificial separations, hierarchical orderings, and essentialist constructions of public and private, theory and practice, self and other. Consider Weedon's (1987) formulation here:
>
>> Language is the place where actual and possible forms of social organization and their likely social and political consequences are defined and contested. Yet it is also the place where our sense of ourselves, our subjectivity, is *constructed*. The assumption that subjectivity is constructed implies that it is not innate, not genetically determined, but socially produced. Subjectivity is produced in a whole range of discursive prac-

tices—economic, social, and political—the meanings of which are a constant site of struggle over power. Language is not the expression of unique individuality; it constructs the individual's subjectivity in ways which are socially specific. . . . Unlike humanism, which implies a conscious, knowing, unified, rational subject, poststructuralism theorizes subjectivity as a site of disunity and conflict, central to the process of political change and to preserving the status quo. (p. 21)

Educators who wish to use biography, autobiography, and narrative as forms of inquiry in teacher education and curriculum research that can challenge current and rampant standardization and measurement of students' and teachers' educational lives must pay attention to implications generated by these perspectives. Teachers and researchers must address issues of identity construction, subjectivity, and power relations that circulate through language as well as human interaction. These issues, at the very least, draw attention to the warmth—indeed, the heat—generated by the unpredictability, the multiplicities, the confusions, and the unknowable in an educational life.

At the same time, concerned with questions of action and agency, many feminist theorists of autobiography are grappling with how to conceptualize "self" and "woman," not as permanently essentialized or naturalized through language and culture, but rather as sites for cultural critique and social change. In constructing a feminist theory of women's self-representation, Leigh Gilmore (1994), for example, emphasizes the writing of multiple, contradictory, experimental "identities" as a means to locate the autobiographical as a point of resistance. She frames the "I" as situated simultaneously in multiple identity constructions and argues that autobiography can demonstrate "how gender identities are specified in cultural identities, how racial identities are sexualized, how ethnic identities are gendered, and how sexual identities are inflected by class, . . . how the 'I' shifts within those places and how power is distributed" (p. 184).

Many feminist theorists find Judith Butler's (1992) discussion of the possibilities for working, for keeping in flux the very notion of identity categories, to be helpful here:

Identity categories are never merely descriptive, but always normative, and as such, exclusionary. This is not to say that the term "women" ought not to be used, or that we ought to announce the death of the category. On the contrary, if feminism presupposes that "women" designates an undesignatable field of differences, one that cannot be totalized or summarized by a descriptive identity category, then the very term becomes a site of permanent openness and resignifiability. (p. 160)

"Teachers' Stories" and Identities

Considering the work of Gilmore and Butler compels me to ask, then: where is the "permanent openness and resignifiability" of the identity category "teacher" in many versions of "teachers' stories," which now represent one of the most vis-

ible uses of autobiography and narrative inquiry in the field of education, in general, and in teacher education, in particular? Both William Pinar and Madeleine Grumet, in their groundbreaking work in autobiography as a form of curriculum theorizing (1976), drew attention to the necessity of rendering multiple accounts of selves and experiences in education in order to "cultivate our capacity to see through the outer forms, the habitual explanation of things" (Pinar, 1988, p. 149). Those multiple accounts "splinter the dogmatism of a single tale" (Grumet, 1991, p. 72).

But given the cautions of Butler, Gilmore, and Felman, among others, I think that analyses of those very multiple accounts are necessary in order to discern ways in which they are not "simply external to the language that unwittingly writes us." Thus, even multiple versions of "self" or story need to be examined as representative of normative and historically specific social constructs of "race," "gender," "ethnicity," "sexual identity" or the identity category of "teacher," for example, that are materially realized within current educational discursive practices that frame (and constrain) our re-writings.

However, in recent years, unproblematized identity constructs of "teacher" as well as "teachers' stories" have proliferated in US educational literature. These often assume one singular, authoritative, and completed (as in "empowered teacher" or "reflective practitioner") version of self, identity, experience, voice and story. These "teachers' stories" often are accompanied by claims about transformative possibilities of the reflective, of the autobiographical, of narrative as forms of teacher research. And in many teacher education programs, teachers are encouraged to tell of their investigations into issues and problems with students in their classrooms or in their pedagogical and curricular practices. These teachers often are expected to write autobiographical tracings and reflections on sources of, changes in, and questions about their assumptions, expectations, and enactments of themselves as teachers. And many instructors encourage such work by saying to teachers, "just tell your story."

But something is missing in this invitation. One difficulty arises when autobiographies, or narratives, or stories about education are told or written as unitary, and transparent, and are used as evidence of "progress" or "success" in school reform, for example, "so that the fabric of the narrative appears seamless, spun of whole cloth. The effect is magical—the self appears organic, the present appears as the sum total of the past, the past appears as an accurate predictor of the future" (Benstock, 1991, p. 10).

Further, such "teachers' stories" often offer unproblematized recountings of what is taken to be the transparent, linear, and authoritative "reality" of those teachers' "experiences." And their "teacher identities" in these stories often are crafted as unitary, fully conscious, universal, complete and non-contradictory—hardly sites of "permanent openness and resignifiability." Of course, such stories and identities are grounded in modernist notions of the Enlightenment individual that many of us in the United States have grown up with, where the dominant narrative in education includes belief in students' linear, sequential, and measurable academic progress as well as "personal" development. That is, many of us

grew up with Western cultural norms that reinforced notions of an "I" that was an always "accessible self," one completely open to observation, rational analysis, and even "correction" by self and others rather than an "I" that is performative, that comes into provisional being through social construction of gender identity, for example (Butler, 1993).

As well, many of us are grounded in a notion of "experience" that fails to interrogate how our notions of meaningful experience too are socially and discursively produced, even as we also recognize that there are human experiences outside discursive narratives—sensory memories of images and events, feelings, desires. A Western, humanist notion of experience does not conceive of individuals as subjects constituted through experience, nor does it consider how we know ourselves through discursive regimes, regimes that serve as (changing) cultural registers for what counts as experience and who counts as an experiencing subject. (Foucault, 1980a; Scott, 1991).

It is not surprising, either, then, that many educators approach pedagogical and research uses of autobiography with an assumption that there are simple and transparent correspondences among "identity," "voice," "experience," "memory." Such forms of autobiography will proliferate in the field of education as long as strong emphasis continues to be placed on the present as sum total of the past and on the past as predictor of the future in terms of student achievement as "evidence" of teacher effectiveness.

One difficulty that I see with Enlightenment versions of "teacher" and "teachers' stories," then, is that many do not explore and theorize social or cultural contexts and influences, including historically specific educational discourses, on constructions of the "selves" who have "experiences." Such "seamless narratives" often do not analyze the work "that language does to limit, shape, and make possible one world or another" (Davies, 1993, p. xviii). As a result, unified, singular, and essentialized versions of "self," "experience," "other" and "voice" continue to be produced in the field of education in general, and in pedagogical strategies and constructions of curriculum in particular.

Consider, for example, conceptions of "voice" and "self" in the work of those known as expressionist theorists of composition within the discipline in which I have worked since 1966—English. Again, from my 1998 *Biography* piece (pp. 231–232):

> On the one hand, those called "expressionists" in composition theory argue for a notion of voice as both inherent and emerging within the individual. Expressionists often encourage the development of the "authentic voice" in student writing and encourage forms of personal writing, including the biographical and autobiographical, as means for tapping into a voice that is faithful to a student's self.

> Other theorists, like Klaus (1994) for example, working from postmodern perspectives that challenge any essentialist notion of one true self or voice, attempt to show how a conception of authentic voice avoids both historically and socially located circulations of power and the unconscious as powerful forces that mediate who can speak:

Such expressions as "having one's own voice," or "having an authentic voice," or "having a distinctive personal voice," or "having the immediacy of a real voice" predicate so intimate a connection as to imply that voice is a fully authentic expression and reflection of self. The grammatically singular form of such expressions also tends to suggest that voice is singular not only in the sense of being distinctive or unique, but also in the sense of being a single, unified entity in and of itself. (p.114)

Bergland (1994) discusses additional difficulties of equating voice with one essentialized version of "self": "I suggest that we need to question any easy relationship between discourse and the speaking subject, particularly the assumption that *experience* produces a *voice*—that, for example, *being a woman* means speaking in *woman's voice*" (p. 134).

One way of questioning the relationships among discourse, power, and the speaking subject is to investigate consequences of even categorizing the multiplicities and complexities of a life being lived into a rigid binary of public and private voice. . . . Instead, autobiographical, biographical, and narrative forms of educational inquiry could point to the ways in which our educator identities and voices are never just—or even—public *or* private. These forms of inquiry can demonstrate that voices are never just pre-existing and awaiting discovery, never fixed and unchanging, never easily separated into distinct and "naturally" existing realms of public and private, never immune to specific social or historical conditions.

Thus, autobiographical, biographical, and narrative work that points to the flux of constructed identities as well as the unknowable in "voice" and "self" might help educators resist one definitive and measurable version of the successful student or teacher, for example. Such conceptions might help educators continue to challenge easy prescriptions for classroom management, organization, and philosophies that guarantee that everyone's voice will be heard, or that everyone's self will be realized.

Therefore, I no longer think that it is possible to engage in autobiographical, biographical or narrative inquiries without asking questions about the ways in which their uses as a "factual" recording of memories of events in the classroom—or as a means by which to find, reflect on, improve or celebrate a complete and whole "self"—are problematic. One goal of autobiography, as conceptualized by Felman (1993), for example, is to create, use, and explore readings and writings of autobiography that recognize their own social construction and cultural conditioning, and that simultaneously call attention to interpretations as always incomplete, always caught up in repression, always interminable. If in fact we educators were to recognize constructions of our "selves" as mediated by discourses, cultural contexts, and the unconscious, then the uses of autobiography as one form of educational research necessarily could move beyond just the simplistic "telling of teachers' stories" as an end unto itself.

Nor should autobiography be used only in the service of simply adding "teachers' stories" into already established educational research and literature. Autobiography, whether in the form of "teachers' stories" or teachers' and researchers' examinations of the filters through which we perceive our work, must

move through and beyond traditional framings of educational situations and issues in order to "take us somewhere we couldn't otherwise get to" (Behar, 1996, p. 14)

Such traditional framings usually have encouraged teachers to resolve discrepancies between theory and practice, between competing versions of our teaching and "personal" selves, or between school-reform goals and objectives and teachers' enactments of them. Rather than encountering "contradictions, gaps, views from the margin, views from the center . . . a field of multiplicities" (Greene, 1997, p. 391) that require the reconsideration and re-making of "the self" and of cultural and social normalizations of that self, many uses of autobiography in the field of education encourage the creation and sharing of "teachers' stories" that simply reinforce stationary, predetermined, and resolved versions of our selves and work. Unlike imaginative literature or other art forms in which, as Maxine Greene reminds us, there are "no clear-cut either/ors, . . . neither truth nor resolution, . . . no firm conclusion" (p. 391), such static autobiographical renderings close down rather than open potential for re-configuring "self" and "other."

Now, I am not arguing that autobiography as one form of educational inquiry be regarded as literature, per se. However, I do want to consider what might happen to the forms and purposes of autobiography in education if they assumed the potential of imaginative literature to disrupt rather than reinforce static and essentialized versions of our "selves" and our work as educators. Indeed, this may be the only reason to use autobiography as a form of educational inquiry. Just as informed encounters with literature can lead to what Maxine calls "a startling defamiliarization of the ordinary" (1995a, p. 4), so too can autobiography call into question both the notion of one "true," stable, and coherent self and cultural scripts for that self. Indeed, autobiography as an educational research practice might become a "site of permanent openness and resignifiability" (Butler, 1992).

Such challenges to the normative, the ordinary, the taken-for-granted can lead to "reconceiving," "revisualizing," and "revising the terms" of one's life (1995a, p. 5). Maxine shows how such "defamiliarization" and "revising" can enlarge our capacities "to invent visions of what should be and what might be in our deficient society, on the streets where we live, in our schools" (p. 5).

For this is one of the challenges, I believe, in working with and in autobiographical research in education contexts. To "tell your story or my story" without challenging either language "that unwittingly writes us," or the self as singular, unified, chronological, and coherent, is to maintain the status quo, to reinscribe already known situations and identities as fixed, immutable, locked into normalized and thus often exclusionary conceptions of what and who are possible.

Instead, addressing "self" and autobiographical investigations of "self" or "woman" or "teacher," for example, as "site(s) of permanent openness and resignifiability" opens up potential for accessing as well as creating new modes of speaking and writing into existence ways of being that are obscured, unknown, or simply unthinkable when one centered, self-knowing story is substituted for another. Changing what it means "to be" or "to become" a teacher or a student or

a researcher cannot happen by "telling my story or your story," if that story sim-
ply repeats or reinscribes such already normalized and descriptive identity cate-
gories as "woman," "man," "student," "researcher" or "teacher."

Reconstituting the world in significant and needed ways requires us as edu-
cational researchers and curriculum theorists to presuppose that such categories
as teacher, researcher, and student can point to "undesignatable fields of differ-
ences," and further, that teacher, researcher, and student cannot and should not be
"totalized or summarized" by unproblematized exhortations to "tell our stories."
Again, from *Biography*:

> At a time when so much teacher and educational research focuses on standards
> and on teaching as a set of delivery systems, with measurable and predictable
> "outcomes," autobiography, biography, and narrative as educational practices and
> methodologies generate material and processes that we educators can use to dis-
> lodge unitary notions, both of our selves and our voices and of prescriptive sys-
> tems of teaching and learning. Such work could also enable us to acknowledge
> that the processes of teaching and learning always interrogate the unknown—
> that is, the meaningful unknown. (p. 234)

Autobiography in Action

I want, then, to consider uses of autobiography in educational inquiry that pry
open identity categories that still frame much of how teaching, learning, and cur-
riculum are conceptualized and enacted—categories such as "learning disabled,"
"at-risk," "gifted," as well as "woman teacher," for example. Autobiography as an
educational practice can construct these categories as permanently open, some-
times unknowable and therefore undesignatable fields of differences. Such undes-
ignatable fields then can be read from the cross-cultural perspective of their
differences and the interactions between different languages and cultures so that
these become available as sites that can be constantly resignified in the name of
and for the sake of specific social and political projects (Felman, 1993).

These are the tensions with which I am working now in my own attempts to
"do" autobiography as a form of educational inquiry. And, as always, Maxine's
scholarship provokes me to ask my own questions and to track the tensions I have
described here. Not that I could ever arrive at any final and complete resolutions.
Rather, still pursuing in particular the tensions generated by "the irreducibly
complex and paradoxical status of identity in feminist politics and autobiographi-
cal writing" (Martin, 1988, p. 103), I am grappling with ways of constructing and
using autobiography as a form of educational inquiry that does not reinforce what
at times seem to be collective desires "to know, define, and sum up" (Benstock,
1991, p. 5) my "self," or the practices of both education and autobiography.

At the same time, I still wish to "take initiatives" by recognizing that it is
"incompleteness that summons us to the tasks of knowledge and action." What
political projects can I, can curriculum scholars, teacher-educators and classroom
teachers, make from uses of autobiography that refuse closure and yet recognize

the constructing and reconstructing of experience and identities as interpretive? That is, subject to the interpretive conventions available to us and to the meanings and identities imposed on us by ongoing uses in culture and language (Felman, 1993). How might we construct our "teacher stories" in ways that fail to conform to socially enforced norms that surround our educators' lives? Such "failures" signal the "possibility of a variation" of "the rules that govern intelligible identity." And with those "failures" come reconfigurations or changes of identities (Butler, 1990, p. 145).

Such conceptions of autobiography point to the "telling of stories" and to the constructions of "selves" in those stories as never-ending, complex, culturally and linguistically conditioned processes. It is to such complexities as well as to possibilities for agency even in the face of "incompleteness" that Maxine's uses of autobiography in "The Shapes of Childhood Recalled" point.

For it is, as Maxine Greene always reminds me, our "incompleteness—the open question, perhaps—that summons us to the tasks of knowledge and action" (1995a, p. 74). Maxine's vision of promise to be found in "incompleteness" certainly points to forms of autobiographical inquiry that challenge any fixed or predetermined notions of who one "is" or "could be." But more than that, Maxine's commitments to constantly "becoming," her grace amidst the unknowability of "self" and life, her desires to be connected to people who make "fighting a plague, seeking homes for the homeless, restructuring inhumane schools" their life-projects—all of these aspects of her "incompleteness" at the same time have constructed a life that indeed has made a difference.

WOMEN, AUTOBIOGRAPHY

The self, like the work you produce, is not so much a core as a process: one finds oneself in the context of cultural hybridity always pushing one's questioning of oneself to the limit of what one is not. . . . Fragmentation is therefore a way of living. —Trinh T. Minh-ha, *When the Moon Waxes Red: Representation, Gender and Cultural Politics*

INTERLUDE 4

The work in Part II contains some of my earliest writings on issues of "women in education," particularly women *as* teachers, as academics. But clearly, issues that I worked with years ago are still at the forefront of my concerns, and one of my first published essays, located here in Part II, serves as inspiration for this book's title. I wrote that essay at the beginning of my academic career, as an assistant professor at Old Dominion University in Norfolk, Virginia. I was absorbed in the work of the reconceptualization, just starting my transition from doctoral student of curriculum theory and English education to academic faculty. And I wanted to work with feminist ideas and perspectives emanating from the US women's liberation movement as well as from initial feminist theorizing efforts within the reconceptualization. At ODU, in 1979, my first year there, I met the director of women's studies, Nancy Bazin, and was invited to participate in the just-developing university-wide women's studies program. That provided an immediate grounding for my academic interests, and those three years at ODU, working with Nancy and other faculty across the university interested in issues of gender, impelled much of my subsequent research and writing.

In 1982, I appeared on an AERA panel entitled "Curriculum and Resistance" with Jean Anyon, Joyce King, and Nancy King, a panel focused on the hot topic of "resistance." Because Paul Willis's *Learning to Labour* (1977/1981) had generated such intense response, especially from education scholars disenchanted with reproduction theory, our group wanted to put forth various feminist "takes" on resistance, especially in relation to issues of race, class, and gender. My version of resistance, of course, was worked into an autobiographical account. I attempted to locate "resistance" to both the official and hidden curriculum of a typical university position, for example, not just in the macrostructural and microstructural foci of "politically oriented" curriculum theorists, but also in autobiographical analy-

ses of effects that gendered constructions of "woman academic" had on my work. The women who participated as both academics and friends in that symposium helped me to further identify and explore what has become an enduring line of inquiry for me, and I'm grateful.

THE SOUND OF SILENCE BREAKING
Feminist Pedagogy and Curriculum Theory

The dream is recurring: The quiet is everywhere. It surrounds my classroom, saturates the halls of the building in which I teach. I wait with my students for the sound of our voices, horrified that we might scream in rage, trembling that we may never whisper. We are on the edge, not quite knowing what holds back the sound, what prevents the total shattering of our silences.

The silence, of both my students and myself, belies the claim that we have overcome historical, social, cultural, economic, racial, gender and class constraints that have denied us the power to decide about curriculum and what counts as knowledge. Both my students and I still are constricted by hierarchical structures of schooling and the legacy of a behaviorist-oriented curriculum field that requires that we separate our responses to readings and classroom experiences from our everyday lives. As teacher I still struggle to speak, still slog through residues of suppression, still am startled at times by a strident cadence that sometimes accompanies utterance. How much it takes to break silence,

> how much conviction as to the importance of what one has to say, one's right to say it. And the will, the measureless store of belief in oneself to be able to come to, cleave to, find the form for one's own life comprehensions. Difficult for any male not born into a class that breeds such confidence. Almost impossible for a girl, a woman. (Olsen, 1978, p. 27)

I have attempted to break my own silences; I have voiced my concerns about the subordinated roles of women in K–12 and higher education and have questioned oppressed forms of "educational consciousness" that characterize many women who choose teaching as a profession. I especially have questioned ways in which I transferred socially constructed expectations of myself as woman into my role as teacher. I have asked: to what extent and in what manner do layers of soci-

etal and cultural expectations and stereotypes become "personal" expectations, and how do these shape women's perceptions of themselves and their potentials to be educated as well as to educate? (Miller, 1979a, 1979b).

As I raise these questions, however, I am startled by the silences that fall after the asking. I fear these silences. These are not, as Tillie Olsen explains,

> natural silences, that necessary time for renewal, lying fallow, gestation, in the natural cycle of creation. The silences . . . here are unnatural; the unnatural thwarting of what struggles to come into being, but cannot. In the old, the obvious parallels: when the seed strikes stone; the soil will not sustain; the spring is false: the time is drought or blight or infestation; the frost comes premature. (1978, p. 6)

The fear is that unnatural silences will envelop me, either lulling me into comforting quiet of supposed completeness, or muffling the sound of my questions. I'm now just at the point of wanting to voice questions, questions that I hope may increase and diversify my understanding of the field of curriculum and of the gendered influences on its relationship to the enterprise called education. The heretofore unspoken connections among gender, sexuality, and curriculum are now emerging as central issues within the field of education in general and curriculum studies in particular. These issues carry the risk of being met with an unnatural silence that stultifies, masks, thwarts.

Curriculum and feminist theorists have moved into areas of inquiry that may break that unnatural silence. These inquiries may give form to conceptions of feminist pedagogy and curriculum theory that could inform and alter one another. From my perspective as an educator, I am drawn to current feminist and curriculum theorists who, I believe, provoke analogous questions that can shatter unnatural silences. For example, Florence Howe speaks of the new feminism:

> Women will no longer be content to pass on a "received heritage"; rather, women have become, are becoming women-of-knowledge, "breaking the accustomed mold" . . . For the first time, feminists in an organized manner are querying education's ultimate—the curriculum and the sources of that curriculum, knowledge itself. . . . The new feminism is profoundly different from . . . forms of the old. We are saying today not simply allow us a piece of the turf . . . or let us into your castle . . . but rather, let us reexamine the whole question, all the questions. Let us take nothing for granted. Most definitely, let us refuse to pass on that "received heritage" without examining its cultural bias. (1976, p. 90)

Similarly, curriculum theorizing in the United States recently has refused to pass on its "received heritage"—a heritage that framed curriculum as an administrative designation rather than as an extension or application of an extant field (Cremin, 1971; Kliebard, 1975). As a group of curriculum theorists work to reconceptualize the field from its mechanistic and design-oriented functions to a focus on understanding the nature of educational experience (Pinar, 1974, 1975a), we are directing attention in particular to "the sources of curriculum"—to knowledge itself and questions of its construction—from a variety of perspectives.

Those who work from a Neo-Marxist approach attempt to reveal contradictions that are inherent in educational experience, and to expose the structural relations that link class interests to curriculum (Anyon, 1979; Apple, 1975, 1979; Beyer, 1979; Giroux, 1980; Macdonald & Zaret, 1975). Those who work within phenomenological, existential, and hermeneutic frameworks focus on experiences of individuals within school situations, and utilize autobiography as one mode of reflection on and expression of what is human about educational experience (Grumet, 1978, 1980; Pinar, 1978a; Pinar & Grumet, 1976).

Thus, those of us who participate in the move to reconceptualize the field of curriculum are refusing to construct theories that only address issues of practice, conceived as linear forms and constructions of curriculum design and development. We reject the simplistic and paternalistic passing on of the "received heritage" of prediction and control in the field. Instead, we work *toward* theories that recognize and refuse to reduce the complex relation of theory and practice:

> We have been reminded that theory and practice are each other's negation, that they exist constantly struggling to coincide and succeed only when they fail to meet in a perfect fit. . . . Although the field situation provides a context where our theory and practice confront one another, our goal is not to resolve their differences, not to reduce one to the dimensions of the other. Rather, we play one against the other so as to disclose their limitations, and in so doing enlarge in capacity and intensity the focus of each. Just as what we think and know about our work is contradicted daily by the events in which we participate, the actual experience of teaching and the certainties that activity offers may be undermined by the questions and alternatives that theory cultivates. (Pinar & Grumet, 1981, pp. 37–38)

Current feminist and curriculum theories, then, focus on ways to undermine the "certainties" that contribute to the perpetuation of unnatural silences for women, indeed for all students, teachers and theorists hemmed in by "received heritages." Both curriculum and feminist theorists study what has been and what is, in order to risk speaking what might be.

Emerging Gender Studies in Curriculum

A growing body of work that attends to issues of gender in curriculum research and theorizing incorporates many feminists' current analyses of patriarchal influences within the structure of the disciplines, as traditionally conceived. But moving well beyond a liberal Second Wave feminist emphasis on equal pay and promotion for women workers at all levels in US society and on integrating women into male power structures, many feminists now are moving to extend initial work to incorporate "women's experience" into existing canons. They are doing so by insisting on examination and revision of both the content and means of structuring the disciplines. As well, they are exploring relations among sexuality and gendered identity. Curriculum theorists also are addressing such relations as they examine effects, on all involved in educative processes, of ways in which patriarchy and its accompanying bodies of knowledge have been constructed.

For example, William Pinar [1982] reviews the works of Grumet and Taubman as important contributions to the understanding of the relations among gender, sexuality, and curriculum. In discussing Grumet's analysis (1979) of the psychosexual dimensions of curriculum, particularly as curriculum functions to perpetuate the law of the father and to contradict the inferential character of paternity through control and predictability, Pinar notes that never before in the curriculum literature has this drive to control been linked to the inferential character of paternity, and the male's attempt to contradict it. Pinar analyzes Grumet's essay as introducing gender considerations that link autobiographical method with political, economic, and psychological issues. As such, Pinar regards Grumet's work as greatly forwarding the work of understanding the complexities of curriculum [Pinar, 1982].

Taubman's work focuses specifically on Michel Foucault's conceptualizations of discourse and discursive analyses as means by which to explore any possible detachment of an interpretative system from the phenomenon it supposedly signifies. Noting Foucault's (1976/1978) notion of power as everywhere, inescapable, and "discursive"—that is, embedded in all the languages of everyday life and in the knowledges produced in local sites—Taubman explores the underlying concepts of the "feminist movement" and "gay liberation" as products of discursive systems that may become rigid and separate from the persons who are represented by such concepts (Taubman, 1979). Taubman's uses of Foucault enable him to posit meaning and interpretation as residing in, or becoming a function of, a particular discursive system, as well as to point to necessary analyses of typical and traditional curriculum discourses and how those discourses possibly function to replicate a gendered status quo.

Further, I maintain that Taubman's work can be seen as extending, for example, Rubin's concern in attempting to construct a theory of women's oppression. That theory, cautions Rubin, initially must borrow from disciplines created within an intellectual tradition produced by cultures in which women are oppressed, and thus runs the risk "that the sexism in the tradition of which they are a part tends to be dragged in with each borrowing" (Rubin, 1975, p. 200). In extending such concerns, Taubman's work forces those of us working within the curriculum field reconceptualized to ask, as Pinar certainly does: will we "drag in," uncritically,— as Huebner indicated that we as a field did with behaviorism—the assumptions of a flawed discursive system?

At the same time, I wonder, will the implications of Taubman's work force us into unnatural silences? We continue to be opposed by those who do not wish to uncover and analyze the assumptions of the specific discursive systems within which we typically have represented our gendered selves in education. And for those who conceive of curriculum only as "design and development," the maintaining of their oppositional stance is a necessary act in order to reify content, identities, and the "proper" work of curriculum scholars.

Pinar's work, too, may draw the ire of those who do not wish to engage in analyses of specific systems and mandated relations that, in a sense, create notions of appropriate gender "behavior." For example, Pinar [1983] explores Guy

Hocquenghem's *Homosexual Desire* (1978) as an extension of gender considerations raised by Grumet and Taubman. Hocquenghem, a major voice in the gay liberation movement, focuses on those who are on the edges of society and who, because they are estranged and culturally free from the mainstream, represent what Hocquenghem describes as revolutionary potential. Pinar traces Hocquenghem's argument, which draws on as well as extends and alters Freud's interpretation of homosexual repression as essential to the maintenance and development of civilization. Pinar points to economic and political exploitation as fueled by homosexual repression. He argues that capitalism and totalitarianism are complex symbolizations of male-male relationships that characterize such repression.

In examining Hocquenghem's work, Pinar heeds Wexler's (1976) claim that representational or correspondence theories of curriculum function to diminish the autonomy of the subject. Pinar admits that curriculum as gender text risks this representational fallacy. And he worries that the extent to which curriculum is viewed as mere reflection or representation of gender, curriculum becomes a moment in a larger system, and possibilities of anything but systematic change are obscured.

Acknowledging this risk, Pinar notes that analyses of curriculum as gender text may function to make curriculum appear more contingent and historically constructed, and he agrees that as such it should necessarily be subject to political and psychological critique. He then raises questions regarding the importance of gender in curriculum research. I believe that these questions provide one framework that we might use to break unnatural silences that envelop curriculum as traditionally conceived. Among the questions:

Is there and can there be a "women's" or "feminist" epistemology and, related, a feminist curriculum?

Is there a male epistemology, and is "objectivism" in its various forms a symbolic male cognitive form?

Does the incipient discussion of gender borrow uncritically from languages that create rather than portray psychological phenomena?

What are the relationships between gender analyses of curriculum and autobiographical curriculum theory, between gender analyses of curriculum and political and economically-oriented curriculum scholarship?

To what extent does curriculum represent and reproduce heterosexuality and repress homosexuality?

What political issues will educators encounter as they study issues of gender and sexuality? [Pinar, 1983]

The questions are not comfortable ones; however, they represent a series of spiraling concerns that have emerged from initial yet divergent reconceptualist viewpoints. The asking of such questions continues aspects of the work to reconceive the US curriculum field and enlarges the potential for as well as the range of our voiced concerns.

The working through of these questions will necessarily require utilization of theories and methodologies derived from a variety of perspectives. At the same

time, those perspectives must constantly be open to analysis and critique of the very discourses used to construct particular theories, methodologies, and conceptualizations of gender, sexuality, and curriculum studies.

Feminist Contributions

Feminist theory in the United States, much like the field of curriculum, has been influenced by a variety of political, economic, and social convergences, and thus results in differing forms of feminist theory and politics.

Liberal feminists, also known as reformists, as part of the Second Wave of feminists in the US, have produced little theory thus far; instead, they concentrate on understanding the organizational strategies of a traditional patriarchal system. Liberal feminism's goals include achievement of full equality of opportunity for women in all areas of life, but these feminists have not focused on any need to transform the status quo in terms of social and political systems in this country (Feminist Anthology Collective, 1981). By focusing on management strategies of the prevailing system, they are much like the first curriculum workers in the US, who were tapped for management duties as a response to administrative needs rather than as representatives of an existing field or discipline. Thus, liberal feminists resemble those who first worked in the US curriculum field, which

> began and has remained until this past decade a field interested in "solving practical problems" rather than in intellectually understanding, in coherent, systematized ways, the multi-dimensional functions of curriculum, and specifically its function in the phenomenon of human learning. (Pinar & Grumet, 1981, pp. 21–22)

Critiques of the reformist or liberal position that recently have emerged in the US (Firestone, 1970; Koedt, Levine, & Rapone, 1973; Morgan, 1970) also mirror recent perspectives espoused by some curriculum theorists associated with the reconceptualization. For socialist feminists, patriarchy is linked to class and racial oppression; they thus argue for a total transformation of the social system. In particular, socialist-Marxist feminists argue for an analysis of class systems, which they claim are at the root of women's oppression. Women as an exploited labor force and as reproducers of the work force are issues that socialist-Marxist feminists claim reveal a lack of such analyses in the liberal emphasis on equal pay for equal work, for example. Similarly, curriculum theorists, Neo-Marxist in approach, work to reveal contradictions that reside in educational experiences and to expose the structural relations that link class interest to curriculum (Pinar & Grumet, 1981).

Radical feminists, also known as cultural feminists, have extended socialist-Marxist analyses to include sexual oppression as the paradigm that can represent all oppression. Radical feminists, some of them calling for a separatist politics, consider gender the most important aspect of all liberation struggles (Evans, 1979). They argue that power operates within and through personal relations,

including sexuality and the family (Koedt, Levine, & Rapone, 1973). Further, by declaring that the "personal is political," by challenging the dismissal of women's claims of injustice as merely "personal," radical feminists, like some curriculum reconceptualists who use autobiographical and psychoanalytic modes of analysis, force silences to be broken with regard to patriarchal constructions of and interests in maintaining a public-private binary, for example.

Emerging from the women's liberation movement and especially from radical or cultural feminist concerns, conceptions of feminist pedagogy perhaps can provide illuminating examples of attempts to reconstitute the power dynamics of knowledge construction and the discourses of teaching and learning. Versions of feminist pedagogy that have emerged in recent years in the US, like versions of reconceptual curriculum theorizing, force redefinition of the relationships between teachers and students; public and private; the "knower" and the "known"; and the academic disciplines and what "counts" as curriculum and as "knowledge." For example, Frances Smith Foster, teaching women's literature from a regional perspective in California, notes:

> A good part of our courses could not be predetermined. Much of the subject matter would be identified and researched by the students themselves. It was they who were to determine individual projects, locate the data, and create new information for us all . . . for an understanding of the cultural and personal relationships between women, their literary filiations beyond region alone, and the sources of their creativity and sometimes of the silences. (1979, p. 19)

Or consider Sherna Gluck, describing women's oral history as one means by which to re-vision modes of knowledge construction:

> Refusing to be rendered historically voiceless any longer, women are creating a new history—using our own voices and experiences. We are challenging the traditional concepts of history, of what is "historically important," and we are affirming that our everyday lives are history. Using an oral tradition as old as human memory, we are reconstructing our own past . . . Women's oral history, then, is a feminist encounter, even if the interviewer is not herself a feminist. (1977, p. 3)

Or Francine Krasno, on teaching a feminist writing workshop:

> Feminist writing makes a conscious attempt to show the lives of women as women see them, not as reflections of male fantasies or sexist myths; feminist writing uses a language in new ways, considers the oppressive ways it has been used and changes them. (1977, p. 16)

Finally, consider Charlotte Bunch's conceptions for the goals and processes of a feminist pedagogy:

> to analyze personal experiences as well as political developments, to sort out our initial assumptions about goals and analysis, to look at the strategies we used and why, and to evaluate the results in terms of what could be learned for the future. . . . Then, to get students personally involved, a teacher must challenge them to

develop their own ideas and to analyze the assumptions behind their actions. . . . Such thinking involves an active, not a passive, relationship to the world. It requires confidence that your thoughts are worth pursuing and that you can make a difference. And it demands looking beyond how to make do, and into how to make "making do" different—how to change the structures that control our lives. (1966, p. 13–14)

I share these descriptions of a range of approaches and purposes of women who are involved in teaching in order to illustrate aspects of necessarily varied and changing conceptions of feminist pedagogies and curriculum as well as theorizing and research processes. Such pedagogies, processes, and theorizing efforts will continue to be created, and then challenged and changed, based on analyses of the discourses used to conceptualize them and the structures that traditionally have contained them. In particular, the study of the relationships among gender, feminist pedagogies, and curriculum may lead us in varied directions, as Sandra Wallenstein has enumerated. For example, we might explore, within the field of education, in general, and curriculum studies, in particular: historical analyses of gender relations; socio-economic analyses that look at the relation of gender to work, status, income; and psychological analyses with respect to sexual relations and body consciousness (Wallenstein, 1979b).

The processes of what Bunch calls changing "the structures that control our lives" are, then, the processes of challenging unnatural silences, of easing the fears that override the asking of crucial questions that may direct us into regions beyond the traditional realms of educational research, practice, and curriculum development. In particular, as women break silences that have constrained our conceptions of ourselves as students, as teachers, as curriculum creators, we must create fresh conceptualizations of curriculum and instruction by attending to and challenging the gendered discourses, relationships, and structures that infuse our taken-for-granted yet always power-inflected notions of public and private, self and other, male and female, the knower and the known.

.

The dream recurs, even as I attempt to teach and to participate in feminist, phenomenological, and autobiographical forms of curriculum theorizing that question any essentialized and thus patriarchal construction of myself as "woman," as "teacher." Silences still threaten to thwart in unnatural ways, to imply unspeakable thoughts, to stifle voices just beginning to resound. But silence has been broken, and will be broken again and again. The sound of silence breaking is harsh, resonant, soft, battering, small, chaotic, furious, terrified, triumphant. And the tentative first murmurs are becoming a chorus:

> And in breaking those silences, naming ourselves, uncovering the hidden, making ourselves present, we begin to define a reality which resonates to us, which affirms our being, which allows the teacher and the student alike to take ourselves, and each other, seriously: meaning, to begin taking charge of our lives. (Rich, 1979, p. 245)

THE RESISTANCE
OF WOMEN ACADEMICS
An Autobiographical Account

I sit in the back seat of a state car, listening to my two colleagues discuss the agenda for today's session with our students who are enrolled in a field-based master's program. The director of the program, his right hand leaving the steering wheel periodically to punctuate his major points, outlines our roles for today's work. My female colleague and I offer suggestions, argue an issue, discuss possibilities for program development. And as we roll through the winter countryside, I am half in conversation, half in suspension, watching the trees and the ocean blur into hypnotizing landscape. Once again, I am feeling the fragmentation that so often accompanies this academic journey.

We arrive at the intermediate school where, weekly, I teach a course in curriculum theory and development while my colleagues work with other cohort students on individualized contracts. As the director announces, advises, and coordinates, I remain in my fragment of landscape, standing quietly in the back of the room. It is only when I gather with my students, themselves tired and frazzled from a day's teaching, that I begin to feel a slight sense of what I long for: an integration of my whole self, a pulling together of the pieces I hold in suspension as a protective device against further shattering. For, in much of my work in academe, I feel as though I may reveal only segments of myself, pieces that function in isolation from one another. My underlying fear is that my desires for a "self" that responds in some kind of "whole" or "centered" way to the varied pressures and requirements of an academic position in the university might well move beyond traditional conceptions of a scholarly and tenure-able "self."

And so I move through portions of my daily work as a segmented entity, floating, watching from the ceiling, much in the way that people who have returned from near-death experiences describe the separation from their bodies as they observe the life-saving attempts of others upon their lifeless forms. I wait

and watch, knowing now, with my third-year tenure-track, assistant professor intuition, that there are a few moments of clearness and freedom in which I may reveal parts of myself that I typically hide in my role as "academic." Those moments come most often while I am teaching: the interaction and exchanges with my students enable me (often, not always) to respond, to react, to create. It is within the teaching context that I feel grounded. My dichotomous self welcomes the floater, the watcher, and, merging, I become, for a moment anyway, an active agent in my world.

The very description of my segmented self is, of course, a frightening scenario. What are the constraints of form, of propriety, or proper academic demeanor and scholarly approach that force such accommodation, restraint, repression within me? At the same time, to what extent does this awareness of my fragmented self enhance my attempts to resist a patriarchal paradigm that comprises, for the most part, the woman professor's world? The questions are ones with which I struggle constantly. To be a woman within academe, where the good-old-boy network still exists, apparently with pride and ever-renewing spirit for some, is to be confronted with attitudes that sometimes question my abilities to function simultaneously as a scholar, teacher, and woman.

As a high school teacher for seven years, married to an industrial engineer, I had experienced acceptance and encouragement for my teaching career. I was not in any way prepared for murmurs that followed my divorce, the completion of my doctoral work, and the beginning of my career as a university professor. Sighed one of my elderly colleagues at the university, a true southern gentleman who welcomed me into the male-dominated department: "Well, at least you've been married."

I now examine my situation, however, with an enlarged understanding of the complexities of women's efforts to resist dominant ideologies that characterize the professoriate. My initial questions as I began my work in the university have expanded; initially, I worked to elucidate the shock of recognition of my own perceived dichotomies (Miller, 1979a, 1979b, 1981a). I still work to illuminate sources of fragmentation that I feel as I assume the role of academic. I also work to acknowledge the varied ways in which an awareness of self-fragmentation might contribute to modes of action that I may use to confront and to resist culturally and socially imposed constructions of "woman" who supposedly has an innate sense of needing to be "whole."

Even conceptualizing "modes of action" is a relatively new practice for me in my experience as an educator. Acknowledging and confronting fragmentation in myself for the first time was a frightening process, and yet was an initial mode of action. However, I felt compelled to further explore, to dissect my internalized oppression in order to take some kind of action in accord with what I initially envisioned as the possibilities of my "evolving self" (Miller, 1979c, 1982a). That action, I thought early on in my career, could include theorizing about women as teachers, researchers, and curriculum creators in ways that challenged patriarchal constructions not only of "woman teacher-professor" but also of the field of curriculum.

Could I have been unaware of such fissures within myself for such a long time? Perhaps. But what appears more likely is that my changing perspectives about myself as a professional educator as well as a woman have allowed the slow unraveling of many of what I long have regarded as my own expectations for myself in my professional as well as private worlds. As these layers of expectations—my own for myself as well as my perceptions of others' for me—are exposed as aspects of social and cultural constructions of how I should be as a woman, I perceive one bared root of a dichotomy: I am a professional educator and I am a woman. Historically, within the confines of US society's constructions of gender roles and expectations, the relationship is neither consonant nor life enhancing.

But in recent years, feminists from a variety of academic disciplines have worked, as a way of challenging the subordinate and marginal status of women, to uncover evidence of women who were active, for centuries, in all aspects of knowledge construction. For example, feminist literary critics questioned the history of patriarchy and the invisibility of women's texts and voices in dominant literary and academic cultures (Ellmann, 1968; Moers, 1976; Showalter, 1977; Spacks, 1972). In reevaluating women's "place" as well as beginning to question the very category of "woman" as "other" in the making of self-consciousness (Beauvoir, 1949/1952, 1958/1959) feminists have revealed the depth to which women have internalized the ideologies of otherness and thus the depths to which they, ironically, have supported a patriarchal paradigm.

For example, Dale Spender (1981), in her introduction to *Men's Studies Modified: The Impact of Feminism on the Disciplines*, discusses issues that are fundamental in the exclusion of women from the construction of knowledge. One such issue consists of the historically polarized and discrete categories of objectivity and subjectivity. As Spender delineates ways in which feminists have moved from a defense of the personal to a critique of objectivity as a distinguishing feature allocated to the dominant group, she notes that women first attempted to construct new knowledge about women in the male-defined mold of objectivity. The resulting contradictions and gaps in those attempted analyses impelled women into fresh ways of perceiving:

> Women came to realize that the knowledge which men constructed about women (from their deviant physiology and psychology to the definition of women as non-workers) was frequently rated as "objective" while the knowledge women began to construct about women (which has its origins in the role of a participant rather than a spectator) was frequently rated as "subjective." . . . But there is a significant difference between the way men have checked with men and often presented their explanations as the complete and only truth, and the way women are checking with women and offering their explanations as partial and temporary "truths." These partial and temporary truths about women, which have their origin in women's experience of the world, are being fed back into the various disciplines and are changing those disciplines. And by putting women into codified knowledge, feminists have transformed not just the knowledge itself but the processes whereby knowledge is produced. (Spender, 1981, pp. 5–6)

In arguing for changes in conceptions of women's "place," contributions, and abilities to create new knowledge in US education, as well as for changes in "the processes whereby knowledge is produced," it is important to acknowledge the still powerful influence of males who first administered the common schools in this country. These men required, from both students and teachers, qualities of dutifulness, respect for righteousness, and obedience to existing social authorities. In attempting to socialize large numbers of children into a life increasingly dominated by industry, and later, technology, US educators throughout the nineteenth and into the twentieth century internalized the notion of subordination as a primary framework for behavior within the classroom:

> Whether the dominating concern was to create a literate and disciplined working class, to impose a middle-class and Protestant *ethos*, or to erect barriers against corruption and disorder, the expressed commitment was to "social control." . . . Anti-social energies and appetites were to be tamped down; "impetuosity" was to be subordinated to "voluntary compliance." The entire effort and the prevailing atmosphere were thought of as redemptive, humane, and benign. (Greene, 1978, p. 228)

Women were expected to project such ideals as well as the gentility and docility needed to maintain such an atmosphere. In the early nineteenth century, for example, teaching still was an activity embedded in family life, and many associated teaching with women's "instinct" for mothering (Hoffman, 1981). With the rise of common school through the 1840s and 1850s and the efforts to establish an effective public school system, women were seen as best suited to "model" and nurture appropriate behavior in the classroom, while men were positioned as the leaders, the administrators (Greene, 1978). At the same time, as Hoffman (1981) notes,

> now the teacher was popularly portrayed as an exalted figure, a custodian of American character whose mission it was to discipline and inspire the young. . . . Three intertwined, massive social changes gave woman her new profession and education its new respect: industrialization, immigration, and urbanization. (p. 8)

Teaching, then, while promoted as a desirable, acceptable, and even laudable "profession" for women in the US from the 1860s on, also became a vehicle for replication and perpetuation of a dominant patriarchal order. And I argue that it would have been difficult even for women who saw teaching as a career opportunity rather than as "natural" work to resist deeply internalized conceptions of themselves as they "should be" within the world. Only recently have feminist education scholars begun to challenge patriarchal assumptions about "appropriate" women's roles as teachers as well as our own complicity in the perpetuation of those assumptions.

Today, a greater range of career choices and mobility for women provides impetus for a necessary re-examination and reconstruction of women's roles within the US educational realm. If we want bright and energetic women to continue to choose education as a career focus, we must examine effects of our own

schooling experiences on our conceptions of ourselves as teachers. By studying our educational experiences, which heretofore have remained in shadows or have been mere reflections of a larger male educational paradigm, women in and drawn to education as a profession can challenge gendered constructions of teaching as well as curriculum and its processes of construction. Potentials for transforming social constructions of knowledge—about teaching and learning as well as about women as teachers, researchers, and curriculum creators—may be among the most compelling incentives for women to pursue education as a career and life choice. For women in curriculum studies, those potentials should inspire us to further examine issues and constructions of gender as we work to reconceptualize curriculum as both a practice and a field of study.

Remembering to Resist

I continue to remember, incompletely, and to review my entry into the professional teaching world, then, and attempt to juxtapose those scattered memories against the fragmentation that I continue to experience as I work in academe. In so doing, I have begun to examine the extent to which my internalized versions of socially constructed and therefore gendered expectations and norms have the power to especially distort and convolute my sense of "academic woman self." By employing the autobiographical method of *currere* (Pinar, 1974; Pinar & Grumet, 1976), by studying my lived educational experience, the impact of social and cultural forces on that experience, and the influence of both milieu and my past experience on my self in the present, I might begin to understand complexities, sources, and the depth of my internalized oppression. These autobiographical engagements also might become, then, "modes of action," first steps in resistance to gender oppression in education.

As a newly married young woman, I recognized that teaching, rather than the other limited career choices for US women in the 1960s, offered the security of a regular schedule and possible tenure. It promised challenge as well as rewards, for, as an undergraduate English major in the early 1960s, I had great hopes of sharing my love of literature with my students. As I examine my conception of teaching as a rewarding endeavor (and as I juxtapose my romantic teaching visions with the typical "realities," both "rewarding" and sometimes difficult, of my seven years of high school teaching), I now understand that one conception of myself as "good girl" and "productive woman" rested on my perceived abilities to give to others, to do something in some way to help, to enrich, to embellish others' lives. I could accomplish this, I thought, in my relationships with my students.

Initially, then, I theorized that teaching provided me with a supposedly positive outlet for my internalized expectations of myself as a woman. I saw that I was able to fulfill my "own" desire to serve others and, at the same time, was able to enlarge upon my perception of myself as a productive and worthwhile person.

There were, of course, several dangers in such a perception of myself. One, of course, was that I existed only in relation to others and their perceptions of me. I had, without thinking and without questioning, transferred an expectation of

myself as a woman, which largely was a societal, cultural, and historically situated creation, to my professional role. And, through the giving of myself in the teaching process, I thought I could feel as though my work, and thus my life, had meaning. So although appearing as my conscious and free choice, the profession of teaching became a vehicle for positioning many of my internalized, but unexamined, expectations for myself. It also especially became a way of re-enacting a social, cultural, and psychological script that I had no conscious part in composing. For, I did not fully understand, as I entered the teaching profession, some of the gendered history in US education that I was replicating.

Nor was I aware of another aspect of gender relations around which such beliefs in my life possibly were based. Concurrent with psychologist Nancy Chodorow, who argued that "feminine personality comes to define itself in relation and connection to other people more than masculine personality does," (1978, p. 44), many feminist theorists have pointed to the many ways in which women organize their lives around the principle of serving others:

> Women have been led to feel that they can integrate and use all their attributes if they use them for others, but not for themselves. They have developed the sense that their lives should be guided by the constant need to attune themselves to the wishes, desires, and needs of others. The others are the important ones and the guides to action. (Miller, 1976, pp. 60–61)

Exploring the manifestations of "relationality," while at the same time attending to Chodorow's psychoanalytic framing of difference as a non-essentialist framing, as *not* innate, poses challenges for me in my autobiographical explorations of what I perceive to be internalized expectations derived from socially constructed patriarchal influences. Chodorow's discussion of women's developmental difference gestures toward formation of women's social roles, including that of the "good teacher," within patriarchy. At the same time, she notes: "To see men and women as qualitatively different kinds of people . . . is to reify and deny relations of gender, to see gender as permanent rather than created" (1978, p. 67). Grumet (1981a), in arguing for the drawing of women's experience of nurturance and reproduction into the discourse and practice of public education, takes up gender relations in education as processes of reproducing ourselves in our present as well as primordial relationships. But in what ways might I attend to manifestations and implications of such processes, as Grumet suggests, without essentializing "women's experiences" and "gender" across educational, cultural, and social practices?

Thus, the fragmentation that I experience even now is partly a manifestation of my struggles with tensions that thread through my questioning. Those tensions pervade my attempts to identify historically, socially, and culturally constructed "realities" of the university that, in particular, create and perpetuate splits that appear "natural" between emotion and intellect, between public and private, between "men" and "women." I want to believe that to identify such splits might also enable me to resist the structures of the institution that often separate self

from self as well as self from other and to begin to participate in action that may be transforming of self, of institution, and even of reified enactments of "gender."

I attempt to resist, then, by searching for, revealing and examining contradictions, tensions, fragments within myself that I partially have come to see as replications and re-enactments of social, historical, and cultural constructions. And in a local sense, as part of such examinations, I have begun to change the form and content of my teaching as well as of my other university commitments.

I see my teaching now as part of an always contested and changing participatory process. I still give of myself in a teaching situation, but I do so in ways that question how I as a teacher have been constructed, rather than as an obligatory enactment of myself as others have conceived me. In turn, I encourage my students, men and women who themselves teach, to explore underlying assumptions and expectations that frame the discourses they use to construct their conceptions of themselves as teachers. We look for examples of patriarchal mandates that historically institutionalized and regulated behavior of women teachers, that positioned women as capable of teaching the ABCs and the virtues of cleanliness, obedience, and respect, while men taught about ideas and organized the profession. But further, we look for examples in both curricula and pedagogical strategies that assume "gender differences as permanent rather than created." And we examine, together, possibilities for taking actions that might address gender norms that become intertwined with inequities based on race and class, for example. At the same time, we analyze patriarchal systems in education that still reinforce gender as well as racial and class differences as permanent.

And to spur our investigations, we attend to those voices from the history of teaching, some of whom—as Nancy Hoffman revealed in *Women's "True" Profession* (1981)—chose teaching as an act of resistance against socially sanctioned versions of "women" and "women's work." They chose:

> work and independence over a married life that appeared, to them, to signify domestic servitude or social uselessness. The accounts of some women tell us that they chose teaching not because they wanted to teach children conventional right from wrong, but in order to foster social, political, or spiritual change: they wanted to persuade the young, move them to collective action for temperance, for racial equality, for conversion to Christianity. What these writings tell us, then, is that from the woman teacher's perspective, the continuity between mothering and teaching was far less significant than a paycheck and the challenge and satisfaction of work. (Hoffman, 1981, p. viii)

Those of us who wish to examine implications of the gendered nature of teaching in the US need to extend our analyses of the patriarchal paradigm of education in order to challenge the taken-for-granted, including the notion of "gender differences as permanent rather than created," while we, at the same time, respond to the spirit and courage of those women educators who struggled and continue to struggle against imposed norms of behavior and identity.

There is no one way in which to approach these issues and countless more that have been raised as a result of attempts to more fully understand the complex, interwoven, and constructed nature of gendered educational experience. If we

recognize the diverse perspectives that have informed the understanding of education as process and project, then we do not wish to reify a form of inquiry or a mode of awareness. I believe that feminists' arguments for fluid conceptions of "woman" as well as educational experience suggest ways in which we may proceed with our individual concerns and yet receive and incorporate the visions of others.

Still, in my teaching, in my development of undergraduate and graduate courses on the role of women in American education, in my participation on university committees (including affirmative action and interdisciplinary studies), in my support of women's studies programs, I still must acknowledge the uneasiness of others as well as myself. I feel myself tighten as a colleague whispers to me in the hallway, "You know, she participated in that university women's caucus and just found out she didn't get tenure." However, I have struggled with my alienated and fragmented "selves" for too long to let myself sink back totally into the mold of others' creation. I still am fragmented [of course!], still often respond in ways that I don't like to the subtle pressures of those who exert influence and power over me, but I am able at least to recognize and to begin to resist the attempts of those who wish to shape and recreate me in a sanctioned form.

At the same time, I listen carefully, drawing strength and intent from those who now command a presence in the academy:

> The new scholarship entails institutional, as well as intellectual, claims. It asks that women, audacious though it seems, be incorporated equitably into the academy. It seeks the presence of women as knowers. (Stimpson, 1981, p. 17)

To envision such possibility within the university structure becomes an aspect of resistance. To write of those visions as well as to reveal individual and collective struggles inherent in the envisioning become aspects of resistance.

I still float. At times, I become enmeshed in habitual response or protective withdrawal. I know that much of the new academic journey for women is uncharted, and it is easy to remain scattered, in fragments, unwilling and unable at times to muster the energy required for agency. The new ways of knowing can be strange, alien, and frightening. The vision is gaining substance, however. As academic women continue to work to understand ways in which we might resist the infiltration, in our minds and hearts, of oppressive conceptions of our (dis)ability and (un)desirability of action, we can continue to move toward truly becoming knowers in our worlds.

INTERLUDE 5

Delese Wear invited nineteen women to contribute to her 1993-edited volume, *The Center of the Web: Women and Solitude*. She edited that book, she said, not to emphasize her educated middle-class privilege that allowed her "to ask questions about, seek, and live solitary moments" (p. xii) but rather to explore "how and where we are situated; our abilities to influence the method and direction of our spinning; and the issues confronting many women living in webs in which they are caught, or living in webs they try to create" (p. xii).

In my contribution, I interrogated some lived relations to the personal-public dichotomy web in which I felt caught, a web especially perpetuated by gendered constructions of academic work. I wanted neither to be totally sifted into others' spaces nor drained from my own, but rather to spin notions of doubled spaces, spaces with permeable membranes that permitted fluid connections between my work and what I had perceived for years as my individual need for solitude as replenishment of mind, body, and spirit. So here, I did not want to get caught up in a Western, humanist version of an intact and fully conscious "individual" who can withdraw or ever be "outside" discourses and power relations. In this piece, I instead wanted to gesture toward

> subjects created in multiple causality, shifting, at relay points of dynamic inter-section. We can take apart the facts of complementarity, of male and female, rational and irrational, active and passive, mental and manual, which form the sites and possibility of our subjugation and of our resistance. We might then adopt a double strategy: one which recognizes and examines the effects of normative models, whilst producing the possibility of other accounts and other sites for identification. (Walkerdine, 1990, p. 57)

I also was attempting to spin versions of autobiographical inquiry that had me working within and against what Patti Lather soon after (1997) described as "dominant . . . normalized borders," where we might trace our complicity and at the same time move toward "some place that might be called feminist imaginaries of a double science, both science and not science" (p. 234). While not overtly framed as a piece of research that took the crisis of representation into account, I did have in mind, as I wrote this piece, questions similar to those that Patti posed about difficulties and limitations of categories and binary constructions within which she, as a feminist, researched and wrote in and out of the university:

> What does it mean to create a different space in which to undertake other per-
> formances, other thinking, power, and pleasures, to create new lines of flight,
> fragments of other possibilities, to experiment differently with meanings, prac-
> tices and our own confoundings? (1997, p. 234)

In the following autobiographical piece, I trace my "experiences" of doubled spaces, mediated through memory and language, by envisioning those spun by my mother. While my attempts to enact such spaces were and are very different from hers, I honor that fact that she acknowledged "the possibility of other accounts" and contested normalized borders until the last day of her life. Any work I now do in the spirit of feminist imaginaries of a double science, a double strategy, is metaphorically related to my mother's creation of doubled spaces of both solitude and connection as means to "undertake other performances," to "create new lines of flight," to constantly seek to create a "different space."

SOLITARY SPACES
Women, Teaching, and Curriculum

I am alone in the house. But for me the world does not recede. . . . Quite the contrary. The world is given point by my solitude. For even as I sit alone in my room, I feel a pull on my attention that necessarily attaches me to the world. Our intellectual work ought to give point to and signify those attachments. Our attachments ought to give point to that work.—Jo Anne Pagano, "The Claim of Philia"

And when is there time to remember, to sift, to weigh, to estimate, to total? I will start and there will be an interruption and I will have to gather it all together again. Or I will become engulfed with all I did or did not do, with what should have been and what cannot be helped.—Tillie Olsen, "I Stand Here Ironing"

One of my mother's favorite Perry Como renditions is "In My Solitude," and I remember her humming that ballad as she ironed, her swaying body keeping gentle time with the music drifting from the radio that was permanently anchored on a shelf above the kitchen sink. That particular form of solitude, a reverie laced with static from both the radio commercials and her two young daughters and embroidered with household and child-care routines, could only have been fragmentary and fleeting. Yet I think that my mother wove together those moments from strands of music and breezes that barely puffed the white sheer curtains shading our apartment kitchen window, knowing that she never would completely sever her musings from the bustle surrounding her.

As I interpret this particular scene from my childhood, I now conjecture that my mother's humming could have signaled doubled spaces—spaces of both insulation and inclusion. The humming keyed us into her desire for time "to remember, to sift," as well as enabled us to locate her within her own solitude. And, although I was busy jumping rope or reading to my younger sister, I know that I listened for her humming as she bent over the ironing board, creating those dou-

bled spaces amidst our squabbles and the banging of screen doors and the squeals of neighborhood kids playing on the swing set in the community backyard.

As a young child, then, I learned to hum like my mother, trundling behind her as she swept through the daily household chores with Perry Como, Rosemary Clooney, or Nat King Cole as her cleaning companions. At that point, replicating only her accompaniment, not her intentions, my hums most often melded into my sister's and my high-pitched inquiries and conversations. And, even though we had learned early that my mother's humming expressed, in part, her desire to be alone with her thoughts, we often disrupted its melodic flow as we called for her to watch us play our games or, more often, to settle disputes over ownership rights of game pieces or a favorite toy.

Later, when my mother went to work outside our home in order to help with family finances, I took over the ironing and dishwashing duties, my adolescent alto replicating my mother's versions of "In My Solitude" or "Mona Lisa" as well as Elvis's renditions of "Hound Dog" and "Blue Suede Shoes." Even as much as I loved those teenage moments when I could be alone, vocalizing to conjured-up images of my latest junior high school crush, I missed her as I hummed and ironed. I was waiting, in the midst of my industriousness, for her to come home from work so that we could talk about the latest incidents at my school or her office.

In the ensuing years, I too have had to learn to extract my own versions of solitude from the patterned inundations of daily work and responsibilities. Lately, my desire for solitude seems to increase in direct proportion to the amount of university-related work and stress that I am experiencing at any particular moment. That desire often demands that I literally separate myself from others and from a routine schedule that suddenly has jumbled into momentary chaos. During those moments, I feel that isolation and separation are the only states of mind and physical being that can enable me to regain a sense of myself and what I want and need to do.

So, sometimes, especially at the end of a semester, I long to spend days alone, puttering in my study or repotting plants—doing anything so long as it's not in any way attached to the required events of university teaching, researching, and writing. The very few times that I have been able to carve out such spaces, I have tried momentarily to withdraw from the world. I have unplugged the telephone, and have built a fortress around me of books, music, and unopened mail and catalogs from every mail-order business in the United States. Then, quite often, I have read, listened, or attended to none of these. Instead, I have waited and watched for signs of myself to return and to enter the spaces that I have been filling with the needs, desires, and requests of others. I now think that, in those moments, I was trying to protect myself, not from the intrusions of others, but against further alienation from myself.

My desire for that particular scenario of solitude as isolation also reflected a certain desperation on my part. That fraught feeling kicked in, I think, especially when I saw myself in either/or positions. Either I was in the university, with all its related committee meetings, student advisement sessions, classes to teach, student

papers to read, and journal deadlines—or I could create a world where none of those pressures existed. The second part of that either/or construction is the idealized academic dream that I've only lately begun to unravel.

What I realize is that idealized version of solitude is not only impossible, but also is not what I really want. I cannot, nor do I wish to disconnect myself from the students, colleagues, and friends with whom I work or from the ideas, theories, and debates that we exchange. Instead, I want to spin and shape and spew out series of doubled spaces, overlapping and intersecting spaces that connect the many passions and commitments in my life and from which I can both replenish and share myself. Thus, what I want and am still learning how to do is to construct moments of both solitude and connectedness for myself—those doubled spaces—in which I am neither sifted into others' spaces nor totally drained from my own.

And so, I still am working to construct possibilities of solitude as moments spun from webs of connectedness. But connectedness is different from immersion in others' versions or demands of me. For that immersion supposedly threatens a suppression or subversion of my own desires and needs to those of others. And that's when I, for years, assumed that I would lose my "self," and thought that I had to concoct an isolated version of solitude as a way of connecting with myself before I could effect similar connections with others, with ideas, and with actions in the world.

Connectedness and attachment, in ways that I now want to construct them, entail spaces of shared as well as individual—and yet always still socially and culturally situated and inflected—questions, challenges, interests, intentions and actions. Those permeable spaces allow me both to enter into relationships with others and to maintain room for my differing selves within those relationships. I watched my mother, seemingly alone with her thoughts as she embellished both her ironing and Perry Como, and she watched me, constantly aware of what my sister and I were doing at any given moment. Her particular version of solitude, swirled together with music and children's prattle and the hiss of the iron as it flattened damp clothing, is not mine. But her version continues to teach me that I need not construct only detached or isolated forms of solitude in order to replenish connections to others or myself.

Thus, I still might wish for those isolated forms on days when students and meetings and deadlines threaten to squeeze me out of myself (as if that were a whole and intact construction!) and into others' versions of who and what I should be. And I am sure that my mother also longed for those forms of solitude that could guarantee protection against children's interruptions and the constant juggling of demands from both her home and outside workplace. But my mother's versions of solitude, shaped within those demands and interruptions, have taught me that I can replenish and at the same time interrogate whole and intact versions and expectations for my "self" even as I acknowledge and participate in my attachments to others and the work that connects us.

By extension, then, in my work at the university I see ways in which my mother's versions of solitude inform my interests in curriculum, teaching, and

research as reciprocal and interactive, rather than as separate and discrete constructions. My mother's adaptations of solitude, in which she momentarily withdrew and watched as well as responded, has enabled me, in turn, to both claim and question constructions of myself and the communities in which I participate, to both honor and challenge boundaries that can enclose as well as exclude, to both thread together and unravel moments of solitude and relationship that inform my life as a woman academic.

Like my mother, I juggle demands and responsibilities. For me, these come in the form of teaching, preparing classes, advising and responding to students, writing and researching. And like my mother, I now attempt to create solitary spaces as pauses, as shifting and momentary respites rather than as definitive and constricted separations between others and myself. As I work to create those doubled spaces, I now can see ways in which the tensions that erupted in me as I tried to construct an either/or version of my life in the university are reflected in themes that have dominated much of my academic work thus far. I have identified and grappled with discursive, material, and psychosocial influences on the fragmentation that I have felt in my life as a white, middle-class woman academic in the United States. I have done so by examining, autobiographically, effects of the academy's privileging of public over private, "expert" over nurturer, theory over practice, that historically have characterized not only the field of education but also what has been constructed as women's work within that field.

I continue to explore how constructions of women's work and voices, as situated within a private, domestic sphere, devalue teachers who wish to be both nurturing and authoritative in our work. I am interested in ways that we might reshape historically rigid boundaries between public and private into spaces that might include notions of communities and collaborations without hierarchies but also without mandated consensus. Instead of promoting educational communities and identities that promise unity and sameness, where we all will become a certain form (white, middle-class) of "reflective practitioners" or cheerful "teacher-researchers," for example, what might we do to shape communities and forms of collaboration in which we could struggle together to create versions of curriculum, teaching, and learning that do not posit particular voices, bodies, and experiences as representative of all?

Thus I fight to create solitary spaces for myself that do not replicate or reify historically, culturally, and discursively constructed boundaries between self and other, between gendered constructions of female and male teachers, for example. But I am also aware of the difficulties of constructing a doubled-spaced version of solitude that does not easily slide into silence or confinement or isolation or privilege or sameness.

And so, like my mother, ever watchful in her solitude, I drive home from my evening's teaching, already casting an eye toward the next class discussion, mindful of a student's request for further reading, of the questions to which I want to attend in our next session, and of the students' papers that I must read before tomorrow night's class. Like my mother, even as I savor the drive home as a small sliver of solitude, shaved from the day's schedule of endless meetings and teach-

ing, I am watching and responding, aware of my connections to others whose varied and multiple interests and concerns inform, but often do not replicate my own.

But as I teach, research, and write as part of my university responsibilities, I continue to confront myriad ways in which schooling structures and discourses perpetuate the separations and compartmentalizations that keep us from others and ourselves. So just as I must work to create solitary spaces that both enclose and invite, that acknowledge my attachments both to the world and to my changing selves, I also want to incorporate such doubled spaces into the ways in which I work as a woman academic. For me, the continuing challenge in all of this is to claim connections as well as to grapple with difference within such spaces.

For example, as I work with graduate students who are themselves teachers and administrators in the schools, we still must grapple with versions of teaching and curriculum that conceptualize pedagogy as a series of discrete skills and curriculum as content, as separate and autonomous disciplines, each with its testable facts and measurable knowledges. To create spaces in which to consider other possibilities for curriculum and teaching, then, we study conceptions that extend traditional definitions of curriculum as content into analyses of discourses and structures of schooling that construct and are constructed by social, historical, cultural and economic events and contexts that in turn shape such content. And we try to examine those discourses and structures as they occur in the contexts of our daily lives and to trace how "school knowledge" gets reified and thus separated from our possible active processes of knowledge creation.

But as we do so, teachers bring to class stories of daily confrontations with their school districts' central office mandate about students' raised achievement scores as evidence of "rigorous curriculum" and "effective" teaching and learning. Or administrators tell of pressures to squeeze curriculum into testable areas, so that chunks of material are "integrated" into conveniently measurable segments of knowledge. Or I talk of my frustration in working with a school administrator who wants to see, in a multiple-choice test format, measurable differences in students' writing. This "evidence" will inform the school district's decision to continue or halt a writing process in-service program for teachers and students in which I have been participating for eight years.

Such vignettes signal that some educators believe that constructions of teaching and curriculum actually are distinct and separable from my students' or my own musing drive home after class or from the relationships that spill from our classrooms and meetings into those momentary, constantly moving and shifting solitary spaces. And those conceptual separations then threaten to become reified spaces that demarcate public arenas of education as places filled with official words and actions of certain others who have been designated as "experts" or as representatives of all—the knowledge creators and measurers.

And so, in order to create the kinds of doubled solitary spaces that I initially experienced as I listened to my mother's humming, I also have had to increase my tolerance for ambiguity and for a conception of constantly shifting spaces as momentary places of both connection and solitude. In order to work in the

schools, I have had to deal with school districts' versions of curriculum as fixed content while trying to spin spaces with teachers that attend to possible ways in which teachers and students themselves create curriculum. And in order to continue to work in the university, I still must struggle with my internalization of how I "should be" in the academy. I am attempting to create versions of myself as a woman professor who is able to claim not only my own sense of authority as teacher, researcher, and writer but also my sense of connectedness to others and myself. At the same time, I still struggle with the "shoulds" that have been constructed from social, historical, and cultural discourses and educational practices that devalue and at the same time reify women's work in education. And as I try to move into fluid conceptions of myself as possibly both/and, I remember my mother and her doubled versions of solitude that I still work to create.

Thus, I continue to confront silences and omissions as well as possibilities within my emerging versions of solitude. For I still want to create solitary and communal spaces within teaching and curriculum that are overlapping and connected, but that also acknowledge and claim differences. And I know that my versions of solitude and of curriculum and teaching, constructed from my position as a white, middle-class woman academic, do not necessarily reflect the same ambiguities, conflicts, and exclusions felt by other women in other positions. And I also know that the luxury of even contemplating such versions may not be in the province of many people who have little, if any time, to "remember, to sift, to weigh, to estimate, to total."

Perhaps my early recollections of solitude, formed in the connected yet ambivalent spaces of my mother's work and reverie, can enable me to enlarge my understanding of my own privilege as well as my particular constructions of myself as a woman academic and how those "personal" constructions reflect and are constructed by social and cultural norms and expectations. Perhaps my understandings of solitude as spaces forged in the midst of daily educational work and connected both to the relationships and the contents that are the focus of those activities also will enlarge. I hope for such doubled spaced understandings in order to work with others to forge educational communities and collaborations without consensus, without the pressure to merge into one position or one right answer or one identity.

I talked with my mother again about this paper and about her versions of solitude. We hummed a few phrases of "In My Solitude" to one another, and then we laughed. "How did you ever remember that?" she asked, just as I voiced the same question to her, knowing that her remembrances and versions would not be mine. We talked for a few more minutes, as she recalled returning to work outside our home full-time when my sister and I were in elementary school, and enjoying new forms of solitude on her daily bus ride into downtown Pittsburgh and the work that awaited her there.

My mother recently moved into a new apartment, and she was unpacking a box of photographs even as we chatted on the telephone. I could hear her humming once or twice during our typical hour-long talk, especially as she debated with me the best placement of the framed photographs of my father and my sister

and me. She was both with me and not, both watching and responding. That slight solitary space in the midst of our conversation hung in the air for a few moments after I hung up the phone, connecting us still across our separations and differences.

"THE SURPRISE OF A RECOGNIZABLE PERSON" AS TROUBLING PRESENCE IN EDUCATIONAL RESEARCH AND WRITING

I welcome the arrival of the conscious memoir, not only because it can illuminate the hidden subtext of scholarly works but because it offers, in the midst of colorless abstraction and obfuscating jargon, the surprise of a recognizable person. —Marilyn Yalom, Signs: A Journal of Women in Culture and Society

How to interject the "surprise of a recognizable person" not only into an academic text but also into a review of that text? How to call attention to the ways in which language in part constructs both that "surprise" and the very notion of a "recognizable person," without collapsing immediately into "colorless abstraction and obfuscating jargon"? How to convey the myriad connections that I see between Cinthia Gannett's work, *Gender and the Journal: Diaries and Academic Discourse* (1992) and the inquiries that many of us attempt within curriculum studies, without lapsing either into cheerful accounts of sameness or embattled stances of defense?

In her book, Cinthia Gannett is not writing her memoirs, per se, as a woman academic who teaches English and composition. Rather, she is presenting, in the center three chapters of her book, a sweeping and thorough review of historical and social traditions of journals and diaries. Within that review, Gannett discusses gender and its relations to language and discourse as well as to journal and diary-keeping traditions. These traditions range from Pepys's and Boswell's personal journals—"the imprint of a man's being-in-the-world" (Gannett, 1992, p. 113)—to public and communal journals, travel journals, journals of conscience or spiritual journals, commonplace books, daybooks and academic journals used for a variety of purposes across the disciplines. Gannet conducts her survey and analysis in order to provide context for her inquiries into what she sees as the gendered nature of her own as well as her students' academic journal writing.

Gannett's inquiries are situated in her college composition and women's studies classes. Often, students' journal writings and responses, as part of their academic work in Gannett's courses, appear to enact the stereotypic assumption that journal and diary writing are "feminine" practices. That assumption motivates Gannett's wide-ranging search for shifting historical, cultural, and social forces that could account for such enactments.

The forces Gannett identifies include "linguistic and material realities" (p. 50) of men and women. From those "realities," which encompass socially constructed binaries of dominance-muteness, public-private, social-personal, masculine-feminine, Gannett traces historically and culturally conditioned discourse norms. In particular, Gannett focuses on claims that "men's and women's asymmetrical constructions in and through language and discursive practice will account for the gendering and frequent marginalization of the various strands of the journal/diary tradition" (pp. 44–45).

Gannett explores these claims as one way of grounding journals and journal pedagogy more fully in their historical and social contexts. She examines, for example,

> the role that gender plays in positioning us and our sense of self in relation to language, to knowledge, and to all discursive practice. Of particular importance is the imposed but shifting demarcation between public and private, dominant and muted domains of experience and discourse and its conceptions: the marginalization of women in both speech and writing. (p. 100)

Throughout her review of research and literature about and in journals and diaries, Gannett interjects her own and others' questions and musings about the relations among gender, language, and power. She does this, she tells us, in order to disrupt academic forms of writing that often obscure the dynamics of power and the selves that get constructed within those relations. Gannett's interjections, including excerpts from her own journals that chronicle her doubts, frustration, and passions about her topic, do not provide her readers with a full memoir. But they do provide, within an academic text, several versions of "the surprise of a recognizable person."

That "surprise" constitutes the power not only of Gannett's text but also of various works that are variously categorized as narrative, autobiographical, biographical, naturalistic or interpretive, among others, within US curriculum studies and educational research. However, not everyone will agree with my assessment of the "surprise of a recognizable person" as a potent reason for engaging in these qualitative forms of inquiry. The status of educational research and writings that incorporate versions of the "personal," and that often appear in the form of journal excerpts, used as data and crafted into "stories," remains questionable for some. Gannett, through her own and others' testimonies as well as through her analysis of changing historical and social contexts, draws particular attention to the currently devalued "feminine" nature of journal and diary writing within academic discourses. Her work, I believe, points to possible reasons for how and why narrative, autobiography, and forms of teacher-research that utilize these modes

of inquiry remain for some as marginal, as secondary among theoretical, analytic, and empirical studies in education.

Of course, I am reading Gannett through my own questions, interests, and musings. I conduct autobiographical and narrative inquiry as a woman academic, as a white, middle-aged and middle-class teacher-researcher and writer. Concurrently, I struggle to engage in forms of narrative and autobiographical inquiry that do not present single, essentialized, or unified representations of "self," "identity," "voice," "woman" or "experience," for example. In particular, I work to examine and to question ways in which those constructs often are normatively enacted and represented in and through research and writing in the field of education.

At the same time, I am an advocate of narrative and autobiography as viable modes of curriculum and education inquiry, in general, and I am disturbed by the ways in which such work sometimes is dismissed as "soft," "idiosyncratic," "under-theorized," "individualistic," even "narcissistic." So, of course, my discussion of Cinthia Gannett's book reveals ways in which my constructed role(s) and identity(ies) as academic woman, as well as my research and writing commitments, shape this analysis, just as Gannett acknowledges that "gender shapes the experiences of reading and writing for my students and . . . even shapes my reading of the workings of gender in their journals" (p. 153).

Multiple Contexts, Theories, and Traditions

Gannett roams across disciplinary boundaries as well as theoretical orientations as she explores social and historical traditions of journal and diary keeping. She does so, because, as she notes,

> The types of writing referred to by the cover terms journal and diary have repeatedly broken free from the verbal vessels designed to categorize and contain them. Shuttling to and fro between domains of discourse, journals and diaries have operated as the verbal vehicles for the sober and serious chronicling of business activity or public affairs in one incarnation, court scandal and witty gossip in another. . . . In the university, the journal can be found at one moment in the library, trying on the mantle of art, loosely draped in the genre of autobiography by literary scholars. . . . A few moments later, it can be located in a classroom, being exercised as a utilitarian tool for the development of critical thinking or prose style. . . . Thus, as chimerical sites of writing which move between dominant and muted discourses, between writing and literature, between convention and self-construction, journals and diaries offer a singular occasion for tracing the inflections of gender and other social constructions through discourse. (pp. x–xi)

Gannett also tells us that she has framed her book theoretically through social constructionist and feminist perspectives that have "burst open the traditional boundaries of literary and literacy studies that have asked important new questions about the relationship between gender and language" (p. x). In working with forms and theoretical orientations that exceed the boundaries of traditional struc-

tures and modes of inquiry within particular disciplines, then, Gannett situates herself and her readers within "widely ranging and exuberantly disarrayed theoretical conversations" (p. 2). For example, those conversations weave in and through Gannett's review of various social constructionist and feminist views of language as not only conveying social reality but also functioning as one of the prime elements in that reality's construction and maintenance:

> No longer seen as the transparent reflection of an objective reality, nor the passive vehicle for the conveyance of ideas, language and discourse are now clearly seen to have the power to marginalize or empower, mute or magnify, hurt or heal. In short, language, the social codes it embodies, and the discursive forms that it employs all write us into the social and cultural positions that we, as we write, experience as intrinsically ours. (p. 4)

As she discusses varying theoretical relations between "self" and "language," Gannett traces the movement away from the "traditional humanist notion of the 'self' as an autonomous, coherent, and completely individual entity and toward the view that the self is partially socially constructed through language and other forms of social organization" (p. 5). Gannett also identifies some of the most interesting questions that emerge for her from among often disparate social-constructionist and feminist conversations about language: "How much of the self is socially or linguistically constructed? Or does saying that the self is multiple and socially constructed mean there is no 'self'?" (p. 4).

Gannett juxtaposes debates about these and other questions among structural Marxists, Lacanian psychologists, poststructural feminists, traditional humanists and others. She does so in order to frame her further discussions about historical, social, and cultural contexts for men and women's relations to language, for the gendering and marginalization of journal and diary forms, and for ways in which those forms demonstrate gendered constructions of "self" and knowledge through language. As she examines the influences of these contexts, Gannett also interpolates her own questions and positions into "widely ranging and exuberantly disarrayed theoretical conversations." She does this with her own journal entries, which give us, her readers, the "surprise of a recognizable person" amidst the abstractions of a traditional scholarly literature review.

Thus, we find out from Gannett's journal entry, rather than from her literature review, some of the questions, frustrations, and ponderings that surround her perspectives on issues of language and the social construction of "self." For example:

> Worried about voice—subjectivity—who is the *I* that writes—how do I connect the postmodern, deconstructive nonself inscribed only by other voices, with *me*, a multiple, changing, person in process, but an *I* nevertheless. The *I* who has dirt under her fingernails from weeding the garden and a cat sleeping next to her, who worries about showing the house to prospective buyers and whether or not she can afford to buy a Cross pen to write. A permeable *I*—inside and outside, but unified over time, which she knows by many things—like by keeping and reading her journals. I guess I'll just have to be comfortable with the fact that the discussion of these issues will take place throughout the text I write. Certainly,

however, some form of dialectic and reciprocal view of the relation between self and language is the one that I find most compatible at present (whoever I am), and this certainly informs my perspectives on gender, journals, and diaries. (pp. 6–7)

Such interpolations occur throughout Gannett's text, as she traces histories, contexts, and themes that gird students' and teachers' gendered understandings and uses of journals and diaries. In grappling with as well as situating herself among varying perspectives on relationships among language, knowledge, and notions of self, Gannett does illustrate the conflicted, conflicting, and changing positionings of her many "selves." She is professor, wife, mother, daughter, friend, feminist—and she discusses how all of these subject positions shift and often come into conflict in relation to her own as well as others' various academic intentions and contexts. In this way, Gannett herself demonstrates that the very notion of "the surprise of a recognizable person" is a product of history, culture, society, and language.

Multiple Narratives of "Experience"

In particular, Gannett explores ways in which she is working with and in academic positionings and intentions (woman professor, composition teacher, journal writer, and advocate) that have come to be associated, as has the diary, "with connotations such as overly personal, confessional, trivial, and . . . feminine" (p. 21).

As such, Gannett's work also points to aspects of narrative, autobiography, and teacher-research as forms of qualitative research in general that have come to be associated with similar connotations. Such work, within curriculum studies especially, often depends on forms of journal and diary writing to constitute, contribute to, or supplement data that are used to constitute teachers' and researchers' personal "stories" of their work, their "tales of the field" (Van Maanen, 1988). One aspect of attempts to legitimate teacher-research, narrative, and autobiographical work that Gannett's work illuminates for me is the difficulty of moving such work out of the historical legacy of "less than" attributed to "personal" writing, especially if that personal writing of research takes the form that Van Maanen calls a "confessional tale." Because "fieldwork is an interpretive act, not an observational or descriptive one" (Van Maanen, 1988, p. 93), research accounts that reflect that major turning point in American social thought now often include explicit examinations of researchers' own preconceptions, biases, and motives that frame their interpretations of fieldwork data. And, as Van Maanen notes,

In skilled hands, the personal voice can be a gift to readers and the confessional becomes a self-reflective meditation on the nature of ethnographic understanding; the reader comes away with a deeper sense of the problems posed by the enterprise itself. (1988, p. 92)

But, as Gannett points out, even within the current pedagogy of many university writing courses (and, I would add, embedded within the often unspoken requirements of many university research projects), "the implicit goal is to move from personal writing into academic writing, which assumes that *mastery* of academic writing is finally different from, incompatible with, and superior to, personalized and connective writing" (p. 199).

An additional complication: many narrative inquiries in education have been conducted with and in relation to elementary and secondary classroom teachers, whose profession we well know is regarded still as "feminized" (Apple, 1986; Hoffman, 1981; Greene, 1978; Stone, 1994). I believe this is one reason that classroom teacher research still is not regarded as "real" research among portions of the university educational research community. Further, those inquiries often focus on "teachers' stories" and include their personal and reflective journal writings as part of both the research process and its representations. Given the legacy that Gannett has detailed in her book, the very limitations that she has traced for forms and functions of writing associated with "the feminine" are limitations especially faced by those involved in teacher-researcher narrative and autobiographical inquiries:

> The ambivalent reception . . . of writings we call journals or diaries is not simply due to this form's status as private rather than public, or relatedly, to its status as nonacademic—and, therefore, not intellectually valuable—rather than academic. Rather, these two statuses derive in large part from the feminization and consequent derogation of the diary. The diary, because of its association with women's experiences, voices, and perspectives, has been labeled a problem. (p. 193)

While the modes of curriculum inquiry to which I am referring and in which I am invested do not necessarily represent only women teachers and researchers' "experiences, voices, and perspectives," the forms that such inquiries take often are associated with "personal" writing.

A further difficulty arises within the educational research community, I think, when some of these personal writings, whether they are called autobiography, narrative, or story, are crafted as seamless, unitary, and transparent as well as what Gannett calls "conversion narratives" (p. 20) of educational experiences. Such narratives sometimes offer testimonies to the "reality" of what are described as "transformative" pedagogical and research experiences. But historian Joan Scott (1991) warns of consequences of not attending to questions about the constructed nature of experience. She raises questions about knowledge posited as "the truth" based on an unproblematized notion of experience. Scott does not argue for abolishing the concept of experience, per se, but rather argues that we need to

> work with it, to analyze its operations and to redefine its meaning. This entails focusing on processes of identity production, insisting on the discursive nature of experience and on the politics of its construction. Experience is at once always already an interpretation *and* something that needs to be interpreted. What counts as experience is neither self-evident nor straightforward; it is always con-

tested, and always therefore political. . . . Experience is, in this approach, not the origin of our explanation, but that which we want to explain. (p. 793)

In the US field of education, where teaching and researching about and across social and cultural difference are of paramount importance, it behooves us to attend to Scott's concerns about what counts as experience, who gets to make that determination, and effects of difference and "different experiences" on constructions and authorizations of knowledge (Scott, 1991).

Obviously, then, one difficulty that I see with "stories" that testify to the benefits, enhancements, even transformative possibilities of reflective, autobiographical, and narrative inquiry within educational research is that many do not explore and theorize social, discursive, historical or cultural contexts and influences on constructions and interpretations of "selves" who "have those educational experiences." Such stories often do not incorporate, as Gannett does through her own journal entries in this book, situated analyses of specific historical, social, and cultural contexts and discourses that influence constructions and representations of self and other. These, then, are the stories that leave us open to critique from those who demand theorized and contextualized accounts of what counts as educational experience and practice.

But it is not as though that work to theorize and situate autobiographical and narrative work within larger contexts has not been part of curriculum theorizing and research, especially during the past twenty years. Pinar's initial work on *currere*, his method of autobiographical inquiry, drew on traditions of existential phenomenology and psychoanalysis as he and Madeleine Grumet worked to reconceive the relation of self to knowing through autobiography (Pinar & Grumet, 1976). In examining that relation, and in offering the individual a way to study her lived experience as well as the impact of social milieu on that experience, both Pinar and Grumet drew attention to the necessity of rendering multiple accounts of our experiences and our selves. Those multiple accounts "cultivate our capacity to see through the outer forms, the habitual explanation of things, the stories we tell in order to keep others at a distance" (Pinar, 1988, p. 149). Those multiple accounts also "splinter the dogmatism of a single tale" (Grumet, 1991, p. 72).

Jo Anne Pagano (1991) also has examined perils of autobiography conceptualized and written in singular and non-relational ways, and calls attention, from a psychoanalytic perspective, to complications of difference:

> Autobiographical writing, particularly in the classroom context, can inhibit that surprise [of otherness] because we are so concerned with the representation of ourselves. When we tell stories with ourselves prominently and self-consciously at the center, we tend to think of others only in relation to ourselves; we tend to reify others. (p. 202)

Rather than focusing on psycho-social or discursive complexities involved in the notion of "constructions of selves and others," per se, Michael Connelly and D. Jean Clandinin have provided both a discussion of methodological issues involved in narrative inquiry as well as "an overview of narrative and storytelling

approaches in and out of education to help locate narrative in an historical intellectual context" (Connelly & Clandinin, 1991, p. 125).

These and other theorists have worked to contextualize, to theorize, to problematize intentions, methods, and forms of autobiographical and narrative inquiries. Yet, some autobiographical, narrative, interpretive and teacher-researcher representations of educational experience ignore or do not incorporate such theorizing. As a result, unified, essentialized, and what might even be called "cheerful" or "conversion" versions of "self, experience, and other," continue to be produced in the field.

Further, what is provocative about Gannett's study, to my reading, is the extent to which it suggests that, for some educational researchers, no amount or kind of theorizing of autobiographical and narrative inquiries will legitimize those forms because of their association with "the feminine." Even if that construct can be called into question for its essentialist assumptions that restrict the meaning of gender to received notions of masculinity and femininity (Butler, 1990), "the feminine" and "academic writing" continue, for the most part, to be oxymoronic within the academy.

Multiple Research Contexts

Gannett does not ignore efforts to theorize cultural, social, and historical constructions of "experience," "the personal," and "the feminine" in the fields of literary and composition theory and criticism. Throughout the major portion of her text, Gannett attends to "the dynamic and interactive processes of reading and writing, and the social and historical contexts of all acts of discourse" (p. 2). She does so in order to "explore the larger connections between journals and diaries as literary practices and the gendering of discourse and epistemology" (p. 212). At the same time, in her quest to underscore the gendered legacy of journals and diaries and the implications of that legacy on her work with and in academic journals, Gannett also confronts dilemmas that are familiar to many of us who work in and with narrative and autobiography as modes of curriculum inquiry.

For example, in the last chapters of her book, Gannett responds to and analyzes students' journal entries written in her composition and women's studies courses. She also analyzes 76 student responses (41 female and 35 male) from a Writing Experience Survey administered to entering composition students. With her review of historical, social, and cultural influences on various journal and diary writing traditions as backdrop, Gannett explores ways in which her students' journal writing, and patterns of response to those writings, conform to what she has argued are gendered understandings of the journal's forms and functions.

Gannett, using excerpts from her students' journals, demonstrates that such gendered understandings could be a result of differing journal legacies for men and women:

> The journal legacy for men includes the general forms and functions of public writing based primarily on discourse models built on the inscription of power and control over language, knowledge, and discursive rights. . . . Unlike men,

women have inherited a marginalized and frequently privatized relation to language and discourse generally and to textuality specifically. As members of a muted group of speakers and writers, they may partake of or even subscribe to the dominant models of discourse, but historically they have had only limited rights to shape or use dominant discourse practices. (pp. 187–189)

Gannett uses her discussions of the differences between men's and women's legacies of journal writing to support her contention that, in her own as well as in other colleagues' academic courses, men were much less likely to participate in a journaling tradition outside of school; they did not enjoy writing school journals because they viewed them as diaries; and they were also less likely overall to perceive their academic journal-keeping experience as valuable or productive as the women did (p. 188).

Gannett's "conclusions" are not surprising, given her stated intentions throughout the book. What is surprising are the ways in which she collapses her attempts to grapple with "the critical insight that women [and men] are not all alike . . . and that race, class, ethnicity, sexual orientation, and religion are also important determinants in the social construction of the self" (p. 11). Although Gannett's stated focus is on gender throughout this book, I was expecting, in the last section of the book, that Gannett might incorporate such a "critical insight" into her analyses of students' journal writings as well as of the very construct of "gender," for example.

Instead, in focusing so deeply on traditions of journal and diary writing as gendered activities, Gannett has inscribed, in the last section of her book, a narrower and more fixed traditional ethnographic narrative, rather than "multiple accounts" of students' "experiences" of responses and writings or multiple accounts of performances of "gender." Ironically, her research narrative in these last chapters depends on stable and unitary categories of "male" and "female" and transparent notions of "experience." Given that little, if any, mention is made of these students' social and cultural markers other than that they are students at a state university or at a small branch of that university in New England, Gannett also has inscribed a version of gender as separate from other social markers of identity. But as Deborah Britzman reminds us,

> Our understanding of gender . . . needs to move beyond singularity, taking into account the reality that each of us embodies a wide range of categorical commitments such as race, sexuality, generation, class . . . ; the shifting meanings of these social markers arrange the experience of gender. (1993, p. 26)

Thus, I am left with this question: how have Gannett's selections and placements of her students' journal excerpts, devoid of discussion about any social markers other than a fairly static conception of gender and devoid of multiple renderings and interrogations of students' "experiences," become "simply an illustration of something we already know about gender, rather than an occasion for learning something about the complicated, and in many ways still mysterious, construction of subjectivity" (Costello, 1991, p. 128).

Further, in what ways has Gannett inscribed these students' tales with her own interpretations of gender as an organizing social construct? For example, as a reader who engages in qualitative research and curriculum theorizing, I want to know if and how and when Gannett shared her interpretations with the students whose journal entries she utilizes to support and exemplify her thesis. How might students' responses to Gannett's choice, placement, and interpretations of their journal entries reveal different understandings, performances, and embodiments of gender? How might students' "shifting meanings" assigned to social markers (re)arrange their experiences of gender, race, and class? How might students' interactions with Gannett's interpretations reinforce, enlarge, complicate, or contradict Gannett's interpretations of their "experiences," of her "findings"? Further, what might such possible responses tell us about "ways in which laws of genre lock the autobiographical subject into certain forms of compulsory gender identity and how the autobiographical subject seeks to unlock the genre and thereby unlock those compulsory identities" (Smith, 1993, p. 405)?

Throughout her text, Cinthia Gannett provides her readers with the "surprise of a recognizable person." A difficulty in representing, in writing, any qualitative or narrative inquiry is to not flatten that surprise into a stereotypic, unified, predictable and fixed version of self or other. Further, I argue that what we need in the fields of curriculum and educational research are extensions of studies like Gannett's that *also* avoid exclusionary gender norms in their portrayals, and that loosen the hold of "identity" by making evident identity's construction (Butler, 1990).

I pose these questions and remarks as indicators of similar difficulties, dilemmas, and puzzles within curriculum research and theorizing that employ the autobiographical, the narrative, the story, the journal as both forms and practices of educational research. Gannett's text, then, provides not only the "surprise of a recognizable person" but also the surprise of the tenacity with which habits of naming selves and others cling to research projects intended precisely to dislodge them. For these reasons, I find Cinthia Gannett's book to be instructive and illustrative of both surprises and difficulties inherent in work to tell, elicit, and teach with stories that are neither complete nor essentialized versions of ourselves and others.

INTERLUDE 6

I originally wrote what I now call "Mr. Brucker's Good Girl" for an edited collection entitled *Thirteen Questions: Reframing Education's Conversation* (1992/1995). Co-editors Joe Kincheloe and Shirley Steinberg invited two scholars each to address major issues in education by responding to specific questions. The general arena, *women and education*, and the specific question posed to Jo Anne Pagano and me: *In what ways does gender affect the educational process?*

Jo Anne and I laughed together about our question—where to start in order to complicate the very construct of gender? I wanted to work autobiographically with this question, to move even further beyond typical constraints of academic writing that usually insisted on a claim of universal judgment and the "objectivity" of a universal critical "I." In fact, the "personal" in academic writing has been a hot topic for a while for many feminists working not only in education and educational research but also in a number of other disciplines, including anthropology, sociology, literature and composition, to name a few. Many of us continue to agree that academics need to imagine ways of using experience critically, of using personal writing as an opportunity for a constant reprocessing of identity (Lu, 2001). Hindman (2003) posits, for example, that academics can use personal writing as a means of reading and writing through our own difference.

During the time that I pondered ways in which to address my assigned topic for the edited collection, I was reading Nancy K. Miller's *Getting Personal*, in which she posits personal criticism as an "explicitly autobiographical performance within the act of criticism" (1991, p. 1). As well, I was persuaded by Joan Scott's (1991) insistence on seeing "experience" not only as an interpretation but also in need of interpretation. And I was taken by Valerie Walkerdine's (1990) analyses of femininity and masculinity as fictions "linked to fantasies deeply embedded in the

social world which can take on the status of fact when inscribed in the powerful practices, like schooling, through which we are regulated" (p. xiii).

So, in the following essay, I set out in particular to perform some personal criticism, to engage "the personal" in academic writing as a way of writing through and across difference as "experienced" in gendered ways. I wanted to entwine autobiographical practices in education with social and political criticism by theorizing and interpreting what, for years, I had regarded as my "personal experiences" as a white, middle-class girl who was educated in the sixth grade by a white male teacher. I did so in order to examine my relationships to the assigned "object of study"—how gender affects the educational process. But I tried to do so in ways that questioned my internalizations of intertwined and contradictory social, cultural, and educational gendered and classed discourses and practices as merely "personal" issues in relation to my learning and, later, teaching. I also wanted to push my work in autobiography and narrative into forms of educational inquiry and academic writing that interrogated experience as a basis for curriculum theorizing and to do so in ways that challenged gendered constructions of what was (and often still is) regarded as "academic" writing.

This piece was written well before Elizabeth Ellsworth's (2005) examinations of emerging theories of experience and of current re-thinkings of pragmatism in order to look at "the experience of a learning self." It also appeared well before Deborah Britzman (1998, 2003) and Alice Pitt (2003) psychoanalytically interrogated "learning." Alice, in particular, poses autobiography as a "laboratory" and conceptualized narratives of learning as sites where the narrator's "educational experience of leaping away from and leaping toward learning is worked through" (Pitt, 2003, p. 23). While "Mr. Brucker's Good Girl" does not overtly represent such leaps, I probably should now investigate why I enjoyed writing this "narrative of learning and a learning self" more than any other in this collection.

MR. BRUCKER'S
GOOD GIRL

In the summer between fifth and sixth grade, I spent a lot of time hoping that I would get Mr. Brucker as my sixth-grade teacher. He was the best—everyone wanted to be in his class, because he was tough and funny, serious and caring. At least that's what all my friends said. I didn't doubt their wisdom, given my fifth-grade observations of this teacher who always spoke gently to us amidst the shrieks and giggles that filled the hallways of our elementary school.

One hot early evening in July, I pressed my head against the front door screen, a nightly habit that I was sure hastened my father's steps home from work. Instead, I saw Mr. Brucker trudging up our front sidewalk, lugging what looked to me like a suitcase. I tripped over my younger sister, who was sprawled on the floor reading the comic pages of the *Pittsburgh Post Gazette*. Stumbling into the kitchen, I announced breathlessly to my mother that my wish had been granted. Mr. Brucker was here, and that must mean that I had been assigned to his sixth-grade class.

What I found out later, as he sat sipping ice water and talking with my parents in the living room, was that Mr. Brucker was selling encyclopedias during the summer in order to make enough money to support his family through the vacation months. His visit to our home had nothing to do with my potential assignment to his sixth-grade class. We were just part of his neighborhood sales route, a route that meandered through the steel-industry-girded south hills of Pittsburgh.

My parents, themselves struggling to financially provide for my sister and me and our still-in-the-future but unquestioned college educations, reluctantly ordered the whole set, only in response to my pleading eyes, I'm sure. Those encyclopedias, arriving coincidentally with the school notice that indeed assigned me to Mr. Brucker's prized sixth-grade classroom, had nothing to do with my

placement. But my anticipation, my desire to be in his class, and my eager partic-
ipation in all aspects of the classroom community that Mr. Brucker constructed
with us that year had everything to do with my learning and subsequent re-learn-
ing and teaching as a woman.

What I already had learned, way before that summer between fifth and sixth
grade, was that Mr. Brucker was prized among students and parents alike, not
only because he indeed was a kind, caring, and enthusiastic teacher but also
because he was the only male teacher at Sickman Elementary School. The other
three sixth-grade teachers, all women, were equally good, or so the neighborhood
lore implied. But to have a man as a teacher, in that last year of elementary
schooling that still sanctioned childhood play even as it prepared us for the
grown-up demands of junior high school, supposedly guaranteed our rites of pas-
sage into the rules, content, and structures of schooling and of the disciplines.
Mastering those constructed versions of knowledge then automatically would lead
us into our appropriate roles as students and, eventually, as productive men and
women. If we learned those rules and forms well, we perhaps could take our
places in a society that could well extend beyond those burgeoning industrial hills
that sometimes seemed to hem in our parents' and our own visions of new ways of
living and being. We could learn those rules and forms best if we studied with Mr.
Brucker. Or so the neighborhood lore implied.

As I began that sixth-grade year, nervous and excited, I could immediately see
why Mr. Brucker had such a great reputation in our community. We all, boys and
girls, were charmed by his spontaneous grin and his willingness to join us in every
aspect of our classroom life. In his spontaneity, he did not separate our learning
from his teaching. Instead of sitting behind his desk, as so many of our other
teachers had done, Mr. Brucker would straddle a chair as he coached us in our
multiplication and division drills. He would leap from one side of the room to the
other, foreshadowing the game show host as he attempted to keep our shouted
answers just a notch below a roar during our spelling bees or math team contests.
He was the sixth-grade pied piper, his glasses slightly askew, and his tall lean body
perpetually braced against the crush of students who surrounded him as he tried
to lead us through the tangled passageways of childhood and into that clearing
known as "real school."

But even as much as he talked to us about how junior and senior high school
would be different from what we were sharing that year, and how we needed to
prepare ourselves for those serious undertakings, I always had the feeling that Mr.
Brucker never quite believed that was how it had to be. And so, I also experienced
in that year some of the disruptive and contradictory positions that Mr. Brucker
occupied within our particular elementary school culture. What I am still inter-
rogating are ways in which those contradictory positions contributed to, affected,
and ultimately disrupted many of my own understandings of myself as a female
attempting to learn and later to teach.

I was aware, in that sixth-grade year, not only of some of the differences that
Mr. Brucker as teacher represented for me, but also some of the differences that
characterized the kids in our class. Even though most of us lived within walking

distance of our school, we girls who had grown up in the neighborhood did not walk home with the new girls in our class. They were part of the group that quickly had become known as "the hill" kids, children of a growing community of men and women from Appalachia who had recently moved to Pittsburgh to get jobs in the mills. But even though most of my friends' fathers and a few of their mothers worked in the steel mills, many of my friends did not consider these new kids as part of the "neighborhood."

So I immediately noticed, in those early weeks of school, ways in which Mr. Brucker tried to include these new kids in every team event or partner activity that he proposed in class. And because this seemed important to him, I began to talk with my friends about including these kids in our daily school rituals.

In a way, I might have wanted to work toward such small attempts at inclusion because I felt different, in some ways, from my friends. My father, for years, was a pharmacist, not a steel worker. And my mother, instead of being a home-maker like most of my friends' mothers, needed and wanted to work a full-time job to help with family finances. She worked not in the mills, like many of the "hill" kids' mothers, but in a real estate office. So I appreciated, in our unit on careers, Mr. Brucker's discussion of possible jobs that we girls might want to consider. He didn't assume that our mothers or we would want—or be financially able—to stay at home to raise our children. I remember that we girls talked, hanging from the monkey bars during recess that afternoon, about what we might want to do in our lives in addition to becoming mothers. I had already determined that I wanted to be a teacher, just like Mr. Brucker.

But I was also learning that, even if I were to teach, and even if I were to explore with my students some of the alternative ways of living and thinking that Mr. Brucker's gentle vision encouraged, I still would not be a teacher just like him. As we worked our way through geography and grammar lessons, and built a clay replica of the Panama Canal replete with water-tight locks, and recited declensions, I began to notice that the other sixth-grade teachers, the women, would often appear at our classroom door—to plead for our teacher's help in calming two students who were fighting in the lunch room, to ask him to open one of the old and constantly stuck windows in the classroom down the hall, to watch our class radio productions every few weeks, where we introduced and shared with classmates, through recordings and our own handwritten scripts, our latest research on Verdi's "Aida" or on the coal mining industry.

Mr. Brucker was the leader of Sickman School, whether he wanted to be or not. I think now that he tried in some ways to resist that role, and in our class, he encouraged us all, girls and boys, to consider the possibilities for ourselves that did not automatically occur to many of us as we trudged home each afternoon through the hanging grayness of our steel town's south hills. He challenged us girls to move beyond stereotypical images of ourselves that we reinforced every recess in our jumprope and hopscotch play, for example, by insisting that we be part of the class kickball team. I still remember his gleeful yelp when I kicked the ball over the fence for my first-ever home run. On rainy days, he insisted that the boys and girls play in the jacks tournaments that he set up for us during lunch and

recess times. And he pushed us all in class, always asking us for another possible way to figure out the current math problem.

I now think that Mr. Brucker was attempting to disrupt our already deeply internalized conceptions of ourselves as gendered beings, as girls and boys who should fulfill certain socially constructed and normative roles within our public and private worlds. But I also think that what I was learning in sixth grade had more to do with my desire to please this teacher than to emulate the disruptive and challenging perspectives that he attempted, unofficially, to enact in his teaching. Ironically, in my desire to earn his acceptance and approval, I was learning the sanctioned forms of gendered relationships, discourses, and curriculum that still officially structured and framed the educational lives of both Mr. Brucker and me.

To please Mr. Brucker meant that I had to take some risks; I had to work to overcome my shyness about speaking up in class and I had to be willing to attempt to move beyond parroting only the "right answers." He pushed us all not only to frantically wave our hands in our moments of certainty but also to offer explanations for those answers that we thought might be possible within each of our multiple points of inquiry. With that kind of encouragement, I was able, slowly, to participate in our class exchanges and debates and to articulate the connections that I could make among the various threads of our sixth-grade curriculum. I was enlarging my own capacities to enter into the official school languages of our textbooks as well as into the unofficial languages and relationships that signaled our connections to one another as we studied and learned together in that effusive sixth-grade community.

And yet, as the year wore on, even as I was becoming aware of those connections among Mr. Brucker, the work of our classroom, and us as his students, I also was becoming increasingly aware of the differences among and within those relationships. The "hill" kids kept walking home in their own group and the neighborhood boys more and more claimed Mr. Brucker's attention on the softball field as well as in the classroom.

I was aware, certainly before sixth grade, that the official languages of schooling were somehow of higher value than the discussions and bantering that characterized much of our interaction in Mr. Brucker's class. Clearly our teacher preferred our spontaneous class discussions rather than just the "facts" that filled our textbooks or our "official" recitations of those disparate fragments of information. But Mr. Brucker tried, for our own good, he said, to separate us as well as himself from the personal, intimate worlds that permeated our casual interrelated conversations about such topics as the geography of western Pennsylvania, the economic interdependence of the industries that grew out of our "steel city," and the work in which many of our parents were engaged.

We knew that we had to "settle down" when his voice would modulate into the somber and serious lower register, and when he would sink his long, lean frame into his chair that he positioned in the center of our double-layered concentric-circle desk arrangement. And then, even though our conversations had been filled with information we had gleaned from parents, siblings, friends, about

what it was like to work in the mills, or to forge new communities in these still forested hills, or to worry about how to feed and care for children when layoffs hit, we began to recite the distant facts of our textbooks as Mr. Brucker questioned us in rapid-fire order.

I had become adept at such memorizations and recitations, having learned early in Mr. Brucker's class that such performances earned his "school voice" praise. But we all worked at moving through such rote activities as quickly as possible so that we could get to the real parts of our learning—for I think now that we all recognized, even in the sixth grade, that the textbooks never captured the depths or complexities of our own stories or of our work together. And I noticed that, even as I could recite lists of economic and industrial histories that tied our lives together in those south hills of Pittsburgh, for example, there was no mention of the kind of bookkeeping and auditing work that my mother did in her job, or of the incessant housework and meal preparation that she, my sister, and I battled each night when we arrived home. The only women we had read about in our history books were Clara Barton, Florence Nightingale, and Jane Addams, and then we only knew of them through descriptions of their extensions of socially-sanctioned women's work.

And so I learned that the stories of our daily lives—the ones that sometimes broke gendered stereotypes of who we were and could become—were the ones that Mr. Brucker asked about on the playground or during our lunch breaks or during our walks down the hall as we headed toward our twice-a-week music class. But he gave official recognition, official school praise, for those facts about Clara Barton as nurse during the Civil War, or about the geography of western Pennsylvania. Thus, as much as I learned from Mr. Brucker about the value of connections, conversations, and new ways of being in the world, I also learned that, in order to receive the sanctioned merits of schooling, to receive his official acknowledgment and approval, I had to impersonate the patriarchal inflections found in others' words, to speak in the modulated serious tones of others' understandings, to memorize others' stories, to replicate others' knowledges. In doing so, I neglected or repressed the unofficial—the desires and dreams for a new way of being inherent in our stories, our personal conversations and relationships that were at the heart of Mr. Brucker's teaching, and yet were separated as much from his enactments of official knowledges as were my replications. And in my ironic desire to please, to receive authorization, I effectively denied or erased parts of my self.

.

I realize that this story too is only a partial telling, a story pieced together from fractured memories and revisioned through lenses that refract subsequent multiple constructions of experiences, conceptualizations, and enactments of teaching and learning. In this particular telling, however, are traces of dominant social constructions of gender and gender relations in US education in the 1950s, in which men teachers were afforded more authority in their creations of, associations

with, and transmission of official knowledge than women teachers, for example. Such constructions and enactments framed my initial understandings of learning, curriculum, and pedagogy.

In this telling, too, are vestiges of the ways in which those gendered conceptions of appropriate teaching and learning stances still manifest themselves in my educational work. I struggle still to voice my challenges to representations of curriculum that replicate normative and gendered constructions of knowledge and identities. But I now think that Mr. Brucker also struggled with what he seemed to perceive as artificial and gendered separations of our public and private knowledges about our selves, our worlds, and our relationships to one another. He chose, for many reasons that I guess still substantiate many teachers' transmissions of others' versions of curriculum, to officially support school knowledge, knowledge often gendered, raced, and classed in its construction, content, and "delivery." At the same time, in his interactions with us, he offered us other visions for ourselves. But I was so embedded in my own already internalized gender role as "good girl," seeking approval and thus replicating his official choices, that I missed, for years, the discrepancies between Mr. Brucker's official and unofficial enactments of curriculum and learning.

I of course do not claim my experiences or understandings as universal for all females and males who were educated in the United States during the 1950s. However, I do think that static and normalizing social markers of identity, such as gender and subsequent role expectations for both teachers and students, have separated and prioritized educational processes and experiences for many. Thus, some of us who teach still struggle with patriarchal conceptions of curriculum as predetermined, "objective," and measurable knowledge, and with versions of teaching and learning as separated from the knowledges generated by and within individuals' relationships and interactions.

But as some of us now work to understand curriculum as particular discursive, cultural, historical, social, economic, and political forces, events and intersections in individuals' lives, we also must view those intersections as mediated by multiple constructions and performances of gender, race, class, (dis)ability, sexual orientation and ethnicity. In particular, as we feminist curriculum theorists engage in debate with others who argue for stable, unified canons that supposedly represent consensus on singular and universal structures of the disciplines or of curriculum content, for example, we also need to work beyond simple inclusions of women's voices and works as a unitary representation of the category "women." As teachers, as curriculum theorists, and as educational researchers, we need to address the contextualized, multiple, complex and changing nature of that category across various discourses and material conditions that both historically and currently constitute women's lives in and out of school.

Thus it is important but not sufficient to speak of elimination of sexism or sexual harassment in classrooms or of inclusion of minority voices in textbooks. It is important but not sufficient to note how women are now integrated into educational institutions as students, teachers, researchers, administrators, as well as subjects of scholarship. It is important but not sufficient to point out the discrep-

ancies, the separations between what counts as official school knowledge and what students and teachers construct and re-construct daily as knowledge-in-relation.

If we truly wish to work toward the creation of just and humane educational communities, I believe that we as educators must examine our internalizations and replications of the binaries, hierarchies, and exclusions that historically have contributed not only to gendered but also to raced and classed versions of educational processes. Certainly we must scrutinize and work to change the very discourses that reify institutions, the disciplines and their representative curricula. But we also must attempt to scrutinize, challenge, and, if necessary, change the very discourses that function to construct, normalize, and thus limit our identities.

John Brucker's sixth-grade class provided me with a memory site for deconstruction of what, for years, I simply considered to be my own "natural" desires and interests as a young girl, a student, a teacher. I still work to understand multiple ways in which the complex interactions, internalizations, and repressions of that year—as well as the influence of discourses available to me to construct myself as "good girl"—continue to infiltrate my conceptions of teaching, learning, and curriculum. But while I still wonder what he might think of this individual account of my sixth-grade year—and how he might construct his own stories of that year—I no longer need Mr. Brucker's permission to tell this particular tale.

TEACHERS, DIFFERENCE, COLLABORATION

There is that excess, that difference within the story, informing how the story is told, the imperatives produced within its tellings, and the subject positions made possible and impossible there. —Deborah P. Britzman, "'The Question of Belief': Writing Poststructural Ethnography"

The questions of representation, self-reflexivity and subjectivity in the collaborative process are ongoing. . . . My quest for understanding the collaborative process has not led me to new definitions or methods for establishing truth, be it partial, absolute, multiple or situated. It has led me to a deeper understanding of ways of knowing and how these are deeply embedded in the relational acts of the research process. —Petra Munro, *Subject to Fiction: Women Teachers' Life History Narratives and the Cultural Politics of Resistance*

INTERLUDE 7

Part III of this collection focuses on my various collaborative projects with university colleagues as well as teachers working in K–12 classrooms. In a large sense, the opening essay in this section—created, performed, and composed with my best friend and my partner—functions as introduction to the essays that represent various tangles with and in the collaborative configurations in which I have worked over the years. Those include six years of collaborative research with four K–12 classroom teachers and one elementary and high school counselor; five years of collaborative inquiry with two elementary school teachers and three of their colleagues; three years of large-team qualitative research in high schools in varying social-cultural contexts across the US; and nine years of in-service work with K–12 teachers in one school district. All of these projects, in one way or another, question what relationships of power feel like from "within" collaborative efforts, and at the same time refuse simplistic, binary accounts of power, of relationships, of "insider-outsider" positions, or of "empowered agency" that proliferate in many educational versions of collaboration.

Several of the articles in this section focus especially on the complex relationships among participants in the six-year collaborative and reveal ways that I was able and not able to put aspects of reconceptual curriculum theorizing in relation to issues and challenges posed by the classroom teachers and counselor in our group. From exploring tensions generated by gendered role expectations for passive, nurturant care-givers especially posed by the early childhood educator to confronting what is made possible and impossible through explorations of power relations in a school-university collaboration, we together confronted contradictions lived out in our daily pedagogical, curricular, and research practices.

The opening essay in this section especially highlights complexities in all collaborative work by demonstrating the concept of "juxtaposition." In this piece,

Mimi Orner, Liz Ellsworth, and I use that concept in order to point to moments in educational theory, research, writing and teaching that "exceed" linear, official forms of educational representation. These are moments—juxtaposed moments, if you will—that require fluid readings and relations constructed across and beyond categorical, historical, discursive boundaries of monolithic, static, or binary constructions of "self" or "other."

One other thing you need to know about the following collaborative essay is that it came about by chance. On an early autumn Sunday afternoon in 1993, Mimi, Liz, and I met, as was our custom, at a local coffee house in Madison, Wisconsin. This time, it was the coffee space at Borders on University Avenue, and we had an urgent agenda, one that we had agreed to on the phone that morning. We all were desperate to kvetch about the individual papers that we were composing for presentation at the soon-approaching Bergamo Conference. We all needed HELP. But in fact there was nothing out of the ordinary about this particular meeting. This was our routine for every conference presentation, every publication, every pedagogical or life crisis that any of the three of us ever encountered.

So, as usual, Mimi captured and saved the table for us, Liz rounded up chairs, and I ordered the food and coffee. After catching up on our daily news—always our first priority—we sat and looked at one another. "I hate my paper." "No, I hate my paper more." And so it went. As usual. Finally, one of us, I don't remember which one, suggested that we each read one or two pages of what each of us had in rough draft. We'd do a round-robin and maybe that would dissipate the immediate awfulness of our individual papers. "OK, you start." "No, I can't. You start." After refills on the coffee, we started to read, one after the other. After the second round, we looked at one another. "Hey, what do you think?" "Isn't that weird—what you just read says something about mine." "Let's keep going, see if it—whatever it is—sustains itself."

We took a few more weeks to spiff up our individual sections, we made a few adjustments to the order of our round-robin, and we rehearsed our collective "paper." "They will think we're absolutely nuts." But we indeed went to Bergamo and "performed" our papers in that round-robin fashion for a large audience, placing the notion of "juxtaposition" at the center of our theoretical and methodological approaches to the concept of "excess." We loved the processes that got us to that session, the audience seemed to love our performance of excess and juxtaposition, and Liz and I miss Mimi more than we can say.

EXCESSIVE MOMENTS AND EDUCATIONAL DISCOURSES THAT TRY TO CONTAIN THEM

Mimi Orner, Janet L. Miller,
and Elizabeth Ellsworth

This article emerges from years of researching, writing, and teaching together. Its early version was a symposium that we presented in 1993 at the annual Bergamo Conference on Curriculum Theory and Classroom Practice.[1] As we prepared for that symposium, we read to each other drafts of our loosely related writings about "excessive moments" in education. One of us wrote on excessive moments in relation to pedagogy, another in relation to meanings and uses of student writings, and the third in relation to school change research. As we read our drafts to each other for the first time, we were struck by how, in any one of our papers, all three of these moments—teaching, writing, and research—were present. Before long, we were certain that we wanted to juxtapose these papers in a way that enacted for our audience the multiple relationships we had begun to draw for ourselves among our research as well as among the perspectives and bodies of scholarship to which they point.

By excessive moments of teaching, research, and writing, we do not refer to the banal truism that all discourses fail to account fully for all aspects of a phenomenon or experience. We do not mean, merely, that the educational discourses that frame each of our moments are exceeded by historical events; unknowable and changing subjectivities of students, teachers, and researchers; the politics of representation and performance; the unexpected. Rather, we want to use the concept of "excess" to call attention to the relation between particular educational discourses and repression: what becomes contained by an educational discourse and what becomes excess or excessive to it is no accident. Excess is a symptom of histories of repression and of the interests associated with those histories.

We think we can learn from the repressed of particular educational discourses. We have been drawn to the notions of "excess" and the "excessive" as a means for examining the repressed in our own sites of theory and practice. We are

curious about how our attention to the repressed of educational discourses might inform and transform our work and thought as educators. Our purpose for raising the highly complex issue of repression and excessivity here, then, is not to offer a fully worked-out discussion of these terms as analytical concepts, per se. Rather, it is to put them to use in a context limited by the issues we raise here concerning teaching, writing, and research in education—a context delimited by the assumption that what is repressed in educational discourses and practice returns, nevertheless, as excess.

In his analyses of popular culture, John Fiske underscores the social and political loadedness of "excess." He defines "excessiveness" as that which exceeds the norms proposed as proper and natural by those with social control. "Excessiveness" is

> meaning out of control, meaning that exceeds the norms of ideological control or the requirements of any specific text. Excess is overflowing semiosis; the excessive sign performs the work of the dominant ideology, but then exceeds and overspills it, leaving excess meaning that escapes ideological control and is free to be used to resist or evade it. . . . Norms that are exceeded lose their invisibility, lose their status as natural common sense and are brought out into the open agenda. (Fiske, 1991, p. 114)

The educational practices we address here—research, writing, and pedagogy—are, normally, representational practices. That is, they are practices that attempt to produce and "contain" excess meaning. Typically, they try to control excessive moments in education through research methodologies and protocols, proper forms of academic writing, and curricular norms and standards. Yet, as Peggy Phelan argues, representation

> always conveys more than it intends; and it is never totalizing. The "excess" meaning conveyed by representation creates a supplement that makes multiple and resistant readings possible. Despite this excess, representation produces ruptures and gaps; it fails to reproduce the real exactly. Precisely because of representation's supplemental excess and its failure to be totalizing, close readings of the logic of representation can produce psychic resistance and, possibly, political change. (Although rarely in the linear cause-effect way cultural critics on the Left and Right often assume.) (Phelan, 1993, p. 2)

In education as an academic field of research and writing, each of the educational sites we address—pedagogy, student writing, and school reform research— is governed by different academic discourses and logics of representation. The more we read our drafts to each other in preparation for our symposium, the more the juxtapositioning of educational discourses not intended to be read together created for us meanings that exceeded the norms of each of the discourses that informed our separate texts. These excessive meanings were not only transgressive of "normal" ways of framing and talking about things such as school reform research, teaching, and student writing. We also began to use them to locate the repressed in each of our texts and make it accessible to our explorations

of the histories and interests bound up in how and why we do what we do when we teach and engage in research.

Here then, we have continued to juxtapose our stories, analyses, and thoughts about the historically and politically significant ways that bodies, subjectivities, pleasures, fears, histories and power relations overflow the protocols, norms, and forms that are intended to "contain" them. Because such juxtapositioning of separate texts is an unorthodox form for an academic essay, we want to set the stage for your reading of this article. Reasons for the structural choices we have made here will become even more clear, we believe, by the discussions of representation, performativity, excess and protocol that unfold through the article's structure itself.

There are three narrator-researchers here.[2] Each of us foregrounds a different though related moment in educational theory and practice: teaching, student writing, and research. We mark off one narrative voice from another, and juxtapose each to the other, as a way of calling attention to what exceeds univocal, linear writing, and to what is multiply voiced and simultaneous in practice.

We present each of our "moments" of theory and practice through three sections entitled "Excessive Pedagogy," "Excessive Writing," and "Excessive Research." *The headings for each section name all three of these moments of theory and practice, placing in italics and bold the particular moment that is being focused upon.* We have done this because even though a particular area may be the focus, such as educational research in schools, we mean to suggest that pedagogy and student writing are still present as concerns, shaping and informing the moment of research. Although each of us has written her own sections of this article independently, we collaborated fully on the juxtapositioning of the sections as well as on this introductory section. In the following section heads, we have not identified particular authors with particular sections because the ways in which the work and writing of each of us has informed the work of the others is impossible to disentangle. To assign an authorial voice to each section negates the ways that our work and the ways we work together overlap, interrupt, juxtapose and extend our individual efforts.

Our individually written sections, then, are not intended to engage each other directly or linearly. This is not intended to be a conversation among three voices. The relation we construct among moments, narratives, and authorial voices in this text is one of *juxtaposition.* We use juxtaposition as a way of foregrounding and negotiating the fact that there are no simple, linear, cause-effect relations between official forms of educational representation and the moments in theory and practice that exceed them. And, as Phelan (1993) argues, there is no simple, linear cause-effect way of producing resistance and change in response to excessive moments and meanings.

Juxtaposition, as an aesthetic device in postmodern art and as a rhetorical device in postmodern theory and writing, provokes viewers and readers to make associations across categorical, discursive, historical and stylistic boundaries— associations never intended or sanctioned by the interests that construct and require such boundaries. The juxtapositioning we enact here, then, presents our

readers with complex, nonlinear, associational relations—which we leave unspecified—among the texts. Some of the juxtapositions are random and unintentional, while others are deliberate placements for aesthetic and rhetorical effect. This calls for a reading that allows the texts to be in fluid, shifting relations to one another and to the reader.

For example, our use of juxtapositioning invites readers to explore notions of performance and the performative across various moments of educational research, writing, and teaching. It invites exploration of how meanings of performance that get solidified in one educational situation are set into play and motion at another time and place, thus interrogating the meanings of performance in the first moment. Juxtapositioning also invites readers to allow what happens in one of the three texts to spur images from that text to the others, and on to the reader's own contexts and practices. The strategy of juxtaposition is one that invites inconsistencies, ambiguities, ambivalence, and it emphasizes that there will always be "unspoken themes" that cannot or will not be interrogated. One of the consequences of the structure we have chosen, then, is that there are at least three "concluding comments" and no conclusion.

Thus, refusing to be contained by linear written forms and exploring rational modes of address that are nonlinear and associational, we use juxtaposition in an attempt to set in motion readings that are—for us as well as for readers—self- and cross-interrogating.

We also want to politicize and legitimate our labor as collaborators, co-researchers, writers, and friends. These relationships are not just tangential to our academic work. Rather they are the forms of sociality that ground our analyses and frame our insights, and these relationships exceed academic discourses and practices that often have the effects of containing, erasing, or minimizing the political commitments and social and cultural identities and relationships through which we work.

Excessive Pedagogy/Excessive Writing/Excessive Research

So we begin. Picture a graduate student seminar in a Department of Curriculum and Instruction. For the past several weeks, we have been reading performance studies and literary criticism and have been looking at the relation of pedagogy to testimony and to "the performative." My section of "*excessive pedagogy*" is, in part, an attempt to pull together thoughts and theories that have been rubbing against and past each other from our class discussions, readings, my "lectures," and student questions.

I am placing questions of pedagogy alongside current studies of performance art and "the performative" in literary and cultural studies. I suspect that the work of some contemporary performance artists and theorists of performance studies can instruct the study and practice of teaching. I am interested in what I, as educator, might learn from the work of literary critics such as Shoshana Felman and Brenda Marshall, and cultural critics such as Judith Butler and Peggy Phelan, who make direct and intriguing connections between performance and pedagogy.

Here I want to gather up some of the connections these writers are making between performance and pedagogy, and add some of my own. I am especially interested in the performative aspects of teaching within and about social and cultural difference. In this article, I stage encounters between moments when performance artists and theorists touch on pedagogy, moments when literary and cultural critics touch on the performative aspects of writing and other cultural production, and moments when educators teach in ways that exceed representation and become performative. I hope to outline just a few of the many ways that educators might remap some of our assumptions about and discussions of pedagogy.

This outlining moves around three paradoxes: the paradox of authority and power in the pedagogical relation; the paradox of the pedagogical event, which leaves no *visible* trace of its happening; and the paradox of pedagogy as an always suspended performance.

Excessive Pedagogy/*Excessive Writing*/Excessive Research

I have been juxtaposing narratives produced by myself about teaching and narratives produced by students about their experiences of education.[3] I have been attempting to find the boundaries between what is say-able and what is not say-able within contexts such as schools. Through their insistence on the personal as political, women's studies classrooms at the college level complicate traditional boundaries that have been established to regulate the interactions among and between students, teachers, and the "unsay-able." The narratives I work with here exceed the personal-political binary, as well as the binary logics of race, sexuality, gender and desire. Although many critiques of binary thinking exist within women's studies contexts, few explore their implications for pedagogical practice.

TEACHER: It was only the second meeting of our class, but already the familiar polarization of women and feminists and womanists, based on who's wearing what, was at work. Toward the window sat the women with short hair, Birkenstock sandals, hairy legs, and no make-up. Near the door sat the women with long curly hair, nail polish, shaved legs, and lipstick. I was intent on making the class as hospitable as possible to everyone present. This is not a watered-down pluralist position. It comes out of a deep commitment to deconstructing the politics of appearance.

I am very interested in working through what is visible (and more importantly what is invisible) through our bodies and how our relations to others are defined or at least delimited by appearance. As teachers and students, we perform ourselves on a daily basis, and these performances are read by others in specified social and historical contexts.

STUDENT: Many times in my life I have felt that I was really someone other than the person I would have others believe me to be. Frigga Haug's (1987) book, *Female Sexualization*, gives me a better understanding of my vulnerability and my desire to please others at all costs for fear of being "found out." Remembering the ritual of my First Communion and the preparation for it, learning how to sit, stand, and walk "correctly," hairstyles, diets—all of these were

just a regular part of my life that I did not question. I know that somewhere between the sixth grade and high school I "forgot" how to throw a baseball sidearm. Girls just didn't throw that way once they reached a certain age. Girls were not supposed to be better than boys in sports.

Excessive Pedagogy/Excessive Writing/*Excessive Research*

While all research studies have limits and boundaries to what they can address, I have become increasingly concerned about what seems to be falling outside the imposed boundaries of the particular study in which I currently am involved.

I am a member of a large qualitative research team that is studying aspects of high school restructuring processes. I have mounds of data gathered from twice-yearly weeklong visits to three of the high schools involved in the study. One of these schools is located in a small town; the other two schools are located in large urban areas.

My data mounds include transcriptions of classroom observations; of interviews with students, teachers, parents, administrators and state education department officials; and of notes from shadowings of students and teachers. Over the shelves in my study spew three years of data: audiotapes, field notes, observer comments, transcriptions and analytic memos. Sometimes, too, these data spill over boundaries of current discourses that shape school reform while ignoring "the value and power relations ingrained in schooling experiences" (Popkewitz & Lind, 1989, p. 576).

There are moments in classrooms and in interviews, especially, where what I see and hear surges through, around, over and beyond the "official" framings of my viewing and listening protocols as a qualitative researcher in this multi-site study. Often, these moments exceed the curriculum and instruction focus that guides this study's participating schools as well as many others in their reform efforts (Anyon, 1994; Clark & Astuto, 1994).

*Excessive Pedagogy/*Excessive Writing/Excessive Research

Tracing the paradox of authority and power in the pedagogical relation, I begin with a moment in Brenda Marshall's *Teaching the Postmodern*. Marshall quotes Linda Hutcheon in her discussion of fiction and postmodern theory: "discourse constitutes more than a repository of meaning; it involves . . . the potential for manipulation—through rhetoric or through the power of language and the vision it creates" (Marshall, 1992, p. 154). If an author's writings alter our perception of history and thus of reality, Marshall argues, then the writer has taken on great authority. At the same time, she says, it is the nature of postmodern practices of writing to assign the responsibility to the reader—responsibility for which readings she makes, out of the multiple interpretations any encounter with a text makes possible. Marshall comes to the conclusion, "A paradox emerges: the writer takes control and manipulates the reader into the position of taking on responsibility" (p. 154).

When I reread this assertion through the residue of the daily practice, dilemmas, and interests that confront me as an educator, and through my intense interest in what the postmodern break in logic has to offer educators, I make it, playfully and seriously, to be: Like the writer, the teacher uses language and rhetoric to create visions, to alter perceptions of history and of reality. The teacher takes on great authority every time her teaching alters someone's perception of reality. A paradox emerges in postmodern practices of pedagogy in the relationship between teacher and students: the teacher takes control and manipulates the students into the position of taking responsibility for the meanings and knowledge they construct.

Excessive Pedagogy/*Excessive Writing/*Excessive Research

TEACHER: On the second night of class, I was calling into question the argument put forth in the readings. In *Gender and History*, Linda Nicholson (1986) offers a version of the women's liberation movement that divides Second Wave feminism into three distinct categories: liberal, radical, and socialist-Marxist. By the end of the evening, the blackboard was covered with at least fifteen more feminist positions and affiliations including African American lesbian postmodern feminisms; materialist feminisms with a touch of radical spirituality; "I know I'm for gender equality but I'm not a feminist" feminisms; and multiple separatisms. Aside from calling into question what we discussed as the "will to categorize," this exercise opened up some space for women to explore various takes on feminism and their own often complex and shifting relations to feminist positions. I was hoping to disrupt the sedimentation of a "true," "correct," or "acceptable" feminist stance. And I was trying to encourage some movement across the invisible barrier that separated the women by the window from the women by the door.

In analyzing the politics of difference in education and thinking through appearance and other signifiers of identity, I want to explore what is absent on the body. The assumptions we make often miss what is invisible on the body and often miss the contradictions and complexities of people's life histories. How can we teach and work in ways that recognize the invisibilities and uncertainties of difference?

Excessive Pedagogy/Excessive Writing/*Excessive Research*

Excessive moments punch holes in my observational and interview protocols. As "interviewer," I am momentarily silenced as I listen to one Hispanic student in the small town school as she describes her exclusion from a party held over the weekend. "Only Anglos were invited," she says as she stares at me, a white middle-class, middle-age woman who is asking her questions about what and how she has learned in school recently. But what she has learned in and around school about her positioning in this small town, and about constructions of her "identity" within and across particular cultures, does not count within the framings of the "official" protocol questions that are guiding our interviews during this visit.

Excessive moments force me to jump from my observational seat in the back of a classroom in one of the urban schools as smoke from a trash can fire set in the fifth-floor hall curls under the worn wooden door of a biology classroom. I log-off my laptop computer as a student flings open that door and rushes to get to her baby in the school's day care center down on the second floor.

Excessive moments are those in which student, teacher, and researcher identities and practices overrun the ways we all have been constructed by intentions, designs, and protocols of this school reform research project. These moments surge over the edges of my "official" observing, interviewing, and writing, and do so with consequences that I cannot ignore or sometimes cannot even know. Here, I want to examine and unsettle how meanings are made, and how researcher, teacher, and student identities are constructed and manipulated through, in, and beyond school restructuring discourses and processes.

*Excessive Pedagogy/*Excessive Writing/Excessive Research

"Manipulating students into taking responsibility" is a self-contradictory gesture. Like all paradoxes, this one does not "make sense." Yet, when I rewrite Marshall's point this way, suddenly, the solidified positions and repetitious prescriptions that, for me, have dulled much of the talk among educators about pedagogy and authority are set in motion. This paradox is *not* another version of: The teacher empowers the student by exercising her own power and authority. Nor is it a version of: The teacher empowers the student by giving up her authority. Certainly it is not: The teacher empowers the student by practicing reciprocal, dialogical relations that equalize power relations among teachers and students. This paradox exceeds these formulations; it cannot be contained by any of these resolutions. Yet it can be enacted. It can be performed in the classroom.

Here is an example of that paradox, enacted from *Testimony: Crises of Witnessing in Literature, Psychoanalysis, and History,* a book by Felman and Laub (1992) about the performative act of testimonial teaching. Felman teaches literature and psychoanalytic criticism at Yale. One semester, in a course on literature and the Holocaust, she asked students to read "a number of testimonial literary texts and to view videotaped autobiographical accounts of Holocaust survivors" (p. xvi).

Toward the end of the semester, the class turned from reading and discussing poetry and literature about the Holocaust, to viewing videotape of Holocaust survivors' testimonies. After viewing the tapes, "the class itself broke out into a crisis" (p. 47). Students were unable to engage in a dialogue—their usual classroom practice—about the videotapes. They were silent immediately after the screening. However, during the following week, it became clear to Felman that students needed and wanted to talk about their experiences of viewing the tapes. Yet, in phone conversations during the week between class meetings, they told her that words were incommensurate with their experiences of viewing the tapes—no "speaking about" grasped the whole experience. One student told Felman:

Until now and throughout the texts we have been studying . . . we have been talk-
ing about *the testimony of an accident.* We have been *talking* about the accident—
and here all of a sudden *the accident happened* in the class, happened *to* the class.
The [Holocaust] *passed through* the class. (p. 50)

The students, Felman concludes, experienced the videotaped testimonies not
as representational text about something else, somewhere else. Rather, the ways
that the Holocaust survivors' testimonies addressed the student viewers as *wit-
nesses* brought students to an unexpected *encounter* with the Holocaust. It posi-
tioned them as witnesses to the Holocaust.

Excessive Pedagogy/*Excessive Writing*/Excessive Research

TEACHER: I felt as if I was bursting their collective bubble by suggesting that
journal writing (which I was asking them to do, too) might be seen as a form of
surveillance. I tried to emphasize my own slippery position in all of this by talking
about my own work and the work of others that attempts to "deconstruct" the
very discourses and practices of feminist pedagogy that we are reading about in
class. When one of the Jennifers (there are five in class) asked me why I wanted to
destroy feminist pedagogy, I told her, "deconstruct, not destroy" and began to
laugh. I'm totally caught up in "feminist pedagogy" in this class as I poke holes all
around me. It's odd, really, to be building community and calling it a fiction at
the same time. No wonder people get defensive.

 STUDENT: In kindergarten, although our mom didn't allow us to watch
TV, I had caught enough to develop a "Cindy Brady Complex." I wanted to be
just like her. I wanted to have golden curly pigtails and two teeth missing in the
front. I wanted to lisp. This television character represented the unobtrusive
"cute" girl to me. She was not only small and delicate, she was completely inof-
fensive. We divided the female world into two categories: the tom-boy and the
Cindy-girl. Although we scorned the latter for her uselessness, we also knew that
was the model we were supposed to follow. Even as I strove to be like this early
picture of femininity, I knew somewhere that I could never achieve it. I am sure I
did not understand what the implications of such a model would mean in the
larger picture. Nor did I understand where to direct the frustration that accom-
panied this socialization.

Excessive Pedagogy/Excessive Writing/*Excessive Research*

I am not claiming that moments I feel, identify, or repress as excessive are experi-
enced as such by the students and teachers with whom I work. Nor am I claiming
that these moments define their experiences within and without the contexts of
their schools' attempts at restructuring. Rather, I am wondering about how par-
ticular discourses of reform shape as well as contain (and constrain) meanings and
representations of "student," "teacher," and "researcher" in relation to school
restructuring projects. At times in my research, such as those I have described
thus far, it does seem that the actions and meanings made by teachers, students,

and researchers exceed educational and reform discourses. Instead of only squeez-
ing interview responses and observational data into the forms and categories
delineated by the research protocols, what would happen if reform research could
turn toward those excesses? Attention to excess at least in terms of multiple
moments, identities, and acts that do not "fit" predetermined research protocols
and intentions might unleash possibilities for students, teachers, and researchers
to examine historical, cultural, social and political antecedents and framings of
those moments, identities and acts. What if school reform efforts included
research on what is repressed in official versions of our educational selves? What
might be gained or lost, I wonder, by having such examinations become an overt
part of school restructuring efforts? These questions intrigue me even as I am
constrained in my efforts to conceptualize, frame, and participate in research
projects that deal with school reform.

Excessive Pedagogy/Excessive Writing/Excessive Research

Like other traumatic historical events that turn on difference, on designated
insiders and outsiders—such as the Middle Passage, Vietnam, Hiroshima—
Felman argues that the Holocaust "inexorably" makes one pass through answer-
less questions (Felman & Laub, 1992). The crisis that her students experienced
was their inability to "answer" the survivors' testimonies. Nevertheless, the class
went through the event of the screening, and now faced, according to Felman,
the personal and political responsibility and right to respond to that experience,
even if their own testimonies would be precocious ones, coming in breathless
gasps and fragments (p. 52).

When the class met the next week, Felman assigned a paper. She asked the
students to witness, in writing, their experiences of "not counting" after seeing
the videotape, and to take "the chance to sign, the chance to count" (p. 51).
Felman concludes this story by asserting that, given the papers she received, stu-
dents accessed the crisis of "not counting," rather than ignoring, denying, or
repressing it, by testifying, in turn, to "the significance of their assuming the posi-
tion of the witness" (p. 52).

According to Felman her own crisis of teaching, and the students' crisis of
finding themselves in the position of witnesses to the Holocaust, broke the frame-
work of her course, moving it out of the representational into the performative,
out of the epistemological into the social, the political, the ethical: "The dynamics
of the class and the practice of my teaching exceeded, thus, the mere concept of
testimony as I had initially devised it and set out to teach it" (p. 55). What Felman
had first conceived of as a *theory* of testimony was unwittingly *enacted*. It became an
event of life, she says, "of life itself as the perpetual necessity—and the perpetual
predicament—of a learning that in fact can never end" (p. 55).

Excessive Pedagogy/***Excessive Writing***/Excessive Research

TEACHER: By seeing our narratives as temporary, contingent, and context-specific fictions, I aim to disrupt the truth value that is attached to our words, particularly when we are allegedly revealing "personal information" or "relating our experiences." I hope to re-present the ideas of students with my own writing in a series of overlaps. I want to work against the notion of "feminist expertise," in which the "truth" and coherence of "woman's experience" supplants the scientific method and data collection truths of empirical social science. I am not working with student narratives in order to reveal the "unmediated truth" of women's/students'/my "experience" or to celebrate the finding and articulation of women's/students'/my *authentic* voice. Rather, I want to explore the pleasure and the horror—perhaps even the necessity—of the stories we tell ourselves and others, the stories that have been told about us by our families, friends, and acquaintances. I want to explore the stories of voice and silence, of becoming and refusing to become "woman," that are being told in, through, and about a class I taught because these stories changed me, changed what and how I taught, and challenged what I thought I knew.

Excessive Pedagogy/Excessive Writing/***Excessive Research***

Here I offer a reading of an English classroom in one of the urban schools in which I have researched. The English class was situated in a program that amounted to a school-within-a-school. Students and teachers stayed together in this program for the students' four years in high school. Classes were multi-aged and heterogeneously grouped.

The English teacher informed me, as I entered the room, that this was her most difficult class and that she was a bit nervous about my being there. I talked for a few minutes with Ms. Clark[4] about my role, not as "evaluator" of her teaching, but rather as "researcher" of this school's reform efforts. As I tried to reassure Ms. Clark (who, I could tell, was not reassured—and why should she be? What is most school reform really about, other than "improving" pedagogy and, as a supposed direct result, producing evidence of students' "improved learning?"), students entered the classroom, laughing and joking as they dumped bags and boxes of props by their desks. I knew, from my previous interviews in this study, that teachers quite often think members of our research team are in their classes to evaluate them rather than to chronicle the daily ways that students and teachers enact their school's particular curricular and pedagogical restructuring efforts. Indeed, as Roemer (1991) has noted, educational change quite often has different meanings for differently positioned people.

And it is apparent that research protocols about school restructuring sometimes do assume various implicit conceptions and definitions of "successful" reform efforts, assumptions that then frame what researchers "see" and "hear" in their data gathering. Those framings, in turn, could contribute to implicit evaluations of, rather than support for, teachers working within particular reform

efforts, even as those teachers explicitly ask for help and even as I officially try to maintain my "neutral" stance.

For, when my research colleagues and I do try to clarify our "official" research purposes to teachers, they quite often do ask us, in light of everything that we supposedly are seeing and chronicling, to "help" them as they struggle to implement a particular school's chosen reform philosophies and practices. When teachers ask for help, I am placed in the midst of multiple and often conflicted perceptions about my work as researcher in the study. As evidenced by Ms. Clark's remark about her nervousness, I *could* be seen by teachers as one of the reform project's representatives who has "expert" knowledge of its predetermined conceptions of "good" reform, and who is in the school to evaluate teachers' "progress" and "success" within those conceptions. (See critiques of such positionings in Goodman, 1994; Moffett, 1994.) Given those perceptions, I also could be seen as an appropriate person to provide feedback and "help" to those teachers whom I observed and interviewed in this study. Yet to "help" in any form exceeded the role that had been defined for me as researcher in this study. But even though my colleagues and I were to take great "official" pains to reject that "expert" or "evaluator" role, I was too influenced by feminist critiques (Ellsworth, 1989; Luke & Gore, 1992) of forms of research and pedagogy that posited possibilities for reciprocal and equitable relationships. Thus, I felt that any rejection of the label "expert" in this situation at the same time would constitute a superficial denial of circulations of power that were already operating in this (and any) school context.

I talked with Ms. Clark after class, and listened to her describe the need for ongoing time, support, and staff development in order to implement her school's chosen restructuring conceptions. (See, e.g., Cambone, 1995; Eisner, 1992.) Similar conversations, repeated many times in many school settings, had me wondering about the meanings of implementing research protocols in the absence of sustained, inclusive, responsive staff development (officially sanctioned "help") from those who had originally conceptualized the project. Similar conversations also had me wondering about the repressed of my researcher role and of this research study. But such questions and musings exceeded my official researcher task of observing in this English classroom.

Excessive Pedagogy/Excessive Writing/Excessive Research

The authority that Felman asserted as teacher in response to the crisis in her class was a ruptured and partial authority. Felman had no authoritative answers to the students' crises or to the Holocaust. She herself passed through answerless-ness. The intended pedagogical and epistemological framing of her class was broken, exceeded. She found herself, with the students, in the perpetual predicament of a learning and teaching that can never end. Her intentions to teach about testimonies of the Holocaust were overrun by what she recognized as the necessity to engage with the ongoing historical crisis of *witnessing* the Holocaust. The students' taking responsibility for the meanings they made of their encounter with

the videotaped testimonies was also fragmented and partial, coming too soon. In this respect, the students' testimonies were not unlike the survivors' testimonies, which seemed to be

> composed of bits and pieces of a memory that has been overwhelmed by occur-rences that have not settled into understanding or remembrance, by acts that cannot be constructed as knowledge or assimilated into full cognition, by events in excess of our frames of reference. (Felman & Laub, 1992, p. 5).

Felman could not teach her students how to respond, but she could enact the paradoxical pedagogical relation of manipulating her students into taking respon-sibility for responding to their unexpected encounter with the Holocaust. Her performance, in the midst of the Holocaust's radical invalidation of all definitions, of all parameters of reference, of all known answers, was to assert relentlessly the absolute necessity of speaking. She did so in a way that called for students' written testimonies of their encounters with the Holocaust as the material and creative enactment of and validation of the necessity of speaking (p. 224).

Excessive Pedagogy/*Excessive Writing*/Excessive Research

TEACHER: January 8. I do not want to represent student narratives and then psychoanalyze the writers in their absence (as if I could). I am not including stu-dent writings in order to subject them to formal or stylistic scrutiny. At the same time, I want to engage the narratives, to respond to them, and to provide back-ground information when necessary as I attempt to be aware of my own authori-tative and authorial positioning. As my readings of student work "speak me" as much as (or more than) those who write, I hope to make at least some of my inter-pretive strategies and investments available for critique (when I can, when I am conscious of what they are). After all, I am not an anthropologist attempting to narrate some "strange others" who showed up to take a class. Nor am I a struc-tural sociologist interested in describing the economic vectors that determined student responses. I hope to produce a work that carries multiple perspectives and a performance of its own excess.

Excessive Pedagogy/Excessive Writing/*Excessive Research*

As we all settled into our seats, Ms. Clark called the class to order. Some of the students around me smiled hello; others just stared at me as I began typing my observational field notes into my laptop computer. The teacher and I are both white, middle-class, middle-aged women. The twenty-six students, like ninety-nine percent of the students in this school, are African American. I considered this to be of great importance in questioning how I sat and observed in this room, how I "saw" the teacher and students, how they "saw" me, and what sense I, as "researcher," and they, as teacher and students, made of classroom interactions, discussions, and processes. Did our varying ways and reasons for making sense of

this class exceed assumptions attached to our particular social, cultural, gendered, aged, racial locations in this class?

However, the interview and observational protocols with which I was working focused not on how and why students and teachers construct meanings in their classrooms, nor on how those very meanings in part are constructed by and, at the same time, exceed the discourses available to these students and teacher. Rather, my research team's protocols emphasized ways in which teachers organized classrooms, presented subject matter, and interacted with students. As well, the protocols attempted to elicit ways in which students "learned" and demonstrated their accumulated knowledge and understanding of particular subject matter content.

The students had read *Antigone* and had been working for a week, since the completion of their reading, on writing revised endings to the play. They worked in small groups, and each group had written a script, with stage directions included. They were to act out their revised endings for the whole class during the two-hour class time in which I was observing. Their revisions, I was told by Ms. Clark, were to follow the themes of power in the play that they had already discussed as a class; but their new endings were to be set in contemporary times and contexts.

Excessive Pedagogy/Excessive Writing/Excessive Research

Phelan (1993) discusses the unrepeatable nature of performance art in *Unmarked: The Politics of Performance*. I read her discussion as indicating a second paradox that marks the pedagogical relation—namely, that events of performative teaching, such as the one Felman describes, take place, but leave no *visible* trace afterward.

Phelan writes that performance occurs over a time that will not be repeated. It can be performed again, but this repetition itself marks it as different. Performance saves nothing; it only spends. Yet performance clogs the smooth machinery of reproductive representation necessary to the circulation of capital. Performance art's independence from mass reproduction, technologically, economically, and linguistically, is its greatest political strength (Phelan, p. 149). Yet, performance art is also vulnerable to charges of valueless-ness and emptiness, Phelan argues. For only rarely in this culture is the "now" to which performance addresses its deepest questions valued. "Performance honors the idea that a limited number of people in a specific time/space frame can have an experience of value which leaves no visible trace afterward" (p. 149).

Excessive Pedagogy/*Excessive Writing*/Excessive Research

TEACHER: Far from attempting to resolve the dilemmas of representing others, particularly students, I raise a series of questions in the hopes of keeping my project open to new interpretations and understandings that continually deconstruct ethnographic, educational, and literary processes of Othering—deeply rooted

impulses to exoticize, romanticize, discipline, or stylize the "objects" of our scholarly gaze.

It is the fall of 1991. Every Tuesday at 6:00 P.M., I meet with thirty-nine undergraduate women to uncover and recover the assorted ways in which we have all learned how to behave, the knowledges we have acquired, and the understandings we have been encouraged to forget. What kinds of stories do we tell? What stories remain unspeakable in the context of our classroom, in the context of the university, in our families, with our friends, in the culture at large? I keep returning to this quote from Valerie Walkerdine's book, *Schoolgirl Fictions:*

> We are not simply positioned, like a butterfly being pinned to a display board. We struggle from one position to another and, indeed, to break free—but to what? . . . what it is that we want to say, what words will take us from the position of schoolgirls to that of powerful women? Is there an authentic female voice? For me the answer lies not, as some feminists have suggested, in some kind of essential feminine voice that has been silenced, but in that which exists in the interstices of our subjugation. We can tell other stories. These stories can be very frightening because they appear to blow apart the fictions through which we have come to understand ourselves. Underneath stories of quiet little girls are murderous fantasies. These are not there because they are essential to the female body or psyche but because the stories of our subjugation do not tell the whole truth: our socialization does not work. (Walkerdine, 1990, p. xiii-xiv)

Is there space for "murderous fantasies" in classrooms or just stories of "quiet little girls"?

Excessive Pedagogy/Excessive Writing/*Excessive Research*

The class had learned that the themes in *Antigone* were power, revenge, heroic acts, familial conflict—and these themes were performed by four student groups during the time I was observing. Each of the groups had a narrator, and in this class, the groups, which the students formed themselves, broke down along gender lines. During the two hours, I watched two groups of girls and two groups of boys perform with gusto their versions of *Antigone*. The students had brought in props, such as plastic guns, broad-brimmed felt hats, suit coats, fake flowers for the funeral home scenes that proliferated in these versions, and boom boxes on which they played musical accompaniment. Each group ended its tragedy with a rap.

In one of the boys' groups, students had plastic guns and pretended to shoot everyone in sight, including members of the audience, as one way of taking revenge on the person who demanded Antigone's death. The rewrite by one of the girls' groups concentrated on the relationship of Antigone to her brother, emphasizing her loyalty and her willingness to die for the sake of her family's honor. In the raps that accompanied each group's version, students expressed their concerns about the necessity of loyalty among family and friends, and about the difficulties of survival without loyalty and support, no matter how that support and loyalty were embodied.

One young man's rap was so explosive—his performance included dancing across the whole length of the room as he rapped about a high school boy who had become a drug runner and who got his whole family involved in helping him with his drug running because they needed money—that many of the students stood, applauding and shouting their approval at the end of his performance.

Excessive Pedagogy/Excessive Writing/Excessive Research

What Phelan says about the interactions between the art object and the spectator may also be said about the interaction between knowledges offered in a classroom and students taking responsibility for the senses they make of that knowledge. That is, the interaction between student and "new information" is essentially performative—different students' reading of any given text will vary considerably, even wildly. Even the same student, asked over and over, across time, about the same text, will describe a different text (Phelan, 1993, p. 147). The student's activity of remembering, restaging, and restating new information is a generative act of recovery and memory. It passes through the student's personal and social meanings and associations (p. 147). It is not an act of repetition or reproduction. The quality of all learning, knowing, and seeing is, Phelan implies, performative.

For pedagogy to be performative, that is, for the teacher to manipulate the students into a position of taking responsibility for the meanings and knowledge they construct—it must be situated. It must be related to the network of relations that make what counts as the taking of responsibility meaningful. Situated pedagogy's only life, therefore, is in relation to its context and moment. A performative pedagogical event cannot be repeated. Such a pedagogy jams the smooth machinery of reproductive representation, because unlike some versions of curriculum, and unlike unsituated pedagogies, it cannot be mass-produced, circulated, or universalized.

Situated pedagogy, under current regimes of efficiency and accountability, is vulnerable to charges of valueless-ness because it honors the idea that a limited number of people in a specific frame of time and space can have an experience of value that leaves no visible trace afterward and cannot be reproduced. Response-ability-in-context, and the awareness of being within a language and within a particular historical, social, cultural framework, leaves no visible trace (Marshall, 1992, p. 3). Awareness and responding in context cannot be reproduced, represented, or circulated across situations and events.

As Patricia Williams says: "the personal is not the same as 'private': the personal is often merely the highly particular" (Williams, 1991, p. 93).

Excessive Pedagogy/*Excessive Writing*/Excessive Research

STUDENT: Pink tutus and diamond tiaras are bullshit, but I guess everyone knows that by now. Don't they? Don't you? Don't you hear horror stories about starving girls, loneliness, dissatisfaction, bloody toes?

No, not every little girl wants to be a ballerina when she grows up. What I really wanted was to fit in. I just wanted to feel good. And I tried, really I tried, but maybe trying too hard is a dead giveaway. Maybe the key to fitting in is becoming so habituated to the correct behaviors that they just happen automatically. Maybe all those other kids had it mastered; they knew it so well that they could sense my awkwardness. They made it seem natural.

I was a bird. And my ballet teacher kept screaming at me, and yelling. She said, "Be a *Bird, be a bird.*" I wasn't brave, I couldn't look at her when she yelled. "Those aren't *arms*, they're your *wings*, they should flutter like wings! You're supposed to be a dainty bird!" She hated me, hated me because I couldn't do it right. The more she yelled, the less bird-like I became, until I was a cow, stomping across the floor, head down. I couldn't fly, I was too heavy. Four-legged and earthbound.

It was as if there was something I was always supposed to be doing or saying, some way I was supposed to be acting, and I could never get it right. There were rules I kept breaking, and nobody knew what to expect from me. So I decided to stop eating. It fit in perfectly, there couldn't have been a more perfect solution.

Ballet. An art form that takes prohibitive female socialization to an extreme, proudly. It makes no excuses. Girls who have no breasts, who have no hips, who spend hours and hours standing and moving in front of mirrors, learning how to notice every detail that is imperfect. When the imperfections become overwhelming enough, I could no longer stand my body. I sometimes felt pain when I caught a glimpse of myself in the mirror; I sometimes looked into my own eyes and hated myself for not being beautiful, for not being wonderful. It was more than I could bear, there was too much of me.

Excessive Pedagogy/Excessive Writing/*Excessive Research*

Ms. Clark and I laughed, clapped, and nodded approvingly at various points throughout all the students' performances. At the end of the four performances, however, Ms. Clark made no "official" comments about the particular forms that the groups' rewritings of *Antigone* took. Rather, she focused her comments and appraisals of students' work on their willingness to participate in the rewritings and the performances. As the students chattered, gathering their props and giving high-fives, Ms. Clark asked students to put their desks back into their regular circle. She passed out lined paper and asked them to respond in writing to three questions: What role did you play in today's performance? (Include everything you did to make today happen.) What stood out for you today? Which group was the best and why? She told them that she was looking for detail and thoughtful reflection about their work, and she especially was assessing how each group connected its enacted version of *Antigone* to the themes of power and authority.

Students wrote quickly, and then, after Ms. Clark reminded them that participation was part of their grade, a few offered to share some of their reflections. As several students, one after another, read in subdued tones their written reflections (which most often concentrated on the fun they had in putting together their pro-

ductions and comprising their raps), Ms. Clark responded by asking for clarification or for a specific example, such as, "which group did you think illustrated the complexities of family loyalties?" As the bell rang, Ms. Clark collected the students' papers, telling me that she was very pleased with the level of participation in this activity.

Excessive Pedagogy/Excessive Writing/Excessive Research

Like testimony and performance art, performative pedagogy inscribes "[artistically bears witness to] *what we do not yet know of our lived historical relation to events of our times*" (Felman & Laub, 1992, p. xx).

Yet, social, political, and educational discourses construct teaching as a representational practice, that is, as a language-based practice of describing or representing things in the world in ways that strive to be truthful and accurate. But confidence in language's ability to deliver truth and accuracy has been shaken to its foundations by the current critiques and crises of representation circulating within and across many academic and social discourses and practices.

Phelan describes the critique of representation this way: Representation follows two laws. First, it always conveys more than it intends to convey, and the "excess" meaning conveyed by representation creates a supplement. This supplement makes multiple and resistant readings possible, and prevents the reproduction of the same meaning or sense from one reading of a text or event to the next. Second, representation is never totalizing; it never gives a complete, exact picture of what is being represented; it always fails to reproduce the real exactly. Therefore, representation also produces ruptures and gaps, making a full, complete, or adequate understanding of the world impossible (Phelan, 1993).

Excessive Pedagogy/*Excessive Writing*/Excessive Research

STUDENT: I hated her, and she was so pitiful. She deserved my pity, but she got my white-hot jealousy instead. See, she had more willpower than I did. She was no victim to her hunger; while I was unable to go a day without eating at least a bowl of cereal, she boasted of her ability to avoid solid food altogether. She ate only Jell-O powder. She would dip her finger into the box and lick the powder off. Her tongue, her teeth, her right pointer finger were all permanently dyed red from cherry flavored Jell-O. It was disgusting and frightening and fascinating, and I would have given anything to have her self-discipline. It didn't matter whether or not she was a good dancer—she had won the contest, she was the skinniest. She was the enemy.

Excessive Pedagogy/Excessive Writing/*Excessive Research*

Meanwhile, in another school in a different city, students also were reading *Antigone*. On the days that I observed there, the students read the play aloud, taking parts. They sat quietly in their seats. After their reading, they wrote five-para-

graph themes about *Antigone* in which they analyzed characters in terms of characteristics of the tragic hero.

In contrast, Ms. Clark and her rapper students could be seen as enthusiastically involved in their meaning-makings around the study of *Antigone*. They also could be seen as demonstrating much of what is currently circulating within school restructuring processes as preferable forms of teacher-learner interactions, including reader-response activities, cooperative learning, collaborative process writing, and performance art as forms of communication and learning. Ms. Clark, for example, placed students' reading, listening, speaking and writing within the context of literature studies. Further, she could be seen as fostering students' trust in the expression of their own unique experiences with a text. The students could be seen as meaning constructors, rather than as receivers of others' information and interpretations. And I, as a former high school English teacher, could be seen as fully appreciating the involvement, enthusiasm, and responses that Ms. Clark and her students performed.

Excessive Pedagogy/Excessive Writing/Excessive Research

For Judith Butler, as well as for Phelan, this "failure of the mimetic function"—this failure of any author or text to "stand for and explain," or fully reflect or know the complexities of the world—"has its own political uses" (Butler, 1993, p. 19). In the absence of the possibility of a complete and adequate master text about the world, or knowing of the world, the production of partial texts "can be one way of reconfiguring what *will count as the world*" (p. 19, emphasis added).

The slippages between text and world, knowledge and the real, and the intended and unintended audiences and fields of reading make it possible, Butler claims, for writers and cultural activists to deviate "the citational chain toward a more possible future to expand the very meaning of what counts as a valued and valuable body in the world" (p. 22).

Dialogue, and other representational practices that dominate current conceptualizations and practices of "critical pedagogy," strives for making rational sense, for understanding, for a match between the text, the world, and the readers' shared interpretations. Dialogue makes claims about what is true, what is valid. Performance, like the production of partial texts with the intent of deviating citational chains, strives instead for political and social efficacy, credibility, and usefulness-in-context, in relation to its particular audience. Performance, like the production of partial texts capable of resignifying what counts as a valued and valuable body in the world, makes claims not about truth and validity, but about what is visible and what is impossible in relation to a particular audience, in a particular situation. As such, these practices construct knowledges and ways of knowing that exceed dialogue.

Phelan argues that the widespread belief in the possibility of understanding, that is, in the possibility of representation to reproduce the real exactly,

> has committed us, however unwittingly, to a concomitant narrative of betrayal, disappointment, and rage. Expecting understanding and always failing to feel and

see it, we accuse (ourselves or) the other of inadequacy, of blindness, of neglect. The acceleration of ethnic and racial violence may be due in part to the misplaced desire to believe in the (false) promise of understanding. . . . [P]erhaps the best possibility for "understanding" racial, sexual, and ethnic difference lies in the *active* acceptance of the inevitability of misunderstanding. Misunderstanding as a political and pedagogical telos can be a dangerous proposition, for it invites the belligerent refusal to learn or move at all. This is not what I am arguing for. *It is in the attempt to walk and live on the rackety bridge between self and other—and not the attempt to arrive at one side or the other—that we discover real hope.* That walk is our always suspended performance—in the classroom, in the political field in relation to one another and to our selves. (Phelan, 1993, p. 174)

Thus, a third paradox: Pedagogy is necessarily a suspended performance—suspended in the sense that its completion is constantly interrupted and deferred by the knowledge of the failure-to-know, the failure to understand, fully, once and for all. And it is a suspended performance in the sense that it is performed "precariously on the rackety bridge between self and other," teacher and student, agency and constraint.

Excessive Pedagogy/*Excessive Writing*/Excessive Research

STUDENT: People sometimes ask me why I don't take dance classes anymore. They say, "You really should get back into shape, you were such a wonderful dancer." I always just say no, and explain that dance classes don't interest me, I find them boring, blah blah blah. . . . How do I explain that I am still recovering from a disease I don't understand? How do I describe the way I feel about what ballet has done to me? I walk into a dance studio, and my stomach starts to swirl, my throat constricts, my eyes race toward a mirror and run a familiar path along the lines of my body. My mind becomes filled with images of tutus, a pitifully ungraceful bird. I stare at the floor.

TEACHER: Joanne Pagano (1990) asks us to consider: How might we represent the other without making her story our own or our stories hers?

Excessive Pedagogy/Excessive Writing/*Excessive Research*

I wanted to stay in that classroom with the students after the bell rang. I wanted to explore with Ms. Clark's students how they constructed identities and meanings for themselves in relation to the text, *Antigone*, because I felt their constructions exceeded not only the theories and reform protocols that were used to frame and guide both teaching and research in this particular situation, but also versions of "what and *who* counts" in schools.

Ms. Clark, by asking her students to rewrite *Antigone* within contemporary contexts, invited them to bring their cultural, gendered, racial and ethnic identities as well as popular cultural forms into their English classroom as a way of making sense of the play. They responded by producing creative, enthusiastic, and culturally detailed performances.

However, the school reform research protocols I was expected to apply, and the pedagogical and subject-area perspectives Ms. Clark was expected to enact, let go un-remarked—let be erased, let become an oversight—social and cultural difference that students were implicitly invited to bring into class and to put in relation to the canonical text, *Antigone*. The students' performances of that difference were minimized and thus remained as excess, not through any intention of either Ms. Clark or myself, but through pedagogical and research discourses that attempted to contain us all.

Excessive Pedagogy/Excessive Writing /Excessive Research

Butler locates political agency on that bridge between self and other:

> Performativity describes [the] relation of being implicated in that which one opposes, [the] turning of power against itself . . . to establish a kind of political contestation that is not a "pure" opposition, a "transcendence" of contemporary relations of power, but a difficult labor of forging a future from resources inevitably impure. (Butler, 1993, p. 241)

The teacher's performance is never in full possession of herself, of the student, or of the texts and meanings she works with. Yet the pedagogical relation is performed, and in that performance it gives material and creative validation to the absolute necessity of speaking and responding.

One possibility of performing a pedagogical relationship lies in the active acceptance of the inevitability of a suspended performance, a performance that leaves no visible trace of its happening, a performance that paradoxically manipulates teachers and students into taking responsibility for producing partial texts that reconfigure what counts as the world and, by doing so, what counts as valued and valuable bodies and lives in that world.

Excessive Pedagogy/*Excessive Writing*/Excessive Research

STUDENT: Haug (1987) asks us to explore linkages, feelings, and attitudes toward other people and toward the world, which have some connection with the body. The majority of my linkages come from having a mother who attended an exclusive, finishing-type two-year college and a grandmother who won't leave the house until she is totally made up. For me these linkages began very early. The main message was always look your best. When I look at my baby book it is loaded with pictures of a baby dressed to the hilt with little bows scotch taped on her head. I wore the latest children's fashions and if I ever complained I would always be told "beauty before comfort." The phrase still rings in my head often.

TEACHER: If there is any common ground we share as a group of forty women, it is the relentless surveillance and judgment (by others and ourselves) of our appearance, our femininity, and our abilities. But how to talk about the panopticon within, the policing of desire, the internalization of the gaze within the bounds proscribed by the institutions within which we work? What do we call into the world by the stories we tell?

This essay is excessive, I am excessive, students are excessive. This essay, my body, my students' bodies, our classroom, all exceeded the boundaries of academic practice as currently constructed. I am acutely aware of the strategies of containment I employ as I edit this work. How far is too far? How much is too much? I would like to conclude with an excessive quotation from Frigga Haug:

> Unexpected and unannounced, the storm breaks. A catastrophe has broken; the writer is turning into a girl. . . . Events are etched on our memory as the triggers of change; we see our socialization and the construction of our identity, in retrospect, marked by twists and turns, breaks and fractures. (1987, p. 86)

Excessive Pedagogy/Excessive Writing/*Excessive Research*

And because their performances remained un-remarked, because students' cultural, racial, ethnic and gendered identities and reinventions of those in relation to the text left no visible trace, their performances of *Antigone* were not officially linked to their learning, or to what counts as school knowledge. Instead, school knowledge became defined, once again, within comparative and competitive assessment procedures ("which group was best and why") and became bounded by what all high school English teachers learn to replicate as "universal" themes within literature (family loyalties).

Similarly, teacher and student identities, within the context of school reform research, were to be encoded by me as examples of either successfully "restructured" or the less-desired "traditional" teaching and learning. The social and cultural locations of students, teacher, and researcher, and the influence of those locations on the knowledge that was constructed in this classroom, exceeded the boundaries of the research study's intentions as well as of student-centered pedagogies.

Within the contexts of many school-restructuring studies, then, questions that potentially could open sites for exploration of identity and knowledge constructions within and across difference are squeezed into universalizing and instrumental conceptions of learning and teaching. What would happen to the very notion of school "reform" (not to mention school reform research and researchers) if we were to open up our teaching and researching practices to consider the excessive—the unpredictable, contextualized, and unrepeatable moments of students', teachers', and researchers' performances of their identities and knowledges? What new versions of schools, of teachers, students, curriculum, and research might we then set into motion?

Notes

1. An earlier version of this article was presented as a symposium at the Annual Bergamo Conference on Curriculum Theory and Classroom Practice, sponsored by *JCT: An Interdisciplinary Journal of Curriculum Studies*, Dayton, Ohio, October 1993.

We want to thank the people who heard that symposium and encouraged us to publish the presentation just as they heard it.

2. In our ongoing search for ways to interrupt the hierarchical listing of names in academic publications, we thought that this time we would choose the order according to how easily and pleasingly all three names could be said one after the other.

3. Students and I voluntarily made some of our writings available to each other by placing them in a folder accessible to everyone. We agreed that anyone in the class could use the writings as long as they were used anonymously, and were not used for the purpose of "trashing" the writer. Some writers signed their work; others offered them anonymously.

4. "Ms. Clark" is a pseudonym.

SHIFTING THE BOUNDARIES

Teachers Challenge Contemporary Curriculum Thought

In mid-summer of 1986, I joined five graduate students in a picnic lunch to celebrate the end of our coursework together. During that extended lunch, we talked about a number of issues that had emerged in our various classes together in curriculum theory as well as qualitative research. By the close of that afternoon, with the summer sun burning low on our backs, we agreed to continue our conversations in an informal and unofficial way. At present, we have been meeting and talking together on a regularly scheduled basis for six years.[1]

As we continue our meetings, discussions, and individual as well as dialogical journal writing, I am acutely aware of just how much I have been influenced in my teaching, research, and curriculum theorizing efforts, by our interactions, reflections, and confrontations with one another. Here I want to sketch some of those influences and to discuss several intersections as well as detours between and among contemporary US curriculum discourses and our collaborative inquiries.

Intersecting Assumptions

I had prepared for our first "official" meeting as a collaborative, in late summer of 1986, by photocopying some articles about then current work within the reconceptualization of curriculum studies and qualitative forms of teacher research. These were areas of inquiry that had dominated sessions of our formal graduate classes together as well as that picnic lunch discussion. Our ensuing agreement to meet as a group, beyond the confines of the university classroom, was prompted, in part, by our varied interests in the possibilities and difficulties of becoming "emancipatory" teacher-researchers who could attempt to address current issues of power relations, oppression and injustice in teaching, curriculum and research relationships (Apple, 1982; Carr & Kemmis, 1986; Culley & Portuges, 1985;

Freire, 1974; Howe, 1983; Lather, 1986; Lincoln & Guba, 1985; Maher, 1985; Marcus & Fischer, 1986; Mishler, 1979; Roberts, 1981; Stanley & Wise, 1983; Wood, 1983). We wanted to pursue these concerns that dominated educational writing and research in 1986 while still attempting to understand, from reconceptualized curriculum theory perspectives, the situated complexities of our own lived educational experiences (Pinar, 1975a; Pinar & Grumet, 1976). We especially were interested in exploring the situated complexities of a notion of curriculum research that could emancipate the researcher in order to offer such a possibility to others (Pinar, 1978b). As well, we wanted to examine some of our "uneasy" pedagogical, curricular and research experiences (Luke & Gore, 1992) in relation to descriptions of "emancipatory" teaching, researching, and curriculum theorizing.

All of these emphases initially had emanated from my own interests, of course, because, as the professor, I had constructed our courses in ways that reflected my questions about as well as my investments in these particular perspectives and research dilemmas.

And so, as I settled into my lawn chair on Marjorie's[2] porch, juggling my coffee cup, a bagel, and my folder of handouts, I felt eager yet nervous about this first "official" meeting. The others were still chatting about events of the intervening weeks since our picnic, and their easy banter gave me a few moments in which to collect my thoughts.

I already had spent three or more years with these teachers, who were students in the graduate program in which I taught, and I was delighted that they wanted to continue our connections and discussions. At the same time, on this late summer weekend morning that signaled our first meeting outside the boundaries of the university, I realized that I was worried, anxious about the directions and intentions of our work together. I had no definitive ideas for ways in which we might further explore possible meanings, manifestations, and relations among "emancipatory" teacher research, reconceptual curriculum theorizing, and K–12 classroom teaching and curriculum work. I only had hunches and questions.

Questions had emanated from my attempts to find intersections among the often disparate approaches and intentions of those working within the reconceptualization of the US curriculum field. During the initial reconceptual work in the 1970s,[3] critical theory and phenomenology were the two predominant philosophical perspectives brought to bear on moving the curriculum field from an instrumentalist orientation on curriculum design, development, implementation and evaluation to a focus on understanding differing perspectives on the nature of educational experience. And those who worked from those two philosophical orientations, whether each group denied it or not, appeared to focus on either "the political" or "the personal" in their attempts to "understand."

But my hunches in 1986 derived from multiple curriculum theorizing perspectives, including a variety of feminisms, that had quickly emerged in the field and that I recently had been pursuing. Some feminist perspectives, even in the late 1970s and early 1980s, acknowledged the interrelation of the personal and the political in attempts to reconceptualize the traditional curriculum field

(Grumet, 1979; Krall, 1981; Lewis & Simon, 1986; Miller, 1979c, 1982a, 1983b; Wallenstein, 1979a). At the same time, the influences of French feminist theorists were expanding; their work challenged the linearity of narrative, a unified concept of self-hood, and the relationship of women to language, to the body, and to systems of representation (Cixous, 1981; Irigaray, 1985; Kristeva, 1984). Other feminist work challenged theories that posited a "universal woman" who was implicitly Western and white (Moraga & Anzaldua, 1981). And some curriculum theorizing perspectives also had welcomed the growing influence of poststructuralism, with its emphasis on provisional and contingent identities and the need to attend to historically and culturally specific discourses of identity through which women and men become speaking subjects (Daignault, 1983; Ellsworth, 1986; Gauthier, 1986; Taubman, 1979).

But those hunches and questions with which I recently had been grappling vanished as the group members turned expectantly to me, as if they were waiting for yet another class to begin. I slowly slid my manila folder onto the floor, trying to hide my carefully prepared supplementary readings as I shifted in my chair. I stretched across the side table to grasp the coffee pot. "Wow," I murmured into my coffee cup, "have I fallen into this one." I had strolled onto Marjorie's porch that morning, fully desiring for our group the collaborative, reciprocal, and equitable relationships that some current feminist forms of research in particular, signaled for me. Within liberatory and feminist conceptions of research that we most recently had studied together (e.g., Lather, 1986; Stanley & Wise, 1983), the notion of professor as "expert," as the one who determined knowledge or research agendas for others, was viewed as impositional and oppressive.

And yet, as the five teachers gathered in a circle around me, I realized that I *had* settled into my seat as that professor, still assuming responsibility for setting the directions and intentions of this fledgling group. Those directions and intentions were framed by reconceptual curriculum discourses that challenge traditional conceptions of curriculum as only prescribed content or course of study, of teaching as only transmission of predetermined content of others' making, and of research as only a means of prediction and control. Ironically, I was assuming that the group members would want to pursue with me such challenges. And I was assuming too, more unconsciously perhaps, that we immediately could do so without attending to the hierarchical and already-in-place power relations that had characterized our student-professor relationships.

Staring back at the silent group, I realized that I still was struggling to create spaces within reconceptualized versions of curriculum theorizing that could enable me to explore, for example, "the personal" and "the political" not as a binary but rather as reciprocal, interactive, constantly changing and (re)constructing influences on my own and other teachers' conceptions of curriculum, pedagogy, and research. I was looking for ways to participate in curriculum theorizing and researching without being drawn into the "either/or" stance that had characterized the early years of the reconceptualization. Those tensions, in 1986, still played a part in that work, and I wanted to attend to both ends of what

appeared to be a tension-filled continuum—without replicating its linear and binary construction.

In choosing to focus much of my own reconceptual work in relation with K–12 teachers, I also was looking for intersecting yet shifting spaces as a way of avoiding any unitary or separatist version of reconceptualized curriculum theorizing. I did not want to be viewed by these teachers only as a representative of just one version or another of curriculum theory reconceptualized, for clearly, given the tensions that characterized the varying perspectives within this loose categorization, there was no one, fixed stance from which to speak and work.

My concern was that in general education settings it was easy to categorize "the reconceptualization" as if it were one thing, even if that reconceptual movement, by 1986, had already succeeded in dislodging, from a variety of theoretical perspectives, the atheoretical, ahistorical US curriculum field of the pre-1970s, and thus was beginning to dissolve as a "movement." I worried that, in K–12 educational settings, any unitary version of the reconceptualization could be set in opposition to a traditional conception of the field, thus perpetuating yet another "either/or" posture. I wanted, instead, to work within and between the multiple and shifting perspectives and tensions of reconceptualized curriculum as well as curriculum as still conceived by, or mandated for, the majority of educators in schools.

Beth, at that time a junior high school mathematics teacher with eighteen years of teaching experience, broke the silence that my hurried reflections had created. "What are we going to do?" she queried, with her usual enthusiasm and directness, as she turned in her chair to stare at me. The others fixed their collective gaze on me, smiling, waiting.

One of my immediate learnings within this group, then, was the degree to which collaboration between university and K–12 teachers is fraught with unarticulated and, in my case, unexamined assumptions. One assumption that Beth's question immediately challenged was that these teachers would even be interested, at that moment, in my detailed worries about investigating multiple rather than linear and binary theories of curriculum. Another assumption that collapsed in that moment was that "collaboration" with willing participants could easily avoid the circulations of power that attend any human interactions, or could "progress" in seamless and transparent ways, with all participants moving as a collective through the collaborative work in similar ways and at identical times. Before Beth's question, I truly thought that I would be able to quickly shed my role as a professor with particular academic interests, and to assume membership within this group as a peer with similar theoretical and practical concerns even as I ironically was selecting journal articles to share with the group. I truly wanted to research with these teachers, and not about them, and I was steeped in curriculum theorizing and feminist research perspectives that addressed such possibilities.

I think now that what I then regarded as my emancipatory and reconceptual intentions obscured, at least initially, the degree to which I would have to work at examining sources and means of construction of my own underlying assumptions about my work and educational "identities" and interests. Or how hard I would

have to work to explore, with the group members, the usefulness and meaning-fulness of contemporary curriculum discourses to the lives of those who teach, research, and create curriculum in settings other than universities.

The difficulties of questioning and tracing roots of such assumptions became, and remain, my particular focus in our constantly changing collaborative. That focus has enabled me to explore, with the other group members, tensions between reconceptual curriculum perspectives and versions of curriculum and modes of inquiry in the varied and diverse worlds of K–12 teachers and students. Within our collaborative group, questioning our assumptions, then, has also enabled us to consider ways in which classroom teachers' theorizing, researching, and con-structing of curriculum can not only contribute to (a notion that still places uni-versity theorizing "above" that of classroom teachers) but also generate new perspectives.

Leaning Against Boundaries

In that first morning meeting, then, Beth's question, "What are we going to do?" contained both challenge and incentive. The difficulties of transposing the myriad theoretical perspectives that we had studied, under the rubric of curriculum the-ory, into forms of action, into something that teachers could "do," pointed to the still-dominant conception, in K–12 settings, of theory as separate from practice. But what we had studied in class, although surely directing my intentions with our collaborative, was not intended to automatically translate into prescriptions for action in our proposed work together. Rather,

> Contradictions between theory and practice compel us to acknowledge the ten-sion in the relation of these two terms. Too often has educational theory been reduced to a form of idealism that must be instantly transferred into activity. Although the field situation provides a context where our theory and our practice confront one another, our goal is not to resolve their differences, nor to reduce one to the dimensions of the other. Rather, we play one against the other so as to disclose their limitations, and in so doing enlarge the capacity and intensify the focus of each. Just as what we think and know about our work is contradicted daily by the events in which we participate, the actual experience of teaching and the certainties that activity offers may be undermined by the questions and alter-natives that theory cultivates. (Pinar and Grumet, 1981, pp. 37–38)

At the same time, I think Beth's question still signaled a deep fissure between the theorizing and critiques of the reconceptualization and the conceptions of curriculum and research that predominate in K–12 schools in the US. Classroom teachers, given current pressures for accountability and raised achievement scores for their students, often must conceptualize their work as some form of action or activity.

Beth and the others had discussed this point many times throughout our studies of curriculum theory. Other members of the group, including Katherine, a first-grade teacher, Cheryl, an elementary special education teacher, Marjorie, a high school science teacher, and Kevin, a child psychologist who worked in both

the elementary and secondary schools in his district, had presented myriad examples of the constraints that traditional curriculum conceptions, with their calls for design, development, and evaluation, had placed on their work as educators. For example, each constantly confronted administrative expectations for "high" standardized test scores as evidence of students' accumulation of knowledge and teachers' abilities to transmit that knowledge. And Kevin, although not having to produce such test scores per se, was expected to produce "objective" evidence of his clients' "progressions" toward predetermined "appropriate school behaviors." All of these constraints assumed some form of responsive action, some "activity" in which teachers and counselors could engage that would "produce" some evidence of students' learning or adaptation of behavior in a classroom setting.

These educators thus described discrepancies between what they were learning in our curriculum theory classes and what they encountered in their daily teaching. In schools where they taught, curriculum still was conceptualized as "content" or "course of study," as information that could be dispensed but not created by teachers, received by students at predetermined, developmentally appropriate stages, and then returned to the teacher in measurable, testable, and standardized forms.

In contrast, contemporary curriculum discourses focus attention on knowledge construction and conditions, discourses, and power relations that structure the production and receiving of knowledge. Thus, the classic curriculum question, "What knowledge is of the most worth?" expands as curriculum theorists now ask, "Whose knowledges are of the most worth? What is legitimated as knowledge? And how? Who decides? How do I experience and construct knowledge? How are those 'experiences' and constructions mediated by the discourses available to me at any one place and time?" Those working from such reconceptual perspectives attempt to acknowledge, and to examine as knowledge, the interwoven relationships among one's perceptions of one's educational experiences, one's contextualizations, via discourses available and predominant, of those experiences within social-political worlds, and one's constructions and understandings of curriculum as both reflecting and creating those worlds (Pinar, 1975a).

But Beth's question highlighted constraints also imposed by attempting to even ask such "reconceptual" questions in school settings where knowledge still is viewed as that which is contained within textbooks (regarded as "the truth," rather than as representations of some one's particular version of "the truth") and that which can be reproduced by students in measurable forms. Her question pointed to the expectation that university teachers would know how classroom teachers might begin such questioning as a way of challenging such fixed and unitary versions of curriculum. And her question also framed ways in which these particular classroom teachers, waiting patiently for me to speak, expected such questions to address their daily concerns.

For example, they have since asked, within our collaborative investigations: How might reconceptualized versions of curriculum enable students and teachers to work together in learning environments where knowledge is viewed as well as

examined as their joint constructions of meanings? And how might students and teachers work to understand even "joint constructions of meaning" as influenced, even constructed by social, cultural, and historical events, contexts, and discourses? And how, the teachers in our collaborative queried, could they participate in such examinations in ways that, while challenging the stimulus-response, end-product mentality of most school bureaucracies, still enabled them to remain in the teaching profession?

And so, Beth's question, "What are we going to do?" illuminated contradictions and tensions that accompany many current attempts to forge collaborative inquiries among university and classroom teachers (Miller, 1989a, 1992a, 1992f). Beth's question also pressed against internalized yet socially constructed boundaries of assumptions and expectations for myself, not only in the standard role of university professor but also in the role of professor enmeshed in the discourses of contemporary curriculum theorizing. That question also leaned against what I saw as borders of that curriculum theorizing, immediately forcing those boundaries to bend, to give, to re-form around the questions and interests and concerns of the teachers with whom I wanted to explore and to create.

During our six years of collaborative inquiry, those boundaries have been shifted, merged, and breached countless times by our changing questions. Those boundaries, which I see now originally served to encircle my own academic interests and investments, have become more like membranes that are porous, malleable—able to be stretched and reshaped by the shifting tensions that inevitably accompany our collaboration.

Working Within Tensions

Beth's question, then, was only the first of countless questions that have emerged throughout our ongoing collaboration. For example, we continue to address ways in which each of us, with our varied intentions and interests and concerns, tries to influence the direction of our collaborative work. Thus, we are seeing ways in which we always are implicated as invested and interested individuals, sometimes voicing only partial or incomplete stances on our work, even as we work to create collaborative spaces in which, ideally, all our voices could be heard. We now incorporate challenges to that ideal (Britzman, 1991; Ellsworth, 1989; Lather, 1988; Orner, 1992) and focus on how both the concept and enactments of "voice," for example, are processes that are constantly changing and under construction.

Because Beth so directly addressed her question to me, and because the other members waited expectantly for my reply, that initial question also has encouraged all of us to examine our expectations for ourselves within the contexts of our research collaborative as well as our respective educational settings. For, on Marjorie's porch, we had slipped into our usual roles as teacher and students, even though we had openly declared our intentions to examine what it might mean to function as an "emancipatory research collaborative." The intersections of those

declared interests with the roles we immediately assumed, and still wrestle with, have formed the impetus for our continuing examinations.

Thus, each of us has since explored, from a variety of angles and perspectives, the particular roles we were playing on that porch in that late summer morning of 1986. In our ensuing work together, we continue to examine the multiple identities (and influences on their construction) as well as various sources and manifestations of underlying assumptions that each of us brought to that first meeting. We also are looking at how and why those roles and identities shift and change within our varying contexts and circumstances. Because our intentions and habitual roles and expectations have continued to erupt and clash, we have had to confront their contradictory aspects. Contemporary curriculum discourses contribute to, help to illuminate, and at the same time, create tensions between and among the K–12 teachers and me as we examine sources and constructions of those contradictions.

For example, during the course of our work together, both Beth and Marjorie assumed administrative positions. Each of them had taught for twenty years or more, and the move from classroom teacher to administrator highlighted a number of contradictory assumptions within our group about their relationships to their familiar as well as newly assumed roles. As well, their new positions changed the dynamics of our group's interactions.

Much of our early work together had concentrated on examining assumptions of ourselves as passive recipients of others' constructions of curriculum, pedagogy, and "appropriate" educational relationships and functions. Katherine, the first-grade teacher, and Cheryl, the special educator, especially wrestled with their unconscious enactments of stereotypes of elementary teacher as prime exemplar of nurturer, caretaker, and mother, as well as behavior manager and controller. As they struggled against such gendered and conflicted stereotypic conceptions, we initially framed our discussions with analyses of teaching as still predominantly "women's work" (Apple, 1986; Grumet, 1988a; Hoffman, 1981; Miller, 1986b, 1989b, 1992b; Tabakin & Densmore, 1986). Later we began to examine curriculum theorizing that included many feminists' concerns about and objections to essentialist constructions of "woman." These objections center on representations of women that reduce the multiple subject positions, including social, cultural, ethnic, racial, aged, ability and sexual orientation differences among women to essential and unitary characteristics that all women supposedly share (Lesko, 1988; Roman & Christian-Smith, 1988; Weis, 1988). And we were intrigued by and wanted to further explore work (Ellsworth, 1989; Lather, 1991a, 1991b; Martusewicz, 1992) influenced by Butler's (1990) claim that identity, no matter what its form, is always produced and sustained by cultural norms.

As we explored these concerns, the tensions Marjorie and Beth were feeling as "women" now working in the traditionally male-dominated field of US educational administration began to emerge. Both attempted to deconstruct the pressure they felt to "know all the answers," now that they were "women administrators." Beth clarified the stress that accompanied her expectations to "over-perform" in order to ensure that she could "play" in the male-dominated

world of educational administration: "What does it do to you if you admit you don't know? What do you risk? In this role, it feels even more like I risk my whole job and my identity as a capable woman."

Both Marjorie and Beth spoke of the ways in which their anxieties were tied to what they realized were socially constructed yet internalized expectations for themselves as female educators. And I was eager to move their questions into areas that pressed against what I regarded as limited and limiting essentialist constructions of women; as well, I wanted us to investigate work that rejected a liberal feminist notion of gender as a biological given that forms the basis for denial of access (Jagger, 1983). I was eager to explore postmodern concerns with a notion of a unified and essentialized "identity" as a fiction of coherence (Butler, 1990; Lather, 1991a, b). But Marjorie and Beth worked in educational settings that daily reinforced and reinscribed those very fixed notions of gender and "woman" that I especially wanted to work against. What did my interests have to do with their particular situations and ways of needing to work and interact in their educational settings?

As I shared these thoughts as brief and situated evidence of the never-to-be-resolved tensions between theory and practice as well as between the habitual and power-infused roles of professors and teachers in any attempt at collaborative research, the other group members gently reminded me that our work together resided in those tensions. There was no getting "out of" those tensions. Maybe instead, Katherine suggested, we could explore Marjorie and Beth's dilemma through its relationship(s) to our own individual and immediate puzzles, and then perhaps look at those puzzles as examples of major educational issues, processes, structures, discourses and "identities" that we had been attempting to address in our years together.

Here then are questions we constructed together as a result of Marjorie and Beth's administrative moves, and with which we still are grappling: How might Beth and Marjorie's current dilemmas as "women administrators" inform concerns that Cheryl and Katherine still express as classroom teachers struggling within stereotypic female roles in their elementary schools? Or inform similar concerns that I express about my constructed role as "woman academic"? Or inform dilemmas that Kevin continues to confront as a male child psychologist working in an elementary school, where he often is still posited as the informal leader? What identities has each of us assumed within the contexts of the administrative concerns that Beth and Marjorie now bring to our collaborative research meetings? How are those "identities" still performing gendered (and raced, classed, aged, ability, sexual orientation) conceptions of our work? How do any performances of our identities shatter any unifying or consistent notion of what it "means" to be a "woman administrator," or "woman academic," for example? What tolls are those performances of identity taking, and what new possibilities are those performances creating in our work to collaborate, to research, and to teach in ways that might gesture toward a more just educational world?

We generated these questions out of our work together, work informed by reconceptualized curriculum perspectives and feminist research orientations,

especially. We tell our "stories" and at the same time interrogate our "experiences" and the stories we tell (Grumet, 1981c; Pagano, 1990; Scott, 1991; Smith, 1987) of the problems, conflicts and small successes in our teaching and researching lives. And, as we participate in curriculum theorizing, we necessarily ground that theorizing in the events and languages of our daily educational interactions and activities.

For, the discourses of various contemporary curriculum perspectives still are not often the discourses of many schoolteachers or guidance counselors or administrators in schools. But, as we have worked together over the course of six years, we have infused our local examples of the dominant "standardize and measure" educational discourse with stories framed by curriculum theories and discourses identified as reconceptual in nature. Those theories and discourses, at the very least, encourage us to move beyond our stories as simply idiosyncratic happenings within our school days. In so doing, we are able now to see ways in which our habitual responses, roles, expectations, and resulting educator "identities" often have been constructed by the very "school" discourses (discourses that are deeply gendered in normalizing ways, for example) that frame and indeed often construct our "personal" understandings of ourselves as teachers, as researchers, as collaborators.

We take heart in knowing that we can analyze, critique, and work to change our habitual responses to static and limiting constructions of our work and our educational identities. We have done so by juxtaposing others' and our own curriculum theorizing with examples provided by our daily educational work. It's a form of local and contingent "emancipatory" work, if you will, and it's what we can do to continue the slow but crucial work to understand and, if necessary, change the nature of our own and perhaps our students' and colleagues' educational experiences. We in no way expect that our versions of such efforts could translate to any other US educators' work or situations. But we hope that our versions might at least encourage others to engage in myriad explorations of current pressing educational issues as well as collaborative forms of inquiry.

As we continue to meet on back porches and living rooms, still juggling coffee mugs, bagels, and conversations, we ponder discrepancies in our expectations as collaborative group members as well as members of various educational communities. We struggle to explore how those expectations, tied to certain educational identities, have been constructed by language, history, culture and power relations, and how we have internalized those constructions as our own. We examine these issues, not only as they surface within the contexts of our collaborative and our studies of curriculum and research discourses, but also as they erupt in our daily work as teachers and researchers. For Beth's question, "What are we going to do?" quickly ushered us off that first comfortable porch, ringed with the certainty of my photocopied academic journal articles. Her question led us into the tangled intersections of theory and practice where we now must (re)negotiate and reconfigure the permeable boundaries of their—and our—relations with and to one another. It is our daily challenge, our daily work.

Notes

1. For an account of this group's first three years of meetings, see Miller (1990a).
2. Here I am using the same pseudonyms that these individuals chose for themselves in *Creating Spaces and Finding Voices.*
3. For comprehensive surveys of the emergence, development, and infusion of reconceptualist perspectives in the curriculum field, see Pinar (1974, 1975a, 1988). Also, *JCT: An Interdisciplinary Journal of Curriculum Studies* (formerly *The Journal of Curriculum Theorizing*), a journal devoted to curriculum history, criticism, and theory, has, since its inception in 1978, represented various aspects and perspectives of the reconceptualist movement. The Bergamo Conference on Curriculum Theory and Classroom Practice, an annual conference sponsored by *JCT*, also provides a national forum for curriculum debate, dialogue, and sharing of myriad curriculum conceptions and perspectives.

TEACHERS, AUTOBIOGRAPHY, AND CURRICULUM

Critical and Feminist Perspectives

As I gently opened the door and slipped into the classroom, I felt, ironically, overwhelmed by the diminutive school desks and chairs that were arranged in two concentric circles in the middle of the room. This tiny furniture framed, yet did not contain, the undulating movements of twenty-two first-graders. I quickly sought the familiarity and comfort of the teacher's calm gaze above the small swells of activity, and I slowly began to tread to her through the children's inquiring glances and a few gestured hellos. "Who are you?" asked one girl, tugging on my skirt and then brushing her red hair from her eyes to clear her upturned stare. "Yes, who are you?" chimed in two others. And I thought, "In these unfamiliar waters, I'm not sure!"

I was entering the first-grade classroom at the invitation of the teacher, with whom I had been working in an in-service program on the writing process. As a university teacher, I am committed to spending a portion of my time in the schools, working directly with teachers and students. Although I teach graduate courses in curriculum theory and qualitative research, my usual in-service focus in schools centers on pedagogical and curricular issues in implementing tenets of what has become generically known in the US as "the writing process" within the teaching of the English/language arts. This focus reflects my prior work as a high school English teacher as well as my academic preparation in English education and curriculum theory. Through my in-service commitments, I wanted to explore with classroom teachers possible manifestations of the reconceptualization of the US curriculum field. That movement known as reconceptualization moved the field from a mechanistic emphasis on design and development of curriculum "materials" to an emphasis on understanding the complex and differing nature of individuals' educational experience.[1]

For example, I work with teachers not only to explore writing processes and pedagogies but also to excavate and analyze underlying expectations and assumptions about our daily work. I believe that such self-reflexive (albeit partial and always changing) processes must be situated in relation to a reconceptual emphasis on examining social, cultural, historical, political and discursive constructions, contexts, and forces that shape "personal" assumptions about teaching, curriculum, and research. Some of us involved with this reconceptualization believe that such situating might enable us "to break with submergence, to transform" (Greene, 1986, p. 429).

As I waded through this sea of first-graders, however, my only thought was to land safely at the teacher's desk without ignoring or floating past any of these children's outstretched hands. I was overwhelmed not only by my lack of experience with early childhood contexts but also by the ways in which the children's immediate and spontaneous responses triggered expectations in myself to respond in kind. In one brief voyage from one side of this every-inch decorated classroom to the other, I felt the pull of social and historical constructions of early childhood educator as "woman" and thus, according to those gendered constructions, as also nurturer, mother, caretaker, as well as facilitator, captain, guide (Apple, 1986; Hoffman, 1981; Walkerdine, 1990). Women who teach, who involve themselves in any aspect of US education, still struggle with contradictory aspects of the feminization of teaching and the ways that feminization has both promoted and sabotaged the interests of women in American culture (Grumet, 1981b). I wondered how this teacher, and every other early childhood teacher, dealt with those problematic and contradictory tensions that such embedded constructions could create within conceptions and enactments of teaching and curriculum.

Since that first-grade initiation, I have worked with a number of teachers who are interested in utilizing critical, feminist, and autobiographical perspectives— perspectives characteristic of a portion of the reconceptualization—to investigate social, historical, economic, cultural and discursive contexts and norms that frame US education. The teachers with whom I work seem especially interested in exploring how these framings become intertwined with what we think of as our personal assumptions about our roles as educators (Miller, 1986a, 1986b, 1987a, 1987b, 1987c, 1990b; Miller & Martens, 1990). Here, in sketching some possibilities that such examinations have created for one first-grade teacher and myself as teacher-researchers, I specifically want to explore contradictory aspects of the construct "teacher-nurturer" that tend to reify early childhood education, especially, as "women's work." Such work is historically grounded in social expectations and schooling structures that rely on women's accustomed roles as subservient, genteel, and docile reinforcers of the status quo (Greene, 1978; Grumet, 1981b).

At the same time, I want to examine ways in which my role as a female academic still is imbued with some of the same gendered characteristics as that of early childhood educator, indeed of all women who teach. Those gendered constructions contribute to an ongoing sense of fragmentation within my professional life, even as I work to explore how gendered identity is socially produced

through repetitions of ordinary daily activities (Butler, 1990), activities that, for me, include teaching and researching. For, as a woman teaching in the university, I still feel the pull of internalized expectations for myself either as distanced "expert" and "conveyor of knowledge" or as nurturer and caretaker of my students' needs and interests. In the academy, my feelings create for me a binary because historically constructed expectations for university professors clearly still focus on the "expert" end of the binary. Historically, both elements of that binary, ironically, have ensured "pedagogy for patriarchy" (Grumet, 1981b).

I want to describe, then, how the first-grade teacher and I are struggling, within the context of an ongoing six-year collaboration with four other classroom teachers, to both nurture and teach in ways that acknowledge our own sense of authority (Pagano, 1990) as dedicated, knowledgeable, questioning and "caring" educators, and yet in ways that do not replicate historically constructed notions of patriarchal, hierarchical binaries of "knower/known," or of "expert/nurturer," for example. Thus, we are trying to understand others' historical and current constructions of ourselves as "women teachers" and to grapple with debilitating effects of such gendered constructions on our attempts to become knowers and creators of knowledge—knowledge that comes to form in new ways and for new reasons.

These attempts reflect similar grapplings with a variety of issues that have emerged within the context of our six years together as a teacher-researcher collaborative. Within our teacher-researcher group, we have explored and continue to examine tensions as well as possibilities in our attempts to effect collaborative as well as social justice oriented research and relationships among university and classroom teachers (Miller, 1992a, 1992c; Miller & Martens, 1990).

Initial examples and narratives of those explorations during our first two and a half years together are chronicled in book form (Miller, 1990a). [In that book, the first-grade teacher chose "Katherine" as her pseudonym. For this piece, she chose to use her given name, Georgette. See Note #5.] Part of our work, as represented in that publication and in our continuing collaborative ventures, involves a critique of any easy, seamless, unified and linear notion of "collaboration" or of "emancipatory teaching and research" that claims potential equality of "voice" or the benefits of "dialogue," for example, without considering power relations that always circulate, that are always "exercised," within such efforts.[2] Another part of our work together is a constant confrontation, both collectively and individually, with ways in which we have internalized socially constructed versions of our roles and identities as classroom and university teachers. These internalizations often reflect assumed gendered hierarchies within our relationships to one another, to our colleagues, and to our students as well as within the structures of schooling, the precepts of educational research, and the very constructions of teaching and curriculum that frame and guide our practices.

Embedded within those assumptions, then, are particular gendered versions of teaching that have created dichotomous expectations for ourselves: we still often assume, for example, given prevalent social constructions of "teacher," that we must be "experts," but experts who ironically often "transmit" others' cre-

ations of knowledge in particular subject areas and pedagogical practices. While these constructions do not necessarily restrict our abilities also to be nurturing teachers in relation to our students, colleagues, and other members of our educational communities, they do tend to emphasize prescriptive, hierarchical, and end-product orientations to teaching and learning. For women and men who teach, and who also wish to attend to contexts and processes that acknowledge the multiple positions, needs, and contexts of ourselves and our students, these expectations sometimes lead to contradictory stances within our particular educational settings. And both Georgette and I continue to discover that, for women who teach, these expectations can lead to reification of stereotypic and essentialized notions of women teachers as only caretakers and nurturers rather than as nurturers and creators and examiners of our own and others' constructions of knowledge and practices.

Georgette and I continue these explorations and discoveries within the contexts and processes of our teacher-researcher group. The processes in which our group participates encourage us in our attempts to challenge and change both those assumptions and those structures that tend to reinforce patriarchal constructions of oppressive and inequitable relationships within educational contexts. We know, at the same time, that this is ongoing, complex, and constantly changing life work. Our collaborative processes include regular meetings and discussions, journal writing to one another, and individual journal writing as ways of situating analyses of what we construe to be our particular educational autobiographies within social, historical, political and discursive contexts in which we teach and do research.

Throughout our collaborative work, we are influenced particularly by autobiographical, critical, and feminist perspectives that represent major work of curriculum theorists initially associated with the reconceptualization of the field. In this article, then, I describe and analyze shifting connections and discrepancies in contexts, positions, assumptions and expectations between Georgette, as early childhood educator, and myself, as university teacher in relation to some of these perspectives and influences. I offer now a brief description of reconceptual work that frames our efforts.

The Reconceptualization: Autobiographical and Feminist Perspectives

In the late 1960s and early 1970s, a disparate group of concerned scholars who were dissatisfied with the prescriptive and positivist orientations of curriculum work in the United States began to analyze, critique, and eventually reconceptualize the field. Although curriculum was relatively young as an academic field of study, having emerged in the US during the 1920s in response to school administrators' needs for curriculum designers and developers within burgeoning school bureaucracies, it quickly had assimilated characteristics, such as task and activity analysis for curriculum development, of the field of education in general. Thus, emphasis in curriculum theory and development from the 1920s through the 1960s was on social efficiency, on linear and sequential constructions of teaching

and learning, with curriculum conceptualized as "content" or "course of study," as information that could be dispensed by teachers and received by students at predetermined, developmentally appropriate stages, and then returned to the teacher in measurable, testable, and standardized forms.[3]

By the 1960s, some curriculum theorists were questioning such "scientific" and behaviorally oriented perspectives; by the 1970s, some began to introduce critical, hermeneutic, and existential-phenomenological questions about the very processes and forms of knowledge production. These questions gained prominence with the coalescence of the curriculum movement in the US known as the reconceptualization. Initial questions that pointed to the shift from a primarily practical interest in development of curriculum to a theoretical and practical interest in viewing curriculum as experienced, created, and changed by individuals included not just the classic curriculum question, what knowledge was of the most worth, but also whose knowledges are considered to be of the most worth? Who decides? In whose interest is this decided? Further, reconceptual curriculum theorists also asked: What is legitimated as knowledge? And how? What are the conditions that structure the production of knowledge? How do I experience others' knowledge (or the limits of my own)? How do I experience what I might consider to be my own knowledges?

Thus, contributing to the reconceptualization of the curriculum field were existential, phenomenological, and psychoanalytic studies of the school and of curriculum, especially from the point of view of the individual, as well as neo-Marxist studies that focused on school and curriculum as preeminently political constructions that replicated existing economic and class inequities.[4] Existential/phenomenological studies especially focused on knowledge as created within the experience of situation, in contexts of daily lives, a focus that child-centered educators have been arguing for decades.

Autobiography was and continues to be a predominant mode utilized by some working within the reconceptualized field as one way in which to examine such contextualized knowledges (Pinar, 1981; Pinar & Grumet, 1976). Early autobiographical work attempted to acknowledge, and to examine as knowledge, the interwoven relationships among one's conceptions, perceptions, and understandings of educational experience, one's contextualizations of that experience within sociopolitical worlds, and one's constructions of curriculum as both reflecting and creating those worlds.

More recent autobiographical work, particularly from feminist poststructural perspectives, encourages individuals to review those relationships within larger contexts of predominant discourses that, in part, construct "selves" as well as accompanying relations of power and authority that frame every teaching practice and curricular creation or choice. Attending to relations among language, subjectivity, social organization and power (Butler, 1990; Marshall, 1992; Weedon, 1987), many working from these perspectives have begun to reconceptualize teaching, learning, curriculum, and "selves" as processes and constructs that are informed, influenced, and shaped by particular discourses as well as cultural, historical and social relations (Britzman, 1992; Ellsworth, 1989, 1990; Lather,

1991b; Martusewicz, 1992). Such versions of teaching, learning, and curriculum might move us, I believe, from mechanistic, developmental, skill-oriented, end-product emphases in education, into awareness of complexities in establishing reciprocal yet constantly shifting relationships with our students, with contents, and with our "selves" as teachers.

Feminist curriculum theorists in the United States working in the early years of the reconceptualization, however, initially utilized autobiography as means by which to acknowledge and include women's experiences in existing curriculum structures and processes (Krall, 1981, 1988b; Mitrano, 1981; Wallenstein, 1979b), even as they challenged those structures and processes as representing patriarchy (Grumet, 1981b). We worked to expand conceptions of women's voices and women's stories as viable curriculum content as well as modes of inquiry. At the same time, we struggled to theorize the very definitions of "woman," "voice," and "story." Feminist curriculum theorists were challenging the processes and intentions of knowledge construction and legitimation, even as we insisted on inclusion of women's experiences and contributions within disciplines and of their representations in all areas of curriculum theory, design, and development (Grumet, 1988a; Lather, 1984; Miller, 1986a, 1986b; Reiniger, 1988).

As the reconceptualization continued to influence and change conceptions of curriculum, feminist curriculum theorists began to further explore and question such constructs as subjectivity, gender, and identity in order to also question tests of knowledge legitimation. Some began to challenge the power dynamics inherent in constructions of the very disciplines in which they initially had demanded inclusion (Grumet, 1981b; Lather, 1989), and some began to interrogate the research methodologies that have historically constrained that which can be said to be known as well as the ways by which it is known (Lather, 1986; Roman & Apple, 1990).

Via a refinement of autobiographical methods, some curriculum feminists also began to explicate as well as question concepts of self in relation to shifting interpersonal and political contexts. Multiple and contradictory conceptions of self emerged, as curriculum feminists worked to develop pedagogical perspectives and research methods that could encourage all teachers and students to understand the particularity and contingency of their knowledges and practices (Britzman, 1991; Ellsworth, 1989; Lather, 1991a, b).

As feminist curriculum scholarship continues to mature, then, autobiography has become one means of "rewriting the self in relation to shifting interpersonal and political contexts" (Martin & Mohanty, 1986, p. 208). As curriculum feminists' growing scholarship vividly demonstrates, autobiography can be a means by which individuals draw their own ever-changing portraits and trace as well as interpret multiple versions of their educational experiences, perspectives, assumptions and situations. Those multiplicities point to the complexity of experience that any one story necessarily reduces (Brodkey, 1987, 1989); to the necessities and difficulties inherent in individuals voicing their different experiences of the same processes and events (Lewis & Simon, 1986); to the different stories that individuals construct that both represent *and* create their particular historical and

social situations; to the necessity of exposing incoherencies in supposedly stable definitions of male and female sexuality and of making evident identity's construction (Butler, 1990; Sedgwick, 1990); and to possibilities for individuals not only to discover evidence of external forces that have diminished them but also to recover their own possibilities (Grumet, 1988a).

Thus, in working to create new forms of curriculum scholarship and research, feminist curriculum theorists influenced by the reconceptualization of the curriculum field also are working to re-write the compartmentalization and predetermined destinies promoted by binary or essentialist constructions of "woman," "man," "self" or "gender," for example. It is crucial work—work that continues to influence the field of education, in general, and the field of curriculum, in particular.

Daily Lives: Contradictions and Potentials in the Work of Women Who Teach

Drawing from both historical and current issues and perspectives in feminists' theorizing of curriculum and autobiography, then, I turn to a local and contextualized description and analysis of tensions within and between two white, middleclass women who teach in the late half of the twentieth century in the United States.

The First-Grade Teacher

Georgette[5] has described her journey through our collaborative attempts thus far as one of "becoming vocal." As a first-grade teacher, she continues to struggle, perhaps more than anyone else in our group, with ways in which historical and social constructions of teaching as "women's work" have framed and constrained her own expectations for herself as early childhood educator. Through autobiographical musings as well as through discussion in our group meetings, Georgette forces us to confront difficulties embedded in constructions of our work that are not of our making but which we have internalized as our own. For Georgette, functioning as a socially constructed nurturer in the first-grade classroom and yet working to conceive of herself as a teacher grounded in her own sense of authority, these dichotomous pulls remain the focus of her autobiographically situated inquiries within our teacher-researcher collaborative.

Georgette and I both are attempting to explore the nature and possible forms of our own "authority" in ways that do not reinforce or replicate unequal power relationships inherent in predominant interpretations of that particular concept in educational settings. We find support for such explorations in the work of many feminist curriculum theorists in particular.

For example, in arguing that our attachments ought to give point to our work, and that those attachments are most often overtly expressed in the nurturing and domestic realms of our experience, Jo Anne Pagano (1988a, 1988b, 1990) illuminates the connectedness between public and private domains that history and culture have separated and reified as gender-role specific. She argues that, for

women who teach, there need be no conflict between nurturance and authority if women can acknowledge, critique, and work to move through the power of masculinist totalizing discourses. Such discourses often portray worlds through one set of lenses—lenses typically worn and created by white males. These lenses condense multiple realities into one unitary vision, thus distorting or even eliminating the experiences and expressions of many who see and live in multiple contexts differently. Pagano argues that women must work to excavate and to claim the sources of our own authority. We must do this not only by challenging unequal power relationships inherent in those totalizing discourses, with their binary constructions of research and practice, emotion and intellect, public and private, for example, but also by contextualizing such challenges within our daily teaching lives.

Thus, Georgette continues to address possibilities and difficulties of claiming the sources of her own "authority" within the contexts of our research group and the elementary school in which she teaches. She does so most directly by grappling with sources and enactments of her internalizations of early childhood education as a premier site of "women's work," essentialized by many as the embodiment of women's "innate, natural" tendencies to nurture, take care of, and guide the young, and to perform those acts in unquestioning ways:

> In . . . pedagogical practices, facilitating and nurturant Others (teachers, mothers) are necessary to the facilitation of a "natural" sequence of development in "the child." These contradictions are lived out by girls in pedagogical practices. The very contradictions in the practice set girls up to achieve the very thing which is simultaneously desired and feared—passivity. It is feared in "children," yet it is the very quality desired in nurturant care-givers, women as mothers and teachers. (Walkerdine, 1990, pp. 142–143)

Georgette's willingness to tackle her underlying assumptions about herself as early childhood educator, with all those accompanying assumptions about nurturing and mothering as aspects of this particular arena of "women's work," constitutes a challenge to the rest of our collaborative group to confront our own assumptions. In addition, her grappling with those assumptions within our group context provides vivid exemplification of contradictory feelings that such excavations often elicit.

For example, even though Georgette had participated in several of our group's public discussions and presentations of our collaborative inquiries, she had decided not to attend the Bergamo Conference on Curriculum Theory and Classroom Practice, where we all had presented a symposium session the previous year. She explained that she felt too great a discrepancy between the active questioning that such a gathering encouraged and the passive, submissive atmosphere that permeated the elementary school where she taught.

In particular, Georgette was wrestling with ways in which our collaborative raises questions about "Who decides?" in all arenas of daily school activity. At the same time, the particular administrative group in her elementary school did not welcome such a question. Georgette knew that our conference presentation and

discussion would focus on such discrepancies, for we were all attempting, in that fifth year of our ongoing work, to move much of our group questioning and reflecting and critiquing into our individual educational settings. We wanted to do such work both within and without our collaborative group as one way of challenging structures of schooling that reinforced and reified hierarchical relationships among teachers, and administrators, for example.

Georgette knew, too, that audience discussion at the conference would be lively, challenging, and extensive on such issues of power and control. She felt, at this point in our collaborative ventures, that returning to her controlled environment after such active and lively exchange would pose too great a conflict within her. She was struggling at that time just to remain in the teaching profession, let alone in our collaborative research group. Georgette had talked with our group about her decision not to attend the conference, and she wrote to all of us a week before we were to leave:

> I know that I have changed as a result of our work together, changed from an accepting, docile teacher, to a questioning, challenging person. . . . With this comes the realization that some people with whom I work are uneasy and uncomfortable around me. Perhaps I've become the unexpected and others are unsure how to "handle" me. For me, "handle" means suppress, control, or keep me in my place. I know that it is my thinking that offends them. I am in turmoil, struggling to exist and not be made quiet again. So to go to the presentation would be to deliberately depress myself. The emotional impact would be too hard for me. I work in a world so far removed from what we do here in our group, and certainly even further removed from what we do at the conference. The differences are too intense, too large for me to try and merge at this time.

We attended the conference without Georgette, and her absence was a presence. After our presentation, in which we relayed Georgette's reasons for not attending, many in the audience talked with us about similar tensions and questions that change-oriented practices raise in traditional school settings as well as in classroom-university collaborations.

Georgette's particular struggle to reposition herself within her elementary school as both a nurturing teacher and a questioning, challenging educator reflects many educators' difficulties not only with hierarchies of school organization and curriculum designs, but also with gender-specified roles that we are expected to play within those hierarchies. Georgette had noted that much of her uneasiness had to do, at that point, with acting and speaking in ways that belied her "good girl" upbringing and professional preparation as an early childhood educator. Another of Georgette's writings about our group's discussions and reflections and their influences on her daily work portrays her willingness to push against theoretical and concrete boundaries of her work as a female first-grade teacher. She wrote on February 8, 1991:

> I feel it important now to eliminate the protection that an alias provides and write as myself. This is contrary to what we, the group, felt at the time of the book's publication. However, I feel that even in this small way, I can begin to give cre-

dence and respect to the elementary teacher within me, and in turn, to other elementary teachers who struggle to be heard as teacher-researchers.

Being aware of such questions as "Who decides?" and "In whose interest is it decided?" has made it difficult for me to accept any statement at face value by either administrator or teacher, male or female. This can have an isolating effect on one's life at work in an elementary school. These questions, though not always vocalized, are thought of, causing uneasiness within me whenever someone else's assumptions or expectations are put forth as "truth" or "mandatory reality." For me, as part of a twenty-three-female, three-male teaching staff, the ideas of elementary teacher as nurturer, caretaker may be part of this forced "mandatory reality" put upon me (or us) by the male-oriented hierarchy.

To illustrate this point, I recall several faculty meetings when the principal of the school compared the teaching staff to a "family." This was meant as a compliment, a positive thing. However, I resented the use of this term, and I can remember thinking to myself, "I don't want to be part of his family." As I thought about my reaction to this term, I began to realize that the word "family" is a loaded comparison, filled with expectations (different for each of us), assumptions, and emotions.

Further comments were made at meetings, again using the term "family," such as "We've always functioned as a family." Is that the principal's way of saying, "OK. I see something that I don't like; it's not good. So do something about this, behave again like you're supposed to." It seems that this remark was made to generate some kind of guilt—since no one wants to be labeled a "dysfunctional family."

How does the principal use this term, "family"? Is he the father image, and we, the teachers, his children? Are the teachers "mothers" to the students? What results does the principal want or expect now that we've been labeled "family"? Has he the right to make such emotional demands on his faculty? What can I do about this? What action can I take? What choices can I make? Right now, my choice of action is to question, internally, for the most part, "Whose reality is this?" and "Why should it be mine?"

In our group meetings, Georgette continued to question the language of administrative and teaching relationships and practices as containing, replicating, and reifying authoritative discourse, unequal relations of power and authority, and particular gender-specified and identified roles within those relations. As Georgette raised questions about her particular teaching situation within such framings, she also challenged me to confront my own discrepancies in the processes and articulations of my work. As she noted in a recent meeting of our group, "It's not easier to feel like you must ask the questions now, but you must, because you can't go back after this kind of work together."

The University Teacher

Georgette's identification of her situational discrepancies as lodged in historical and social constructions of early childhood educators, who "should" perform what has been constructed as the nurturing and unquestioning work of women, has enabled me to confront similar constructions within my own educational arena.

Although Georgette and I do not share similar educational contexts, the similarities in our expectations and in our underlying assumptions about our "selves" as women and teachers continue to intersect. Our long-term examinations of those assumptions and expectations as reflections of socially and historically constructed and situated conceptions of teaching as "women's work" are also framed by our changing understandings of our "selves" as white Western women who are trying to raise questions about how we "perform" ourselves as women teachers, how we might address the provisional and political nature of identity construction (Butler, 1990), and how, at the same time, we often still speak through dominant cultural representations of "woman teacher." Those examinations have led to some understandings of difficulties and dangers of essentializing all women teachers and their examinations of the constructions of their roles in US education as similar to our own.

Crucial to this work, then, is exploring our similarities to and our differences with one another as well as other women who teach. In particular, I think that Georgette's willingness to grapple with discrepancies and contradictory feelings about herself as woman teacher has encouraged me to examine sources of many contradictions that characterize my work as a woman academic. At the same time, I cannot generalize from my middle-class, white woman enactment of US curriculum theory professor. I can only attempt to understand ways in which I have internalized social and cultural constructions of my academic "identity," in particular, in order to gesture toward potential gender analyses still to be done in the field.

For example, Georgette's struggles have provided me with incentives for parallel analyses of my own expectations and internalizations of caretaker and responsible leader roles within our research group. These internalizations reflect in many ways similar conceptions of myself as woman and as teacher that Georgette confronts. Those conceptions reflect my early and unquestioning acceptance of my "teacher self" as nurturer and caretaker. I saw others, the "experts" in the field (usually white men as principals, superintendents, and supervisors in my early teaching experience), as the sources of authority and knowledge creation. These enactments of educator predominated in my early understandings of curriculum as evidence of others' knowledge, even though I chose secondary and university teaching rather than elementary or early childhood teaching contexts. In the mid-1960s, when I began my teaching career, the scripts for many white, middle-class, suburban and rural women teachers in the US were similar, regardless of the instructional level.

Thus, much of my present work continues to focus on the excavations of those assumptions that continue to encapsulate and to limit understandings of my own possibilities. For me, those possibilities include being both nurturer and authority. I want to be, with my students, colleagues, and collaborators, an

explorer and a creator of knowledges. At the same time, I examine and utilize autobiography as means of avoiding not only constructions of "self" that attribute to discourse the total determination of the subject but also those conceptions of "self" that imply total freedom of the subject to make meaning.

This is my current challenge within curriculum theorizing and within my collaborative relations. It builds on, even as it deviates from, my work as a particpant in the reconceptualization since its formal inception; that work to both incorporate and extend feminist curriculum critiques and analyses within my own practice as well as in my collaborations with teachers in graduate classrooms and inservice contexts (Miller, 1983a, 1986a, 1987a, 1987b, 1987c, 1990b) still informs my current interests. However, even as I waded through those waves of first-graders on that important in-service day more than five years ago, and even as I continue to excavate assumptions with Georgette and others in our teacher-researcher group, I often feel the still dominant dichotomous pull between "teacher as nurturer" and "teacher as expert" within myself. As I began my in-service work in that first-grade classroom, and as I continue my collaborative research with our group, I know that my own work must continue to focus on the sources, constructions and expressions of those contradictions that appear to be inherent in my role as woman academic.

As a woman teaching in academe, I have often been posited, as have my male colleagues, as "the expert," especially in in-service contexts with teachers. As I worked to re-write that construction and to forge collaborative relationships with teachers and with students at the university and in schools, I also experienced expectations, from others as well as myself, to nurture, to guide those students and teachers in ways that often were not expected of my male counterparts. I felt tensions embedded in my attempts to forge collaborative rather than hierarchically imposed "expert" relationships with students and classroom teachers. I felt similar tensions in my attempts to pursue the authority of my own educational experiences and knowledges. And I felt those same tensions again as I met those twenty first-graders on that initial in-service day and, in another context, as I listened to Georgette explain why she could not attend the curriculum theory conference.

Even before these particular encounters, I had been employing autobiography as a method within research, writing, and teaching contexts in attempts to examine sources of my internalizations of others' expectations of me as woman teacher (Miller, 1983b). As I grappled with never-ending excavations of those assumptions, especially as they reflected my complicit acceptance and enactments of myself as teacher-nurturer-caretaker, I also began to confront the socially constructed nature of my heretofore-unexamined assumptions. I thus became interested in the possibilities and concurrent contradictions emerging in feminist teachers' attempts to develop collaborative relationships with students and colleagues as ways of challenging and working through what Pagano calls the power of masculinist totalizing discourses (1990).

Academic configurations of research, especially in the field of education, are replete with such totalizing, generalizing, and encapsulating discourses. I felt that emerging feminist conceptions of research processes and methodologies might be a particular area in which I could attempt my own challenges and my own inves-

tigations into the sources and forms of my own authority as teacher and researcher. Because feminist conceptions concentrate on the relational aspects of researcher and researched, in particular, I joined with five classroom teachers, including Georgette, to investigate possibilities of integrating critical and feminist conceptions of research, curriculum, and teaching into standard enactments of teacher-as-researcher.

Working together now for six years, we have begun to challenge power relationships and totalizing discourses that often characterize even inquiry that supposes to be collaborative and reciprocal. And in our work together, as Georgette and I so vividly demonstrate, we have come to understand that "finding" our own voices as teachers, and creating spaces for collaborative and critical inquiries about schooling are never definitive, boundaried events but rather ongoing, constantly changing, contradictory and complex processes.

For example, Georgette's assessment of her workplace, situated within the discrepancy between the questioning that our work together elicited and the schooling structures that repressed or discouraged such questioning, heightened my ongoing concerns about the ways in which my own intentions and interests in our research collaborative might be imposing on the needs and desires of Georgette and others in this work.

So even though others in the group also now chronicle our group's collaborative research attempts, through journaling and through some collaborative writing, I still struggle with issues embedded in attempts to de-center my authorial voice as the one in charge of both the group's processes of collaboration and the researching of those processes. Even though the chronicle of our first years together, in book form, reflects each group member's participation in the construction and reviewing and revisioning of this representation of our work together, I must acknowledge that the book is my version of our group's interactions and movements. I worry about the ways in which my writing, my curriculum and feminist discourses, construct and are constructed as partial, interested, and academically positioned perspectives of our work together. I struggle with the ways in which my critiques of collaboration and empowerment as potential forms of both teacher-proof administrative maneuverings and "critical" catchphrases—important more for their promises of liberation than for their power to actually help teachers transform their practices and workplaces, for example—are caught up in the very processes and mechanisms and languages that I am analyzing.

Thus Georgette's reluctance to participate in what I had accepted as appropriate academic forums for the sharing and questioning of our work enabled me to confront the ways in which I had internalized, so deeply, others' constructions of scholarly representations of research. By her willingness to point to discrepancies and difficulties inherent not only in collaboration between university and classroom teachers but also in the ways and forms in which we might share the processes of that collaboration, Georgette also drew my attention to social and historical constructions of each of our teacher-researcher roles. And she vividly articulated her felt discrepancies between early childhood teacher and curriculum maker-knower in the world. In sharing those discrepancies, she also highlighted

embedded issues of hierarchy and unequal power relations in our own as well as her classroom work. Further, she drew attention to the ways in which the polarization between perspectives that assume discourse as totally determining the subject and those that assume total agency of the subject could lead to forms of paralysis in terms of any emancipatory project.

Georgette was unwilling to participate in academic forums that signaled her relative lack of autonomy as well as time and space in her school context in which to consider and reflect on our collaborative issues. Her withdrawal from our planned conference presentation also pointed to my unexamined acceptance, bolstered by the appearance of relative autonomy in choice of research directions and methods, of the sanctioned forms, arenas for and discourses of scholarly research and writing. This unquestioning acceptance mirrored those issues of compliance and complicity that had characterized my entry into the teaching profession and that still undergirded, to some extent, my conceptions of university teaching and research, even as I had been working to disrupt and dislodge those conceptions as potentially reifying hierarchical and oppressive relationships.

Given Georgette's illumination of such discrepancies that emerged from our collaborative work, I had to consider again the ways in which my initial conceptions of our work, centered in what many identify as Second Wave feminism, focused on transformative possibilities of teaching, research, and curriculum, and assumed the possibility of the transformation of patriarchy. Now, however, I wished to address processes of subject formation and agency as informed by poststructural feminisms that also would reject patriarchy understood as a general, ahistorical, transcultural essence. But I still had to consider impositional tendencies embedded in traditional constructions of university researcher roles and to bear in mind the potential of my own compliance with others' (e.g., the ones "in charge" of tenure and promotion) conceptions of appropriate academic forms and forums for our work. Such compliance denied my own as well as other group members' capacities to generate new forms and arenas for the reporting and sharing of our collaborative work.

In effect, I had to consider the ways in which I still carried vestiges of myself as "good girl" teacher and researcher, now willing to attempt fresh and challenging forms of collaborative research and autobiographical inquiry, but still hesitant to report such attempts in forms that defied or challenged socially sanctioned constructions of research reporting and writing within the academy. Thus, in the published book, while I had attempted to describe in self-reflexive ways my roles as member of the collaborative and as narrator, and while I wrote from our group's collective discussions and choices of journal entries, I also felt compelled to include what I now call the "bookend" chapters. These chapters in the book, the first and the epilogue, more so than the other chapters, contain examples of traditional academic writing—that is, referenced and researched and inscribed in Chicago style—as well as my constant attempts at self-reflexivity within that writing and research. I still saw that writing as unorthodox in comparison to much of what, at the time, was reported as educational research. I now also see that writing as reflecting my ambivalence and discrepancies in moving beyond accepted

and traditional research and writing norms. This article also reflects such ambivalence and discrepancies.

Potential and Always-Changing Autobiographies

Georgette and the other group members continue—by their willingness to question me and to examine their own discrepancies and contradictions—to challenge, to push, to extend my theoretical perspectives into new forms of writing and research. We want to extend the boundaries of such work to include accounts of possibilities, discrepancies, and contradictions incited by collaborative research. As well, we want those forms to include analyses of the influences of discourses and historical as well as local and contingent contexts on constructions of our work and of our "autobiographies."

We know, at the same time, that others' educational experiences and assumptions may not contain and reflect situations, assumptions, or expectations that our work together reveals, and so we share multiple and often repetitious versions of our stories within those critical frames that encourage us to question our similarities and our differences, even as we continue to grapple with seemingly ever-emerging manifestations of assumptions we often feel we have already excavated. As we move through our sixth year together of collaborative inquiries, we are aware of the reciprocal relationships that we have forged among ourselves, among our theories and practices, and among our research, teaching, and curriculum processes. At the same time, through those reciprocal relationships, we have begun to understand that excavations and examinations of assumptions do not eradicate their constant and habitual influences on our educational experiences. We really only have begun to examine our "assumptions" as socially, culturally, and discursively constructed rather than as uniquely and individually "our own."

For Georgette and me, those examinations still center around our changing understandings and questionings about what it means to be white Western women who teach, women who simultaneously value and yet question the very attributes of nurturer and caretaker with which we have identified and have been identified since our own early childhoods. The extent to which we grapple with our still evident and deeply felt contradictions about nurturance as well as about sources and manifestations of our own authority reflects ways in which we now struggle with constructions of gender, identity, and "selves."

Within the contexts of our collaborative research group, the (partial) excavations of those assumptions, the individual and collective reflections that we share around those assumptions, and the resulting actions that we are able to attempt in our daily educational lives are evidence of the strength and support that autobiographical perspectives and processes potentially can provide to critical inquiries on teaching, research, and curriculum. We continue to share, to re-view, and to add new versions of our collaborative work in order that we might see through and beyond specific situations in order to envision new educational possibilities for our students and ourselves.

Thus, autobiographical work that focuses not only on individuals' multiple and shifting narrations of what we take to be our educational experiences but also on the discourses, historical contexts, and social and cultural contexts that construct those experiences and remembrances encourages us as educators to integrate similar processes into our conceptions of curriculum, teaching and learning. The educator who engages in self-reflexive and critical analyses of her or his own educational biography might also approach teaching with similar intents, recognizing social and historical constructions of the classroom as perhaps representing particular discourses that maintain as isolated, solitary, and segmented the learning and teaching processes and interactions of children and teachers.

As I gingerly approached those first-graders a few years ago, I could not deny the immediacy of their presence and of their gentle invitation to jump in—to further submerge myself in the turbulent and vigorous waves of their questions and their answers, their declarations of personhood and connectedness to one another and to their emerging worlds. I am grateful for their invitation, for my resulting plunge has allowed me and those educators with whom I work to explore the depths of our own relations to one another, to those whom and with whom we teach, and to our own and others' constructions and possible reconstructions of educational worlds.

Notes

1. For comprehensive surveys and analyses of the emergence and establishment of the reconceptualization within the curriculum field, see Pinar (1974; 1975a; 1981; 1988). Also, *The Journal of Curriculum Theorizing* (now *JCT: An Interdisciplinary Journal of Curriculum Studies*), a journal devoted to curriculum history, criticism, and theory, has, since its inception in 1978, represented various aspects and perspectives of the reconceptualist movement. The Bergamo Conference on Curriculum Theory and Classroom Practice, an annual conference sponsored by *JCT*, also provides a national forum for curriculum debate, dialogue, and sharing of myriad curriculum conceptions and perspectives.

2. Drawing especially on Foucault's (1980a, b) accounts of the interconnections among power, knowledge, and the subject, Ellsworth (1989, 1990), Gore (1993), Lather (1991a), and Luke and Gore (1992) offer incisive critiques of assumptions that underlie various conceptions of "critical pedagogy and research."

3. See especially Kliebard's histories (1986, 1992) of US curriculum as well as his well known "Reappraisal: The Tyler Rationale" (in Pinar, 1975a) for extensive discussions of various movements within US education that have framed and influenced conceptions of curriculum.

4. See James Macdonald and Esther Zaret's co-edited volume (1975), *Schools in Search of Meaning*, for early discussions of political and socioeconomic issues in curriculum. In addition to work noted above, see early histories of the reconceptualization that especially analyzed tensions between what were regarded as differences in intent and focus between "politically" and "personally" oriented curriculum scholars (Klohr, 1980; Miller, 1978).

5. I am deeply grateful for Georgette Neville Vosseler's enduring commitment to our research processes and for her willingness to here share her insights, reflections, and

questions. Georgette, a first-grade teacher in a small school district in Long Island, New York, is a member of our ongoing collaborative and has been, at this writing, an early childhood educator for fourteen years. In this article, she chose to use her "real" name rather than the pseudonym, Katherine, that she chose for the book, *Creating Spaces and Finding Voices: Teachers Collaborating for Empowerment* (Miller, 1990a). She did so, as she noted, as part of her continually changing perspectives on the politics of teaching and researching. It is to Georgette that this piece is dedicated.

TEACHERS, RESEARCHERS, AND SITUATED SCHOOL REFORM

Circulations of Power

Some school reformers during the past decade have assumed that particular conceptions of school reform could be implemented in similar ways across diverse classrooms in the United States. Some education researchers, too, have assumed that similarities within and across sites, especially in teaching approaches and constructions of curriculum, could count as "evidence" of successful school restructuring. One problem with this emphasis on "similarities" in school reform, as well as in research on reform, is that all subjects involved in research, curricula, and pedagogical and administrative practices are situated, as Foucault noted (1980a), in social networks. That is, people work and educational events take place within particular historical moments, specific institutions, and cultural-social settings. And power operates in innumerable places, taking many different forms that may or may not work in tandem. Such local and contingent factors, fluid and often unrepeatable across time and space, make it difficult to claim one universal "best way" to enact school reform or research—and yet many school reform "models" presume a superior and complete(d) knowledge about such matters, and thus claim the right to speak and act for others.

In contrast, a situated notion of school reform conceptualizes restructuring of pedagogies, curricula, and school organizations as necessarily changing in purpose and form across differing educational settings and circumstances. As teachers, students, and researchers respond to diverse situations, they often act on (and not just enact) certain reform efforts, thus reshaping intentions, methods, and programs. A concept of situated school reform disrupts any essentialized or generalized notion of school restructuring processes or goals. It draws attention to how these processes and goals constantly are re-written within specific school cultures and by particular individuals.

Some school reform movements do encourage administrators, teachers, students and parents to consider carefully their particular schools' organizational and social cultures as they arrive at their own interpretations of school improvement tenets. These movements encourage educators to conceptualize school change as a "complex . . . process responsive to the unique culture of each school community, rather than simply as the adoption and implementation of a series of innovations that are generally unrelated to one another" (Merchant, 1995, p. 267).

Yet, what I have observed, as a qualitative researcher working for seven years across four different school sites, is that the time for reconceptualizing some general tenets of reform to fit particular school populations' needs and cultures often is not included in teachers' schedules as part of any reform effort. Even if that time were provided, my observational and interview data provide numerous examples of teachers who say they would use that time to address specific student and classroom needs, rather than to work on what they still view as "generalized" goals of reform within their schools. These are teachers who see the goals and tenets of school reform differently from many of their colleagues and others in their school community. These teachers in particular point to the need for a situated conception of school reform. That conception allows for "local definitions" that necessarily differ as well as change over time, not only because of varying social, cultural, and historical influences, but also because of constantly changing and unpredictable situations, relationships, and intentions within any one school or classroom.

But under the pressure of providing public accountability and quick, visible "evidence of improvement," school reform often gets reduced to changes in school organization or scheduling patterns, or to teachers' adoptions of certain pedagogical practices. Examples of such practices include versions of cooperative learning, or teamed clusters of teachers working with the same group of students throughout the school day. And these practices then often become the generalized and only versions of what constitutes "evidence" of effective school reform, even in schools where participants have been encouraged to reconceptualize certain tenets of reform within their particular situations and needs.

Further, the drive toward conformity and generalizability in reform intentions and structures presupposes that schools and the individuals within them are part of a stable, predictable, and developmental reality. Within this version of reality, which assumes that people can "progress" together in linear and sequential steps, teachers then struggle to acquire and to enact certain skills and approaches. These usually have been defined and determined by others as versions of "reformed" teaching. Thus, the pressure on teachers to contain their differing conceptions of reform as well as their constantly changing relations to teaching within standardized versions of curriculum and pedagogy sometimes positions teachers in covert or occasionally overt adversarial relations with one another. Such complications and divisive relationships point to the necessity of conceptualizing school reform, especially from teachers' perspectives, as a constantly changing series of new, unexpected, and situated interactions and relationships rather than as linear approaches to pedagogical and curricular "skill acquisitions."

However, many current reform efforts continue to standardize, and thus to reduce, school change to common, static, and replicable denominators:

> Unfortunately, most school reform proposals merely call upon schools, as an abstract construct, to change in this way or that, thus ignoring the politics of location and treating all schools as if they fit into some universal norm. . . . If we are to seriously engage in a discourse on school reform, then we need to have more lucid understandings of what it means to alter the education found in a particular setting within a particular culture. (Goodman, 1994, pp.134–135)

I believe that a focus on teachers' actual responses to and engagements with school reform efforts might point toward "more lucid understandings" of the need for school reform conceptualizations that take into account the constantly changing nature of teaching and learning within particular classrooms and school settings. Given the universal prescriptions and short time frames that characterize many school reform projects, teachers especially are hard pressed within reform efforts to respond and engage in situated ways to the particularities of their students and their educational settings. And because I have been involved in research projects during the past seven years that have attempted to examine what happens to teachers, students, and others involved in school restructuring projects, I find that I too often am pressured to use generalizations and standardization to document what supposedly characterizes effective school reform efforts.

But my research data constantly illuminate unpredictable twists and turns within pedagogical moments or curricular constructions in the classroom. Such moments could and should point to complexities and uncertainties within any school reform project. Further, teachers' very often differing perceptions about the processes and intentions of reform, if taken into account, could turn the attention of many school reformers away from "standardization of conduct, increased bureaucracy, and greater monitoring" (Popkewitz & Lind, 1989, pp. 575–576) and toward a complicating of the discourses, processes, and research of school reform. Their differing insights could call attention to the "play of many voices that characterize any program for change," as well as "some of the discorrespondences that can abort the best intentions of the most hard working and well-meaning participants" (Roemer, 1991, p. 435).

Here I discuss a number of teachers' responses to what has been prescribed for them, or to what they even have agreed upon as "appropriate" pedagogies, organizational patterns, and curricula in their schools' reform efforts. Teachers' responses take various forms, obviously depending on particular social-cultural settings and the individuals involved. It is important to note that although the forms and degrees of response vary, many teachers I have observed and interviewed responded in ways that disrupted, called into question, subverted, divided, or re-formed what had been presented or agreed upon as "the ways" to proceed in their school reform projects. As a researcher of these reform efforts, I also responded in ways that sometimes disrupted the generalizing intentions and design of the research projects in which I was participating.

What I explore here are multiple examples of teacher responses to school reform efforts. Unlike some, I do not view these responses as "failed" or "aberrant" school reform attitudes, nor do I "blame" teachers or myself for resisting change. Rather, I consider some difficulties and divisive effects that emerge, for both teachers and "outside the school" reform researchers, when teaching and school reform are conceptualized, not as situated, but as universal and generalizable in both form and intention.

Variations on "Total" School Reform

During the past seven years, I have participated in qualitative research studies on issues of school reform in four US schools. In one three-year study, I was part of a large research team investigating issues of school reform across five high schools in the United States. During those three years I researched reform efforts in two high schools in a large East coast city and in one high school in a small Southwestern town. In each of these three schools, as part of a sub-team of three researchers, I was assigned to shadow the same two teachers and two students as well as to observe and interview the same focus groups of teachers, students, parents and administrators for the duration of the three-year study. Each focus group had ten to twelve participants.

In another long-term and ongoing study, I have been working, for four years thus far, with five women who teach in a multi-age program in an elementary school that borders a medium-size Midwestern city. I am conducting qualitative research in relation to the multi-age program as one example of school reform efforts in the local school district.

Although they differ greatly in terms of diversity, geographical setting, and socioeconomic context, these four schools have attempted school reform projects in similar ways. Perhaps the similarity in approach to school reform, even in these divergent settings, is a result not only of continuing pressure for uniformity and standardization in education, but also of a widely held tenet of school reform. That is, the total school and district—faculty, students, administrators and parents—should be moving toward implementation of collectively agreed upon strategies and practices. These typically include school-based management; schools within schools; student-centered classrooms with cooperatively oriented teaching and learning; some version of authentic and performance assessments; and the involvement of all in site-based decision making (Donahoe, 1993).

In my interview data, I noted that reasons teachers recited for necessarily having to think in terms of whole school reform were similar across the three high schools. For example, although located in vastly different sections of the United States, teachers in all three high schools were under pressure to produce evidence of what everyone referred to as "total or whole school reform." When I pressed for individual accounts of that concept, all teachers responded that "whole school reform" in their schools had been reductively conceptualized as "raising students' achievement scores." When I asked teachers if there were any variations on or elaborations of this "reform theme," they all said that they were told that, given

their schools' reputations for substantial dropout rates and low scores for students on standardized measures of achievement, students' raised achievement scores would be *the* criterion used to measure "successful" reform efforts. And, many teachers added, it was the criterion used to measure who was a "successful" teacher.

Many teachers in each of the three high schools voiced commitment to reforming curricula and pedagogies that traditionally had construed the student as passive receiver of others' information. Through interactive pedagogies, curricula that responded to and incorporated students' needs and interests, and assignment of students to small groups that worked with the same teachers over time, some administrators and teachers in these three high schools were attempting not only to retain students and to "raise their scores," but also to involve them actively in their own learning.

The elementary school, located in an upper-middle-class suburb, also was part of its school district's attempts to restructure approaches to teaching and learning. Although the forms and goals of restructuring appeared similar to those of the three high schools, this district's reform rationale did not carry the urgency of the three high schools' attempts. Rather, this elementary school, like the rest of its district, was responding to current research and best practice as espoused by many teachers in the district and by its well-educated parents; many parents either had attended or taught in the nearby university.

But in all four of these schools where I have observed and interviewed students, teachers, parents and administrators over long periods of time, only a portion of each school's members were actively involved in their schools' restructuring processes. The reasons for this lack of whole-school involvement varied within and across particular settings and circumstances. But within all four schools, some teachers' reluctance to engage in their school's attempts at reform echoed an observation that Donahoe (1993) made about the reform project in which he was engaged:

> Organizational activities were crammed into every available corner of the day. It wasn't just a matter of finding time for meetings; there had to be time for all the additional interaction, assignments, and emotional energy that stitch an organization—a culture—together. For those teachers who thought a lot about what they did, we were crowding the time they would otherwise have spent thinking about their children and their classrooms by giving them the additional responsibility of thinking about the whole school. (p. 300)

Certainly, the pressures of added responsibilities for teachers were apparent in the four schools where I researched. For example, administrators expected teachers to participate in shared decision-making processes, develop alternative forms of student assessment, and learn and enact teaching approaches that incorporated cooperative learning strategies and problem-oriented student inquiry and learning. Underlying these expectations was a notion of total school involvement in reform practices and processes.

But the push for teachers to think about the whole school's participation in such practices ignored variances in conceptualizations of reform that existed among individuals in one school building or district. It ignored complications of both intention and desire as well as hierarchies of power that were implicated when certain individuals or program structures mandated or implied that other teachers should "change" in similar ways.

Further, the notion of total school involvement presupposed a fixed and stable vision toward which all involved could strive. The notion assumed, too, that all would know when the total school had "progressed" in identical ways and in synchronous time frames and thus had attained "reformed" status. That notion also demanded that, as an "outside" researcher of school reform, I remain a "stable observer" producing "stable pictures of reality" (Denzin, 1995) so that school officials could compare and contrast steps in the school's "progress" toward successful reform.

The longer I engaged in these reform studies, the more I worried about large-scale attempts to implement versions of whole school "reform." I was convinced, via my long-term informal discussions with teachers in each of the four schools as well as via my interpretations of my "official" observation and interview data, that whole-school reform efforts that involved assumptions I've just detailed led to divisive and fragmented relations rather than to any congruent and harmonious community of "reformed" educators and students.

Divisive Consequences of Universal Versions of Reform

In each of the four schools, one particular program or small group served as example or pilot for possible restructured forms of pedagogies and classroom contexts toward which each whole school might strive in order to "raise" students' test scores. In each of the four schools, the reform programs exhibited some form of alternative scheduling that enabled students to work together with teams of teachers in large blocks of time and across age groups. The coordination among teams of teachers, working with students who moved among them each day, was a demanding priority for all teachers within these programs. At the same time, working together ensured these teachers at least a possible framework for attempting to build collegial and supportive relations as one way of "dealing" with reform pressures.

However, many teachers who were not teaching in these exemplar programs told me in interviews that they resented collaborative possibilities that teachers in the pilot programs enjoyed, even when the non-pilot teachers recognized that those possibilities were not always acted on in congenial ways. Teachers in all four schools described this tension as a binary, as conflicts between "insiders" and "outsiders," to use their terms. It is this binary construction, and the fact that each of the teachers involved in the long-term studies in which I was engaged actually used the words "insider" and "outsider" to describe primary effects of reform efforts that I want to further interrogate here.

For teachers working "inside" the programs that supposedly best represented the four schools' restructuring efforts, difficulties were most apparent in their relations with teachers working "outside" those programs. In all four schools, those self-identified "outsiders" viewed the "reform" teachers as receiving more material as well as verbal administrative support for their work. In each of the schools, the teachers who supposedly exemplified reform versions of teaching and utilized reform approaches to structure programs and curricula often were described by other teachers as "insiders." These "insider" teachers were described by "outside" teachers as being privy to special in-service training (often off-site and sometimes involving travel to other cities), and receiving extra supplies, curriculum materials, and time for planning among team and cohort faculty. Insiders were perceived by the other teachers as receiving special attention from administrators, who often promoted their efforts, in both the schools and the communities, as exemplary.

These perceptions of the self-designated and sometimes self-chosen "outsider" teachers apparently reflected those of many teachers in myriad school reform projects across the country. These teachers describe themselves as being

> "sidelined" in the early stages of a school improvement initiative. A small group of "chosen" teachers and/or administrators mysteriously vanished from their district for a few days to learn about an innovation that has impressed someone with enough influence and resources to support such an undertaking. What, if anything, is known about the "core group" selection process leaves those who remain behind with a vague sense of unworthiness. The pathfinders return to their district energized by their trip, enthusiastic about the innovation, and eager to share "the word" with their colleagues (whose relative marginality to the innovation has now made them suspicious and defensive). (Merchant, 1995, p. 265)

In reality, most teachers working within the programs considered to be exemplars of reform in these four schools received no advantages or materials beyond their initial participation in reform workshops or information-gathering ventures. Rather, these teachers, all of whom I have interviewed, observed, and worked with for multiple years, often speak of the vast amounts of uncompensated time that they contribute to building programs, schedules, and teams, or to developing curricula and activities that could shift their pedagogies from teacher-directed to student-centered. They remark that some administrative support appears only in the form of public relations. Thus, those teachers called insiders by many—because of their perceived "chosen" status—often think of themselves as outsiders, separate from the rest of the faculty because of their association with pilot reform programs.

In the three high schools, some of the reform program teachers wondered why other faculty members did not appear to support or engage in the reform strategies toward which the total schools supposedly were moving. In the two East-coast schools, some of the teachers who supposed themselves to be outside the pilot reform programs in fact were attempting to organize blocks of students and faculty who would work together during the students' years in high school, thus replicating the pedagogical and organizational models initiated by those whom they had designated insiders. However, the original insiders still were viewed by these teach-

ers as receiving benefits, including public recognition, that were not possible for those who "followed." So, even though there was movement to replicate the pilot programs, thus supposedly more closely attaining the goal of whole school reform and creating a whole corps of teachers who worked in similar ways, teachers separated themselves from one another by the artificial, static, polarized, and yet often simultaneously occupied categories of "insider" and "outsider."

In the Southwestern school, for example, many of the outsider teachers also expressed interest in possibly restructuring the whole school schedule, rather than just the insider program, into blocks of time. This would enable all students and teachers to participate in two-hour classes that would meet on alternating days. Although a majority of the faculty voted to install such a block schedule, the administration vetoed this move. One administrator told me in an interview that "some teachers can't even teach for one hour at a time, let alone two."

Further, interviews with many in this Southwestern school who saw themselves to be "outsider" teachers, and yet had voted for block scheduling for everyone as a move toward total school reform, revealed yet another twist in the hierarchical and constitutive construction of insiders and outsiders. Coaches, whose last period classes were devoted to team practice, had lobbied the administration to veto implementation of the block scheduling because it would interfere with their practice sessions. At the same time, some of these coaches taught in the exemplar program and had flexibility within their teams of teachers to leave for practice during the last part of their block schedule. These coaches therefore could be considered to be "double insiders," as one teacher labeled them. The other coaches were outsiders in terms of not teaching in the exemplar program. Yet all of the coaches were deemed insiders because of their relationships of power with key administrators. Thus, multiple complications within and between the constructed categories of "insider" and "outsider" call attention to power circulations and complications in terms of who gets to say what counts as reform and how and by whom it gets enacted.

Another example: During my third year of research in the elementary school, the two teachers who originally had conceived of and implemented the pilot multi-age program were working with three new teachers. One new teacher had joined the original 1–3 grade combination, and two new teachers were working through the first year of the 4–5 combination. The two new 4–5 teachers were finding that their pedagogical approaches were differing from those of the 1–3, and they were anxious about ways in which the two originators of the program perceived their work thus far. One of the new teachers described to me her worry in this way:

> I think that because our kids are older, we are trying to have them take more
> responsibility for their own behavior. And we are still trying to have this program
> be student-centered and project-based. So there's lots of activity and moving back
> and forth between our two rooms. And these kids' voices are louder, their bodies
> are bigger. So when Julie and Pam come into our rooms, I think that they are
> still expecting to see the smaller versions of these kids that they had in their com-
> bination when these kids were 6 or 7 years old. But these kids have changed so

much since they had them, even just since last year. So I'm afraid that Julie and Pam think we are out of control compared to their teaching and behavior expectations. (Interview transcription, with pseudonyms, May 1995)

The two new 4–5 combination teachers also felt pressure from the "outside the multi-age program" fourth- and fifth-grade self-contained classroom teachers to have their students behave in particular ways and to "cover" the curriculum traditionally taught in those grades. However, their greatest concerns centered on their differences in pedagogical and classroom management approaches from the multi-age program's originators.

Thus, just as the "outsider" teachers in this elementary school expressed in interviews with me their fears that this multi-age program might indicate "one best way" to enact school reform, so too did the new 4–5 combination teachers perceive that there might be unwritten expectations for "insider" teachers to conform to one best way of enacting the program's philosophies and theories of learning and pedagogy. To not conform to those expectations meant that these teachers saw themselves risking becoming outsiders within the insider program.

Presumptions of "Inside" and "Outside"

One foundational and necessary humanist precept that keeps the binary "insider, outsider" in place is the assumption that both knowledge and power, constructed and produced by either side of the binary, are unified, stable, unchanging—and "possessed." But as Foucault (1980a) argued, through his term "power/knowledge," there is no inside or outside of power. Power is not possessed, but rather "exercised." Power is everywhere and inescapable; it operates in innumerable places, taking many different forms that may or may not work together. Further, Foucault reminds us that power is "discursive," embedded in the languages of everyday life and in the knowledges produced at everyday sites. Discourse orders knowledge along lines that produce subjects, individuals open to power's control.

Further, as Judith Butler (1990, 1993) argues, identity, most specifically gendered identity, is socially produced as a form of knowledge through repetition of ordinary daily activities. The supposed stabilities and reiterations, both material and discursive, that produce the effects of identity boundaries are won, in part, by creating a domain of outsiders. Still, Butler argues, the meanings and categories by which we understand and live our daily lives *can* be altered.

But the identities of those with whom I was engaged in school reform research—as well as my own researcher identity—often seemed reified by unofficial but controlling hierarchies of relationships between and among teachers and administrators. There was a drive to "possess" power by categorizing, or so it appeared. At times, depending on who was categorizing and for what purposes, teachers could be said to occupy, simultaneously, both insider and outsider roles. But, from whichever category(ies) individuals spoke, there was no deviation from the binary in any descriptions provided to me by teacher interviews or by my own observations and discussions with individuals in the four schools.

As researcher, constructed within and by the administrators' and teachers' insider-outsider discourse, I often was positioned too as occupying simultaneously the insider and outsider roles. I supposedly was outside the daily interactions and power relations that dictated the particular and varying categories that teachers used to describe their relationships to one another and to the administration in each of the four schools. Or I was an insider observer with whom teachers sometimes shared feelings, attitudes, assumptions or questions about school reform. Sometimes I was a trusted confidante to whom certain teachers could reveal, without worry of retribution, their hesitation about participating in pilot reform pedagogies. At other times, I was an outsider, a threat to teachers who perceived the reform research as a way of evaluating them, of recording the ways in which they did and did not conform to the school's conceptions of appropriate reform pedagogies.

Administrators at the elementary school often positioned me as an insider, especially in terms of my long-term working relationship with the two teachers who had initiated the multi-age program in the elementary school, and yet I was considered an outsider by the "new" teachers in the program as well as by the other teachers in the school.

Especially in the three high schools, where I visited, along with other team members for one week in the autumn and one week in the spring for three years, I often was positioned as outside the myriad relations that framed particular teachers' attitudes and feelings. Our team surely was perceived most often as outsiders, who appeared periodically to observe, interview, shadow and record "what was happening" in schools attempting reform. Within contexts and purposes of that large study, I was an insider, working as a member of a large qualitative team who researched in three of the five high schools in the study. And yet I often was positioned as an outsider on that team because of some of my assumptions about qualitative research and the focus and scope of the large study.

For example, most members of the large research team working in the study's five high schools assumed that qualitative research methods could "directly capture lived experience" (Denzin, 1994). Like Denzin, I question this key assumption. I attempted to discuss this point of difference with my team members throughout the research process. Most team members preferred to position themselves within positivist and post-positivist orientations about qualitative methods that assume that out there in the schools there is one "reality," which researchers are able to "capture" via field notes, interviews, and observations. Within these orientations it is assumed that, as on-site researcher, I could indeed describe "what happened" in any of the schools. But I was an outsider on my team because of this assumption, given my preference for feminist qualitative research stances that argue that "the view from nowhere" is indeed "the view from somewhere," from that of connected, embodied, situated participants (Haraway, 1988). I also support "strongly reflexive" accounts of the researcher's own part in the research process (Fine, 1992), and what Lather (1993) calls "paralogical validity," which seeks out differences, oppositions, and uncertainties rather than one version of the truth.

Given the constantly shifting designations between the artificial, socially constructed categories of insider and outsider that constituted many teachers' and researchers' talk about reform in the studies in which I have participated, I think that it is important to remember:

> If we recognize discourse as guided by historically and culturally specific purposes, all categories will bear some marks of the needs of their creators. . . . Our best safeguard may ultimately lie not with the kinds of discourse we rule acceptable or not but with the more practical issue of who is able to take part in discourse—that is, with the question of access to the means of communication. (Nicholson, 1994, p. 83)

For both the teachers and myself in these particular school reform efforts and studies, the issue of who was able to take part in the education and research discourses that predominated within both the schools and the research team contributed in great part to the maintenance of the insider-outsider categories.

But a notion of situated pedagogies and school reform implies that those involved in efforts to "reform" schools as well as those who research such efforts must directly address the social, cultural, and discursive influences that frame and often determine what and who is deemed as important, as having "access to the means of communication," and as worthy of our concerted attention. However, most national school reform efforts are constructed, across all educational contexts, by means of universalizing frameworks, agendas, and definitions of what constitutes reform. An emphasis on "similarities," on "totalities," in the framings of school reform precludes meaningful connections to local and particular situations and to the potential in and for schools to provide arenas for the construction of new "identities," beyond the insider-outsider binary, for example.

I have tried to show how teachers' responses as well as my own researcher positionings in relation to static versions of reform exemplify the activity that constructs cultural and social identity (here, insider or outsider) as a "process of materialization that stabilizes over time to produce the effect of boundary, fixity, and surface" (Butler, 1993, p. 9). While reform efforts might appear to change practices in a school, and thus "change" power relations so that teachers might "become" curriculum creators or equal collaborators or "team players" or "insiders" rather than "outsiders," for example, power itself is embedded in the language and knowledges that, in these specific cases, actually produce and maintain the constructed categories of insiders and outsiders.

Instead, a notion of situated reform and research enables me to notice how the very categories of insider and outsider are themselves socially constructed and complicated by the ways power is defined (by the discourses available to students, teachers, researchers, administrators, parents and local community members) and used in particular schools. This shifts the focus or issue from "who is an insider and who is an outsider?" to "how will we exercise power?" and "how will we define and use power in this school in relation to this reform effort?" As a researcher, it shifts my work away from capturing the "lived experience" of school reform to examining and interrogating the processes of "materialization" that

produce the stabilities and reiterations of already "known," determined, unwavering identities.

A notion of situated school reform and research thus refocuses my work so that I look for ways that particular situations might enable both teachers and myself to re-write and re-work any discourses of reform and educational research that would generalize, universalize, standardize and reify teacher or researcher identities. We might do this, Butler (1993) suggests, by utilizing the ever-present threat of the "outside" to expose the founding presumptions of the inside, to rewrite the history and the very uses of those terms, and to expand the meanings of what and who counts in particular situations. I believe it is this situated and, yes, even potentially and positively disruptive version of school reform practices and research that holds promise for "school change" that does not restrict to normalizing or exclusionary or reifying categories the meanings, identities, and work of teachers and researchers who wish to create spaces in schools for a multiplicity of selves and knowledges.

INTERLUDE 8

Of all the essays in this collection, the article that follows here took the longest to compose. And it represents a very small portion of the most challenging and sustaining conversation in my life.

Liz and I started to think about writing an article about "working" difference as soon as we both finished reading Patricia Williams's *The Alchemy of Race and Rights: Diary of a Law Professor.* For months we drew magic-marker circles and arrows around and through our ideas, trying to map out the upcoming conference presentation version of our possible journal article on big brown butcher paper taped to the walls of the farmhouse's second-floor study, the one we renovated with skylights after I moved in. But we just couldn't settle on one version that we liked, because we were so involved in "working" the very concept—and our enactments—of difference.

So, once again, we were facing a Bergamo Conference deadline, and this time we were really down to the wire. We took turns reading our draft of a presentation to Mimi as she drove one of her shifts on our trek from Madison to the Bergamo Conference Center in Dayton, Ohio. Mimi *always* was able to spin great responses just seconds after hearing either of us pose an issue or problem or idea. But at the close of our reading, Mimi frowned, let out one low "blah" and just kept driving.

In our room at the conference center, Liz and I tore the paper apart yet again, jotted notes in margins, and practiced "speaking" the clumps of ideas joined together by magic-marker arrows and stars. Mimi sat on the bed for a while and then got up and started to pace. "You guys—you have to go do this in twenty minutes!" Her "whomp"—Mimi's word for "that's it"—only erupted as we were rehearsing our connect-the-dots paper for the last time, in the midst of packing up our note scraps and heading to our assigned presentation room. I'm not sure how

Liz and I actually managed to perform this piece, other than through riding the waves of energy that connect us to one another as well as to ideas that engage us.

It took Liz and me many more months after Bergamo to re-craft our session "speakings" into the essay that you'll read here. It presents the notion of "working difference" in education as one means of dealing with—rather than containing— the excesses to which Liz, Mimi, and I pointed in our collaborative essay that opened this section. This essay on "working difference" also closes the section in this book that for me represents the very processes of collaborative researching, theorizing, and writing as complicated and complicating conversation.

WORKING DIFFERENCE
IN EDUCATION

Elizabeth Ellsworth and Janet L. Miller

We are two educators[1] who teach in graduate schools of education and who "work" issues of difference as they intersect with our teaching, writing, and daily lives. In this article we offer a reading of Patricia Williams's *The Alchemy of Race and Rights: Diary of a Law Professor.* This reading uses Williams's text for the purpose of exploring the meanings of "working difference" and "multiple and fluid identities" for educators. Specifically, we understand difference to be fluid and therefore able to be worked strategically against, for example, racist and sexist uses. We argue that Williams provides a much needed, detailed account of how she works the meanings and uses of her "oxymoronic" positionings as black woman, professor, and Harvard-educated scholar-lawyer. With her account, Williams shows the work that it takes to resignify racist and sexist uses of such positionings in particular contexts. We suggest that by showing the work of working difference, Williams draws important implications for how teachers and students might enact multicultural curriculums in classrooms. We suggest that textured accounts of working difference may both ground and call into question more abstract educational discourses that currently address difference. We argue that situated accounts of *working* difference may constitute a form of pedagogical address—one that is missing in current multiculturalisms. It is an address that may productively shift some of the tensions that teachers often report when they try to teach about difference.

Patricia Williams begins *The Alchemy of Race and Rights: Diary of a Law Professor* with this sentence: "Since subject position is everything in my analysis of the law, you deserve to know that it's a bad morning" (1991, p. 3). With sentences such as this, Williams forges an academic writing style that holds the simultaneity of intellectual, social, historical, aesthetic and personal effort in complex and compelling tension. Nothing less is adequate to the task she sets for herself. Williams

has become an influential scholar of critical legal studies, in part through her efforts to teach and to write critical legal theory, critical race theory, feminisms, and postmodernism, as they intersect with her daily life as an "oxymoron": "I am a commercial lawyer as well as a teacher of contract and property law. I am also black and female, a status that one of my former employers described as being 'at oxymoronic odds' with that of commercial lawyer" (1991, p. 6).

Teachers who read the first sentence of this law professor's book must look outside of educational research and practice for the debates about subjectivity, difference, and power that inform it.[2] For the most part, they must also look outside of the field of education for the provocative reading strategies currently available for making sense of it.[3]

For the past twenty years, the reconsideration of relations among subjectivity, power, and difference has had both intellectual and political urgency for a number of other fields, including literary criticism, cultural studies, women's studies, gay and lesbian studies, queer theory, critical legal studies, critical race theory and anthropology.[4] Many scholars and activists in these fields have concerned themselves with theorizing difference and debating its uses in cultural and social criticism and activism. Their concentrated academic and political attention has challenged disciplinary foundations and boundaries as well as presumptions about how and why social and political changes come about.

Some of these challenges are especially relevant to our work and interests as two women teaching in graduate schools of education. Current constructions of difference across diverse disciplines have unsettled notions of social and cultural identity that are widely used and circulated in education. For example, this work across disciplines calls into question separate and fixed categories of identity, such as gender, race, and sexuality. The troubling of these static categories raises serious implications for teaching about and across social and cultural difference.

In this article, we offer a reading of Patricia Williams's *Alchemy of Race and Rights* for the purpose of elaborating some of these implications for educators. In particular, we suggest meanings and uses for educators of a situated working of difference and identity, and of "showing the work" of the social construction of identity and difference.[5] We want to illustrate possible ways of working difference that may productively shift how difference is "read" and taught in many educational versions of multiculturalism.

By "working difference," we do not mean "working through difference" or "working against conventional notions of difference," for example. Such constructions suggest a prior difference, with meanings already in place, that is either put to use or replaced by some other oppositional or alternative difference, just as known and static. Rather, "working difference" suggests a constant kneading of categories and separations. Just like the kneading of bread starts a process of transformation of separate elements into something that gives those elements new meaning and uses, "working difference" is a "continual motion that keeps breaking down the unitary aspect of each new paradigm" (Anzaldua, 1987, p. 80) of difference. As Anzaldua writes in her description of *mestiza consciousness*, "*Soy un amasamiento*. I am an act of kneading, of uniting and joining that not only has pro-

duced both a creature of darkness and a creature of light, but also a creature *that questions the definitions of light and dark and gives them new meanings*" (p. 81, our emphasis). We use "working difference" to refer to the possibility of engaging with and responding to the fluidity and malleability of identities and difference, of refusing fixed and static categories of sameness or permanent otherness.

Drawing on Marshall's (1992) distinction between "interpreting" and "reading," our intent is not to interpret Williams, that is, not to drive toward and close down to one authoritative meaning that we assign to her text. This is not a critique of her book, nor is it an article review; rather, our aim is to construct a particular reading of Williams's text that is capable of "opening up a field of questions" (Marshall, 1992, p. 16) for ourselves and other educators. We read Williams to open up these questions about multiple and fluid identities and their meanings for "working difference" in education. We read *Alchemy* in a way that explores the notion of "situated working" of "multiple and fluid" identities.

By "multiple and fluid" identities, we refer to the insistence by some post-modern theorists that identity and difference are social constructions whose meanings shift and slide across times and places (Butler, 1993; Flax, 1993; Marshall, 1992; Trinh, 1989). By "situated working" of identities and difference, we refer to the insistence by Butler (1993) and other feminist postmodern theorists that the boundaries and meanings of identities and difference are a social achievement. As Caughie argues in a discussion of the difficulties of the teacher's and students' positions in a classroom: "we can take neither similarities nor differences for granted, which is to take them as 'natural,' as something that goes without saying, rather than as something constructed *by the very dynamics of our engagement*" (Caughie, 1992, p. 791, our emphasis). Identities and difference are constructed in and through the dynamics of our engagement with each other over time, not only in the service of oppressive relations such as racism and sexism, but also in the service of the contestation of such oppression (Butler, 1993).

Our reading of Williams's *Alchemy* shows how she works and reworks shifting and sliding meanings of identities and difference, with both political and educational intentions and consequences. Although Williams manages to take up some of this work playfully, she does not do so for the purpose of endlessly deferring meaning. On the contrary, we read Williams as using the fluidity of identity and difference as a resource for revealing, interrupting, and reconstructing meanings and power relations that would otherwise position her within static, fixed categories. Exclusive and absolute categories serve oppressive and exploitative uses of race, gender, social status and sexuality, for example, because "to believe in absolute truths is to position something or someone as *permanently* 'other'" (Marshall, 1992, p. 193). We read Williams as wanting to destabilize any form of permanent "othering" by putting to situated uses the multiplicities and fluidities of identity and difference.

Reading and Performing Difference as Work-in-Progress

To read Williams through notions of multiple and fluid identities, however, is to read against the grain of most approaches to difference that currently inform educational literature and practice. Curriculums, pedagogies, and research practices most readily available to us from the field of education continue to work difference through static categories that tend either to polarize and dichotomize or to "alleviate" difference by emphasizing commonalities and similarities.

Given reading strategies currently available to us in education, for example, we could read Williams as an academic woman struggling, like ourselves, to change what is "acceptable" academic writing. Williams provides legal analyses and social criticism through poetry, journal writing, autobiography, and storytelling. In attempting to forge our own versions of academic writing that also incorporate these forms, we could ignore, dismiss, or forget the socially constructed racial difference between us as "white women" and Williams as a "black woman" and its meanings for the academic work of all three of us. Or we could read Williams and respond only to descriptions of oppression and commitments that we feel we "share" with her, such as those related to gender. That is, we could absent ourselves from responding to what we do not "share," rationalizing that we could not possibly respond appropriately or knowledgeably to what is so different from us. Or we could read in ways that "appreciate" her voice that is different from ours without changing how we relate to our selves as constructing, and as being constructed by, whiteness. Or we could read her in ways that glorify her strength and resilience as a black woman and that "celebrate" the cultural and social "diversity" that is produced through resilience in the face of oppression. Or we could read Williams in ways that mine her work for insights, citations, and rhetorical tropes that allow us to build our own arguments, already decided and unaffected by our readings of her text. Or we could read her in ways that respond to her work by incorporating her perspectives, histories, and needs into ours to show how "we" can all be "enriched" and humanized by "her" social and cultural diversity. Or we could read Williams in ways that attempt to see through her eyes. But each of these ways of reading positions us *either* in a relation of polarized, fixed difference from *or* in a relation of unproblematized sameness to Williams.

Recently, each of these strategies for reading difference has come under scrutiny when applied in women's studies, literary criticism, or cultural and media studies. Each has been criticized for how it reduces the working of difference to polarizations, rationalizations, abstractions, platitudes, universals, fixed categories or simplistic "solutions" (Fuss, 1989; Lippard, 1992; Marshall, 1992; Morrison, 1992).

Refusing such reading strategies ourselves, we use "working difference" to refer to the process of constructing and acting upon tentative, provisional, in-process difference and identity. "Working difference" foregrounds the possibility and significance of reading and performing difference as work-in-progress. It calls attention to the work of configuring and reconfiguring the boundaries and meanings of difference over time and within particular historical contexts.

We propose, then, that the boundaries, meanings, and uses of gender and race can be reworked. By no means, however, do we want to imply that they are "artificial," dispensable, and able to be put on and taken off at will. Indeed, Butler (1993) argues that some social constructions, such as gender, are "constitutive." They have acquired a kind of necessity that is not an essential one but rather a product of history and power relations. That is, without them, "I" or "we" would become unintelligible.

At the same time, even seemingly "necessary" identities do not exist prior to social activity. Butler describes the activity that constructs social and cultural identity as a "process of materialization [a persistent and reiterated acting] that stabilizes over time to produce the effect of boundary, fixity, and surface" (1993, p. 9). The stabilities and reiterations that produce the effect of identity "boundary, fixity, and surface" are won, in part, by producing a domain of outsiders.

Such exclusions have consequences that cannot be fully controlled. Butler (1993) argues that this situation should not be considered as a permanent contest between insiders and outsiders, in which outsiders are condemned by their "lack of power" to the pathos of perpetual failure. Rather, the ever-present threat of the outside to expose the founding presumptions of the inside can be seen as a critical resource that can be used to rewrite the history of "insideness" and "outsideness," to rearticulate the very meaning, legitimacy, and uses of "insideness" and "outsideness," and to expand the meaning of what counts as a valued and valuable body.

With our reading, we intend to show that Williams works difference, as a resource, in these ways. She exposes the founding presumptions of the "inside" in a way that turns them against their racist usages. The multiple entendres of "working difference" also point, then, to intellectual, physical, emotional, aesthetic and political labor. Our reading points to the workings of difference that it takes for Williams to *materialize* threats and disruptions to fixed identity in ways that contest racism, for example, within specific contexts.

Our own lived daily realities and current ways of thinking about our work as teachers, as women in academe, as women involved in political work, make it impossible to deny that constructing and disrupting fixed meanings of difference is profoundly situational, and often tedious. It also is personal and social at the same time, risky, never predictable, and requires imagination and courage of the intellect as well as of the heart. We are drawn to the ways that Williams's text challenges appeals to universals and abstractions in legal theory and in pedagogy. Williams shows instead the personal, social, historical, political and aesthetic nature of the work of contesting meanings and uses of difference.

Refusing to deny or ignore any of these aspects of working difference, then, we read *The Alchemy of Race and Rights* through simultaneous desires. We want to meet Williams's stories, stories of social and cultural difference that are different from the ones we tell, with *response-ability*—that is, with shifts in how we perceive our "selves" and others' "selves" so that we do not simply incorporate or appropriate "her" stories into the ones we have been telling about ourselves or her. We want to politicize postmodern conceptualizations of identity and difference, and we want to trace the consequences of reading identity and difference as works-in-

progress, rather than as fixed and unified categories, for how we might work in and with difference as teachers and researchers in education.

Motivations for a Reading of Williams

That life is complicated is a fact of great analytic importance. Law too often seeks to avoid this truth by making up its own breed of narrower, simpler, but hypnotically powerful rhetorical truths. Acknowledging, challenging, playing with these as rhetorical gestures is, it seems to me, necessary for any conception of justice. Such acknowledgment complicates the supposed purity of gender, race, voice, boundary; it allows us to acknowledge the utility of such categorization for certain purposes and the necessity of their breakdown on other occasions. It complicates definitions in its shift, in its expansion and contraction according to circumstance, in its room for the possibility of creatively mated taxonomies and their widely unpredictable offspring.

I think, though, that one of the most important results of reconceptualizing from "objective truths" to rhetorical event will be a more nuanced sense of legal and social responsibility. (Williams, 1991, pp. 10–11)

Williams presumes to speak of "wildly unpredictable" crossings of semantic boundaries and justice in the same breath, and she presumes to set her rejection of "objective truths" in productive relation to legal and social responsibility. These apparent incommensurables have troubled many readers of postmodernisms, but as she puts postmodernisms to use, one of the reasons we are so drawn to her book is that Williams clearly shows how these do not have to be incommensurable. She shows the labor it takes to complicate, expand, and contract definitions according to circumstances, and as a result, to produce more nuanced senses of social and legal responsibility.

Indeed, for Williams such complication has become a necessity. As an "oxymoron," "objective truths," narrow and simple analyses, and pure identity categories are not only closed off to her, they are used to render her as other. As one of the social actors "whose traditional legal status has been the isolation of oxymoron, of oddity, of outsider" (Williams, 1991, p. 7), Williams must find ways of working "oxymoron," "oddity," and "outsider" against their racist, sexist uses.

To do so, she must write against legal scholarship that is based exclusively on deductive reasoning. Such scholarship "is rather like the 'old math': static, stable, formal—rationalism walled against chaos" (Williams, 1991, p. 7). Not unlike legal discourses, educational discourses and practices most often depict the "subject who knows" or the "subject who learns" as a rational, coherent, complete, homogeneous entity capable of autonomy and unmediated self-reflection (Flax, 1993, p. 92). Flax, in her discussions of how postmodern concepts of subjectivity challenge traditional notions of justice and knowledge, argues that it is increasingly evident that the credibility of this particular "rational" subjectivity "has required repression or denial of many other, interrelated aspects of subjectivity" (1993, p. 92). "No singular category [such as rationality] can do justice to the vast and highly

differentiated variety of processes in and through which subjectivity can be constituted and expressed" (Flax, 1993, p. 100).

Because no singular category can do justice, and because she believes that "theoretical legal understanding and social transformation need not be oxymoronic," Williams writes from between categories, from the "gaps between those ends that the sensation of oxymoron marks" (1991, p. 8). She writes with a "multivalent" voice, from a "fluid positioning that sees back and forth across boundary, which acknowledges that I can be black and good and black and bad, and that I can also be black and white, male and female, yin and yang, love and hate" (Williams, 1991, p. 130).

Yet that "ambivalent, multivalent" perspective (Williams, 1991, p. 130) does not leave her paralyzed. As we will show, it does not prevent her from acting, in specific situations, against bigotry, exploitation, or discrimination. Deconstruction of the notion of a coherent, solid subjectivity does not necessarily leave us with splintered fragments incapable of critical, response-able action. How this might be so is difficult to grasp. It is worth quoting Flax at length here because she offers a convincing and accessible discussion of how fluid and multiple subjects *are* capable of critical, response-able action. She argues that "only multiple and fluid subjects can develop a strong enough aversion to domination to struggle against its always present and endlessly seductive [and, we add, endlessly variable] temptations" (Flax, 1993, p. 110). This is because a unitary subject "can only sustain its unity by splitting off or repressing other parts of its own and others' subjectivity. . . . Even if the initial motive for such isolation was emancipatory, eventually its repressive consequences will be evident" (1993, p. 109).

Just as Williams's "multivalent, ambivalent" perspective does not leave her incapable of critical response-able action, fluid subjectivity does not necessarily mean aimless subjectivity. According to Flax,

> Temporary coherence into seemingly solid characteristics or structures is only one of subjectivity's many possible expressions. When enough threads are webbed together, a solid entity may appear to form. Yet the fluidity of the threads and the web itself remains. What felt solid and real may subsequently separate and reform. (1993, p. 94)

Flax adds: "This subjectivity is simultaneously embodied, gendered, social, unique, bounded, determined, open, and unfinished. It is capable of telling stories about and of conceiving and experiencing itself these ways" (1993, p. 119).

Stories of separating and re-forming in critical response to oppression, analytical accounts of lived relation to coherence and fluidity, to multiple, complex, even oxymoronic social and cultural identities, are necessary if postmodern claims about the political usefulness of its concepts and critiques are to be convincing.

Accounts of and by subjectivities who experience and conceive of themselves as multiple, fluid, bounded and open, gendered, raced, classed yet unfinished, are few and far between in educational literature, research, and practice. They are more easily found—and perhaps more easily told—in fiction, autobiography, film and poetry (Trinh, 1989; Mariani, 1991; Pratt, 1991). They are stories that, according to our reading, Williams provides.

Williams uses poetry, criticism, journalism, autobiography, journal writing, analysis and anecdote to put identity and difference into motion. The moving, crossing, interweaving strands of her stories give texture to her accounts of her own temporary and strategic coherences. Her extraordinary accomplishment is to weave coherences that are flexible, and therefore able to respond to the unpredictable and unforeseeable consequences of her strategic fixing of identity. At the same time, she weaves working coherences that are meaningful and useful within the immediate events that threaten to render her as permanently other.

A Reading of Williams

In the following reading, we want to show the work that it takes for Williams to separate and re-form weavings of power relations and identities that otherwise attempt to position her permanently as other. It is work that both includes and exceeds rational critical thought about her situation.

To exemplify the notion of "situated working of identities and difference," we want to focus here on Williams's textured account of one particular series of incidents: those surrounding the day that she went shopping at a Benetton store. We read this series of incidents through Butler's (1993) recent reference to *Alchemy* in her book that addresses, among other questions, which bodies come to matter and why? Butler writes:

> In a postscript entitled "A Word on Categories," [Williams] remarks, "While being black has been the most powerful social attribution in my life, it is only one of a number of governing narratives or presiding fictions by which I am constantly reconfiguring myself in the world" (p. 256). Here the attribution of being black constitutes not only one of many "presiding fictions," but it is a *mobilizing* fiction, one "by which" her reflective reconfiguration proceeds. Here the attribution, however fictive, is not only "presiding," that is, a continuous and powerful framework, but it is also, paradoxically and with promise, a resource, the means by which her transformation becomes possible. I cite these lines here to underscore that calling race a construction or an attribution in no way deprives the term of its force in life; on the contrary, it becomes precisely a presiding and indispensable force within politically saturated discourses in which the term must continually be resignified *against its racist usages.* (1993, pp. 247–248)

In Williams's autobiographical stories about shopping at Benetton and its aftermath, she is mobilized by the presiding fiction of "blackness." She uses it, paradoxically, as a "force" by which she resignifies her "selves" against racist power relations. In so doing, she gains leverage to reconfigure and resignify those relations. She confronts how race is worked to justify the use of clothing store buzzer systems, which salespeople use as a means of admitting desirable customers and excluding undesirable ones, a determination that, Williams argues, is racial. Williams's telling of these Benetton stories focuses on moments and contexts in need of strategic unfixing of solidified and solidifying readings of her identities. In these moments, narrow either/or practices, meanings, and discourses about "race" and "rights" threaten to position her as other within fixed

racial categories of "thief" and "undesirable black woman." The actions she took, and the stories she tells about those actions, work difference for the purpose of interrupting the intended permanence and uses of socially constructed identities such as "thief" and "undesirable black woman."

Williams begins by telling about going shopping two Saturdays before Christmas to buy a sweater for her mother. A white teenage salesman refuses to buzz her into the Benetton store in SoHo. Buzzers had become widespread in New York City in an attempt to reduce the incidence of robbery. Williams writes: "if the face at the door looks desirable, the buzzer is pressed and the door is unlocked. If the face is that of an undesirable, the door stays locked. Predictably, the issue of undesirability has revealed itself to be a racial determination" (1991, p. 44).

Williams moves through and is moved by multiple categories: Harvard-educated law professor, African American, contract lawyer, woman, shopper with money to spend, daughter buying a sweater for her mother. But that day, the salesperson's determination had the effect of positioning Williams as other: "He saw me only as the one who would take his money and therefore could not conceive that I was there to give him money" (Williams, 1991, p. 45). In this context, then, Williams's immediate need was to unfix the identity that had been attached to her by the actions of the young man behind the buzzer; by the racialized practices associated with using buzzers in the act of determining desirability; and by the historical and social legacies that converged to create the fixed category of "black as undesirable and probable thief."

The next day, she writes, she typed up the story of the previous day's outrage, "made a big poster of it, put a nice colorful border around it, and, after Benetton's was truly closed, stuck it to their big sweater-filled window" (Williams, 1991, p. 46). By creating and posting a public notice, she temporarily reconfigured her identity-in-context: from that of black woman shopper positioned as undesirable to that of black woman shopper positioned by the law as citizen of the United States who has "equal" legal rights to enter the Benetton store, as well as the First Amendment right "to place [her] business with them right out on the street" (Williams, 1991, p. 46). In the face of actions that responded to her as different, and to her difference as "undesirable," Williams positioned herself within the most salient discourses of "equal rights," and thereby asserted that she was "the same under the law." In this context, positioning herself as "not different" gave her leverage to challenge "racial determinations," predicated precisely on difference, involved in buzzer use.

A few months later, Williams writes, she told the Benetton story at a symposium on "excluded voices" sponsored by a law review. The shifts in context from the street to a law conference, and in identity from black woman shopper to black woman legal scholar, required of her another kind of leverage and another situated working of identity and difference.

Using the Benetton incident as a case in point, Williams presented an essay at the law conference that analyzed "how the rhetoric of increased privatization [materialized in the form of a buzzer system], in response to racial issues, func-

tions as the rationalizing agent of public unaccountability and, ultimately, irresponsibility" (Williams, 1991, p. 47).

Williams tells us that in preparing for the publication of that essay, editors revised the first version of her "rushing, run-on-rage" as spoken at the symposium into "simple declarative sentences." In a second edit, they deleted all references to Benetton, saying that naming the store would be "irresponsible," and that the review was not in the habit of publishing things that were unverifiable. Williams wondered, as she tells of this incident, "what would it take to make [her] experience verifiable. The testimony of an independent white bystander? (a requirement in fact imposed in US Supreme Court holdings through the first part of the century)" (Williams, 1991, p. 47). In the final page proofs, editors eliminated all references to her race, because it was against "editorial policy" to permit descriptions of physiognomy "as a matter of style." Such descriptions, in their opinion, did not "advance the discussion of any principle" (Williams, 1991, p. 48).

In the act of posting a notice on the Benetton store window, Williams used the leverage afforded her by civil rights legislation and the Bill of Rights. That leverage turns on the "fact" of her "sameness" under the law—on the legal "fact" that her locations within racial and color difference make no difference to her right to shop at Benetton, or to publicly tell the story of her exclusion. But the terms of her othering shifted as her daily life took her from the street to the editorial offices of the law review, requiring her to perform her "self" differently. In the name of affording her "equality" or "sameness," the law review editors insisted on editing her conference presentation according to "principles of neutrality." Neutrality, in this institutional context, meant in part eliminating references to her "physiognomy" as she stood at the door of the Benetton store. Yet, in the Benetton context, it was precisely her appearance, and the racialized meanings that have been historically attached to it, that made the difference between being buzzed in or not. Even though the adherence to neutrality is often determined by reference to an aesthetic of uniformity in which difference is simply omitted, Williams finally and with much effort convinced the editors that "mention of my race was central to the whole sense of the subsequent text" (1991, p. 48).

Williams critiques this particular journal's assertion of "color blindness as neutrality." Without being allowed to give the journal's readers information about racial difference and how it was worked in this incident, without being allowed to describe her appearance as she stood at Benetton's door, Williams could only appear "crazy" for posting her notice on the store's window. Although the intention behind the journal's "neutral" and "color-blind" language was to not mark Williams as other, in this particular context it left the readers to supply their own reasons for her exclusion from the store. And that, in Williams's view, would push the reader to position her as permanently other, because it would require readers to participate in "old habits of cultural bias" by supplying for themselves the missing signifiers of race that would have been necessary to make sense of the story (Williams, 1991, p. 48).

As a response to this editorial policy, Williams shifts the form of her intervention in the ways she is being rendered "other" within racialized discourses and

practices. Instead of basing her intervention on asserting "sameness," she bases it on asserting social and historical "difference." In her arguments to the journal editors, Williams separated her identity from discourses of "color-blindness," and "neutrality," and asserted her positioning within discourses of racial difference. By insisting that, in this incident, race *made* the difference between inclusion and exclusion—and that she must be marked as "different" in the journal article—she gained leverage against the "abstract, universalizing" legal and academic practices that continued the exclusion begun at Benetton, albeit in another form.

Williams ends her stories about the various positionings and repositionings within the Benetton incident by describing the responses she often receives when she recounts the incident at speaking engagements. Often, she says, listeners call her story into question by focusing on the "subjective bias" of her telling. Williams reiterates the kinds of questions audiences typically ask:

> Am I not privileging a racial perspective, by considering only the black point of view? Don't I have an obligation to include the "salesman's side" of the story? . . . Am I not using the store window as a "metaphorical fence" against the potential of his explanation in order to represent my side as "authentic"? . . . "It's one thing [says an audience member] to publish this in a law review, where no one can take it personally, but it's another thing altogether to put your own interpretation right out there, just like that, uncontested, I mean, with nothing to counter it." (1991, pp. 50–51)

Rather than making links between these individuals' responses and the situated workings of multiple identities Williams has had to perform in order to live through and respond to the incident, she ends her chapter by simply listing those questions and statements without comment. Doing so requires us, her readers, to "finish" the chapter: "I would like to write in a way . . . that forces the reader both to participate in the construction of meaning and to be conscious of that process. . . . I hope that the gaps in my own writing will be self-consciously filled by the reader, as an act of forced mirroring of meaning-invention" (Williams, 1991, pp. 7–8).

By assuming that her story cannot be accepted as "valid" until "the other side" is heard, the questions and statements listed at the end of the chapter (re)position Williams in a relation of fixed opposition to the salesman—the same positioning that rendered her undesirable the day she stood at the door. Those who ask such questions and make such statements—including, possibly, some of her readers—appear to assume that the validity or truth of her story can (and should) be arrived at through a dialogic process of hearing "both sides." Audiences seemed to expect that she position and regulate her readings and responses within a dialogic process—that is, within a language game of "rational" debate between two opposing sides. Yet this expectation skirts the complex, shifting, nonlinear and multivalent workings of power, fear, desire, identity, history, meaning and difference that rendered this incident possible in the first place. Given the particular power relations of her exclusion from Benetton, asking to hear the other side of the story, in the terms imposed by these questioners, amounts to requiring the testimony of an "independent white bystander."

Williams refuses to cast her stories in terms of a face-to-face, oppositional encounter with the real or symbolic independent white bystander (the salesman, the questioners, her readers—no matter what color). Instead, she tells her story in a way that shows how the buzzer system permanently and asymmetrically positions both her and the salesman into fixed, racialized identities.

Power and racializing discourses and practices shifted and moved from the Benetton store to the law review's editorial offices to the lecture halls to the writing of *Alchemy*. Therefore, Williams's interests and needs do not include proving the one, authentic representation of what "really" happened that day. Rather, she tells the Benetton story differently from situation to situation. Telling it differently, she works "difference" against the oppressive uses of race that are employed in each specific context.

Responding to Williams

Listing frequently asked questions, without comment, at the end of the Benetton chapter, Williams also creates an ironic gap in meaning, in connection, in closure. The irony stems from the distance and disjuncture created when she juxtaposes typical audience questions against the rest of her story. On the one side is the seemingly dogged determination by some audience members to pose questions that are fixed and fixing of both the one who asks and the one who is asked. On the other side are the fluid, elegant, and strategically useful shiftings of meaning and identity that Williams performs in the face of such tenaciousness. The leverage she gains by concluding ironically with unanswered questions is pedagogical. It positions us, her readers, in a relation of mirrored meaning making with her, rather than in a position of opposition to her that mirrors the salesman's. How will we read these typical audience questions in ways that do not re-fix her and ourselves in static categories of racialized opposition?

As we read Williams's textured account of situated working of identity and difference, then, we also read her text as enacting a particular pedagogical address. That address, paradoxically, manipulates us as students and readers into taking responsibility for how we work meanings of difference as we respond to her text (Marshall, 1992).

For example, we have shown how Williams unsettles racial and other identities intended to be permanent, and she does so at moments when they are used in her daily life as a means to "other" herself and others. In writing about her work to do this, it is in the interest of her project to address her readers in ways that make it difficult to read her stories from fixed and fixing social and cultural positions. For the two of us to read only *as* white, or for her to address us only *as* white, for example, makes her positionable only and permanently *as* black. Williams has told us, however, the many ways in which it has become imperative for her to challenge such "mutually exclusive categorizations" by asserting "an overlapping of black and female and right and male and private and wrong and white and public, and so on and so forth" (1991, p. 10).

And she refuses mutually exclusive categorizations as much in her address to us, her readers, as she does in her lived presentation and uses of her own selves. Williams tells us that she wants to write in ways that compel us to participate self-consciously with her in historicized and contextualized meaning-invention about justice. She wants this because most writing about legal theory takes theoretical legal understanding to be based on static, exclusive categories and definitional polarities; transcendent, a-contextual, universal truths, and pure procedures; and objective, unmediated voices. She shows how this kind of understanding severs the connection between lived experience and social perception.

It is for these reasons that Williams tells a story that is racially determined and hinges on racial difference, yet addresses us in ways that refuse to place us, her readers (just as she refuses to place herself), permanently on any one side of racial determination. She does not address us *as* black, nor does she address us *as* white. Yet, she addresses us.

Return to the very first sentence of *Alchemy:* "Since subject position is everything in my analysis of the law, you deserve to know that it's a bad morning" (Williams, 1991, p. 3). In the course of the book, "I," the reader, who she says deserves something from her, becomes an "I" who must constantly shift reading strategies to meet Williams's address. Williams addresses her reader *as* herself, when she writes to herself on the pages of her diary, and when she includes others' writings to her, such as the editor's responses to the paper she submitted to the law review. She addresses her reader *as* her sister through the monologue she directs toward her sister across her mother's kitchen table; *as* her lawyer and professor colleagues through a memo she composes to her department faculty; *as* a judge and jury through her arguing the case for affirmative action; *as* one of her law students through fragments of a lecture she delivers; *as* a trusted friend and confidant, by "sacrificing" (1991, p. 92) herself in her writing, leaving no part of herself out and risking to share with her reader, in letter-writing fashion, her intimate terrors, rages, desires and hopes.

Some of these positions "are" "black," according to current racial determinations (Williams herself and her sister, for example). Some of them "are" "white" (the young man at the Benetton store window, some of Williams's colleagues, some of the questioners at her presentations, and the two of us, for example). How will we respond to such a shifting, excessive address that positions us multiply *as* sister, colleague, the author herself, and law student, for example? What would be the consequences to our abilities to respond to her text if we only constituted our reading selves through interpretive strategies predicated on exclusive, static forms of the categories "black" and "white"? What workings of difference must we perform if we are to meet her moving address and participate in the responsive shifts of our reading identities that Williams calls for?

Questions such as these call for stories of and by subjectivities who experience and conceive of themselves as multiple, fluid, bounded *and* open, gendered, raced, classed *yet* unfinished. As we have said, such stories are few and far between in educational literature, research, and practice. Those that are told often depict linear stages or steps that teachers and students "should" take in order to move from

ignorant to knowledgeable, non-critical to critical, oppressed to emancipated, racist to antiracist, homophobic to tolerant. When told in these terms, such educational stories position students and teachers at one end or the other of static, "exclusive categories and definitional polarities," such as ignorant-knowledgeable, intolerant-tolerant, white-black. They draw "bright lines and clear taxonomies that purport to make life simpler in the face of life's complication" (Williams, 1991, p. 8).

Yet Williams's stories, told in her lectures in law classes, at academic conferences, in her articles submitted to academic journals, and across the kitchen table to her sister, cannot be recounted in such terms. Because of her "oxymoronic" positioning, they can only be told and responded to in and from the gaps between ignorant and knowledgeable, oppressed and emancipated, racist and antiracist:

> I want this book to occupy the gaps between those ends that the sensation of oxymoron marks. What I hope will be filled in is connection: connection between my psyche and the readers', between lived experience and social perception, and between an encompassing historicity and a jurisprudence of generosity. (Williams, 1991, p. 8)

Writing this article, we have wanted to respond to Williams's address from "the gaps between those ends that the sensation of oxymoron marks," and to do so without repositioning either her or ourselves within the static, exclusive categories that make up those ends. Our desires to read and respond this way emerge from memories of countless moments in classrooms when discussions about social and cultural difference have become stuck in seemingly endless repetitions of guilt, accusation, ignore-ance, platitude or denial. Our desires also are informed by articles and commentaries by classroom teachers at all levels, who report their frustration and confusion in their attempts to teach about and across social and cultural difference (Caughie, 1992; Sleeter, 1992; Willis, 1993).

In many instances, it may be the pedagogical address of either/or, rather than the "news" of social or cultural difference, that leads to what teachers have been reporting as resistance, increased tension, rejection, angry denial and separatism when they try to teach about and across social and cultural difference. Such responses might actually entail resistance to "the sensation of oxymoron"—to being forced to read oneself and others as either oppressor or oppressed, either black or white, either gay and lesbian or straight, either racist or non-racist. To what extent does this linear, fixing, and dichotomizing way of addressing students and teachers sever or make difficult, if not impossible, connections between our "lived experience and social perception" of ourselves and others?

Such a question gestures toward the possibilities of students- and teachers-in-motion. Examples of groups, such as some AIDS educators, and other individuals like Williams who are living and working multiple and fluid identities in non-dichotomizing ways, already exist (Crimp, 1988; Goldfarb, 1993; Klusacek and Morrison, 1992; Meyer, 1993; Morrison, 1992; Patton, 1990; Pratt, 1991). Their work enacts and suggests already available reading strategies and teaching practices capable of responding to texts such as Williams's in ways that do not re-fix

and re-solidify difference and identity. Their work goes beyond "acknowledging" or "celebrating" or "accepting" the social and cultural differences of others. Like Williams, their work attempts to materialize a "new we" that is predicated upon the alchemical abilities of our personalities to undo old formalisms and refuse a merely inclusive new expansionism (Baker, 1991). These are workings of difference that so many educators miss or fail to consider as pedagogical possibilities when they concentrate only on inclusive or celebratory multiculturalism.

For us, it is Williams's showing of the work of working difference that makes her text a crucial intervention in teaching about and across difference. In the context of pedagogies and curriculums that require and reproduce fixed, static, and ultimately stultifying identities, Williams's textured accounts of her workings of difference teach about the work that it has taken for her to mobilize and re-signify static and fixed identities *against* usages that are, for example, racist.

Showing the work of how selves become selves through working difference, Williams departs from and exceeds a multiculturalism that simply "accepts," "celebrates," "tolerates" or "incorporates" already defined differences. By showing the work, she provides resources for social and cultural production of identities and difference, and refuses passive reception of already defined information about herself and others, produced elsewhere. Her situated working of difference draws from the experiences, meanings, histories and materials of her locations and multiple daily lives. Because none of these is knowable beforehand, situated working of difference opens to the possibility of "creatively mated taxonomies" with "wildly unpredictable offspring" (Williams, 1991, p. 11). But not for the sake of playfulness—rather, because

> rights contain images of power, and manipulating those images, either visually or linguistically, is central in the making and maintenance of rights. In principle, therefore, the more dizzyingly diverse the images that are propagated, the more empowered we will be as a society. (Williams, 1991, p. 234)

When we work identities and difference with students through life stories such as Williams's, we connect theories and concepts "about" social and cultural difference to a life. And we connect the living of a life to the processes of theorizing and analyzing "difference," to the processes of "reconfiguring what will count as the world" (Butler, 1993, p. 19). Rather than addressing students through disembodied theories and concepts about identity and difference, using stories such as Williams's enables us as teachers to pose the question: how does a life lived in ways we respect and are attracted to affect what we count as "the validity" of theories or analyses of difference?

Reading Williams here, we have focused on the possibilities that her workings of difference have raised for us as educators. At the same time, she tells us that, for her, working difference always exists alongside fear, shame, exhaustion, rage and danger (Williams, 1991, p. 129). Williams shows us how re-signifying the meanings and uses of difference, although imbued with difficult emotions and conditions, is possible. And, Williams reminds us, working difference is life work. "Nothing is simple. Each day is a new labor" (1991, p. 130).

After Words

Because holding the simultaneity of intellectual, social, historical, aesthetic and personal effort in complex tension is everything to the ways we want to work difference and to work differently as academic women, you deserve to know that there is another desire that informs the reading we offer here. We want to work together, not only or primarily because we are interested in the potentials of collaborative work, and not necessarily because of the political and intellectual commitments and interests we share, but because we derive great pleasure in each other's company and in working side by side.

This reason exceeds many of the usual reasons given for collaborative academic research. Desires such as this provoke theoretical and critical questions and assertions, leading us to consider, for example, what kinds of knowledges we might construct when our reason for working together is the pleasure of working together. That pleasure transforms academic work into academic play, into a heightening of academic imagination, and into a shifting of the social relations of academic life. This shifting is one way of taking action to change what has been defined for us as academic work and the ways that we should accomplish that work.

At the same time, as much as we desire to work together, each of us brings differing autobiographical and disciplinary backgrounds to reading Williams. Janet brings habits of reading from curriculum theory, qualitative research, English and English education studies. Liz brings the language and preoccupations of film theory and cultural studies. These differing backgrounds and perspectives have led to many versions, many stops and starts in our conceptualizations and writings of this article. Other kinds of knowledge become possible when we interrupt each other's habits of thinking, not for the purpose of asserting any one of our perspectives as authoritative, but out of a desire to construct a third space that is neither one of us nor the other, neither subjective nor objective, neither purely inner nor outer. "Culture, like play, exists [and is produced] in this third area" (Flax, 1993, p. 121).

And you deserve to know that this reading is informed by our attraction to Williams's text. This text gives us aesthetic pleasure and feeds our academic imaginations and our visions of enlivening our academic work and lives. Other kinds of knowledge and forms of sociality are constructed when we work with particular theoretical and critical texts for the reason that they give us aesthetic pleasure. The domination of certain forms of reason within Enlightenment concepts of public life and the academy remain "impoverished in [the] absence of ritual, sensuality, spectacle, . . . and aesthetics" (Flax, 1993, p. 88).

Working Words

They finished this article after a year and a half of writing. They wondered at how long it took, and at how hard it was to finish. And yet, what a pleasure, sometimes. Maybe that is why they couldn't ever settle on a final version. Maybe they

could not settle because situated writing about situated working of identities and difference meant that each day's writing was jolted away from yesterday's. Often everything seemed to have changed because of what happened in last night's class, during this morning's breakfast conversation, or in the article one read over lunch. Yet some things never were disregarded, like their attachments to certain "visceral beliefs about justice and how people should be treated" (Flax, 1993, p. 7). It was through those visceral beliefs that they read Williams, and wrote this working version of working difference in education.

Notes

1. We are full coauthors of this article and have listed our names alphabetically. Nevertheless, given current academic practices, one of us will always be listed as the "first" author of this article. Given our desire to work together, we plan to alternate the alphabetical listing of our names on our collaborations.
2. By "subjectivity" or "subject positioning" in this article, we are looking at the human being "as neither totally subjected or constituted (that is, determined completely by the social or linguistic structures around him or her), nor totally individualistic or constituting (that is, the source or agent of full meaning), but rather, as both constituted and constituting" (Marshall, 1992, p. 82). By "difference," we are referring to "a structuring principle that suggests definition rests not on the entity itself but on its positive and negative references to other texts" (Rosenau, 1992, p. xi). With other feminist and postmodern writers, we argue for a politics that is responsive to rather than repressive of difference. "Some feminist and postmodern writers have suggested that a denial of difference structures Western reason, where difference means particularity, the heterogeneity of the body and affectivity, or the inexhaustibility of linguistic and social relations without a unitary, undifferentiated origin. . . . [S]uch a denial of difference contributes to social group oppression" (Young, 1990, p. 10).
3. There are, of course, a number of scholars in the field of education whose work concentrates on these issues. They, too, rely on theories, interpretive methods, and analytical concepts generated outside education, per se. But they seldom provide concrete portrayals of the complexities of daily, contextualized efforts to work specific subject positionings and difference as teachers, with students, within particular institutional, cultural, economic constraints. The vast majority of researchers in education have yet to explore the potential of such work for educational theorizing and practice.
4. Examples of such work are too numerous to reference completely here. However, a number of scholars in fields outside of education place many issues currently circulating around the notion of difference in direct relation to issues of curriculum and pedagogy in their own fields as well as in education in general. Those we have found most helpful in the writing of this article include Toni Morrison (1992), Shoshana Felman and Dori Laub (1992), Brenda K. Marshall (1992), and Diana Fuss (1989).
5. We do not subscribe to the kind of identity politics that "erase[s] differences and inconsistencies in the production of stable political subjects" (Fuss, 1989, p. 104). Rather, in this article, we take identity to be contingent, unstable, and potentially disruptive. At the same time, we agree with Gallop: "I do not seek some sort of liberation from identity. That would lead only to another form of paralysis—the oceanic passivity of undifferentiation. Identity must be continually assumed and

immediately called into question" (Gallop, 1982, p. xii). It is this assumption and immediate calling into question of identity that, we argue, Williams so vividly enacts and describes.

AUTOBIOGRAPHY, CURRICULUM

Perhaps there is something healthy about claiming the right to ambivalence. Or at the very least, there may be something deadening about having to renounce one's ambivalence too soon, on someone else's terms. If resistance is always the sign of a counter-story, ambivalence is perhaps the state of holding on to more than one story at a time.—Barbara Johnson, *The Feminist Difference: Literature, Psychoanalysis, Race, and Gender*

INTERLUDE 9

The work in this closing section elaborates and extends themes, ideas, concerns that have reverberated throughout this collection. These selections of course don't constitute any final words, any cumulative sounds of silence breaking. But they do point to issues and problems, both conceptual and pragmatic, that continue to rattle through my academic work.

The first piece, a revised version of my 1999 American Educational Research Association (AERA) vice presidential address to Division B (Curriculum Studies), informs and frames the subsequent selections, and yet returns to perennial issues with which I and others in the curriculum field grapple. In many ways, all the essays in this final section mark a return, certainly in the sense of the repressed in various other pieces in this collection, but also in the sense of revisiting and revising my relations to themes, ideas, places, events and sites of work that fill the pages of this book.

In some cases, I am returning to mourn and avow a loss.

In positing "performative pedagogy" as a structure of address that may be directed toward loss, Paula Salvio (2001) discusses Anne Sexton's teaching performances, which are "drenched in melancholia, and these performances allegorize losses that are deemed ungrievable in academic institutions where grief is preempted by the absence of cultural conventions for avowing loss" (p. 111).

One person with whom Liz and I can no longer collaborate, re-sound themes, or debate current notions of pedagogy as means of engaging in the daily re-making of our work and our lives is our dear friend, Mimi Orner. The loss of my mother and Mimi, just three days apart in November of 2000, remains a most profound and impenetrable silence in my life.

WHAT'S LEFT
IN THE FIELD. . . . A
CURRICULUM MEMOIR

I am experimenting with examining my life, with charting the course of my feelings, with giving my work purpose and direction, through remembering where I have been.
—Louise DeSalvo, *Vertigo: A Memoir*

A vice presidential address to the members of the American Educational Research Association (AERA) is a ritual of reflection and transition. This particular address marks the close of my two-year term as AERA vice president for Division B— Curriculum Studies—and could provide a context for looking to the past, present, and future of our field. However, I do not pose "What's left in the field" as a survey question, because there is no definitive reading of that phrase, and no authoritative answer. Rather, I read the phrase "What's left in the field" from multiple angles in order to conceptualize the US curriculum field as an ongoing and never-ending human project, situated within differing contexts and variously interpreted lived educational experiences.

If conceived and enacted as a recurrent and yet always changing project, curriculum studies would entail both recognizing and welcoming the need to constantly un-make and re-make the field. It would also require taking into account differing subject locations, prevailing discourses, social-cultural contexts, and historical moments. And as a human project, the field of curriculum would require readings of identity, difference, and curriculum as works-in-progress, rather than as predetermined, unified, transparent and universal categories or processes.

Of course, I need to acknowledge that I read "What's left in the field" in multiple ways, in what I am here calling a "curriculum memoir," through reconstructions of my own desires as well as experiences and perceptions of the field over time. A memoir makes no pretense of replicating a whole life. It is more of an essay, what memoirist Judith Barrington calls a "track of a person's thoughts struggling to achieve some understanding of a problem" (1997, p. 88). It contains

both retrospective and current musings on the themes and puzzles that run through the writing subject's constructions and interpretations of particular life experiences. Further, memoir recounts stories of the non-continuity of "self" and others as well as events or movements in which the writing subject has taken part (Corbett, 1998).

But like autobiography, a memoir is never an absolute or linear version of supposed Truth about a chosen theme or problem or life. Nor is it a completed portrait of a fully conscious and non-contradictory "self." Memoir, like autobiography, must recognize its own social construction and cultural conditioning. As Felman (1993) reminds us, it simultaneously must call attention to interpretations as always incomplete, always caught up in repression, always interminable.

Thus, remembering, says Daisy in Carol Shields' novel *The Stone Diaries* (1993, p. 196), is full of "systemic error, of holes that connect like a tangle of underground streams." Memoir, like fiction, is filled too with what novelist Toni Morrison (1990, p. 305) calls "acts of imagination" bound up with "emotional memory—what the nerves and skin remember as well as how it appeared."

My readings of the problematic phrase, "What's left in the field," thus are bound up with what my "nerves and skin remember" about the very tangle of connections and identities that comprise the US field. My readings are framed by associations with particular individuals and ideas, and by a recognition that any way I view the world is also mediated by the contexts, conscious and unconscious desires, and discourses out of which I engage in the processes of human interaction.

As a human project, the curriculum field too is "full of systemic errors," bound up with what "nerves and skin remember" and with the implicated responses of particular individuals who work within and across differing discourses, historical and social contexts, locations, needs and desires. Here is what I hope to suggest, then, through multiple engagements with and representations of "What's left in the field": If indeed curriculum studies is a human project, it will never be fully conceived or realized. It will be obligated every day to reinvent itself.

I

In the new convergence, we become . . . tellers of stories about our work—local, partial, prismatic stories. . . . And the field is unbounded. —Laurel Richardson, *Fields of Play*

As I simultaneously juggled the myriad duties associated with concluding my vice presidential term and pondered multiple readings of "What's left in the field," I struggled with ways in which to frame my readings of that phrase. My first thoughts about linking those readings to a "curriculum memoir" segment focused on tracing my feminist commitments (Miller 1994, 1998a, 1998b, 1998c) to autobiographical explorations of connection, collaboration, and curriculum that call into question any seamless, unmediated, power-neutral, static version of "self," content, relationship—or curriculum field.

But the people, the settings, the circumstances that influenced those commitments kept crowding into my writing drafts and my dreams. In the middle of

one night, during an insomniac interlude, I recalled attending my first president's reception at AERA:

> *A spacious suite, lined with floor-to-ceiling windows, atop a hotel, I forget in what city. I squeezed past the bottleneck around the bar and joined the crammed line of people who jockeyed for position in the quest to congratulate Maxine Greene. This was her presidential reception and the mood was celebratory, the noise level beyond any decent conversation level. It didn't matter. Maxine hugged a circle of well-wishers as she exclaimed: "An existential woman philosopher as president of AERA. Who could guess!"*

The implications of a "woman educational philosopher," with passionate commitments to the arts, social imagination, and teaching, and their capacities to move individuals to see and act together against habit and indifference, were evident in Maxine Greene's first column as president-elect of AERA in its monthly academic journal, *Educational Researcher.* Many of my current readings of "What's left in the field" as well as what my "nerves and skin remember" are framed by what Maxine Greene wrote in that column entitled "Response to a predecessor":

> Education, for me, involves initiation into the multiple perspectives needed for sense-making. . . . I do not believe that educators or educational researchers can be neutral or value-free, particularly at a time like the present. Detachment will not do; the paradigm of the natural scientist will not do. I would like to see a community of researchers engaged in studies that attend to the fundamental problems of human welfare and the quality of life. I would like to see more and more openness with regard to the social consequences of what we do, more and more clarity about our public purposes, our interests, and what we come to value as we work and we live. There ought to be controversy among us, open debate, an ongoing conversation. And there ought to be mutual respect, regard for each one's "competence and integrity." If we cannot listen to each other with consideration, our house will not be "ethically in order"; indeed, the house may fall. (Greene, 1981, p. 6)

Given current examples of the strife and contentious debates surrounding what counts as research, what counts as curriculum, what counts as knowledge both within US curriculum studies and within the field of educational research in general,[1] Maxine Greene's visions for education as a field of study remain unfulfilled. Between journal articles published in recent years that display little regard for each one's "competence and integrity" and recent tendencies to carve out positions and defend them for the sake of what sometimes seems to be nothing more than ego, I could surmise that there's nothing in the field but posturing, fiefdoms, and self-interest. Perhaps there's nothing ethically left in the field.

But so many of us continue to fight for the project called education that it is impossible for me to consider the field as totally bereft, abandoned, devoid of consideration for one another or of what Maxine Greene calls the "multiple perspectives needed for sense-making." But education as project, Maxine Greene (1995b, p. 305) also reminds us, "must be chosen by persons intentionally and cooperatively involved in learning to learn." Perhaps such choosing is still "What's left in the field" to learn.

Or, I could read "What's left in the field" in another sense: that is, of what is departed, what is no longer present, in our work in curriculum studies. For example, many of us have argued for a while against the "paradigm of the natural scientist" in the curriculum field. Indeed, many of us in curriculum studies have worked to claim that a narrow, technocratic, prescriptive version of curriculum studies as guidance for practitioners, if not altogether absent, at least no longer dominates the field. But in my work with US classroom teachers, I witness their daily struggles to move beyond curriculum still conceived only as predetermined content. My graduate students, most of whom have ten to twenty years of teaching experience, complain that their only work with curriculum is to "age- and ability-sequence it" and then "to cover it." Curriculum in their schools still means content linked to objectives that are then measured in terms of students' standardized tested "achievement."

In response to such static and controlling conceptions of curriculum, my students and I deconstruct, for example, the blatant ignoring of difference in recent versions of pre-packaged curriculum. These versions are informally referred to by many teachers as "school reform in a box"—the ready-made curriculum reforms peddled by mass-market curriculum developers. In class, we read, analyze, critique and develop strategies we can use to challenge or at least modify uniform conceptualizations of students and teachers as well as of the current (albeit recycled) demand in the US for standardization of curriculum, pedagogy, and student responses. But then three of my teachers come into class after spring break and announce that their school system has bought into one of the reform models, with no input from them or any other teachers, students, or parents in the school. Obviously, the technocratic and prescriptive versions of curriculum work have not left the field, nor will they any time soon, given current political conditions in this country.

My ongoing conversations and work with classroom teachers also suggest multiple readings of "the field." From these angles, "the field" does not necessarily refer to curriculum studies per se, but rather to the classroom teacher's domain. It's the "field" of "field-based" programs, the "field" to which many of us go from the university in order to participate in, for example, professional development schools, or teacher-researcher collaborations, or school restructuring projects. What part of our work with classroom teachers gets left in *that* field, never really regarded as curriculum studies within academic constructions of research or collaboration? And what is our relationship to classroom teachers who wish to claim *or* reject, as part of their "field," aspects of their knowledge that finally cannot be narrated, codified, prescribed or "corrected" by university researchers, curriculum studies professors, school administrators or "top curriculum developers"? What could possibly constitute a "community of researchers" in these contexts and situations?

Five teachers sat facing me. "Maybe we should withdraw our session from the program," Marjory said quietly. Our group of six teacher-researchers[2] had attended the Bergamo curriculum theory conference[3] for three out of the six years of our collaboration. Bergamo was the conference that I had attended, in various forms, since 1973, the one sponsored by

The Journal of Curriculum Theorizing *since 1979, the journal for which I served as managing editor from 1978 through 1998.*

Immediately, I had to deal with my own internal struggles about withdrawing from this conference at the same time that we were pondering our next steps as a collaborative. In other years at Bergamo, our group had presented various versions of the power-relations that circulated through our work together. This year, we wanted to elaborate on constructions of our identities as ever changing within collaborative inquiries. Our proposal also stated that we were going to talk about how we were trying to confront complexities of simultaneously engaging in and representing our collaborative efforts.

At the last minute, Katherine, the first-grade teacher, decided not to attend the conference. She told us that she had to withdraw because she felt torn apart by the active questioning and discussion at Bergamo, where curriculum often is conceptualized and researched as lived experience of the politics, discourses, and cultural/social contexts that influence constructions of content as well as of the processes of teaching and learning. There was too great a discrepancy, she said, between the kinds of curriculum studies represented at the conference and the passive, submissive atmosphere and pre-determined content that was mandated in the elementary school where she taught.

"I can handle those discrepancies, most of the time, in our group, because we always talk about the limits and possibilities of the ideas we're studying and researching in our own classrooms," Katherine told us. "But the discrepancies just get too big and overwhelming for me at that conference. I leave there and I'm all charged up to go back to school and change my whole teaching life and the ways my administration thinks about and handles curriculum. But I never can. I work in a world so far removed from what we do in our group. I don't need the conference to make that an even bigger discrepancy for me."
(From field notes and audiotaped transcriptions, September 1991)

Thus, my nerves and skin remember contentious, confusing, and contradictory times within these lived binary versions of "the field." Throughout our six years together, our collaborative research group faced constant discrepancies between university and K–12 research intentions as well as curriculum definitions and enactments. Twists and turns in power as "exercised" rather than as possessed (Foucault, 1976/1978) and conflicting and conflicted views and voices also characterized our collaboration and research.

II

Such discrepancies and conflicts in some senses replicate disjunctures that I have felt working as an academic in curriculum studies. Those with whom I am most aligned are concerned with moving the field beyond its emphasis on curriculum as only technical design and development of predetermined content. But how, and on what theoretical bases, have been contentious questions for some time, often exceeding mere discrepancy and erupting into full-blown conflict.

For example, a small number of curriculum theorists began in the 1970s to explore psychological, autobiographical, political and cultural dimensions of curriculum. They worked to "reconceptualize" the solely technical emphasis in the

curriculum field so that it might include psycho-social, economic, cultural and historical analyses of curriculum as both content and the experiencing of that content (Pinar, 1974, 1975a). The disagreements between what was then characterized as the "existential/phenomenological" and the "political" in curriculum theorizing constituted a major split in ways different scholars thought the field could and should be "reconceptualized."⁴ [See also Chapter 1, *Curriculum Reconceptualized: A Personal and Partial History* in this text for an elongated discussion of this split.] Pinar (1988, p. 7) has argued there never was a "reconceptualist" point of view, or even points of view, yet particular theoretical stances do remain in apparent opposition to one another.

The notion of a curriculum field split into only two camps now seems simplistic to me in relation to the multiple perspectives and ways of working that have emerged over the past twenty-five to thirty years in the US field. Further, as I have noted, some in the field continue to strenuously object to any of these multi-variant "reconceptual" perspectives as ignoring or deserting the field's original school-based design and development functions.

So, in a sense, we remain in a crisis of identity precipitated by "the cataclysm that was the reconceptualization" (Pinar, Reynolds, Slattery & Taubman, 1995, p. 42). Perhaps what's left in the field is the work that it will take to address one another, not to merely mend or to make the field whole, but to engage one another with "*openness with regard to the social consequences of what we do*" (Greene, 1981, p. 6, my emphasis).

Yet, back in 1979, given the grassroots nature of the work to organize the journal, *JCT: The Journal of Curriculum Theorizing*, and the conferences founded to support such work, I was initially unwelcoming of conflict, any kind of conflict in the field.

I tried to project my voice, but instead I squeaked out my welcome to the fifty or so people who disembarked from two Greyhound buses and stood politely in a circle on the manicured lawn of the Airlie Conference Center. Some swayed from one foot to the other, unkinking their legs from the hour-long bus ride from Dulles Airport, outside Washington, DC. I recognized some of these people. I had met them at the other curriculum theory conferences that had been held since 1973, first at University of Rochester, then at Xavier University in Cincinnati, University of Virginia, University of Wisconsin-Milwaukee, Kent State, Rochester Institute of Technology, and Georgia State.

But this was the first curriculum theory conference officially sponsored by our new journal, The Journal of Curriculum Theorizing, *and I was making my first official conference greeting as* JCT's *managing editor. It was not the greeting I had rehearsed. Instead, I had to inform these trusting people, who already had endured difficult travel arrangements, that they needed to double up in their rooming arrangements because all the single-room accommodations at the conference center had been taken over for a "retreat" by the US Central Intelligence Agency.*

My eyes narrowed against the glare of both the setting sun and these potential conference deserters. Would they revolt, storm back onto the buses, refuse to even be in a space inhabited by the CIA, let alone share a room with someone who might have a differing theoretical framework? They hadn't agreed on very much in the conferences that preceded

this one. Why should they suddenly agree now? After a long pause, during which I glanced brightly around the circle, giving what some of my friends call the "pedagogy-of-encouragement" smile, one hesitant hand went up. "Can I choose my new roommate, or are you managing that part of the conference too?" Everyone laughed and I began to breathe again. Later, at the registration table, Jim Macdonald helped Bill Pinar and me distribute the nametags that Bill and I had hand-written the night before. "I think it's going well," Jim said.

Since that first *JCT*-sponsored conference, my understanding of conflict as a productive element in the field has grown in proportion to the degree to which I can understand that multiple perspectives can be held in productive tension with one another. My current understanding of conflict as always accompanying a conception of curriculum studies as project, as a field in the making, is grounded in the productive tensions of Greene's urging: "There ought to be controversy among us, open debate, an ongoing conversation."

However, as I have noted, some regard the recent proliferation of "multiple perspectives needed for sense-making" within curriculum studies as what's "left" in the field, as what is radical and therefore disruptive of what they see as the US field's original school-based and design and development purposes. "Left" here still implies political, usually neo-Marxist/critical theory analyses of myriad aspects of curriculum.[5] However, I am pointing not only to the importance in the field of those theoretical orientations, but also to what I (Miller, 1996a, 1999a, 1999b) have called a riotous array of theoretical stances, including phenomenological, feminist, psychoanalytic, poststructural, postmodern, hermeneutic, historical, action, cultural studies, advocacy-oriented and aesthetic, among others, that now are brought to bear on curriculum issues and inquiries. In varied and often dramatically different ways, such theoretical frameworks and perspectives enable curricularists to analyze, critique, rewrite, and change technologies of curriculum that try to separate pedagogy and learning into discrete and measurable units of content and behavior. Such frameworks challenge any construction of curriculum that ignores its psycho-social, historical, political, economic, cultural and discursive dimensions. And I argue that the ultimate usefulness of such frameworks depends on an "ongoing conversation" among curricularists.

But some in the field still insist, from an argumentative stance, that these multiple perspectives that I and others think are necessary for "sense-making" have led to the increasing fragmentation and balkanization of curriculum studies into "theory" and "practice" camps, where "theory" resides only in universities and "practice" is limited to K–12 classrooms. However, a number of developments in current approaches to "sense-making" belie the separation of theory from practice. The diverse intellectual traditions just named offer important critiques of "official school curriculum" as constructing, in part, unified and standardized versions of student and teacher subjectivities. The myriad theoretical perspectives that now characterize contemporary curriculum theorizing also offer vivid interpretations and critiques of social and economic realities of classrooms, school districts, and communities, and the always invested-ness of curriculum policies, practices, and performances.

Thus, any *singular* prescription for what counts as curriculum studies, what counts as the field, what counts as the relationship and location of theory to practice, ignores the situated diversity of our work and lives. It is obvious that there is no one field, no one fixed, coherent, and shared version of what our work in curriculum studies is and should be. Even if we all did agree on a particular version of the interrelationship of theory and practice, the historical, political, theoretical and generational complexities among those involved in curriculum studies make the notion of one united US field an impossible and, I would argue, undesirable goal.

For, the humanness of curriculum construction, teaching, and learning is intractable. Our work must begin anew each day in response to particular questions and contexts of teaching, learning, theorizing and curriculum. Only in this situated and contextualized manner might our work heed Greene's exhortation to address "the varied fundamental problems of human welfare and the quality of life," with "more and more openness with regard to the social consequences of what we do." In such a conception of curriculum studies as project, acts of curriculum theorizing and construction always begin where they are needed, most often at varied points of tension, discontinuity, exclusion and rupture. It is in the rough spots, the breaches, where there is still critical and imaginative work to be done. "Acts of imagination" can and must, if we are to attend to the social consequences of what we do, emanate from classrooms, from creative pedagogical and curricular spins that add humanness into prescriptive codes and mandated testing procedures, and from our ongoing conversations in and about the field.

Maxine Greene directs us to the arts as potent sources for those imaginative acts, which are created within and because of the very disjunctures and tensions to which I am pointing. Such acts of imagination might enable and inspire our nerves and skin to learn, to remember, to engage in ongoing conversation, and to take action in and on our worlds. As Greene argues, "action always signifies a new beginning, a new initiative, so that fixed and final frameworks remain inconceivable" (1995a, p. 197).

III

Struggling against the limitations we place upon our minds is our own imaginative capacity,
a recognition of an inner life often at odds with the external figurings we spend so much
energy supporting. When we let ourselves respond to poetry, to music, to pictures, we are
clearing a space where new stories can root, in effect we are clearing a space for new stories
about ourselves.—Jeanette Winterson, *Art [Objects]*

My nerves and skin remember a work of art, a curriculum if you will, that was created where it was needed, within and because of massive and horrific social, political, and cultural disjunctures and tensions. That work of art, Picasso's *Guernica*,[6] influenced and ultimately impelled me to consider the possibilities inherent in conceiving of both curriculum and teaching as human projects, where "ongoing conversations" and "new stories can root." My initial viewing of Picasso's painting aroused what Greene (1995a, p. 5) calls "social imagination: the

capacity to invent visions of what should be and what might be in our deficient society, on the streets where we live, in our schools." And that viewing eventually inspired in me a conception of curriculum as a never-ending but potentially transformative human project.

I first saw Picasso's Guernica *when I was a junior in high school. As I stared at the huge painting, I felt as though life itself had been squashed, twisted, contorted—destroyed for reasons that I neither understood nor could forgive. I felt frozen by this painting, unable to speak even after I had backed away from the canvas, in retreat from the pain that emanated from Picasso's vision of the wanton destruction of war. As I struggled to make sense of the electric light bulb hanging above the shredded newsprint and the convoluted forms of humans and animals, the sounds of my friends' voices and the explications of our guide were muted to me. I was aware only of my bewilderment and the immensity of my confusion and outrage.*

As our group was gently nudged into movement by class chaperones, I recall that, even as I was able to slowly re-enter the chattering world of my peers, I was pondering the intensity of my reaction to Guernica. *However, as we made our way through the crowds at the Museum of Modern Art, I was not even dimly conscious of the changes that had just irrevocably taken place in my ways of seeing my own and others' lives. What I felt at that moment but could not articulate was that all the color had been drained from the world.*

Earlier, my friends and I had lurched up and down the aisles of the train that was meandering through the hills of Pennsylvania, hauling us on our eleventh-grade class trip from Pittsburgh to New York City. We had laughingly prioritized our tourist stops and had made pacts with one another about seating arrangements on the several bus tours that had been arranged for us. This was a first trip to New York for most of us, and we were excited about seeing the lights of Broadway and Times Square. I knew that we would be touring the museums, too, and I looked forward to seeing some of the paintings that our teachers had discussed in our art and English classes. However, as we voted on our absolutes for this trip, the mandatory snapshot for our group included waving from the crown of the Statue of Liberty and hugging one of the New York Public Library stone lions. Art was something that our teachers had put on our itinerary, something that we would talk about in class upon our return. Although I secretly was pleased about our museum stops, I also was caught up in being a tourist. As I entered the whirlwind of our city tours, and even after we had exited the Museum of Modern Art, I could not have anticipated that the force of my response to one particular painting eventually would point to my efforts to understand some possible connections among curriculum, the arts, my work as an academic and my life.

Before I viewed Guernica, *the visual arts had been removed from the everyday for me. Paintings existed as images, color, and light melded together as representations of life as it should or could be, and hung on walls of museums located miles from the south hills of Pittsburgh, where I lived. As a child growing up on the cusp between the steel mill town and the still-forest-strewn suburbs of Pittsburgh, I always looked forward to our elementary school "art and music" field trips into the city or to the galleries of Shadyside or to exhibitions and concerts at the University of Pittsburgh or what was then Carnegie Tech. I remember that, even in the fourth grade, when the emphasis among my friends was on kickball games and bike rides after school, I loved clambering onto the school bus to go to the symphony or the planetarium or the museums. Returning home, amidst the singing*

and jostling of my fellow classmates, I sometimes tried to envision myself within the frames of the paintings that we had viewed of bucolic landscapes or serene dignitaries whose portraits appeared to attest to their importance and bearing in the world. Such paintings represented a life foreign to me, appealing in its apparent serenity, beauty, and dignity, yet separated from my world not only in dimensions of time and space, but also in terms of wealth, power, and circumstance.

Always, as we returned from these outings, the school bus would lumber past the steel mills as it rolled us away from the city, crossed the Liberty Bridge, and returned us to the south hills. Often, on darkening winter afternoons, we stared out the bus windows at wavering red skies that reflected the glow of molten steel being dumped down mountainous slag heaps. Some of my friends waved at the steel mills as we bounced by, sending symbolic salutes to their fathers who were just beginning the night shift. As the driver wedged our bus into its parking place next to the school gate, those paintings I had viewed during the afternoon at the museum faded, replaced by the grey air and the familiar faces of the people who lived and worked in my neighborhood. Art was remote for me, distanced by the idealization of form and content to which I, even as a fourth-grader, had attributed its function.

Although I continued to be drawn to art and music, by my junior year in high school I knew that I wanted to become an English teacher. Literature was at the center of my academic interests, and I thought that I was lucky to have been able to decide so easily and quickly on a career. What could be better than getting paid for loving to read and sharing that love with one's students? It was easy to be a high school romantic.

In my junior year, too, I was influenced by my favorite high school English teacher, who could quote extensively from American poets, including Longfellow, Poe, Emerson and Irving, but who also introduced us to the verse of Whitman and Dickinson and Lanier and to the regionalists and realists. Miss Biedle talked about these authors as among those who revolutionized the forms and intentions of literature in the United States. She often would make connections among painters, artists, and musicians whose works represented similar challenges to notions of a romantic idealism or an aesthetic purity. Although I was interested in these challenges, I was connected to words, to written expression, as the primary means of creating meaning and eliciting response from others. I was learning about literature as a discipline, as a separate entity, and although Miss Biedle made countless connections for us, way before interdisciplinary studies and response-centered curriculum had hit the high schools, I still saw my art and music classes as auxiliary in my awkward attempts to interpret the meaning of life. I felt confident that this was the primary function of literature, and, by extension, of the English teacher. I was sure that novels and poems and short stories and plays were the direct connections to Truth, and I was just as certain that there was Truth to be found, if one could just learn how to interpret those symbols.

What's scary about all of this is that I continued to learn about literature and its functions and its genres in this segmented, definitive (and gendered!) manner throughout my college years as an English major. As I began to teach eleventh- and twelfth-grade English, just as I had hoped to do since my own junior year in high school, I could feel in my teaching, in my skin and bones, the further splintering of the disciplines into discrete subject matter areas.

As a high school English teacher, I was expected to emphasize my students' mastery of factual details, such as the elements of a short story or the parts of speech or the characteristics of a tragic hero (never mind the heroine). My colleagues and I all taught furiously, as if in a race to cover the canon before it could enlarge and encroach upon our established grade-level content. We also taught as though there were one agreed upon interpretation of Hawthorne's The Scarlet Letter, *the main choice for a novel selection among all the eleventh-grade English teachers in my department who were preparing our students for the New York State Regents exams.*

Throughout my college studies, I had felt that there was more to literature than the facts surrounding its creation or the categories into which we constantly placed each selection. As I taught high school English, I wondered how Miss Biedle had found the room in her curriculum to even mention the connections she saw among music, art, and the literature we were studying at the time. I attempted to juggle the demands of a curriculum, conceived as a set of predetermined objectives for my high school English students to achieve, and my own need by now to make connections among works of art and the circumstances of our everyday lives. I began to wonder how I might encourage students to make their own connections, given the structures of schooling that encouraged them only to replicate mine. And I thought of Guernica.

After that junior class trip to New York, I had spent time talking with Miss Biedle and my classmates about our reactions to Guernica, *which, of course, were varied in their intensity and focus. I chose to read more about the Spanish Civil War and tried to figure out Picasso's political stance by learning more about the historical and political circumstances that impelled Picasso to paint* Guernica. *I did this research not as an assignment but as a form of questioning about my own passionate response to the painting. I did not especially want to know into what period of Picasso's work we might classify this particular piece, or what techniques he borrowed or rejected from Cubism in order to create his angry and anguished response to the destruction of a small Spanish town and its people. Still, I think that I fell back on the traditional ways that I already had learned were means to understanding, because I did not know how to trust my own responses.*

But even as I pursued these traditional routes to knowledge about the circumstances that evoked Picasso's fervid response to the senseless murder of innocent people, I found myself remembering foremost my reactions when I first saw Guernica. *I knew, after that initial encounter, that words were not necessary to evoke or to express response to a work of art or to a human condition. Ultimately,* Guernica *shattered my learned and limited ways of seeing, forced me to consider new ways of looking at life and death, demanded that I encounter, confront, and, most importantly, respond to and take action within tensions generated by competing visions of the world.*

The horrors, ruptures, fragmentations and exclusions of war provoked Picasso's impassioned and challenging response. While the "controversies among us" in the curriculum field are *not* in any way analogous to the inhumanity that provoked Picasso's shattering images, our controversies may necessitate and ignite creative and imaginative acts of curriculum construction and reconstruction— visions of what "should be and what might be" in the curriculum field as well as in our schools. Intractable humanness and always changing circumstances, with their

accompanying potentials for "acts of imagination" and new beginnings, provoke us to engage one another.

IV

I push my friend Mimi's wheelchair through the maze that is the Hospital of the University of Wisconsin. We enter the oncology wing and the nurses wave to us. There's building construction in the area, and I have to maneuver Mimi's chair through a narrow passage in order to push her up to a small window where she checks in. It is sort of like a McDonald's drive-through for chemotherapy. Mimi directs me into a room filled with people reclining in what look to be cushioned lounge chairs. Bags of fluid hang from metal stands that stand like patrol guards along side each chair. No one looks at anyone else. No one talks.

We both are happy when we're directed into a corner of a smaller room adjacent to the big one. There's only one other person in this room: a frail woman with white hair reclines on her lounge chair, her eyes closed, one hand resting on the tube that enters her arm.

Mimi settles into her lounge chair and begins answering the litany of questions the nurse poses to her as he sets up the chemo bags above Mimi's head. Mimi immediately engages with the nurse in what she calls the discourse of medicine and cancer—what's healthy, what's not, who's healthy and who's not, and why—in order to get her chemo protocol going. As soon as we are left alone, she brilliantly deconstructs today's discourses about her body. "I'm in better shape than he is," she says as the nurse wheels the chemo cart away.

We spend some time catching up with the field. Who has a new job, whose proposals got accepted at AERA, whose paper just got published and where—"Can you believe that!" And then we stop. Look at one another. We have to parcel out our talk about everything that has happened in the past few months. It's too much to comprehend, too much to feel, too many discrepancies to sort through all at once.

Liz and I have told Mimi of our fondness for Beth, one of her major intensive care nurses at the hospital of the University of Pennsylvania, where Mimi had her second surgery and clinical trial treatment. Beth's daily assessments of Mimi's condition propped us up: "Marilyn is so strong." But Mimi, who hasn't been called Marilyn since she was a child, remembers a different Beth, and tells us of the horror she felt when Beth leaned over her restrained body and intubated mouth: "Come on, Marilyn, you can do it."

Our momentary silence acknowledges that we can never fully know each other's constructions of that intensive care unit, will never fully comprehend each other's perceptions of our radically divergent experiences there. Our nerves and skin remember very differently. As I push Mimi's wheelchair past the lounge chair at the other end of the room, the white-haired woman opens her eyes and smiles at me.

Six weeks later, after Mimi's morning chemo session, Liz, Mimi, and I are at Ancora, our favorite coffee house. We sprawl on couches by the gas-lit fireplace. It's March in Madison. We've just had lunch together, like we always do, and have walked down State Street to enjoy the sun, even though it's only 42 degrees outside. Springtime in Madison. Now at Ancora, we're spinning angles on this manuscript, just as we three have spun

ideas for conference papers and presentations for years. It feels like everything is the same. And not.

V

What do we want from each other
after we have told our stories
do we want
to be healed do we want
mossy quiet stealing over our scars
do we want
the powerful unfrightening sister
who will make the pain go away
mother's voice in the hallway
you've done it right
the first time darling
you will never need
to do it again.

Audre Lorde, *There Are No Honest Poems About Dead Women*

What's left in the field, then, are people with nerves and skin, whose memories, representations, and connections with one another are full of "systemic error, of holes that connect like a tangle of underground streams." Thus we must *work* our relationships to one another if we are to construct and reconstruct the curriculum field as an ongoing and human project, incapable of closure yet dedicated to taking action in order to create what "should be and what might be." To work our selves, relationships, and thus our field, requires "a constant kneading of categories and separations" in order to refuse "fixed and static categories of sameness or permanent otherness" (Ellsworth & Miller, 1996, pp. 246–247). I believe that we can creatively and imaginatively work those relationships most often in the gaps created by tension, rupture, disjuncture—"the controversy among us."

The relationships that constitute "the field" always need to be re-made, always need to be "done again" in ongoing conversation, with "mutual respect" and "regard for each one's competence and integrity." We haven't done it right the first time. We will need to do it again. What's left in the field is the need to remake our work, and our selves, again and again. That we have the opportunity to do so is both the challenge and the gift.

Acknowledgments

This paper is a revised version of the 1999 American Educational Research Association (AERA) vice-presidential address for Division B (Curriculum Studies) at the AERA annual meeting in Montreal, Quebec, Canada. This work benefited greatly from the insightful suggestions and comments of Karen Evans, Craig Kridel, Mimi Orner, and especially my partner, Elizabeth Ellsworth. I also thank Deborah Britzman for inspiring the title segment, "What's left in the field," as well as Jean Anyon, Jean Clandinin, Judith Glazer-Raymo, Maxine Greene, Pat

Hulsebosch, Maureen Miletta, William Pinar, Carol Pope, Paula Salvio, William Schubert, and Patrick Slattery, whose friendship and encouragement supported the writing of this address.

Notes

1. See, for example, John K. Smith's (1997, p. 10–11) discussion of the "balkanization of the educational research community that we are now witnessing." Smith analyzes the disagreements as residing in "the different vocabularies that are being used to tell different stories to ourselves and to others about research and about who we are as researchers." See also William G. Wraga's (1990a) critique of "reconceptualized curriculum studies" as a willingness to divorce curriculum theorizing from school practice; William F. Pinar's (1999a) analysis of Wraga's critique as an example of a political, gendered, and racial text; and Wraga's (1999b) critique of Pinar's "master narrative for reconceptualists." See also Craig Kridel's (1999, pp. 521–522) "The Bergamo conferences, 1973–1997: Reconceptualization and the curriculum theory conferences," where Kridel raises questions about curriculum development for curriculum theorists as having to occur only in a K–12 setting. Kridel poses post-secondary curriculum development in the area of teacher education as a prominent component of the Conference on Curriculum Theory and Classroom Practice, commonly known as the "Bergamo Conference" (see below).

2. See Miller (1990a) for a detailed description and interpretation of the first two and one-half years of the six-member group's research collaboration. Here, group members' chosen pseudonyms are the same as those they chose to represent themselves in that book.

3. I follow Craig Kridel's (1996, p. 41) lead in using the term 'Bergamo' to "represent all avant-garde curriculum theory conferences that have been held in the autumn since 1974," all of which have been sponsored by *JCT* since 1979.

4. See Pinar, Reynolds, Slattery & Taubman (1995), especially Chapter 4, for elaboration on the history and politics of "the reconceptualization" in US curriculum studies.

5. See Pinar, Reynolds, Slattery & Taubman (1995), Chapter 5, for extensive discussion of representative political scholarship by Apple, Giroux, McLaren, and Wexler, among others.

6. I first wrote about my responses to the relationships between the arts and curriculum at the invitation of George Willis and William Schubert (Miller, 1991). With their permission, this "curriculum memoir" section on Picasso's *Guernica* is adapted from that piece, and I thank George and Bill for their support and encouragement.

INTERLUDE 10

Bergamo, October 1991

The two conference session organizers I mention in the opening paragraphs of this next piece were Mimi Orner and Liz Ellsworth. No wonder I was there.

Recently I found, inserted into one of my old journals, my scribbling in that session that motivated the writing of the following essay. Here it is:

"Yellow Paper"

This yellow pad of paper—how many times I've written on this yellow—
cramming my words together and shoving others' versions of what I was think-
ing onto this page. How many hours of writing—my dissertation
written in longhand, on yellow pages like these. I know that eight
of these yellows—short version, not this elongated kind—equals
five typewritten pages. And so I would push to eke out eight pages—yellow
words—every day, day after day, in order to push myself into
my deadlines. I welcomed the process of hand-writing-out
quotations. They used up those yellow pages and I would be
that much closer to my goal—but that much further from myself.

Because I wasn't in
those yellow pages.
Other people were—mostly men—
even though I was writing about another
woman's versions of curriculum.
She quoted men most often.
And so did I
in order to write about what she
wrote about.
What were we both writing about?

Not ourselves—not about how terrible it felt to be filling yellow pages
with words that I thought needed to feed long convoluted sentences, sentences
that would show I knew my way around the field, that I was half-way smart,
that showed I had read and debated and digested others' words.
Where were words for me on those yellow pages?

Words jumped
out of my skin when I
couldn't sleep at night because I
worried
that I wouldn't finish
this writing about
other people's words.
Worried that I had nothing to say.
Now I see that I should have
worried
that they had nothing to say.

I have plenty to say now—about how it feels so scary to say my own words, how
I can't/won't go back on my words now. They are words that at least, if not
totally mine, address what I care about in my teaching and writing and research.
And I want to read and write and laugh and cry about the words that I dream
and then talk about in the morning with the woman I love.

I'm fierce about those words now. I love this yellow paper.

AUTOBIOGRAPHY AS A QUEER CURRICULUM PRACTICE

One evening at the Bergamo curriculum theory conference[1] in October 1991, I attended a very crowded session billed as "(Sm)othering Ourselves: Women Writing as Academics." As the session organizers distributed poster paper, magic markers, tablets and tape to their chatty audience, latecomers jostled for floor space and plopped themselves down in between the occupied chairs. As women and more than a few men settled into the hush that always seems to signal the start of any conference presentation, the two organizers invited us to explore, autobiographically, tensions and contradictions we experienced as women (and men) working in academe. We especially were encouraged to explore ways that our daily living out of required "activities for gaining tenure"—teaching, researching, publishing and service—exceeded, oozed through, spilled over the academic frameworks that typically girded our work. The organizers then gestured toward the materials they had handed to us, the signal to begin composing writings or visual representations of our academic lives.

For twenty minutes, we all wrote, doodled, or constructed collages of our varied lives as "academics." People sprawled on the floor, slouched in chairs, or huddled over the few tables in the room. Some splayed segments of their lives across poster board with purple, green, and yellow magic markers and then stumbled over others' feet, briefcases, and water bottles in order to tape their creations to the walls. Others penned small notes on colored sheets of paper or in lined notebooks. I scrunched down into my gray institutional chair, my left-handed writing supported only by the stiff-backed legal pad of yellow lined paper on which I hastily scribbled.

When the facilitators reconvened the group, they invited us to display our representations or to read from our rough drafts as means to begin discussions about the implications of "excess." Many women and some men read or discussed

vignettes filled with examples of daily lives and identities that leaked out over the edges of university tenure and promotion handbooks and dribbled into class-rooms, research sites, and official forms of scholarly writing. People responded to each reading or presentation with nods of recognition, murmurs, and occasional hoots of laughter.

I listened for a long while, and then suddenly decided to offer a reading of my rough draft, although this was not something that I usually felt comfortable doing in a large group. (Note the irony of my socially constructed English teacher expectations for my own students to freely "share" drafts of their dissertation proposals or research data interpretations.)

I called my piece "Yellow Paper" and in it described the writing, in the mid-1970s, of my dissertation in longhand on the same kind of legal yellow writing paper that I had grabbed for this particular writing event. My theme in this free verse was the distancing of myself from my own work through the mandated use of others' words to support my dissertation thesis. In the last part of "Yellow Paper," I spoke of not wanting to avoid or contain or silence my own words now and of my desiring to share those words with the woman I love.

What was notable, at least to me, about this event was not that I was describing tensions and "excess" created by mandated, distanced, and representational scholarly writing. Nor that I was grappling with issues of authorial authority as a possible fiction, or of women's academic words as only replicating rather than exceeding patriarchal discourses in the university. Without any preconceived intentions, I had queered an "educational" use of autobiography in this session by spontaneously declaring, to a room full of colleagues, friends, and strangers, my new and, until then, fairly private relationship with a woman.

I privileged that particular aspect of my life by reading "Yellow Paper," but, at the same time, my statement did not represent a desire to enact a "modernist tale about how to claim an authentic lesbian identity" (Martindale, 1997, p. 29). I rejected such a modernist tale especially because I was exploring forms of autobiography in relation to Judith Butler's (1992) argument for "permanently unclear" identity categories:

> Identity categories are never merely descriptive, but always normative, and as such, exclusionary. . . . [I]f feminism presupposes that "women" designates an undesignatable field of differences, one that cannot be totalized or summarized by a descriptive identity category, then the very term becomes a site of permanent openness and resignifiability. (p. 16)

I had been working with autobiography as a form of curriculum theorizing and research for a long while. In recent years, I had been wanting to work with autobiography in ways that defamiliarized, or "queered," static categories and versions of my academic, woman, teacher, researcher selves. I wanted to explore autobiography's social and political potential while refusing any one account of identity or experience. I did not want those accounts to become fixed or reified as sufficient for claiming the benefits of "enlightened" agency that humanistic, modernist forms of autobiographical inquiry implied. I wanted to use autobiography

in ways that shifted autobiography in education from its modernist emphasis on producing predictable, stable, and normative identities and curricula to a consideration of "selves" and curricula as sites of "permanent openness and resignifiability."

My ongoing work in autobiography thus provided an incentive and a reason, in the conference session, to tell how my life, my "identities," and my love exceeded the very academic and social normative discourses and frameworks that tried to contain them. My long-term autobiographical work also provided a backdrop against which, at that point in my life, I could queer both the subject and the forms that autobiography typically took in educational settings. I was interested not only in pointing to the "undesignatable field of differences" within identity categories of lesbian, woman, teacher, and researcher, for example. I also was interested in exploring uses of autobiography that addressed and even exemplified performativity, the power of discourse to produce, through reiteration, an "I" that is always coming into being through social and cultural constructions of gender identity and, simultaneously, failing to cohere (Butler, 1993).

In contrast to Butler's theorizing of the political, provisional, and reiterative process of identity formation, many current uses of autobiography in education work against any notion of the "permanent openness" or "performativity" of identity. Such uses reinforce classroom representations of a knowable, always accessible, conscious self who "progresses," with the help of autobiographical inquiry, from ignorance to knowledge of self, other, and "best" pedagogical and curricular practices. Such normalized versions of autobiography serve to limit and close down rather than to create potential for constructing permanently open and resignifiable selves and performative accounts of always changing cultural meanings of "identities."

Further, in the context of such prevalent constructions of autobiography in education, one could use the example of my coming out in an academic context to construct yet another modernist tale: when educators use autobiography in the classroom, we invite all kinds of closet doors to open. But do we? Here, I address what I perceive to be gaps and silences in current constructions and uses of autobiography in education that in particular promise the benefits of "self-reflection" as means to "self-understanding." Such a promise replicates rather than questions tenets of the Enlightenment "I"—the "self" as rational, coherent, autonomous, unified, fixed and given—and therefore capable of working toward complete and conscious "development" and "understanding" of one's "identity."

Because teachers and teacher educators especially are under pressure, in this unrelenting era of standardization of educational practices and student "outcomes," to conform their self-representations to particular and predetermined identity frames such as "the reflective practitioner," their identities often get hardened into rigid, polarized, constitutive categories—the "good" or "bad" teacher, for example. And they duplicate such categorizations with their students.

Instead of looking for explanations or characteristics of autonomous individuals, or demanding conformity to or development of certain attributes, what might happen in educational theory and practice if we were to use autobiography

to "trouble" the links between acts, categories, representations, desires and identities? What possibilities might open if we were to make evident identity's construction in order to create more space for and recognition of the various actions and "selves" performed daily in a social landscape often blinded and hostile to variety (Butler, 1990)?

In asking such questions, I necessarily point to groundbreaking autobiographical work of those involved in the reconceptualization of the curriculum field that produced queer or atypical curriculum theory. I posit some possibilities that open when autobiography is conceptualized as a queer curriculum practice that can help us to dis-identify with ourselves and others: "To dis-identify and to denaturalize, to make one's object un-natural is to strategically produce difference out of what was once familiar or the same" (Greene, 1996, p. 327).

Strategically producing a difference out of what was once familiar or the same about what it means to "be" a teacher or student or researcher or woman, for example, cannot happen by "telling my story" if that story repeats or reinscribes already normalized identity categories and attributes. Further, strategically producing a difference cannot happen if difference is only construed as "binary and oppositional rather than nuanced, plural, and proximate" (Greene, 1996, p. 326). Thus, addressing "self" as a "site of permanent openness and resignifiability" opens up possibilities for queering autobiography, for speaking and writing into existence denaturalized ways of being that are obscured or simply unthinkable when one centered, self-knowing story is substituted for another.

I argue, then, that autobiography as a queer curriculum practice opens potential for "strategically producing difference out of what was once familiar or the same" by making "assumptions and occlusions subject to analysis" (Greene, 1996, p. 325). Autobiography as a queer curriculum practice can cast in new terms the ways in which we might investigate our multiple, intersecting, unpredictable and unassimilatable identities:

> "Queer" spins the term outward along dimensions that can't be subsumed under gender and sexuality at all: the ways that race, ethnicity, post-colonial nationality criss-cross with these and other identity-constituting and identity-fracturing discourses. (Sedgwick, 1993, pp. 8–9)

Rigid and monolithic "identity-constituting" discourses of education and many of its current uses of autobiographical practices, I argue, maintain the status quo and reinscribe already known situations and identities as fixed, immutable, and locked into normalized conceptions of what and who are possible.

Modernist Autobiographical Tales

I have argued thus far that autobiography as a genre of inquiry and writing in educational research and as a method of reflective practice for teachers has become codified in recent years. And the conventions of autobiography, as they have been codified within educational practices such as teacher research and teacher "reflection," are normalizing conventions.

For example, many teacher-educators at both the undergraduate and graduate levels encourage students to write or speak autobiographically in order to "tell their stories" as a way of examining and constructing their educational assumptions and practices. I have taught in graduate programs where students conduct teacher research and are encouraged to write up the findings of that research in narrative form. Their research projects, they are told by many instructors, should "tell the story" of their research processes and resulting individual changes in their classrooms as well as in their perspectives about curriculum, research, and themselves as teachers.

But what I have found is that admonitions to "tell your story" often lead to what I and others fondly referred to as "cheerful" versions of teacher research, in which teachers learn about and then implement new pedagogical approaches and curriculum materials without a hitch. Those admonitions also often impel teachers to craft autobiographical accounts of how they were "mistaken" or "uninformed" or "ill-prepared" but now have become fully knowledgeable and enlightened about themselves, their students, and their teaching practices.

What often gets normalized in such uses of autobiography is a singularity of story that a subject is encouraged to tell about herself as a teacher. Such singularity closes the doors to multiple, conflicting, and even odd and abnormal—queer—stories and identities. What also gets normalized is how autobiography only can be used in education to address a very narrow range of questions, issues, or purposes. Thus, many of the currently circulating uses of autobiography in teacher education and research assume the possibility of constructing coherent and "true" portraits of whole and fully conscious selves, or teachers at least are encouraged to work autobiographically in order to "develop" teacher selves who are always capable of fully conscious and knowledgeable actions and decisions in the classroom.

But consider what normalizing conventions of educational research, practice, and identity are reinforced when educators, consciously or unconsciously, insist on autobiography as a means to conceptualize and to work toward narrow, definitive, conclusive, and uni-dimensional portraits of "developed," "reflective," and thus "effective" teachers, students, and teacher-researchers. Rarely if ever do teacher-educators encourage future or practicing teachers to address issues of, say, sexuality, the body, the unconscious, or desire in relation to conceptions of what constitutes an "effective" or "good teacher." Instead, typical educational uses of autobiography perpetuate a Western history of polarization of thought and feeling, and associate rationality with a disembodied self-consciousness. What gets left out of such normalizing autobiographical practices is the unfixing of the relationship of gender identity to sexed body, or of gender performance to gender identity, for example. Such unfixing could queer not only educational autobiographical practices but also educational identities for the purposes of creating what Butler (1990) argues for: more space for and recognition of the various actions and "selves" performed daily in a social landscape blinded and hostile to variety.

Consider too what normalizing conventions of educational inquiry and practice are reinforced when autobiography is used as means of arriving at solutions

and answers to pedagogical and curricular issues and problems, and when the arrival at a solution through an autobiography is somehow seen as proof or evidence of some fully examined, accessible, and thus "accountable" teacher or student "self" or unit of study or teaching strategy. I worry, then, that many current uses of autobiography in education assume a developmental "end" product as well as possibilities of "best practice" in constructions of teacher selves, curriculum materials, and pedagogical approaches. Conventions of using autobiography in education also assume the possibility of a conclusive self-reflective examination that can illuminate "flaws" or "problems" that can be corrected in one's educational philosophy, pedagogical approach, or constructions of curriculum.

Given rampant normalizing conceptions of school and of autobiography, many students and teachers find no incentive or place to explore how we are situated simultaneously in multiple and often conflicting identity constructions—some of which must be hidden in order to remain in "normal" school. Modernist conventions of autobiography allow no space for exploring the possibilities that might emerge if we attempted to resist the normalizing "identity-constituting discourses" of education and, simultaneously, to create and use "identity-fracturing discourses."

Ironically, however, normalizing uses of autobiography in education also often strike a pose of inclusiveness, as if, through autobiography, all voices heretofore silenced or marginalized can now be heard. Deborah Britzman (1997) speaks of the difficulties in such versions of inclusiveness:

> In educational research it seems as though the more voices, the merrier the field becomes. And while stories of difference proliferate in education, along with the pluralistic desire to count them all, making room for diversity and making diversity a room is not the same as exploring the tangles of implication. For to explore the tangles of implication requires something more than the desire to know the other's rules and then act accordingly. One is also implicated in one's own response. Implication is not so easily acknowledged because the otherness that implicates the self is beyond rationality and consciousness. . . . The question at stake here is not so much that the voices are proliferating but that the rules of discourse and engagement cannot guarantee what they promise to deliver: the desire to know and be known without mediation and the desire to make insight from ignorance and identity. (p. 32)

When only certain stories can be told in certain ways and for certain reasons, even in the name of inclusiveness, what "tangles of implication" are refused or ignored in teachers' autobiographical examinations that assume a "self" that can "know and be known without mediation"? Rather than constituting autobiographical work in education as a means of finding, correcting, developing, celebrating or including one true and authentic self as teacher or student, I instead consider potentials that open when we conceive of autobiography as a queer curriculum practice.

Queering Autobiography in Education

By encouraging an educator to examine disjunctures, ruptures, break-ups and fractures in the "normal school" version of the unified life-subject and her own and others' educational practices, autobiography can function to "queer" or to make theory, practice, curriculum *and* the self unfamiliar. To "queer" is to denaturalize conceptions of one singular, whole, and "acceptable" educator or student "self" as well as versions of autobiography and curriculum and pedagogical practices that rely on such conceptions.

"Queered" autobiography can challenge humanist educational research and practices that normalize the drive to sum up one's self, one's learning, and the other as directly, developmentally, and inclusively knowable, identifiable, "natural." Queered autobiography suggests a focus on a range of sexualities as well as racialized and classed identities that exceed singular and essential constructions of "student" or "teacher," with fixed attributes of "masculine" or "feminine." Autobiography as a queer curriculum practice also compels us to consider "tangles of implication"—how we are implicated in our desires for and enactments of, as well as in our fears and revulsions toward, those identities and practices that exceed the "norm."

Further, autobiography as a queer curriculum practice can intervene in the practice of defining ourselves through already available and legitimized discourses. From queer theory perspectives, such interventions point to possibilities for agency:

> Queers participate in positioning themselves through both authoring and authorizing experience. As lesbian and gay (queer) subjects are located in an evolving discourse that preexists and constitutes them, they are, at the same time, its creative agents. Any claim to a queered perspective is therefore an embrace of a dynamic discursive position from which subjects of homosexualities can both name themselves and impact the conditions under which queer identities are constituted. (Honeychurch, 1996, pp. 342–343)

Such interventions in education could turn the uses of autobiography in education toward examinations of ways in which students and teachers might negotiate the official discursive terrains of schooling that bound the "design and development" of curriculum as well as "identities." By investigating our "tangles of implication" in what we might come to see as contradictory and conflicting discursive constructions, we also might glimpse spaces through which to maneuver, spaces through which to resist, spaces for change (Butler, 1990; Scott, 1991).

Queering Curriculum Theorizing

In a sense, the current rage for autobiography and narrative only gestures toward that which already had been theorized and enacted in the field of curriculum theory and research. Autobiography as a form of curriculum theorizing certainly was regarded as not normal or typical in the US during the 1970s, the time when

some curriculum scholars began to reconceptualize the curriculum field.[2] In particular, Pinar and Grumet (1976), through phenomenological and psychoanalytic perspectives, elaborated Pinar's autobiographical method of *currere* (1974; 1975b). That elaboration enabled examination of relations among life history, school knowledge, and intellectual development, but was regarded by many in the traditional curriculum field as a queer phenomenon. Certainly many still would maintain that autobiography as a form of curriculum theorizing was and is a queer kind of theory, theory that is not normal or typical within the academy, given the positivist or even post-positivist social science frameworks that still gird most theory, practice, and curriculum conceptualization norms in education.

But reconceptual versions of autobiography queered curriculum theorizing in that they directly challenged behaviorally oriented and mechanistic as well as political theories of curriculum that ignored, minimized, or cast in abstraction individuals' lived experience of schools. As such, that work was a major contributing factor to the curriculum field's reconceptualization. However, having participated too in those initial reconceptualist forays into the complexities of autobiography as a form of curriculum theory and research, I find that what appears queer to me now is that curriculum theorizing about autobiography as both method and practice has been ignored in many mainstream versions and uses of autobiography in education.

Perhaps the queer practice of curriculum theorizing through autobiography invited too many denaturalized stories that many educators did not want to hear, stories where official school knowledge, identities, and visions of revolutionary educational practice were exceeded by heretofore unimagined or unarticulated constructions of students, teachers, and curricula. Perhaps autobiography as a queer curriculum practice challenged too directly the limits of a developmental and incremental notion of both learning and autobiography. As such, perhaps queered versions of autobiographical work threatened to dismantle the dominant educational narrative in which one, through linear learning of official and predetermined curricula, passes from ignorance to knowledge about "self" and other.

But an educator who conceives of autobiography as a queer curriculum practice doesn't look into the mirror of self-reflection and see a reinscription of her already familiar, identifiable self. She finds herself *not mirrored—but in difference.* In difference, she cannot simply identify with herself or with those she teaches. In the space she explores between self and other, nothing looks familiar; everything looks a little unnatural. To queer the use of autobiography as a curriculum practice is to produce stories of self and other with which one cannot identify. It is to recognize that there are times and places in constructing versions of teaching, research, and curriculum when making a difference requires making one's autobiography unnatural.

Notes

1. The first conference associated with the reconceptualization of the US curriculum field was held in May, 1973, at the University of Rochester, organized by then

Assistant Professor William F. Pinar. See *Heightened Consciousness, Cultural Revolution and Curriculum Theory* (Pinar, 1974) for the proceedings of that conference. The Bergamo Conferences on Curriculum Theory and Classroom Practice have been held every autumn since 1974, and have been sponsored by *JCT: The Journal of Curriculum Theorizing* since 1979. Following Craig Kridel's (1996) lead, I refer to the "Bergamo" conference rather than its more official title of the *JCT* Conference on Curriculum Theory and Classroom Practice or its various locations over the years. See Kridel's section in *JCT* on "Hermeneutic Portraits" for historical groundings of both the conference and the work of those who have participated in its deliberations. As well, see especially Chapter 4 of *Understanding Curriculum* (Pinar, Reynolds, Slattery & Taubman, 1995) for an extended discussion of *JCT* and its conferences.

2. For extensive discussions as well as annotations of autobiographical curriculum theorizing within the reconceptualization, see especially Chapter 10 of *Understanding Curriculum* (Pinar, Reynolds, Slattery & Taubman, 1995). See also Graham's (1991) account of the importance of Pinar and Grumet's (1976) *Toward a Poor Curriculum* to autobiographical work in education.

ENGLISH EDUCATION-IN-THE-MAKING

In *Playing in the Dark: Whiteness and the Literary Imagination*, Toni Morrison (1992) writes about the construction of "literary whiteness" and "literary blackness" and the consequences that those constructions have had on US writers' literary imaginations. Through her readings of several texts, Morrison shows how their writers' assumptions of the "whiteness" of American fiction readers have posited their literature as "free of, uninformed and unshaped by the four-hundred-year-old presence of, first, Africans and then African-Americans in the United States" (pp. 4–5).

Such assumptions of "whiteness," Morrison claims, have sabotaged various American writers' imaginations. She shows how racially inflected language and literary strategies have made writers such as Cather, Hawthorne, Hemingway and Melville unable to enter, imaginatively, the lives of African Americans, and to write about those lives meaningfully and responsively. Morrison engages in a serious intellectual effort to see "what racial ideology does to the mind, imagination, and behavior" (p. 12) of these and other authors who "choose to talk about themselves through and within a sometimes allegorical, sometimes metaphorical, but always choked representation of an Africanist presence" (p. 17).

Morrison, writing as an African American woman in a "genderized, sexualized, wholly racialized world," thus explores her interest in "what disables the foray . . . into corners of the consciousness held off and away from the reach of the writer's imagination" (p. 4). She argues that for a writer, writing and reading

> require being mindful of the places where imagination sabotages itself, locks its own gates, pollutes its vision. Writing and reading mean being aware of the writer's notions of risk and safety, the serene achievement of, or sweaty fight for, meaning and response-ability. (xi)

Morrison's powerful work compels us, as teachers of writing and reading, to work with our students to identify what Morrison calls a "willful critical blindness"—those "habits, manners and political agenda" (p.18) that have contributed to an objectified Africanist persona as "reined-in, bound, suppressed, and repressed darkness" (p. 38–39). In order for us as English teachers and English educators to expose these and other literary sites of "willful critical blindness," we also must be aware of places where our own pedagogical imaginations may have been sabotaged as well as sabotage, may have been polluted and pollute our visions of what it could mean to read and write, teach and learn across social and cultural difference.

As detailed recently (Callahan, 2000; Davis, Sumara & Luce-Kapler, 2000; Mayher, 1999; Slattery, 1995; Tremmel, 2000; Vinz & Schaafsma, 2000; Young, 2000), some of that sabotage and pollution may result from conflicts, bifurcated emphases, and external pressures for standardization and accountability that currently characterize the teaching of English/language arts and the field of education, writ large. Thus, our fragmented, overloaded, constrained and "normalized" pedagogical imaginations indeed might pollute our visions as English educators, teachers, and researchers. Especially in the press for standards, accountability, and standardization of curriculum and teaching, we easily may lose sight of ways in which reading and writing in the English classroom and teacher education sites can challenge static and stereotypic constructions of "literary whiteness" and "literary blackness," for example. Such constructions erase or objectify or polarize the presence of difference, not only in literature but also in the classrooms where we teach and learn.

Thus, the very pressures to conform, especially to what Mayher (1999) calls "the traditional path of skill and drill instruction and the transmission of the cultural heritage" (p. 118), should impel English teachers, English educators, and our students into a daily "sweaty fight" for "meaning and response-ability," if we indeed intend to respond to particular needs and interests of diverse students in local contexts (Tremmel, 2000). For, it is the very concept of a situated and thus contingent and constantly changing "sweaty fight" for meaning and response-ability that points to the field of English education as always in-the-making.

For example, English education can be conceived as in-the-making in the sense that our knowledges as well as our teaching and learning selves are always positioned by and positioning, framed by and framing specific yet differing and always changing contexts and discourses:

> Language is the place where actual and possible forms of social organization and their likely social and political consequences are defined and contested. Yet it is also the place where our sense of ourselves, our subjectivity, is *constructed*. . . . Subjectivity is produced in a whole range of discursive practices—economic, social and political—the meanings of which are a constant site of struggle over power. . . . [Subjectivity is theorized] as a site of disunity and conflict, central to the process of political change *and* to preserving the status quo. (Weedon, 1987, p. 21)

One aspect of conceiving of our selves as in-the-making revolves, then, around the notion of identity as a reiterative process of coming into being and simultaneously failing to cohere; one way of engaging in the "sweaty fight" for "meaning and response-ability" is to make evident identity's construction, to "trouble" the links between acts, categories, representations, desires and identities (Butler, 1990, 1993, 1999), to disrupt the normative and controlling status quo. We are in-the-making, then, in the sense that our pedagogical, professional selves—our multiply inflected and constructed identities as gendered, raced, classed selves, for example—are always "sites of disunity and conflict," unfinished and incomplete, in part because we must respond to differing and disunified contexts, individuals, and historical moments at the same time that we often are required to respond to normative demands for similar and "acceptable" performances of our students' and our own selves.

Thus, given the drive to categorize, predict, and control both students' and teachers' behavioral and curricular "outcomes," a conception of English education in-the-making highlights as daily work an "ability to respond" to curricular and classroom texts and unpredictable performances of social and cultural difference as well as to pressures for standardized and predetermined objectives. At the same time, English education in-the-making acknowledges the necessity of plural, culturally situated responses (Corcoran, 1994) because of textual as well as contextual contradictions, gaps, changes and silences in students' and teachers' daily constructions of meaning. It calls attention to those very constructions of meaning as always situated in language that "unwittingly writes us" (Felman, 1993, p. 157). And it calls attention to the "difficulty of the teacher's and students' positions in a classroom where we can take neither similarities nor differences for granted, which is to take them as 'natural,' as something that goes without saying, rather than as something constructed by the very dynamics of our engagement" (Caughie, 1992, p. 791).

A conception of English education as always in-the-making also suggests that teachers and teacher-educators will insist on students' and teachers' awareness of "risk and safety" in their constructions and deconstructions of meanings and identities in classrooms. It gestures toward ways of meeting stories of social and cultural difference with "response-ability"—that is, with shiftings in how we as teachers, students, and teacher-educators perceive our "selves" and others' "selves" so that we do not simply incorporate or appropriate "others" and their stories into the ones we already and always have been telling about ourselves or "them" (Ellsworth & Miller, 1996). Thus, English education in-the-making suggests a program where both teachers and students take on responsibility for the meanings they make, understanding all the while that the meanings and categories by which we typically comprehend and live our daily existence can be altered (Butler, 1990).

Difference in-the-Making

I've come to this conception of English education in-the-making because, ironically, the only constants in my professional life are changing and shifting versions

and constructions of my "selves" as English teacher, educator, researcher, woman, partner, writer and learner. In multiple configurations, I have had to challenge each of these as "fixed" and permanent categories and to re-form around and through the constantly changing "dynamics of engagement" in classrooms and with/in my selves. Many times in my teaching career, I've longed for the comfort of sameness and unity in my pedagogical and research identities and methodologies as well as in students' responses. But difference intervened.

In order to not simply engage in "willful critical blindness" about difference in my classroom or to conceive of difference "through static categories that tend either to polarize and dichotomize or to 'alleviate' difference by emphasizing commonalities and similarities" (Ellsworth & Miller, 1996, p. 248), I've had to work to understand that exclusive and absolute categories can function to "position something or someone as permanently 'other'" (Marshall, 1992, p. 193). For example, in humanist epistemology, which insists on absolutes,

> difference is always understood as the difference between one particular, individuated subject and another—one particular, unique category and another. "Difference between" constructs identities by delineating the clearly marked boundaries between coherent entities or individuals that are self-same, identical with themselves, in their difference from the other. . . . Difference *between* is a quest for certainty. The contestation of postmodernity with "difference between," then, is the contestation with certainty—with the unshakable grounds and foundations which give the traditional humanist epistemology a basis from which to know the real in a "decidable" manner. (Ebert, 1991, p. 892)

Most English teachers and English educators work within schooling structures and institutions that promise, even demand, certainty in terms of assessment of students' and teachers' performances and academic achievements. The educational establishment bolsters that air of certainty with the press to label, categorize and track students and now teachers with performance-based standards that still reinforce hierarchical rankings, that still focus on the "difference between." Through such sortings that drive toward certainty for classifying both students and teachers as "above" or "below" what is considered the norm, or "the best," some will always be "positioned in closer proximity to 'truth' depending on their relation to other terms of value: gender, class, race, and sexuality, among others" (Gilmore, 1994, p. 107).

I believe that we therefore must enact a concept of English education in-the-making that exposes categorizations and labels as constructs of certainty. As such, these constructs in particular shape educational identities that are presumed as permanent and un-changeable—and that therefore could be positioned easily as "other." We must argue, instead, that identities are continually constructed within particular social and cultural contexts, are assumed, and, at the same time, immediately called into question (Gallop, 1982). And we can use the fluidity of identity and difference as a resource for revealing, interrupting, and reconstructing meanings of labels and power relations that could otherwise position our students and ourselves within static, fixed categories that limit possibilities for all (Ellsworth & Miller, 1996).

Autobiography in-the-Making

My autobiographical work to theorize my "selves" as unfinished, and to consider both identities and difference as fluid, initially was grounded in reconceptual curriculum theorizing that challenged any definition of curriculum as only predetermined and prepackaged versions of knowledge.[1] Such curriculum theorizing posits, in part, that

> curriculum is not comprised of subjects, but of Subjects, of subjectivity. The running of the course is the building of the self, the lived experience of subjectivity. Autobiography is an architecture of the self, a self we create and embody as we read, write, speak and listen . . . [it] is a self we cannot be confident we know, because it is always in motion and in time, defined in part by where it is not, when it is not, what it is not. (Pinar, 1994, p. 220)

Further, that theorizing utilized autobiography as a method of curriculum research:

> The narrative, an autobiographical account of educational experience, serves to mark the site for excavation. What is returned in the process of excavation is hardly the original experience but broken pieces of images that remind us of what was lost. What is restored is our distrust of the account, as the experience, pieced together and reassembled, fails to cohere. There in the interstices, the spaces where the pieces don't quite meet, is where the light comes through. What the restoration returns to us is doubt in the certainty of our own assumptions. (Grumet, 1981c, pp. 122–123)

Thus, in order to engage in the "sweaty fight for meaning and response-ability" in relation to constructions of identities and difference, I, like others (Britzman, 1992; Clandinin & Connelly, 2000; Grumet, 1990; Pagano, 1990) push myself and my students to tell situated and multiple stories of our educational experiences of teaching, learning, and research. But I also push for us to then immediately call into question the "certainty of our own assumptions" as well as the languages that we have used to tell even multiple and situated stories. We must attend to how those discourses, in part, construct our "selves," our "experience," and our "differences." By working autobiographically in ways that do not reify or glorify a unitary, linear, and always fully conscious "self," or a concept of language as fully transparent, English teachers and educators also can help students challenge humanist notions of "experience" as well as the reified meanings we often make of "what's really happened" in our educational lives. We can do so by calling attention to a notion of "experience" and the meanings we construct from that experience as never located outside language, never beyond need for interpretation (Scott, 1991).

For Felman (1993), the conscious and unconscious frames of reference from which we construct our autobiographies, our subjectivities, our curricula certainly are never transparent: "We can neither simply 'write' our stories nor decide to write 'new' stories, because we do not know our stories, and because the decision to 'rewrite' them is not simply external to the language that unwittingly writes

us" (p. 156–157). Thus, we need to attend to intertwined complexities of language and subjectivity:

> For this "I" that you read is in part a consequence of the grammar that governs the availability of persons in language. I am not outside the language that structures me, but neither am I determined by the language that makes this "I" possible. This is the bind of self-expression, as I understand it. What it means is that you never receive me apart from the grammar that establishes my availability to you. (Butler, 1999, p. xxiv)

So, if we do write multiple and situated stories of ourselves as educators and immediately call those into question, rather than try to create just one summarizing "true" autobiographical rendering, we also must wrestle with those still normative meanings and identities that society, history, cultural conditioning and discourses have constructed for us as well as those that we have constructed or perhaps unconsciously assumed. We might analyze ways that predominant educational discourses as well as social and cultural norms have influenced and framed our versions of our selves as English teachers, educators, learners. We might also analyze the multiple and sometimes contradictory or exclusionary ways we embody and perform our socially constructed identities as we interact with schooling conditions and structures that attempt to standardize us all. We might even dislodge the normative and unproblematized notion of "experience" as a founding basis for our pedagogical decisions and practices.

But traditional forms of autobiographical work in education often still assume a linear, developmental "self"—what Bergland (1994) describes as "an essential individual, imagined to be coherent and unified, the originator of her own meaning" (p. 134)—as well as transparent notions of language and experience. I'm convinced, however, that current autobiographical work in education instead should posit what Bergland describes as a "postmodern subject—a dynamic subject that changes over time, is situated historically in the world and positioned in multiple discourses" (p. 134). Such a conception could avoid or at least interrogate the proliferation of "teachers' stories" in education that offer unproblematized autobiographical renderings that assume a "factual" and "true" recording of memories and experiences and that often represent "selves" as whole, found, celebrated or ultimately transformed. As Felman (1993) reminds us, such forms of autobiography do not recognize their own social construction and cultural conditioning, nor do they call attention to interpretations as always incomplete, always interminable.

Autobiography in-the-making, then, includes multiple tellings, multiple questionings of those tellings, and multiple angles on representations of "self" that give strategic leverage on two central questions that frame a notion of English education in-the-making: (1) As a teacher, as a teacher-educator, how will I respond to students' and colleagues' identities and responses that deviate from the "norm" or that are different from "mine?" And (2) how will I respond to educational discourses and practices that function to position some as permanently

"other," knowing that, at the same time, I am always caught up in the very languages and resulting practices that I wish to challenge?

So, I will not use autobiography here to delineate completed, wholly conscious, and linear representations of my "experiences" as a high school English teacher and later university professor and researcher in order to exemplify my unified and "fully-developed" self. Rather, I use autobiography as also in-the-making, as one means of grappling with multiple versions and questions about various constructions of my identities *as* English teacher, teacher-educator, researcher, curriculum theorist, writer, partner, feminist, woman who struggles to not close down, in the press for standardization, around "certainty," or around only one definition or enactment or identity category of the English teacher-educator I think I should be.

Response-ability in-the-Making

As a beginning high school English teacher, I felt constrained to teach for the test, to cover the curriculum, to fill in the blanks—in short, to prepare my students for what was coming next rather than to respond to what was happening in our classroom. What was on the horizon for many of my high school students in the upstate New York school where I taught was the end-of-the-year standardized test called "the Regents," followed by a senior year of literature study that would "prepare" them for university studies. For another group of my high school seniors, what was coming next was initiation into their parents' labor in the town mills and factories and construction sites that dotted the craggy landscape of that town perched on the edge of the St. Lawrence Seaway.

My own perceptions of the potential for engaging students in the work of the English classroom were fueled by my love of reading and by my senior-year high school English teacher, Miss Biedle,[2] who engaged us in student-and-response-centered activities before they ever were deemed "best practices." But during the two days of new teacher orientation for my first teaching position, my department chair handed me a copy of the Regents review book and said: "This is how we all start out the year. Just have your students complete about three practice Regents exams during the first few weeks, and then you'll see what you have to do for the rest of the year."

Confronted by this officially mandated, test-driven, and dissected approach to the subject of English, I tried to justify the required distancing from my own passions for learning in order to sustain a curriculum and pedagogy that kept students from theirs. But I did so with a deep sense of loss and frustration—loss of the space, time, and official sanction to explore and share with my students the love of literature that had propelled me into this teaching career, and frustration at the implicit requirement, fostered by the ever-present threat of the Regents exam for many of my students, that we only take what Louise Rosenblatt (1978, 1988) terms an "efferent stance," reading primarily for the information provided.

To have students take an "efferent stance" in relation to the literature we studied often meant that I had to employ "correct answer" worksheets and "end

of the chapter" questions that decontextualized and fragmented both language and literature. It often meant that I had to push students toward the Regents version of a New Criticism close reading of the text's language. To reinforce such readings, the only non-worksheet strategy I could think of was to have the students form teams—a sort of relay-race approach to the literary terms and identification drills that filled the review book. Which team could name a particular author's uses of techniques such as figurative language, point of view, meter and rhyme, for example, and could fill in the blank in the quickest time?

Firmly ensconced in my new teaching job in 1966, I so wanted to teach literature to my high school students via Rosenblatt's (1938, 1988) transactional theory that posited no generic readers or generic interpretations but only innumerable relationships between readers and texts. But what I found in my college-bound English classrooms was that I could only begin to enact Rosenblatt's transactional theory of literature by teaching in the cracks between the skill-oriented and our lived curriculum.

Thank goodness there were cracks in the official curriculum and predetermined objectives through which my students and I could connect the words that we were studying—in separate literature, composition, vocabulary, spelling, usage and grammar lessons—to our selves, to one another, and to the world around us. For example, the big hard-backed literature anthologies that students lugged to class everyday emphasized chronology and genre, an organization and emphasis that supposedly supported my teaching and my students' learning of literature. But my students' flat, perfunctory answers, and my frustration and boredom in reviewing their answers, propelled me to stop using those incessant questions located at the conclusion of every short story, or poem, or essay or play contained between those hard covers.

Instead, my eleventh-graders laughed, jostled, and bantered with me and one another as they eagerly practiced their small group dramatizations of Emily Dickinson's "A Bird Came Down the Walk" or their favorite, "I Heard a Fly Buzz When I Died." Seniors in my modern literature classes propelled one another around the room as they blocked out their upcoming video shoot based on their high school versions of existential themes we studied in Camus's *The Plague*.

My students were not necessarily intent on mastering the literature anthology's elaborate notes and introductory comments on authors, or the literary devices those authors employed in their short stories or poems. Nor did my students seem to read *Hamlet*, *The Scarlet Letter*, or *Giants in the Earth* with intentions of fulfilling the implicit moral purpose of English teaching in the 1960s—what John Mayher (1990) has described as "the assumption that reading the great works of the literary canon would enrich the spirit and enlighten one's tastes as well as sharpen the mind" (p. 16). Rather, they were intent on responding to and interacting with our texts, with one another, and with what was happening in our town and in the world around us (Lesko, 2000), no matter what the moral and pedagogical purposes of English teaching implied. And I had to respond.

So even though reader response theories, the writing process movement, Stanley Fish's notion of interpretive communities, or Miles Myers's translation/

cultural literacy model did not inform the mid-1960s to mid-1970s versions of English education that I enacted with my high school juniors and seniors, I had to respond to my students' insistence on abandoning our stiff desks and taking action on what we were reading and writing. Students let me know that they had to interact with each other, with me, and with the ideas, symbols, and literary devices we had studied in order to relate what we were studying to what they were thinking about and wishing for and questioning in that small and often frozen New York town on the rocky shores of the St. Lawrence River.

My pedagogical awareness that kids had to stand up, move around, talk with one another about literature as well as vocabulary words, grammar drills, the spring prom and last night's basketball game emerged on the cusp of paradigm-competing work in the field of English education. The conceptual framework for improving English teaching in response to Sputnik was prepared by a Commission on English in 1965, the year before I started to teach high school English. That document, *Freedom and Discipline in English*, endorsed what Commission members referred to as the tripod curriculum of literature, language, and composition study.

But Commission members, mostly higher education professors appointed by the College Entrance Examination Board, paid little attention to how these three areas of English study were to be integrated in classroom teaching. The very structure of the report separated the three subject areas, and posited the teaching of high school literature as mirroring the study of literature in universities (Mayher, 1990). That document thus ironically reinforced the New York State Regents exam's separations of the subject of English into units of content and skills and justified the English Regents exam's emphasis on an "efferent stance" in order to fulfill the traditional information processing goal of a decoding/analytic literacy (Myers, 1996).

The Dartmouth Conference in 1966 gathered US English educators together with their peers in Great Britain. John Dixon's subsequent book, *Growth Through English* (1967), advocated for a "personal growth model" rather than a skills or cultural heritage model. Dixon's report centered the focus for language education on the individual language learner. A further dimension of the personal growth model of English was its insistence on imagination and creativity as vital parts of the linguistic and human capacities of all learners. As well, that model insisted on the inseparability of the cognitive and affective domains. In many ways, this all sounds much like the "experience" curriculum proposed by Dewey and the progressives of the 1930s and supported by NCTE in Hatfield's 1935 document, *An Experience Curriculum in English*. But one difference that prevented this model from being defeated by advocates of decoding/analytic literacy was that Dixon argued for writing as a creative process that contributed in significant ways to individual and social development. That emphasis provided momentum for the whole language and writing processes movements—but only after I finally left the high school classroom. I departed both loving the interactions with my students and hating the fragmentation of daily demands to juggle students' desires and needs, my love of literature, and a still-mandated and separate subject approach to

the teaching of English that ignored one of Dixon's (1967) main points: "Language is learned by operation, not by dummy runs" (p. 13).

Few of the shifts induced by the Dartmouth Conference from content-centered to student-centered pedagogies or Rosenblatt's transactional theory had begun to infiltrate English as officially prescribed in the high school where I taught from the mid-1960s through the mid-1970s. Certainly the later post-structural critiques (Gilbert, 1988; Patterson, 1990, 1992) of the "personal growth model" that gestured toward a conception of "student" as "subject" who is constituted as a meaning-maker of a particular type by the practices that are available to her at specific points in time and space were not yet an issue in constructions of English classroom pedagogies. But my then-situated pressures to "teach for the Regents" in linear, compartmentalized, similar and repetitious ways across all of my classes were shattered by the students themselves and their refusals to sit still and receive my interpretations of the literature we were studying, or to endlessly practice composing their literature essays that had to begin with Regent exam words, "In literature as in life. . . ." Many of my eleventh-graders interrupted our practice essay time in order to ask: "Whose life are they talking about?" I began to realize that their bodies, their emotions, and their minds had to be engaged, or else the giant hands on the industrial-sized clock on the wall above my desk would freeze, suspending us all in English-class hell.

So, I smiled from the back of the classroom as Jim leaned his football-captain body against the blackboard, rested his hand on the chalk tray, and murmured, "Hello, Daisy" to his fellow seniors as they pulled *The Great Gatsby* from the stack of texts they carted from one classroom to another. And my sixth-period modern lit students and I then had to call for Jimmy's daily performance of Gatsby throughout our reading of Fitzgerald's novel. Not to do so would have been to ignore the very human connections that we had forged in spite of the teacher-centered, skills-oriented curriculum and pedagogy that then dominated New York State's version of the subject of English.

The Spaces In-Between

But I was a different teacher in another class that I taught at the end of the day. That class was labeled as English 12D on my grade-sheet—D is for 'dumb,'" one student announced to me on my first day in that class. My seventh-period pedagogy, just like all my teaching, was informed and shaped by specific cultural contexts of that small upstate New York town. As well, it was formed by the institutional structure of a typical small town, working and middle class, predominantly white high school classroom in the US that included tracking as a general practice and that still advocated, through its standardized testing, an approach to English that favored the decoding/analytic model of literacy. Within those structures, I tried to create spaces for all responses to and interactions among curriculum, students, and myself.

But I was stymied by the relational and experiential tensions between the plant managers' kids who lived on Mortgage Hill and who were students in my

modern literature classes, and the plant workers' kids who lived at the bottom of that hill, or on the Mohawk Indian Reservation six miles down the road, who were my students in English 12D. The only way I could think of to get those seventh-period seniors to even enter my classroom as the modern lit seniors were leaving was to find paperback novels that they could carry into class. These paperbacks replaced the student editions of *Reader's Digest*, the school's mandated English "curriculum" for these students who had been grouped as the D section for all their academic classes since ninth grade.

The paperback books weren't enough, of course, to change those 12D students' beliefs about themselves that years of labeling had solidified. They couldn't easily read the paperback versions of *Ethan Frome* or *The Red Badge of Courage* that I had dug out of the English department storeroom. Nor did they see any reasons why they should read these texts. And I didn't know how to respond to their rejection of themselves as readers and writers or to their disdain for literature that they felt did not touch their lives. They knew that soon they would be working in the mills next to their mothers and fathers, or swinging high above the St. Lawrence River, building bridges with their fathers and brothers, or short-order cooking in the local diner. "Just teach me to read these recipe cards, so that I can get a job," Sterling said as he shuffled his note-cards in my face. "I want to be a cook."

Once again, I set aside the "cultural heritage model" of teaching literature, but this time, we set aside the paperback novels as soon as I closed the classroom door on the departing modern literature seniors. Instead, we worked on whatever skills the 12D students thought they needed in order to pass their vocational courses for their high school diploma program. And because I did not know any other way to respond, that work often ended up as worksheet drills, recitations, fill-in-the-blank vocabulary tests and spelling bees—dummy runs. Five of the twelve students in the 12D track did not graduate at the end of that first year of my professional English teaching life.

In some ways, these fragmented, contradictory, and stymied English teacher experiences and memories could allude to a gap between how I was inspired by language and literature in my own academic life and how that inspiration was tempered by routine, by numbers of students, and by debilitating structures of tracking. Or they could allude to a gap between thirty-five years or more of English educators' research that commends student- and response-centered curricula and pedagogies and the still-dominant skills-oriented, content-focused symbolic order in secondary education. But my contradictory experiences and memories also could allude to how my responses to students (and to their differing life-contexts and situations) varied according to what I myself had lived through as a student and, thus, still expected as constituting subject English. My responses varied according to the range of practices available to me at the time, including a strong humanist conception of individualism, especially promoted through "personal growth" pedagogical practices that were just coming into vogue; they varied according to my just-beginning sense that students of different

genders, races, social classes or religions, for example, might be located and positioned differently by both the texts and practices of my classroom.

Yes, in some ways, I still did teach within and between the cracks of mandated and unspoken expectations for predetermined and teacher-centered curriculum and teaching strategies. But I was able to pry open those cracks more readily for the students with whom I shared social, cultural, and academic backgrounds. So, daily, between sixth and seventh periods, in the momentary lull that signaled the modern literature students' departure and the English 12D students' entrance into my classroom, I had to face the bifurcated English teacher I denied I could ever become.

The differentiated processes that I engaged in with my students during that time cannot be understood only as mandated, or as additive, or as separate from one another, or as static. As a teacher, I did not move simply between sites of skill acquisition or student response. Instead, all of these processes in which I engaged differently with different students simultaneously rubbed up against each other. They (and we) interrogated one another because they (we) were never fully separated or finished or fully known.

For, the teacher or researcher can never fully know her "self" nor her students nor what she teaches or researches, and can never fully control or predict what is learned. What is learned varies with and within each teaching and researching setting and clearly is framed and influenced by social, cultural, historical and economic contexts, discourses, and identities. At the same time, both teaching and learning can unpredictably erupt in the cracks between officially mandated curricula and pedagogies and the differing realities of daily lives. As Ellsworth (1997) notes: "At the heart of teaching about and across social and cultural difference is the impossibility of designating precisely what actions, selves, or knowledges are 'correct' or 'needed'" (p. 17).

Thus, the indeterminate, culturally situated, and unpredictable processes of teaching, learning, and researching indeed can provoke the "sweaty" and interminable fight for meaning and response-ability. But not having had the beneficial experiences of grappling with "critical teaching incidents" (Vinz, 1995) in my English preparatory program that could have at least alerted me to the "multiple and contradictory forces that shape real teaching situations" (p. 203), I left the English high school classroom hardly knowing that I had only just begun that fight.

English Education as Response-ability in-the-Making

English education in-the-making, then, alludes to curriculum, teaching, and researching practices that are situated within and take into account specific and thus often unrepeatable moments, contexts, situations, discourses, identities and social and cultural relations of similarity and difference. It conceives of curriculum and teaching not as technologies constantly driving toward definitive, repeatable strategies but as performative acts that allude to the provisional and political nature of identity formation (Butler, 1993) as well as curricular and pedagogical

creations. It conceives of curriculum and teaching as performative acts that can make a difference in the moment. As feminist theorist Peggy Phelan (1993) argues, curriculum and teaching conceived as performative acts would honor "the idea that a limited number of people in a specific [classroom] time/space frame can have an experience of value which leaves no visible trace afterward" (p. 149). There may be no achievement score raised, no journal entry written, no homework assignment or worksheet completed, no behavioral objective met, no Regent exam passed, no "excellent student" certified as a result of a particular teaching and learning experience. And yet something of value has happened in that classroom.

Further, a concept of English education in-the-making sanctions a kind of questioning that, in turn, provokes another response between teacher and student rather than an answer. It makes it possible to formulate questions and practices that enable us to challenge the "stuck places" in our work as teachers, students, administrators and researchers with questions that, in the very process of their construction and articulation, move and change our learning, teaching, and research (Ellsworth, 1997; Henderson, Hawthorne, & Stollenwerk, 2000). In responding to those moving questions, we take on responsibility for the positions and identities we momentarily construct and argue from.

By extension, we, as teachers and teacher-educators, can encourage our students to take responsibility for what meanings, identities, and relationships they too construct in a classroom and for examining what discourses have enabled or constrained those meanings, identities and relationships. Further, we must teach our students that, as teachers and researchers in the English classroom, they too must respond to whatever readings they and their students and colleagues make out of the multiple interpretations any encounter with a text of content or classroom interaction makes possible.

But a conception of English and English educator-researcher in-the-making also includes a commitment to reflexivity, to the act of "turning back to discover, examine, and critique one's claims and assumptions in response to an encounter with another idea, text, person, or culture" (Qualley, 1997, p. 3).

English Education as Culture in-the-Making

Another autobiographical telling here points to particular ways in which my pedagogical and research imagination often "sabotages itself, locks its own gates" against the "sweaty fight for meaning and response-ability" in relation to difference. It points to the effects of blind spots, silences, crossed purposes and conflicted versions of identities on the quest to question and change repetitious, habitual, or deferred responses, and it forces me to critique my claims and assumptions about English education in-the-making.

I served on a team of qualitative researchers that, for three years, studied five US high schools, located in different parts of the country. All of the schools were involved in whole school change processes. Like my team members, I observed, shadowed, and interviewed the same groups of teachers, students, administrators,

parents and community members for one week during the fall and the spring semesters for three consecutive years. On this particular visit, I was again observing Ginny, an English teacher and a member of one of four English and history interdisciplinary teams who taught heterogeneously grouped ninth through eleventh-graders. From my field notes, in the third year of the three-year study:

Ginny sits on a stool in front of the rows of students and reads aloud from Nadine Gordimer's short story, "A Chip of Glass Ruby." She then drills the students: who are the main characters, what's the setting, what's the first plot point. On my laptop, I type her comments and questions to the students: "Don't worry about reading, just listen to me and write down what I put on the board." "What are some of the test questions I could ask you here?" "Could you write a good character description?" Students scribble in their notebooks as Ginny talks.

Then, abruptly, Ginny tells the group to close their literature anthologies and to open their vocabulary books. She reads through the week's assigned list of twenty words and directs the students: "Write a sentence for each of these words." The noise level in the classroom increases as students begin to mill about the room, work in tandem with their desk mates, or form small groups. Ginny strolls over to my observation post at the back of the room and murmurs to me: "These kids will move now when the bell rings. There's no way we'll keep them for two hours."

And indeed, at the sound of the bell, these students exchange classrooms with a group coming from history class right across the hall. All these students were to have been taught for a two-hour block by the interdisciplinary team of Ginny and Mr. Herbert Green.

As this new group enters the classroom, Ginny tells them to finish their sentence diagramming from the day before, and then move on to their vocabulary words.

Ginny tries to catch me up with the latest news by pulling me aside to tell me that her teaching team decided to homogeneously group their ninth-graders this year. The team's teachers agreed, she said, that it was ridiculous to move the ninth-graders on without basic skills in English and history. (I keep my smile, even though I'm surprised at this major disruption in the school reform interdisciplinary structure that all faculty members in this school, five years ago, had voted unanimously to support).

Ginny interrupts her discussion with me to prompt a student who has asked a question: "First, find your prepositional phrases, and what's left is what you work with for subject and verb."

After class, I walk with Ginny to the faculty lounge. She continues her explanation of the team's decision: "We're pulling our team out of the integrated curriculum program. We've had it with this school's so-called reform. We want to make sure these kids get the basics, you know, grammar and sentence construction and history in chronological order. And we think that a lot of kids will want to choose our team because they really want to learn. Some of the other program teams think we are ruining the intention of the reform effort. But we want to

work with kids who want to learn, and we think more direct teaching is the way to go. So, will we become exclusionary, in terms of the students we'll recruit into our team, like some teachers are accusing us? Well, let's face it—lots of the Hispanic kids and their parents just don't value learning as much. I don't think they'll particularly want to choose our team. That's OK, we want kids who want to be challenged to have that chance."

In the same school later in the day, a young Latina stares at me for a long moment after I ask her, during our regularly scheduled interview session, what and how she learned well in school recently. This is a prescribed protocol question that I'm to ask each of the students I shadow and interview this week. "I'll tell you what I learned well this weekend. There was a big party for all the sophomores. But only Anglos were invited."

Nothing in my official protocol questions or probes encourages me to follow up on either of these incidents or particular learnings.

Now, in a certain sense, I've just told this research story as a "constrained" researcher, as a researcher who is "outside" this school's particular social and cultural contexts and thus as one who is almost absolved from response. I could also tell this story as one who subscribes to a construction of qualitative researcher who lets data "speak" by functioning as a "stable observer" who "captures" lived experience and produces written slices of "reality." I could also tell this story as one who subscribes to a specific theory of social justice and liberation and who thus can account for this teacher's actions and what she needs to do to liberate herself and her students. Or I could tell this story as a teacher who knows now that, in her own secondary school teaching experiences, she did not know how to respond at all.

Obviously I subscribe to versions of qualitative research, curriculum theorizing, and English education in-the-making that require me to re-work and rewrite and re-search any particular situations and identities of research or curriculum or English education discourses and practices that would universalize, or categorize, or refuse the "sweaty fight for meaning and response-ability."

Yet I didn't respond to Ginny's comments, and I can't tell this story as an English teacher-educator-researcher who didn't know the difference, so to speak. What response-ability did I have to interrupt Ginny's constructions of students who "value" and "don't value" learning—her constructions of approaches to learning that permanently "othered" all Hispanic students in her classrooms? To her constructions of a separate-subject and skill-oriented English classroom? In what ways did my own lack of response as a high school teacher to a fragmented English curriculum as well as social and cultural difference haunt my reactions to Ginny's English teaching and her constructions of students' identities and desires for learning?

I believe that we can and must construct teacher preparation programs that provide theoretical and contextualized reasons that teachers should respond to difference. The trick is that such response-ability cannot be prescribed or mandated because of contingent and shifting "meanings" of identities, contexts, and

relationships among students, teachers, and texts in the classroom. The production and performance of meaning is always culturally, socially, and historically located as well as mediated by and through language. Thus, no response can ever be totally inclusive of all possible constructions of meaning around an issue, text, or identity. Sometimes, still, there is no response at all.

But (I tell myself in the hall as Ginny disappears into the teachers' lounge), we need not become paralyzed by the "incomplete" stories and responses that our reading, writing, and research projects have illuminated. We must consider as a daily challenge the "sweaty fight" to develop highly situated responses in the moment, even as we know our responses always will be partial and incomplete. English in-the-making does not take us off the hook in a nihilistic way, as in: "There's no final answer, so there's nothing I can do." Rather, a construct of English education in-the-making puts us as teachers and researchers *on* the hook, for every pedagogical and research action is a choice, and we daily must choose to be response-able for those choices. By asking "how *will* we respond?" we also must realize that

> a most impoverished form of response is repetition—whether it be in the form of a repeated ignoring, or in the form of the duplication of some model behavior that "worked" at other times or "made sense" in some other context. Repetition is a response, but it's not a response that is contemporaneous with the unique and inaugural aspects of the difference of this event happening right here and now. (Ellsworth, 1997, p. 137)

Thus, the "sweaty fight for meaning and response-ability" is an always-new struggle over how, through what discourses, and for what reasons we construct certain curricula, pedagogical and research strategies, identities and meanings in our classrooms and in our research that respond—or do not respond—to difference. It is also an ongoing struggle to examine and address how these constructions do or do not get taken up, responded to, and valued. It's difficult, challenging, exhilarating, discouraging, numbing, mandatory and exciting work— daily work that's always in-the-making.

Notes

1. For extended discussions of "autobiography as curriculum text" as well as of the history and myriad theoretical perspectives that characterize the reconceptualization of the curriculum field in the US, see Pinar, Reynolds, Slatter & Taubman (1995) and Pinar (1999b).
2. All student and teacher names used in this article are pseudonyms.

INTERLUDE 11

For the 2003 American Educational Research Association (AERA) annual meeting, Susan Talburt, Georgia State University, served as a section chair for the Division B program committee. In that role, she proposed a panel of curriculum scholars who might help to foster substantive discussion about the US curriculum field's present purposes and future possibilities in light of what some have characterized as the field's current lack of relevance and coherence. Among questions Susan posed for the panel members to address: What social and educational conditions are affecting the field? What are curriculum scholars doing? Why? To whom are they addressing their research, theory, and practice?

I accepted Susan's invitation to be part of what was billed as an interactive symposium, in large part because of my great regard for her as well as the other invited panelists: Herbert Kliebard, University of Wisconsin at Madison; William Watkins, University of Illinois at Chicago; Paula Salvio, University of New Hampshire; and Craig Kridel, University of South Carolina.

I also accepted because I thought there were some major "social conditions" that we needed to confront in relation to a much broader constituency than is typically addressed in US curriculum studies. I wanted to do so by following up on the piece that I had presented as my AERA vice presidential address for Division B in 1999, the piece that opens Part IV: Autobiography, Curriculum, this final section of the book. There I had juxtaposed a variety of readings of "the state(s) of the US curriculum field," and I wanted in this piece to both reinforce and update those readings by proposing that, especially in the wake of current national and international world-altering events, we could no longer afford to maintain our various narrow and sometimes even separatist stances about the purposes, forms, or states of our field.

Even though I live on the upper west side of Manhattan, in the Teachers College neighborhood now known as SoHa (south of Harlem), four or so miles from Ground Zero, I, like millions of others, felt my insulated world crumble on September 11, 2001. So for me this panel was an opportunity to challenge my colleagues and myself again: we must look beyond ourselves in order to fashion a field always in-the-making, a field that is both cognizant of and responsive to what always has been the necessary "worldliness" of US curriculum studies.

I had presented a much longer version of this piece as my first presidential address at the first annual meeting of the American Association for the Advancement of Curriculum Studies (AAACS) in 2002 at Loyola University in New Orleans. That original piece grappled in more detail with the concept of "worldliness" and with its theoretical and pragmatic relations to my teaching and research at Teachers College in New York City. Here, I present the 2003 AERA panel version of that piece in order to briefly gesture not only toward some aspects of my future work in curriculum studies but also toward what many of us see as the necessary internationalization of curriculum studies.

But of course, on the 2003 panel, there was no agreement among panel members on Susan's appointed title and focus: "Whither Curriculum? Thinking through the Present of Curriculum Studies." Our panel was scheduled immediately following Reba Page's vice presidential address, entitled "Invitation to Curriculum," where she too spoke of her sense that "curriculum studies—an area of study with its own important inquiries and astute inquirers—is nevertheless in some disarray." The call for proposals for the third annual meeting of AAACS, held in April 2004 in San Diego, yielded at least three proposals for symposia that yet again addressed the "state of the field" of US curriculum studies. And for the 2005 Annual Meeting of the American Education Research Association (AERA) in Montreal, Barry Franklin, Utah State University, has proposed a symposium entitled "Whatever Happened to the Curriculum Field?" The "state of the field" obviously still is a contentious topic, one that speaks to what some call the drift, the slide, the balkanization, or the very dissolving of the field. But that's my point: we have to re-make the field every day, in relation to particular events, issues, people—and it is our intellectual and moral obligation to do so.

THE NECESSARY WORLDLINESS OF AMERICAN CURRICULUM STUDIES

Is there no way of dealing with a text and its worldly circumstances fairly? —Edward Said,
The World, The Text, and The Critic

To teach curriculum theory, qualitative research and English education studies, and to live in New York City while doing so, means that I often conceive the city itself as text, as process. I'm not alone in perceiving New York as a cacophonous and unwieldy text, produced as conditional moments, always in motion, and produced too by myriad social practices and institutions, cultural products, and human actions and interactions. But conceiving the city as text, as a multi-dimensional space in which a variety of "writings" blend and clash (Barthes, 1968/1977), also obviously has been complicated by the terrorist acts of September 11, 2001 and the city's resultant "high" security risk-status that continues even when the rest of the nation moves down the color chart to "elevated."

For me, one tricky part of conceiving the city as text involves working tensions to which literary critic and theorist Edward Said alludes: working those tensions, as Pennycook notes (1994), involves attempts to deal fairly with a text in ways that do not leave it as a hermetically sealed cosmos with no connection to the world, or that simply reduce it to its contexts, determined by worldly circumstances. Conceptualizing New York City as text, for example, forces me to constantly work in, between, and beyond tendencies to see the city as simply either immutable, insulated, and unique or only as a prime target for more atrocities.

As Said notes, all texts simultaneously are always "in the world" *and* have social resonances. Said argues that we cannot invoke a "disinfected" textuality, without reference to the social networks in which all texts are embedded (1983). Thus, if we conceive of the *US* curriculum field as text, another cacophonous and unwieldy text, then one major obligation is to also work the tensions to which Said alludes: how might we construct a field of US curriculum studies that does

not leave it as a hermetically sealed cosmos with no connection to the world, but which also avoids reducing that text to its worldly circumstances? For many of us in the US, the point of much of our work with fellow teachers, students, administrators and parents has been to work with and within these tensions. Many of us deny any version of curriculum constructed either as pre-ordained and sequenced systems of subject matter, disconnected from diverse persons with hopes, dreams, bodies and desires, or as only determined by its material circumstances in the US, such as the press, yet once again, for curriculum standardization, this time in response to government demands for high-stakes testing, accountability, and consensus reports.

As one way of working in and with these tensions, many of us have engaged over the years with a goal of "understanding" curriculum so as to put those understandings to use in active and just ways. The reconceptualization moved the US field from what Pinar, Reynolds, Slattery & Taubman (1995, p. vxi) described as "an essentially institutionalized aim to maintain practice (by improving it incrementally) to one with a critical, hermeneutical goal of understanding practice and experience."

Over time this has meant conceptualizing curriculum not only as text but also as intertextual—as dependent on prior and multiple writings, and as reflecting interrelationships among differing concepts connotations, codes, conventions and texts. Attending to intertextual complementarities or disjunctures among competing discourses, including "traditional" as well as Neo-Marxist, feminist, psychoanalytic or post-structural, for example, many curriculum scholars have worked toward self-conscious understandings of ourselves, our teaching, and our curricular efforts as situated within contexts in which relationships of power, subjectivities, and knowledge are embedded in social and political institutions and practices. Further, many have argued that there is a complex interweaving of both local and national discourses and power relations surrounding both curriculum construction and curriculum studies in the United States. Thus, many of us involved in what became known as the reconceptualization have studied national and local discourses and how they support or undercut both "doing" and "understanding" curriculum.

In part because of the reconceptualization, then, it now is commonplace to view US curriculum studies as situated, always located within larger discursive frameworks, always part of US cultural, political, and educational moments of the day and place. American curriculum studies and curriculum design and development are seen as bound up in a wealth of local political, cultural, economic, social, historical complexities. Curriculum is taken as embedded in multiple local contexts of use, multiple contexts of construction and relationships.

But current contexts and conditions that include effects of and responses to recent and ongoing, worldwide terrorist attacks, war, globalization (and some would say its wars), new media, ecological instability and myriad Diasporas are vastly different from those in the 1970s and early 1980s that framed the initial reconceptualization of curriculum studies in the US. To conceptualize curriculum and curriculum studies as text now implies understanding curriculum within

tensions created by local, national, and global struggles over different and differing representations of content, self, and other—produced by the contact between and among language, culture, history and the discourses used to represent.

One danger for our field, I believe, is that the tragic events of September 11, 2001, the most recent war against Iraq, and further re-shapings of the world through effects of globalization, ecological instability, bioethics debates, instant and constant interconnection through the Internet, and new waves of immigrants and refugees could compel those of us engaged in American curriculum studies to focus more exclusively than ever on a narrow, standards-centric version of our worldly circumstances as one means of supposedly maintaining some semblance of control in our lives. Or, these same events and situations could persuade us to retreat into what seems to be our field's version of a hermetically sealed cosmos that encapsulates endless, often contentious and decidedly un-worldly debates about functions, purposes, and the varying discourses used to frame conceptions of our work in American curriculum studies.

However, I believe that the US curriculum field, especially given these most recent world events, must move beyond such dichotomous choices in order to confront the implications of curriculum as international and global text. To understand curriculum studies globally means to understand our work as potentially embedded in multiple local contexts of use, not only around the world but also in the world, with/in relationships of power/knowledge that are embedded in social institutions and practices (Foucault, 1980a). It is to understand, and to take as points of inquiries, the potentials as well as the dangers of proliferating American versions of curriculum studies around and in the world—to understand the implications, if you will, of the now necessary conception of the worldliness of American curriculum studies. We must work the tensions of that now unavoidable concept: in what ways will we, as members of the US curriculum field, investigate and deal fairly with our field and its position not only as reflective but also as constitutive of worldly curriculum affairs?

Drawing from Pennycook's (1994) notion of worldliness, I propose that several key conditions currently contribute to a conception of the worldliness of American curriculum studies:

- The rapid expansion of American curriculum studies into international arenas of inquiry and concern. For example, *The Internationalization of Curriculum Studies* (Trueit, Doll, Wang & Pinar, 2003) as well as the *International Handbook of Curriculum Studies* (Pinar, 2003) point to global interests of some US curriculum scholars and to US curriculum studies as materially existing in a global context
- Increased participation of US curriculum scholars in international forums and studies, pointing to multiple and myriad engagements in an intellectual project that might produce and change social relations in local and global educational contexts
- The constant in-process nature of curriculum as an academic field of study in relation to its worldly aspects.

Further, I suggest that such a conception finds support in (and grounds for studying implications of) the following:

- The material existence of US curriculum studies in the world, as embodied, among others, in Division B (Curriculum Studies) of the American Educational Research Association; in the Professors of Curriculum; in the Association for Supervision and Curriculum Development's conferences and journals; in the Bergamo Conferences sponsored by *JCT: Journal of Curriculum Theorizing;* in the Curriculum & Pedagogy conferences and journal; and most recently, in the American and International Associations for the Advancement of Curriculum Studies and their journals and conferences
- Potential encounters between American curriculum studies and curriculum studies in other countries
- The recognition of and engagement with American curriculum studies by various curriculum scholars around the world
- The participation of American curriculum studies in constituting both US and global conceptions of curriculum (for example, the First World Curriculum Studies Conference [the First Triennial Meeting of the International Association for the Advancement of Curriculum Studies], held at East China Normal University in Shanghai, P.R. China, October 26–29, 2003, with the theme "Curriculum Studies Worldwide," was attended by curriculum scholars from around the world).

Further, if we agree that there is now an urgent need as well as desire among some curriculum scholars to look beyond our sealed cosmos, beyond our self interests to the implications of understanding the worldliness of curriculum studies as international and global text, then we also must ask: How is American curriculum studies implicated within transnational social, cultural, historical and political contexts of curriculum studies worldwide? How might cross-national and cross-locational approaches to and encounters with "understanding" curriculum disrupt, shift, challenge or deny the admittedly differing, but still often US-centric interests and desires represented in American curriculum studies? What new disciplinary, interdisciplinary, and transnational pedagogical and curricular practices and discourses might infuse and bring fresh life to what some see as a bifurcated and balkanized American curriculum field?

In imagining such possibilities, we cannot rely on a center-periphery model of world culture *or* of curriculum studies. Circulations of ideas, languages, and curricular practices in contemporary education on a global scale are more accurately described as proliferating, multi-centered, and multi-peripheried. Further, we should not accept uncritically a global-local binary, for

the parameters of the local and the global are often indefinable or indistinct—they are permeable constructs. How one separates the local from the global is difficult to decide when each thoroughly infiltrates the other. Global-local as a monolithic formation may also erase the existence of multiple expressions of

"local" identities and concerns and multiple globalities. (Grewal & Kaplan, 1994, p. 11).

Thus, we need new analyses of how "understanding" curriculum as both a field of study and a practice could be constructed in the dynamics of globalization as well as in the countermeasures of new nationalisms, nationalistic versions of curriculum, and ethnic and racial fundamentalisms, for example. Such analyses will need to draw from emerging understandings of these global phenomena that currently are being developed outside of the field of education, for example in peace studies, new media studies, Middle Eastern and other area studies. The work of scholars and practitioners in and of American curriculum studies, in part, will be to bring these understandings to bear on current curriculum theories and practices.

For we, as participants in the American field of curriculum, already are both implicated in and complicated by the internationalization of curriculum studies. How, then, might the notion of the "worldliness" of US curriculum studies extend, expand or disrupt both "traditional" and reconceptualized versions of curriculum as both a field and a practice, or disrupt local, national, and international versions of "understanding" curriculum? Further, acknowledging that there is no monolithic field of American curriculum studies, what might the notion of "worldliness" contribute to those of us who work in the US field, some of whom are transplanted and transnational or teach transplanted and transnational students and texts? How might a notion of "the worldliness of US curriculum studies" take into account Spivak's warning about the inevitable distortion that accompanies descriptions of the subaltern (Spivak, 1988)? How might a notion of worldliness thus challenge US-centered descriptions and analyses of transplanted and transnational teachers, students, and texts?

Even further: what might it mean to address potentials and challenges within encounters among worldly curriculum discourses, among worldly political, social, and psychological forces that drive and shape cultures? How might such encounters alter or shift ways in which we understand curriculum in the US? We could argue, for example, that the discourses of "understanding curriculum" have contributed to the worldliness of American curriculum studies by drawing on theories and philosophies that have roots in a number of non-North-American fields. But such appropriations, as Pennycook warns (1994), should not happen uncritically. Such appropriations require us to ask: how might a conception of the worldliness of American curriculum studies contribute to generative versions of both US and worldwide curriculum studies that enhance and expand intellectual work and relationships?

By here considering some possible implications of—and our implicated-ness in—the "necessary worldliness of American curriculum studies," I urge those of us who work in the US curriculum field to move beyond endless and insulated debates about how this field is fragmented, struggled over, resisted, rejected, diverse, broken, centrifugal and even incommensurable with itself. To argue for a "healing" of these fissures is potentially to fall into a political psychology of

nationalism, sameness and closure, and possibly and ironically to replicate an education system focused solely on standardizing and technologizing curriculum.

Instead, I suggest that the notion of the "worldliness" of American curriculum studies is a useful position from which to conceive the field as both implicated and "in relation." The worldliness of American curriculum studies implies an understanding of how it, as a field, is implicated in a range of both national and international social, cultural, and political educational relations. We must work to understand how we are implicated in that worldliness—implicated not only in the sense of our vested interests but also in how American curriculum studies folds in, on, and around (in a Deleuzian way) other cultures, knowledges, and identities, and how those, in turn, enfold American curriculum content and practices. To address such implications requires proliferating, in multi-variant ways—not constraining in a hermetically sealed cosmos—the discourses and practices that comprise our work in curriculum studies. Perhaps aspects of the "worldly," "secular criticism" promoted by Said (1983), although too focused on the humanistic Western tradition with its accompanying lack of attention to issues of gender (Ahmad, 1992; Fraiman, 1995), suggest one possible way of conceptualizing our future work in the US curriculum field as it necessarily moves toward the internationization of curriculum studies. In light of the pressing social, cultural, and historical conditions that necessarily frame our work, might we, as Said suggests, shun party-line thinking and dogma and instead ask: How will we rethink curriculum studies, yet again, as text that is fully implicated in its unavoidable worldly circumstances?

INTERLUDE 12

"I think this applies to us. And it's very mysterious—it's that, on the surface of things, we have a worldly interest. We talk about Teachers College or curriculum or literature or what I do at Lincoln Center or what you do with your students there, or how you and I teach, and so on. But underlying that is another subjectivity that can only be described by the delicate term, 'a web of relationship.' A web, it's delicate, you know, so that underneath the worldly interest, it becomes something else, it connects persons together." Maxine Greene, April 23, 2003. (From transcription of audiotaped conversation between Maxine Greene and Janet Miller)

At each of the 2000 and 2001 Annual Meetings of the American Educational Research Association (AERA), Craig Kridel and I served as co-directors of an all-day workshop on biographical and autobiographical research, sponsored by the Special Interest Group on Archival and Biographical Research. Maxine Greene asked if she could join us during the 2001 workshop. That was the year that the video, "Exclusions and Awakenings: The Life of Maxine Greene" (Markie Hancock, director, and Kathryn Gregorio, producer, 2001) was screened to a filled ballroom of enthusiastic AERA members. Maxine was interested in pursuing in-depth, in the context of our workshop, some questions the video raised for her in terms of being the "subject" of a biography.

So, in a windowless conference ballroom at one of the AERA hotels in Seattle, Craig, Maxine, and I engaged in far-ranging conversations with our workshop participants about the doing of educational biography and autobiography. Then, as Maxine especially considered the representations as well as necessary limitations of the one-hour video of her "life," she turned to me and said: "You're the one to do my written biography." (I was sitting between Craig and Maxine in our "panel" configuration. "What did she say?" I asked Craig).

Thus began what, at this June 2004 writing, is now a three-year project, a project in every existential sense that Maxine might want to address, and a project nowhere near completion. Maxine and I continue to construct what we now variously call our "collaborative, double-voiced, recursive, co-authored auto/ biography," an obviously in-the-making hybrid form based on our meandering, recursive, and intertextual conversations.

Thus, it seems fitting that I end this collection, situated as it is within a book series devoted to "complicated conversations" in curriculum studies, with a description of our ongoing project. This piece is a much abbreviated and updated revision of a proposal that garnered me a Tenured Faculty Research Award for the fall 2003 academic semester at Teachers College. It has a social science research emphasis, especially focusing on initial conceptual and methodological framings of our work; but near the end of the piece, I also signal ways in which I want this work to slide between and among social science and humanities perspectives in the "doing" of educational biography.

The general qualitative research emphasis in this piece also reflects a major focus of my teaching responsibilities at Teachers College and indicates my commitments to research perspectives and methodologies that take into account

> a habit of generosity toward difference at every stage of our work . . . so that radically different readings of the world might function more or less side-by-side, not necessarily happily or easily, but learningly. If we could take that ethical position, what might our science look like and what knowledge might we make? What might we be able to think and who might we become? (St. Pierre, 2004, p. 4)

Thus, methodologies that Maxine and I enact in this project constantly address challenges of who we might become. These are interactive, relational, always in-the-making methodologies that necessarily draw from existential phenomenology as well as feminist postmodern perspectives, and are in keeping with our theoretical and research commitments and interests as well as with themes that have resounded throughout this collection. These themes, in their muted, reverberating, or sometimes-noisy ways, raise questions about collaboration and research, about intersecting constructions of gendered and classed identities, in particular, and about forms and purposes of autobiographical inquiry in education. Our enacted methodologies are in keeping with my call for "worldly" rather than isolated, insulated conceptions of curriculum studies where one presumes that there is—or should be—one story of the curriculum field to tell for all.

So in our project are multiple stories that Maxine and I circle around and through, often ambivalent and contradictory stories of curriculum, teaching, academic strictures, and disciplinary as well as personal attachments. We tell stories filled with gaps, pauses, interruptions, corrections, revisions, silences. As of this writing, we are continually reworking, abandoning, rewriting, discarding, re-weaving our myriad stories *as* women academics in and through current personal, professional, and worldly challenges.

The following, a glimpse of a rough and always incomplete project, thus details a major commitment and direction for my future academic work. Placing this brief description of our collaborative project here not only again acknowledges the decades-long connections that I've felt to Maxine and her scholarship, but also gestures toward work that—we hope together—holds potential for creating fresh and myriad meanings that reverberate back, in, around and through "sounds of silence breaking."

CONVERGENCES
A Collaborative Biography
of/with Maxine Greene

When persons open themselves to one another, there is always a sense of new profiles to be experienced, new aspects to be understood. . . . If we attend from our own centers, if we are present as living, perceiving beings, there is always, always more. —Maxine Greene, *Variations on a Blue Guitar*

In 2001, I was invited by Maxine Greene to write a "biography" of what she identifies as her "woman academic US existential phenomenological educational philosopher" life. As conceived by both Maxine and me, this project questions the central assumption of the traditional biographic method: that a life can be totally "captured" as well as transparently represented in a text. That central assumption still shapes humanist research protocols through which we could assume to know "a life," or through which we could construct "a curriculum" or a "curriculum history" that represents aspects of that life. In contrast, our project rests on the assumption that a life represented in a biography is "a social text, a fictional, narrative production" (Denzin, 1989, p. 9).

This ongoing project initially required me to address methodological complexities of researching and writing an educational biography of a still-vibrant academic who resists iconic reification or singular and isolated constructions of "self." Maxine's resistance comes from her existential stance of always "becoming" in order to meet "the challenges of being in and naming and (perhaps) transforming the world" (Greene, 2001, p. x). My resistances to writing a biography that only reinscribes Maxine as "icon" or as any singular version of "woman academic" are framed by feminist poststructural critiques of a wholly conscious and unified "self"; the foundational status of "experience"; the romance of an "authentic voice"; the recourse to transparent notions of the "truth" of educational narratives autobiographies and biographies; the "truth teller" status of the biographer or autobiographer; and even interactive and reciprocal forms of research (Alpern,

Antler, Perry & Scobie, 1992; Hasebe-Ludt & Hurren, 2003; Lather, 1997; Lather & Smithies, 1997; Scott, 1991; Smith & Watson, 1998; St. Pierre & Pillow, 2000; Weis & Fine, 2000, 2004).

Here are a series of issues and questions raised by these critiques that Maxine and I agree our collaborative project must address:

- Because many feminists argue that any biography is as much about the author as it is about the "subject" (Backscheider, 2001; Smith & Watson, 1998), to what extent might the confounding of experiential history and its representation as "a life" invite both Maxine as "researched" and me as "researcher" to collaborate in examining what spills, as excess, over and beyond our intertwined (auto)biographical acts?

- To what extent and in what ways might this "fictional, narrative production" point to biographical methods that keep moving into a new "now," in which past memories are cited as well as staged as the material for "present ways of making visible an evanescent subject" (Smith and Watson, 2001, p. 8)?

- Further, if the biographical "subject" is female and gender thus moves to the center of the analysis (Alpern, Antler, Perry & Scobie, 1992), how might Maxine and I investigate gender as "what is put on, invariably, under constraint, daily and incessantly, with anxiety and pleasure," but at the same time not "mistaken for a natural or linguistic given" (Butler, 2003, p. 426)? On what narrative and interpretive practices are our "different selves, different performances, different ways of being a gendered person in a social situation" (woman academic), based (Denzin, 2003, p. 86)?

- How might this project interrogate the limits of biography and autobiography at a time when "the rule" is breaking the rule (Gilmore, 2001)? We do not wish to make up new rules that simply might replace the old, but rather to explore what might happen when we openly admit we no longer know what to do so that things might be done differently (Lather, 2004).

- How might our collaboratively constructed "biography" not "divest experience of its rich ambiguity" and instead stay "close to the complexities and contradictions of existence" in order to "face unanswerable questions" as well as to "foster understanding, reflection, and action instead of a narrow translation of research into practice" (Lather, 2003, p. 9)?

We think that such questions can help clarify ways that we both interpret our own and others' pasts in order to attend to how we currently narrate our selves. "Working" auto/biographically thus may enable us to construct alternative versions of our "selves" in these roles, "selves" that can work to resist standardization and that can respond to and act on the divergent, the paradoxical, and the unanticipated in our educational lives.

More than two years into this study, then, this project obliges me, "as researcher," to question any construction of biography that assumes the possibility of (re)constructing a unitary, linear, and whole version of a "self." Instead, drawing on postmodern notions of a non-essentialized "self"—a dynamic subject who changes over time, is situated historically in the world, and positioned within multiple discourses—I am interested in exploring, for example, how Maxine Greene has negotiated, re-negotiated, and resisted, throughout her career, those discourses that have constructed and reconstructed her within the category of "woman academic," and how she has engaged with and in social constructions (and contestations) of her "identity" as a woman who "does" educational philosophy.

Further, our study compels me to attend to an emphasis in postmodern thought on knowledge and knowledge production as interrelational, interwoven in webs of language, history, and material contexts. For qualitative researchers who wish to use interviews as a major means of data collection, as I do (albeit as "conversation") in this study, the interrelationships between "researcher" and the "researched" as located within particular discursive and social contexts are primary:

> A postmodern approach focuses on interrelations in an interview, on the social construction of reality in an interview, on its linguistic and interactional aspects . . . and *emphasizes the narratives constructed by the interview.* (Kvale, 1996, p. 38, my emphasis)

My initial data-gathering sessions with Maxine quickly evolved from standard qualitative semi-structured interviews into interpersonal conversations. Initially, thinking that I would research "the biography" Maxine had invited me to write, I tried to play "the researcher" by asking Maxine a series of questions about her desires to become an academic, for example. But she immediately responded by returning those questions to me. We thus began to ask one another questions that led us to tell stories of our separate and yet connected lived worlds as women academics, as first-born daughters in our very different families, as teachers who are committed to addressing issues of difference, for example. We thus now converse with one another in the original Latin meaning of *conversation* as "wandering together with" (Kvale, 1996, p. 4). These "narratives constructed by [wandering] interviews" have become, in part, the "subject" of this study.

Thus, what began as Maxine's invitation to me to write her biography has evolved into hybrid forms: the project, on one level, still is to construct a "biography" of Maxine Greene and to chronicle as well as analyze the myriad influences on her life as an educational philosopher. But the project is now informed and shaped by our in-depth and elongated series of collaborative conversations where we most often focus on intersections, divergences, contradictions and convergences in philosophical orientations and educational practices that form and inform both of our educational and personal biographies. Our collaborative conversations also have allowed us to compare, contrast, and ruminate on personal, political, and ideological issues of our respective eras.

Thus, we could also be engaged in what Denzin (1989) calls "interpretive biography;" that is, Maxine and I create as well as analyze literary, narrative

accounts and representations of our lived experiences. In our conversations, we tell and inscribe stories. We engage in reflection on why we tell some stories rather than others, and we try to analyze how these particular versions of our "selves" are or are not authorized by others. From these stances, then, one of my major tasks as biographical researcher would be to examine the choices I make in the process of (re)constructing "a life" of Maxine Greene that now is intertwined with the stories in and of our conversations. Given the now collaborative nature of our venture, we both must examine ways in which our storied lives could become tales of a particular sort (Van Maanen, 1988).

So even if I were to attempt to "write the biography" of Maxine Greene, major traces of my (always under construction and reconstruction) autobiography, my expectations for and perceptions of this study, and my personal and professional relationships with Maxine, would be intertwined throughout my interpretive text:

> what happens when the traditional boundaries between the Knower and the Known begin to break down, are reversed, or crosscut with mixed and hybrid identities? . . . Unavoidably, the many locations that shape my identity and notions of self influence my choices, access, and procedures in/of research and also permeate the representation of research subjects in my writing. (Lal, 1999, p. 105)

Because a major portion of this project's research design now is framed by our series of interactive conversations, notions of "collaborative or double-voiced or co-authored biographical conversations" allow us to consider the above-noted variations on "biography" as well as dilemmas of "interactive, interpretive biographical research" as explicit aspects of study in this project.

Primary questions that guide our conversations now include:

- What social, cultural, historical and autobiographical contexts and events helped to shape Maxine's conceptions of herself as teacher? As educational philosopher? As writer? As advocate for the arts as a means of "releasing the imagination"?
- How does Maxine perceive herself as inhabiting and inflecting a range of identities in her work? How does she construct herself, and how does she perceive that has she been constructed by the discourses of educational philosophy and research, for example, *as* woman, scholar, teacher, daughter, wife, mother and friend, in relation to her academic work? In relation to the field of education?
- What happens when the writing of Maxine's "biography" becomes an interactive, intertextual, collaborative event? That is, in what ways do my autobiographical "answers" to the above questions interact with and influence my understandings and representations of her answers? In what ways are my constructions of Maxine's "educational biography" as much about me as they are about Maxine? As Tierney notes: "Any text is co-produced. As researchers we are participants in the creation of the data" (2000, p. 543).

- How might our ongoing conversations contribute to a complicating of our knowledge and conversations about the identity marker "woman academic" in education and, at the same time, interrogate those very frameworks and discourses within which we have interpreted our educational "identities" and "histories"?

In particular, Maxine and I are compelled by these questions to challenge, as others do (Barone, 2001) discourses and organizational structures that construct and maintain static "teacher identities" as well as conceptions of curriculum that prohibit or constrain what Maxine calls the "project" of education. That project, she says, should be to enable students and teachers to question and to imagine in order to meet "the challenges of being in and naming and (perhaps) transforming the world" (2001, p. x).

To explore influences of autobiographical as well as social, historical, and cultural contexts on our teaching and scholarship also enables us both to relate our (re)constructions of our academic and personal lives to larger issues and questions in education. We wish to explore the connections between our lives and personal, political, and ideological problems of constructing educational projects and "identities" in the twenty-first century. We are particularly interested in the relations between abstract philosophical ideas and actual educators' lived relations to those ideas.

We hope that our collaborative biography, framed by questions about constructions of authoritative knowledge, research representation, and performances of identities, might provide examples of scholars and teachers who grapple, in both educational research and practice, with complexities of plurality and the fractured totality of everyday experience and identity. This collaborative biography also might provide incentive for educators to consider what happens when "individuals come together in a particular way, . . . when they have a project they can mutually pursue" (Greene, 1988, p. 16–17).

Approaches to Our Collaboration

Maxine and I consider our project, in part, to be framed by a specific form of conversational technique in which knowledge is constructed through the interaction of the interviewer and the interviewee (Kvale, 1996). In this form, unlike more traditional research interviews, the roles of interviewer and interviewee are constantly shifting back and forth between Maxine and me.

Indeed, our shifting roles in the construction of this proposed project will be a focus of study especially for me as I further explore feminist concerns with power relations and issues of representation in research writing (Richardson, 1997; Weis & Fine, 2000). As a researcher, I employ feminist notions of reflexivity that include attempts to unpack what knowledge is contingent upon, how the "researcher and researched" are socially situated, and how my/our research agendas and processes have been and continue to be constructed (Ramazanoglu with Holland, 2002). As Fine (1992) notes, the researcher needs to ask herself in what

ways she has grown in and shaped the process of research. Such an aspiration assumes no monopoly of knowing but rather attempts, through what Fine calls mutuality, to name more of what is difficult to say or articulate, and to think about its meanings collaboratively. This process surfaces power relations, discomforts, dead ends and uncertainties. Thus, reflexivity requires us to attend to relations of power and especially to ways that our portrayals, simultaneously, both describe and constitute our selves.

Even further, because feminist poststructural researchers insist that data are generated, not collected, many suggest that, rather than just reflexively interpreting the effects of the subjectivity of the researcher, we should consider research practices as wholly implicated in processes of ever-changing subjectivities (of both the researcher and the researched) even as these subjectivities form the objects of study (Cosslett, Lury & Summerfield, 2000). As well, both social science and humanities-based poststructural feminists call attention to ways that the auto/biographical is "a performative site of self-referentiality where the psychic formations of subjectivity and culturally coded identities intersect and 'interface' one another" (Smith & Watson, 2002, p. 11).

To draw attention to our project as a "performative site of self-referentiality," I describe the form of data collection in which Maxine and I are engaged as "conversation," and I use postmodern perspectives and raise questions framed by those perspectives in the construction (and analysis of the construction) of this project. However, there remains an element of the traditional qualitative semi-structured interview in my research methodology. That is, Maxine and I build each of our scheduled conversations on the grounds of the previous conversation, and we identify certain themes or ideas or areas of our lives that we want to address in following sessions, knowing, at the same time, that our subjectivities and their "interfacings" will lead us into unanticipated and unknown arenas of inquiry.

After a series of scheduled conversations (every three or four meetings), our audiotaped two- to three-hour conversations are transcribed. I make copies of the transcriptions for Maxine and me. Separately, we read these transcriptions, I identify some on-going and overlapping themes from conversation to conversation, and then, together, we tap themes and issues that we want to explore further, clarify, or deviate from in our next sessions. In turn, our interpersonal interactions in the audiotaped conversations as well as in our negotiations over future themes and issues become another source of data for this project. Thus far, we continue to explore aspects of initial questions that shaped the original study: what social, cultural, historical and autobiographical contexts and events helped to shape Maxine Greene's conceptions of herself as teacher? As writer? As woman academic? How do I respond to the same questions about myself? What connections or disconnections are there among and between our responses? And why are we telling our stories in these ways?

Additional data for the project include Maxine's myriad personal letters to me over the years as well as extensive notes on the wide-ranging personal and professional discussions in which we have engaged during our thirty-year professional relationship. Using my own and Maxine's files, as well as Teachers College

archives of Maxine's published work, I am combing through copies of many of her major academic presentations at national and international conferences and reprints of most of her academic publications as part of my document analysis.

Although we are engaged in this collaborative construction of biographical conversations, in a sense, I still serve as a "primary researcher," because I am the one who manages data and has the tapes transcribed, who codes, analyzes, and then offers my first tentative "readings" of these data to Maxine. She responds, questions, contradicts, elaborates upon, and most often challenges these readings. I undertake the recording of our ongoing revisions and re-constructions of analyses and interpretations, based on her comments, responses, and often-differing views on our "conversations."

I continue to work, then, from a postmodern stance that challenges me to "accept the multiple mediations at work in the creation of the text and expose them, rather than try to hide them away, or assume that they can be resolved" (Tierney, 2000, p. 547). It is within this interpretive, self-reflexive, and performative (Butler, 2003) interactive process with Maxine that I anticipate utilizing as well as extending postmodern and feminist qualitative researchers' inquiries into questions of representation, gendered identities, voice, and the "easy logic of foundational rationality" (St. Pierre & Pillow, 2000, p. 11).

At the same time, in this work I want to shift within and without biographical traditions,[1] to blur genres and glide among and transgress the perspectives of social science and the humanities. Especially given Maxine's vast knowledge and uses of literature in her "doing" of educational philosophy, and given my own pedagogical connections to literature and literary forms of inquiry, I want to work in between "authorized" spaces that traditionally separate social science and humanities research. Asking, too, "how can collaboration across the social science/humanities border be encouraged," (Cazden, 2004, p. 342), I hold the possibility that this work, in the tradition of literary biography, will honor without idealizing Maxine's life. In reviewing her complex life as an educator, as a woman academic who re-formed spaces daily in her commitment to always becoming, I also desire to situate this particular individual and her scholarship in education without succumbing to transparent descriptions of linkages between her life and her work, and without romanticizing or memorializing her as an "exceptional woman" in education. I struggle to avoid the trope of singularity while, at the same time, attending to those who

> posit that the postmodern expression of the biographical in academic discourse can be re-mapped as "historiographies of the individual subject" marking a path to the ways in which these "othered" subjects (traditionally, prodigious, monstrous, deviant, or marginalized) negotiated, embraced, rejected, created and transformed the rules and behaviors for them and us. (Ross, 1991, p. 5)

Maxine and I continue to co-construct and re-construct interpretations of our conversations. In so doing, I hope to be able to contribute to our endeavor some insights into ways that Maxine indeed has "transformed the rules and behaviors" for all who are committed to what she calls the project of education.

And together, we hope to move toward a kind of transgressive work that is not only different from what has come before but also different from what either of us, individually, might have imagined.

Note

1. See Oates (1986, 1991) for descriptions of "biographical types," including the scholarly chronicle, the critical study, and the narrative biography. Also see Kridel (1998) for his and others' discussions of how those working in the broadest conception of educational biography—namely those "involved in telling the life of another whose career falls within the field of education—draw from all disciplines" (p. 8).

REFERENCES

Ahmad, A. (1992). *In theory: Classes, nations, literatures.* London: Verso.

Alpern, S., Antler, J., Perry, E.I., & Scobie, I.W. (Eds.). (1992). *The challenge of feminist biography.* Chicago: University of Illinois Press.

Althusser, L. (1993). *The future lasts a long time and the facts.* (O. Corpet & Y. M. Boutang, Eds., & R. Veasey, Trans.) London: Chatto & Windus.

Anyon, J. (1979). Ideology and United States history textbooks. *Harvard Educational Review,* 49(3), 361–386.

Anyon, J. (1994). Teacher development and reform in an inner-city school. *Teachers College Record,* 96(1), 14–31.

Anyon, J. (1997). *Ghetto schooling: A political economy of urban education reform.* New York: Teachers College Press.

Anzaldua, G. (1987). *Borderlands/La frontera: The new mestiza.* San Francisco: Spinsters/Aunt Lute Book Company.

Apple, M.W. (1975). The hidden curriculum and the nature of conflict. In W. F. Pinar (Ed.), *Curriculum theorizing: The reconceptualists* (pp. 95–119). Berkeley, CA: McCutchan.

Apple, M.W. (1979). *Ideology and curriculum.* London: Routledge.

Apple, M.W. (1982). *Education and power.* New York: Routledge & Kegan Paul.

Apple, M.W. (1986). *Teachers and texts: A political economy of class and gender relations in education.* New York: Routledge & Kegan Paul.

Ayers, W.C. (2001). *To teach: The journey of a teacher (2nd Edition).* New York: Teachers College Press.

Ayers, W.C., & Miller, J.L. (Eds.). (1998). *A light in dark times: Maxine Greene and the unfinished conversation.* New York: Teachers College Press.

Backscheider, P. (2001). *Reflections on biography.* New York: Oxford University Press.

Baker, B.M. (2001). *In perpetual motion: Theories of power, educational history, and the child.* New York: Peter Lang.

Baker, H.A. (1991). Jacket cover. *The alchemy of race and rights: Diary of a law professor.* Cambridge, MA: Harvard University Press.

Barone, T. (2001). *Touching eternity: The enduring outcomes of teaching.* New York: Teachers College Press.

Barrington, J. (1997). *Writing the memoir: From truth to art.* Portland, OR: The Eighth Mountain Press.

Barthes, R. (1977). The death of the author. In *Image—music—text* (S. Heath, Trans.). New York: Hill and Wang. (Original work published 1968)

Beauvoir, S. d. (1952). *The second sex* (H. M. Parshley, Trans.). New York: Alfred A. Knopf, Inc. (Original work published 1949)

Beauvoir, S. d. (1959). *Memoirs of a dutiful daughter* (J. Kirkup, Trans.). New York: Harper & Row, Publisher. (Original work published 1958)

Behar, R. (1996). *The vulnerable observer: Anthropology that breaks your heart.* Boston: Beacon Press.

Benham, B.J. (1976, July). Transcript of interviews with James Macdonald and Maxine Greene.

Benstock, S. (1991). The female self engendered: Autobiographical writing and theories of selfhood. *Women's Studies, 20,* 5–14.

Bergland, B. (1994). Postmodernism and the autobiographical subject. In K. Ashley, L. Gilmore, & G. Peters (Eds.), *Autobiography and postmodernism* (pp. 130–166). Amherst: The University of Massachusetts Press.

Berlak, A. (1994). Antiracist pedagogy in a college classroom: Mutual recognition and a logic of paradox. In R. Martusewicz & W. M. Reynolds (Eds.), *Inside out: Contemporary critical perspectives in education* (pp. 37–60). New York: St. Martin's Press.

Beyer, L. (1979). Aesthetic theory and the ideology of educational institutions. *Curriculum Inquiry, 9*(1), 13–26.

Britzman, D.P. (1991). *Practice makes practice: A critical study of learning to teach.* Albany: State University of New York Press.

Britzman, D.P. (1992). The terrible problem of knowing thyself: Toward a poststructural account of teacher identity. *JCT: Journal of Curriculum Theorizing, 9*(3), 23–46.

Britzman, D.P. (1993). Beyond rolling models: Gender and multicultural education. In S. K. Biklen & D. Pollard (Eds.), *Gender and education* (pp. 25–42). Chicago: University of Chicago Press.

Britzman, D.P. (1997). The tangles of implication. *Qualitative Studies in Education, 10*(1), 31–37.

Britzman, D.P. (1998). *Lost subjects, contested objects: Toward a psychoanalytic inquiry of learning.* Albany: State University of New York Press.

Britzman, D.P. (2000). "The question of belief": Writing poststructural ethnography. In E. A. St. Pierre & W. S. Pillow (Eds.), *Working the ruins: Feminist poststructural theory and methods in education* (pp. 27–40). New York: Routledge.

Britzman, D.P. (2003). *After-education: Anna Freud, Melanie Klein, and psychoanalytic histories of learning.* Albany: State University of New York Press.

Britzman, D.P., Santiago-Valles, K., Jimenez-Munoz, G., & Lamash, L. (1993). Slips that show and tell: Fashioning multiculture as a problem of representation. In C. McCarthy & W. Crichlow (Eds.), *Race, identity, and representation in education* (pp. 188–200). New York: Routledge.

Brodkey, L. (1987). Writing critical ethnographic narratives. *Anthropology and Education Quarterly, 18,* 67–76.

Brodkey, L. (1989). On the subjects of class and gender in "The literacy letters." *College English*, 51, 125–141.

Bunch, C. (1966). Feminism and education. *Quest*, 5(1), 13–14.

Burton, W. (1974). Personal letter to William Pinar, November 4, 1974.

Butler, J. (1990). *Gender trouble: Feminism and the subversion of identity*. New York: Routledge.

Butler, J. (1992). Contingent foundations: Feminism and the question of "post-modernism." In J. Butler & J.W. Scott (Eds.), *Feminists theorize the political* (pp. 3–21). New York: Routledge.

Butler, J. (1993). *Bodies that matter: On the discursive limits of "sex."* New York: Routledge.

Butler, J. (1999). *Gender trouble: Feminism and the subversion of identity* (10th anniversary edition). New York: Routledge.

Butler, J. (2003). Performative acts and gender constitution: An essay in phenomenology and feminist theory. In C.R. McCann & S.-K. Kim (Eds.), *Feminist theory reader: Local and global perspectives* (pp. 415–427). New York: Routledge.

Butler, J., & Scott, J. (Eds.). (1992). *Feminists theorize the political*. New York: Routledge.

Callahan, S. (2000). Conversations and competence: How English teachers fail to connect. *English Education*, 32, 182–193.

Cambone, J. (1995). Time for teachers in school restructuring. *Teachers College Record*, 96(3), 512–543.

Carr, W., & Kemmis, S. (1986). *Becoming critical: Education, knowledge and action research*. London: Falmer.

Caughie, P. (1992). "Not entirely strange, . . . not entirely friendly": Passing and pedagogy. *College English*, 54(7), 775–793.

Cazden, C.B. (2004). "Analysis" and "interpretations": Are they complementary? *Research in the Teaching of English*, 38(3), 338–343.

Chodorow, N. (1978). *The reproduction of mothering: Psychoanalysis and the sociology of gender*. Berkeley, CA: University of California Press.

Cixous, H. (1981). The laugh of the medusa. In E. Marks & I. De Courtivron (Eds.), *New French feminisms* (pp. 245–264). New York: Schocken Books.

Clandinin, D.J., & Connelly, F.M. (2000). *Narrative inquiry: Experience and story in qualitative research*. San Francisco: Jossey-Bass Publishers.

Clark, D.L., & Astuto, T.A. (1994). Redirecting reform: Challenges to popular assumptions about teachers and students. *Phi Delta Kappan*, 76, 513–520.

Connelly, F.M., & Clandinin, D.J. (1991). Narrative inquiry: Storied experience. In E. C. Short (Ed.), *Forms of curriculum inquiry* (pp. 121–153). Albany: State University of New York Press.

Corbett, M.J. (1998). *Literary domesticity and women writers' subjectivities*. In S. Smith & J. Watson (Eds.), *Women, autobiography, theory* (pp. 255–263). Madison: The University of Wisconsin Press.

Corcoran, B. (1994). Balancing reader response and cultural theory and practice. In B. Corcoran, M. Hayhoe, & G. M. Pradl (Eds.), *Knowledge in the making: Challenging the text in the classroom* (pp. 3–23). Portsmouth, NH: Boynton/Cook Publishers, Heinemann.

Cosslett, T., Lury, C., & Summerfield, P. (Eds.). (2000). *Feminisms and autobiography: Texts, theories, methods*. London: Routledge.

Costello, J. (1991). Taking the "woman" out of women's autobiography: The perils and potentials of theorizing female subjectivities. *Diacritics*, 21(2–3), 123–134.

Cremin, L. (1971). Curriculum-making in the United States. *Teachers College Record*, 73(2), 207–220.

Crimp, D., (Ed). (1988). *AIDS: Cultural analysis/cultural activism.* Cambridge, MA: MIT Press.

Culley, M., & Portuges, C. (Eds.). (1985). *Gender subjects: The dynamics of feminist teaching.* New York: Routledge.

Daignault, J. (1983). Curriculum and action-research: An artistic activity in a perverse way. *Journal of Curriculum Theorizing, 5*(3), 4–28.

Davies, B. (1993). *Shards of glass: Children reading and writing beyond gendered identities.* Cresskill, NJ: Hampton Press.

Davies, B. (2000). *A body of writing 1990–1999.* Walnut Creek, CA: AltaMira Press.

Davies, B., Dormer, S., Honan, E., McAllister, N., O'Reilly, R., Rocco, S., & Walker, A. (1997). Ruptures in the skin of silence: A collective biography. *Hecate, 23* (1), 62–79.

Davis, B., Sumara, D. J., & Luce-Kapler, R. (2000). *Engaging minds: Learning and teaching in a complex world.* Mahwah, NJ: Lawrence Erlbaum Associates.

Denzin, N.K. (1989). *Interpretive biography.* London: Sage Publications.

Denzin, N.K. (1994). Evaluating qualitative research in the poststructural moment: The lessons James Joyce teaches us. *Qualitative Studies in Education, 7,* 295–308.

Denzin, N.K. (1995). On hearing the voices of educational research. *Curriculum Inquiry, 25,* 313–329.

Denzin, N.K. (2003*). Performance ethnography: Critical pedagogy and the politics of culture.* Thousand Oaks, CA: Sage Publications.

DeSalvo, L. (1996). *Vertigo: A memoir.* New York: Dutton.

DeVault, M. L. (1999). *Liberating method: Feminism and social research.* Philadelphia: Temple University Press.

Dixon, J. (1967). *Growth through English.* Oxford: Oxford University Press.

Donahoe, T. (1993). Finding the way: Structure, time, and culture in school improvement. *Phi Delta Kappan, 75,* 298–305.

Ebert, T.L. (1991). The "difference" of postmodern feminism. *College English, 53,* 886–904.

Eisner, E.W. (1992). Educational reform and the ecology of schooling. *Teachers College Record, 93*(4), 610–627.

Ellmann, M. (1968). *Thinking about women.* New York: Harcourt, Brace & World.

Ellsworth, E. (1986). Elicit pleasures: Feminist spectators and *Personal Best. Wide Angle, 8*(2), 45–58.

Ellsworth, E. (1989). Why doesn't this feel empowering? Working through the repressive myths of critical pedagogy. *Harvard Educational Review, 59*(3), 297–324.

Ellsworth, E. (1990). The question remains: How will you hold awareness of the limits of your knowledge? *Harvard Educational Review, 60*(3), 396–404.

Ellsworth, E. (1997). *Teaching positions: Difference, pedagogy, and the power of address.* New York: Teachers College Press.

Ellsworth, E. (2005). *Places of learning: Media architecture pedagogy.* New York: Routledge.

Ellsworth, E., & Miller, J. L. (1996). Working difference in education. *Curriculum Inquiry, 26*(3), 245–263.

Evans, S. (1979). *Personal politics: The roots of women's liberation in the Civil Rights Movement and the New Left.* New York: Vintage Books.

Felman, S. (1993). *What does a woman want? Reading and sexual difference.* Baltimore, MD: The Johns Hopkins University Press.

Felman, S., & Laub, D. (1992). *Testimony: Crises of witnessing in literature, psychoanalysis, and history.* New York: Routledge.

Feminist Anthology Collective. (1981). *No turning back.* London: The Women's Press.

Fine, M. (Ed.). (1992). *Disruptive voices: The possibilities of feminist research.* Ann Arbor: University of Michigan Press.

Firestone, S. (1970). *The dialectic of sex: The case for feminist revolution.* New York: Morrow.

Fiske, J. (1991). *Understanding popular culture.* London: Routledge.

Flax, J. (1993). *Disputed subjects: Essays on psychoanalysis, politics and philosophy.* New York: Routledge.

Foster, F.S. (1979). Voices unheard, stories untold. *Radical Teacher,* (December), 19–20.

Foucault, M. (1978). *The history of sexuality: Vol. I. An introduction* (R. Hurley, Trans.). New York: Vintage. (Original work published 1976)

Foucault, M. (1980a). *Power/knowledge: Selected interviews and other writings 1972–1977.* (C. Gordon, Ed.). New York: Pantheon Books.

Foucault, M. (1980b). Truth and power. In C. Gordon (Ed.), *Power/knowledge: Selected interviews and other writings 1972–1977* (pp. 109–133). New York: Pantheon Books.

Fraiman, S. (1995). Jane Austin and Edward Said: Gender, culture, and imperialism. *Critical Inquiry,* 21(4), 805–821.

Freire, P. (1974). *Pedagogy of the oppressed* (M. B. Ramos, Trans.). New York: The Seabury Press.

Fuss, D. (1989). *Essentially speaking: Feminism, nature and difference.* New York: Routledge.

Gallop, J. (1982). *The daughter's seduction: Feminism and psychoanalysis.* Ithaca, NY: Cornell University Press.

Gannett, C. (1992). *Gender and the journal: Diaries and academic discourse.* Albany: State University of New York Press.

Gauthier, C. (1986, October). *Postmodernism, desire and education.* Paper presented to the Bergamo Conference on Curriculum Theory and Classroom Practice, Dayton, Ohio.

Gilbert, P. (1988). *Writing, schooling and deconstruction: From voice to text in the classroom.* London: Routledge.

Gilmore, L. (1994). *Autobiographics: A feminist theory of women's self-representation.* Ithaca, NY: Cornell University Press.

Gilmore, L. (2001). Limit cases: Trauma, self-representation, and the jurisdictions of identity. *Biography: An Interdisciplinary Quarterly,* 24(1), 128–139.

Giroux, H. (1980). Dialectics of curriculum theory. *Journal of Curriculum Theorizing,* 2(2), 27–36.

Gluck, S. (1977). What's so special about women: Women's oral history. *Frontiers: A Journal of Women Studies,* 2(Summer), 3–5.

Goldfarb, B. (1993). Video activism and critical pedagogy: Sexuality at the end of the rainbow curriculum. *Afterimage,* 12, 4–7.

Goodman, J. (1994). External change agents and grassroots school reform: Reflections from the field. *Journal of Curriculum and Supervision,* 9(2), 113–135.

Gore, J. (1993). *The struggle for pedagogies: Critical and feminist discourses as regimes of truth.* New York: Routledge.

Graham, R. (1991). *Reading and writing the self: Autobiography in education and the curriculum.* New York: Teachers College Press.

Greene, F.L. (1996). Introducing queer theory into the undergraduate classroom: Abstractions and practical applications. *English Education,* 28, 325–339.

Greene, M. (1973). *Teacher as stranger: Educational philosophy for the modern age.* Belmont, CA: Wadsworth.

Greene, M. (1978). *Landscapes of learning.* New York: Teachers College Press.

Greene, M. (1981). Response to a predecessor. *Educational Researcher* 10(3), 5–6.

Greene, M. (1986). In search of a critical pedagogy. *Harvard Educational Review*, 56(November), 427–441.

Greene, M. (1988). *The dialectic of freedom*. New York: Teachers College Press.

Greene, M. (1995a). *Releasing the imagination: Essays on education, the arts, and social change*. San Francisco, CA: Jossey-Bass.

Greene, M. (1995b). What are schools for and what should we be doing in the name of education? In J. L. Kincheloe & S. R. Steinberg (Eds.), *Thirteen questions: Reframing education's conversations*, (2nd ed., pp. 305–313). New York: Peter Lang.

Greene, M. (1997). Metaphors and multiples: Representation, the arts, and history. *Phi Delta Kappan*, 78(5), 387–394.

Greene, M. (2001). *Variations on a blue guitar: The Lincoln Center Institute lectures on aesthetic education*. New York: Teachers College Press.

Grewal, I., & Kaplan, C. (Eds.). (1994). *Scattered hegemonies: Postmodernity and transnational feminist practices*. Minneapolis: University of Minnesota Press.

Grumet, M.R. (1978). Songs and situations. In G. Willis (Ed.), *Qualitative evaluation* (pp. 274–315). Berkeley, CA: McCutchan.

Grumet, M.R. (1979, October). Conception, contradiction, and curriculum. Paper presented at the Airlie Curriculum Theory Conference, Airlie, Virginia.

Grumet, M.R. (1980). Autobiography and reconceptualization. *JCT: Journal of Curriculum Theorizing*, 2(2), 155–158.

Grumet, M.R. (1981a). Conception, contradiction and curriculum. *JCT: Journal of Curriculum Theorizing*, 3(1), 287–298.

Grumet, M.R. (1981b). Pedagogy for patriarchy: The feminization of teaching. *Interchange*, 12(23), 165–184.

Grumet, M.R. (1981c). Restitution and reconstruction of educational experience: An autobiographical method for curriculum theory. In M. Lawn & L. Barton (Eds.), *Rethinking curriculum studies: A radical approach* (pp. 115–130). London: Croom Helm.

Grumet, M.R. (1988a). *Bitter milk: Women and teaching*. Amherst: University of Massachusetts Press.

Grumet, M.R. (1988b). Women and teaching: Homeless at home. In W.F. Pinar (Ed.), *Contemporary curriculum discourses* (pp. 531–539). Scottsdale, AZ: Gorsuch Scarisbrick.

Grumet, M.R. (1990). Retrospective: Autobiography and the analysis of educational experience. *Cambridge Journal of Education*, 20(3), 321–326.

Grumet, M.R. (1991). The politics of personal knowledge. In C. Witherell & N. Noddings (Eds.), *Stories lives tell: Narrative and dialogue in education* (pp. 67–77). New York: Teachers College Press.

Hancock, M. (Director). (2001). *Exclusions and awakenings: The life of Maxine Greene* [Film]. (Available from Center for Media and Independent Learning, 2000 Center Street, 4th Floor, Berkeley, CA 94704).

Haraway, D.J. (1988). Situated knowledges: The science question in feminism and the privilege of partial perspective. *Feminist Studies*, 14, 575–599.

Hardt, M., & Negri, A. (2000). *Empire*. Cambridge, MA: Harvard University Press.

Hasebe-Ludt, E., & Hurren, W. (Eds.). (2003). *Curriculum intertext: Place/language/pedagogy*. New York: Peter Lang.

Haug, F. (1987). *Female sexualization*. London: Verso.

Henderson, J.G., Hawthorne, R.D., & Stollenwerk, D. (2000). *Transforming curriculum leadership (2nd Edition)*. New York: Prentice Hall.

Hindman, J.E. (2003). Thoughts on reading "the personal": Toward a discursive ethics of professional critical literacy. *College English*, 66(1), 9–20.

Hirsch, Jr., E.D. (1999). *The schools we need: And why we don't have them.* New York: Anchor Books.

Hocquenghem, G. (1978). *Homosexual desire.* London: Villiers Publications.

Hoffman, N. (1981). *Women's "true" profession: Voices from the history of teaching.* New York: The Feminist Press and McGraw-Hill.

Hollingsworth, S., & Miller, J.L. (1992). Issues of gender equity in teacher–research. *Institute for Research on Teaching: Occasional Papers Series #143.* East Lansing: Michigan State University.

Hollingsworth, S., & Miller, J.L. (1994). Rewriting "gender equity" in teacher research. In S. Hollingsworth & H. Sockett (Eds.), *Teacher research and educational reform* (pp. 121–140). Chicago: National Society for the Study of Education, University of Chicago Press.

Hollingsworth, S., Dadds, M., & Miller, J.L. (1997). The examined experience of action research: The person within the process. In S. Hollingsworth (Ed.), *International action research: A casebook for educational reform* (pp. 49–59). London: The Falmer Press.

Honeychurch, K.G. (1996). Researching dissident subjectivities: Queering the grounds of theory and practice. *Harvard Educational Review*, 66(2), 339–355.

hooks, b. (1989). *Talking back: Thinking feminist, thinking black.* Boston: South End Press.

Howe, F. (1976). Feminism and the education of women. In Judith Stiehm (Ed.), *The frontiers of knowledge* (pp. 79–93). Los Angeles: University of Southern California Press.

Howe, F. (1983). New teaching strategies for a new generation of students. *Women Studies Quarterly*, 11(2), 7–11.

Huebner, D. (1976). The moribund curriculum field: Its wake and our work. *Curriculum Inquiry*, 6(2), 153–167.

Irigaray, L. (1985). *This sex which is not one.* (C. Porter & C. Burke, Trans.). Ithaca: Cornell University Press.

Jagger, A.M. (1983). *Feminist politics and human nature.* Sussex: Harvester Press.

Jelinek, E.C. (1980). *Women's autobiography: Essays in criticism.* Bloomington: Indiana University Press.

Johnson, B. (1998). *The feminist difference: Literature, psychoanalysis, race, and gender.* Cambridge, MA: Harvard University Press.

Kincheloe, J., & Steinberg, S. (Eds.) (1992/1995) *Thirteen questions: Reframing education's conversation*, 1st and 2nd Editions. New York: Peter Lang.

Klaus, C.H. (1994). The chameleon "I": On voice and personality in the personal essay. In K.B. Yancey (Ed.), *Voices on voice: Perspectives, definitions, inquiry* (pp. 111–129). Urbana, IL: National Council of Teachers of English.

Kliebard, H. (1975). Reappraisal: The Tyler rationale. In W. F. Pinar (Ed.), *Curriculum theorizing: The reconceptualists* (pp. 70–83). Berkeley, CA: McCutchan.

Kliebard, H. (1986). *The struggle for the American curriculum 1893–1958.* Boston: Routledge & Kegan Paul.

Kliebard, H. (1992). *Forging the American curriculum.* New York: Routledge.

Klohr, P.K. (1974, October). Curriculum theory: The state of the field. Paper presented at the Curriculum Theory Conference, Xavier University, Cincinnati, OH.

Klohr, P.K. (1980). The curriculum theory field—gritty and ragged. *Curriculum Perspectives*, 1(1), 1–7.

Klusacek, A. & Morrison, K. (Eds.). (1992). *A leap in the dark: AIDS, art and contemporary cultures.* Montreal: Vehicle Press.

Koedt, A., Levine, E., & Rapone, A. (Eds.). (1973). *Radical feminism.* New York: Quadrangle.

Krall, F. (1981). Navajo tapestry: A curriculum for ethno-ecological perspectives. *JCT: The Journal of Curriculum Theorizing,* 3(2), 165–208.

Krall, F. (1988a). Flesh of the earth, voice of the earth: Educational perspectives on "deep ecology." *JCT: Journal of Curriculum Theorizing,* 8(1), 55–80.

Krall, F.R. (1988b). From the inside out: Personal history as educational research. *Educational Theory,* 38, 467–479.

Krasno, F. (1977). On teaching a feminist writing workshop. *Women's Studies Newsletter,* V(Fall), 16–17.

Kridel, C. (1996). Hermeneutic portraits: Section editor's notes. *JCT: Journal of Curriculum Theorizing,* 12(4), 41.

Kridel, C. (Ed.). (1998). *Writing educational biography: Explorations in qualitative research.* New York: Garland Publishing.

Kridel, C. (1999). The Bergamo conferences, 1973–1997: Reconceptualization and the curriculum theory conferences. In W. F. Pinar (Ed.), *Contemporary curriculum discourses: Twenty years of JCT* (pp. 509–526). New York: Peter Lang.

Kridel, C., Schubert, W. H., Richards, V., & Long, R. (1995, September). *An examination of curriculum theory conferences, 1973–1993.* Paper presented at the Annual *JCT* Conference on Curriculum Theory and Classroom Practice, Monteagle, TN.

Kristeva, J. (1984). My memory's hyperbole. In D.C. Stanton (Ed.), *The female autograph* (pp. 219–235). New York: New York Literary Forum.

Kvale, S. (1996). *InterViews: An introduction to qualitative research interviewing.* Thousand Oaks, CA: Sage Publications.

Lal, J. (1999). Situating locations: The politics of self, identity and "other" in living and writing the text. In S. Hesse-Biber, C. Gilmartin, & R. Lydenberg (Eds.), *Feminist approaches to theory and methodology* (pp. 100–137). New York: Oxford University Press.

Langness, L.L., & Frank, G. (1981). *Lives: An anthropological approach to biography.* Novato, CA: Chandler & Sharp Publishers.

Lather, P. (1984). Critical theory, curricular transformation, and feminist mainstreaming. *Journal of Education,* 166, 49–62.

Lather, P. (1986). Research as praxis. *Harvard Educational Review,* 56(3), 257–277.

Lather, P. (1988). Feminist perspectives on empowering research methodologies. *Women Studies International Forum,* 11(6), 569–581.

Lather, P. (1989). Postmodernism and the politics of enlightenment. *Educational Foundations,* 3, 7–28.

Lather, P. (1991a). *Getting smart: Feminist research and pedagogy with/in the postmodern.* London: Routledge.

Lather, P. (1991b). Deconstructing/deconstructive inquiry: The politics of knowing and being known. *Educational Theory,* 41(2), 153–173.

Lather, P. (1993). Fertile obsession: Validity after poststructuralism. *Sociological Quarterly,* 34, 673–693.

Lather, P. (1997). Creating a multilayered text: Women, AIDS, and angels. In W.G. Tierney & Y.S. Lincoln (Eds.), *Presentation and the text: Re-framing the narrative voice* (pp. 233–258). Albany: State University of New York Press.

Lather, P. (2003, April). This IS your father's paradigm: Government intrusion and the case of qualitative research in education. The Guba Lecture, sponsored by AERA Special Interest Group: Qualitative Research, American Educational Research Association Annual Meeting, Chicago.

Lather, P. (2004, April). Getting lost: Toward a stuttering knowledge. Paper presented at American Educational Research Association Annual Meeting, San Diego.

Lather, P., & Smithies, C. (1997). *Troubling the angels: Women living with HIV/AIDS.* Boulder, CO: Westview.

Lesko, N. (1988). *Symbolizing society: Stories, rites and structure in a Catholic high school.* New York: Falmer.

Lesko, N. (2000). *Act your age: A cultural construction of adolescence.* New York: Routledge Falmer.

Lewis, M.G. (1990). Interrupting patriarchy: Politics, resistance, and transformation in the feminist classroom. *Harvard Educational Review,* 60(4), 467–488.

Lewis, M.G. (1993). *Without a word: Teaching beyond women's silences.* New York: Routledge.

Lewis, M.G., & Simon, R.I. (1986). A discourse not intended for her: Learning and teaching within patriarchy. *Harvard Educational Review,* 56(4), 457–472.

Lincoln, Y., & Guba, E. (1985). *Naturalistic inquiry.* Beverly Hills, CA: Sage.

Lippard, L. R. (Ed.). (1992). *Partial recall: With essays on photographs of native North Americans.* New York: The New Press.

Lorde, A. (1986). *Our dead behind us.* New York: W. W. Norton.

Lu, M.-Z. (2001). *Shanghai quartet: The crossings of four women of China.* Pittsburgh: Duquesne University Press.

Luce-Kapler, R. (2003). *Writing with, through, and beyond the text: An ecology of language.* Mahwah, NJ: Lawrence Erlbaum Associates.

Luke, C., & Gore, J. (Eds.). (1992). *Feminisms and critical pedagogy.* New York: Routledge.

Macdonald, J.B. (1971). Curriculum theory. *Journal of Educational Research,* 64(5), 196–200.

Macdonald, J. B. (1977). Value bases and issues for curriculum. In A. Molnar & J. Zahorik (Eds.), *Curriculum theory* (pp. 10–21). Washington, D.C.: Association for Supervision and Curriculum Development.

Macdonald, J.B., & Zaret, E. (Eds.). (1975). *Schools in search of meaning* [1975 Yearbook]. Washington, D.C.: Association for Supervision and Curriculum Development.

Maher, F. (1985). Pedagogies for the gender-balanced classroom. *Journal of Thought,* 20(4), 49–57.

Marcus, G., & Fischer, R. (1986). *Anthropology as cultural critique.* Chicago: University of Chicago Press.

Mariani, P. (Ed.). (1991). *Critical fictions: The politics of imaginative writing.* Seattle, WA: Bay Press.

Marshall, B.K. (1992). *Teaching the postmodern: Fiction and theory.* New York: Routledge.

Martin, B. (1988). Lesbian identity and autobiographical difference. In B. Brokzki & C. Schenck (Eds.), *Life/lines: Theorizing women's autobiography* (pp. 77–103). Ithaca, NY: Cornell University Press.

Martin, B., & Mohanty, C. (1986). Feminist politics: What's home got to do with it? In T. deLauretis (Ed.), *Feminist studies, critical studies* (pp. 191–212). Bloomington: Indiana University Press.

Martindale, K. (1997). *Un/popular culture: Lesbian writing after the sex wars.* Albany: State University of New York Press.

Martusewicz, R. (1992). Mapping the terrain of the post-modern subject: Post-structuralism and the educated woman. In W. F. Pinar & W. Reynolds (Eds.), *Understanding curriculum as phenomenological and deconstructed text* (pp. 131–158). New York: Teachers College Press.

Mason, M.G., & Green, C.H. (Eds.). (1979). *Journeys: Autobiographical writings by women.* Boston: G.K. Hall.

Mayher, J.S. (1990). *Uncommon sense: Theoretical practice in language education.* Portsmouth, NH: Boynton/Cook Publishers, Heinemann.

Mayher, J.S. (1999). Reflections on standards and standard setting: An insider/outsider perspective on the NCTE/IRA standards. *English Education*, 31, 106–121.

McClintock, R. (1971). Toward a place for study in a world of instruction. *Teachers College Record*, 73(2), 161–205.

McNeil, L.M. (2000). *Contradictions of school reform: Educational costs of standardized testing.* New York: Routledge.

Merchant. B. (1995). Current educational reform: "Shape-shifting" or genuine improvement in the quality of teaching and learning? *Educational Theory*, 45, 251–268.

Meyer, J. (1993). AIDS and postmodernism. *Arts Magazine*, 66(8), 62–68.

Miller, J.B. (1976). *Toward a new psychology of women.* Boston: Beacon Press.

Miller, J.L. (1978). Curriculum theory: A recent history. *JCT: Journal of Curriculum Theorizing*, 1(1), 28–43.

Miller, J. L. (1979a). Greene as artist: The challenge to see anew. *Curriculum Inquiry*, 9(4), 333–337.

Miller, J.L. (1979b). Women and education: The dichotomous self. *Impact: The Journal of New York State Association for Supervision and Curriculum Development*, 14(3), 24–28.

Miller, J.L. (1979c). Women: The evolving educational consciousness. *JCT: Journal of Curriculum Theorizing*, 2(1), 238–246.

Miller, J.L. (1981a). The sound of silence breaking: Feminist pedagogy and curriculum theory. *JCT: Journal of Curriculum Theorizing*, 4(1), 5–11.

Miller, J.L. (1981b). Three language-arts curriculum models and a guide for developing an English curriculum for the Eighties: A critique. *English Journal*, 70(5), 70–71.

Miller, J.L. (1982a). The breaking of attachments: Feminism and curriculum theory. *JCT: Journal of Curriculum Theorizing*, 4(2), 10–20.

Miller, J.L. (1982b). Writing and the teaching of writing: Case studies of self-concept and composing processes. *Writing Processess of College Students*, 2, 37–47.

Miller, J.L. (1983a). A search for congruence: The influence of past and present in preparing future teachers of writing. *English Education*, 15(1), 5–16.

Miller, J.L. (1983b). The resistance of women academics: An autobiographical account. *The Journal of Educational Equity and Leadership*, 3(2), 101–109.

Miller, J.L. (1986a). Marking papers and marking time: Issues of self-concept in women and men who teach. *Teaching and Learning: The Journal of Natural Inquiry*, 1(1), 26–38.

Miller, J.L. (1986b). Women as teachers: Enlarging conversations on issues of gender and self-concept. *Journal of Curriculum and Supervision*, 1(2), 111–121.

Miller, J.L. (1987a). Folded memories and future dialogues: The teaching of language arts. *Teaching Education*, 1(1), 16–18.

Miller, J.L. (1987b). Teachers' emerging texts: The empowering potential of writing inservice. In J. Smyth (Ed.), *Educating teachers: Changing the nature of pedagogical knowledge* (pp.193–206). London: Falmer.

Miller, J.L. (1987c). Women as teacher-researchers: Gaining a sense of ourselves. *Teacher Education Quarterly*, 14(2), 52–58.

Miller, J.L. (1989a). Academic repositionings: Issues of imposition and community in collaborative research. In T.R. Carson & D.J. Sumara (Eds.), *Exploring collaborative action research: Proceedings of the Ninth Invitational Conference of the Canadian Association for Curriculum Studies* (pp. 89–102). Edmonton: Canadian Association for Curriculum Studies.

Miller, J.L. (1989b). Gender studies: Impact on school curriculum. In T. Husen & T.N. Postlethwaite (Eds.), *International encyclopedia of education: Research and studies* (pp. 371–374). Oxford, England: Pergamon Press.

Miller, J.L. (1990a). *Creating spaces and finding voices: Teachers collaborating for empowerment.* Albany: State University of New York Press.

Miller, J.L. (1990b). The teacher as curriculum creator. In J.D. Marshall & J.T. Sears (Eds.)., *Teaching and thinking about curriculum: Critical inquiries* (pp. 85–96). New York: Teachers College Press.

Miller, J.L. (1991). Reflections on Picasso's *Guernica*. In G. Willis & W.H. Schubert (Eds.), *Reflections from the heart of educational inquiry: Understanding curriculum and teaching through the arts* (pp. 239–243). Albany, NY: State University of New York Press.

Miller, J.L. (1992a). Exploring power and authority issues in a collaborative research project. *Theory into Practice, 31*(2), 165–172.

Miller, J.L. (1992b). Gender and teachers: In B. Appleby & N. McCracken (Eds.), *Gender issues in the teaching of English* (pp. 174–190). Portsmouth, NH: Heinemann-Boynton/Cook Publishers.

Miller, J.L. (1992c). Shifting the boundaries: Teachers challenge contemporary curriculum thought. *Theory into Practice, 31*(3), 245–251.

Miller, J.L. (1992d). Teachers, autobiography, and curriculum: Critical and feminist perspectives. In S. Kessler & B.B. Swadner (Eds.), *Reconceptualizing early childhood education* (pp. 103–122). New York: Teachers College Press.

Miller, J.L. (1992e). Teachers' spaces: A personal evolution of teacher lore. In W. Schubert & W.C. Ayers (Eds.), *Teacher lore: Learning from our own experience* (pp. 11–24). Albany: State University of New York Press.

Miller, J.L. (1992f). The politics of teacher-research. *The Council Chronicle, 2*(1), 14–15. Urbana, IL: National Council of Teachers of English.

Miller, J.L. (1993a). Constructions of gender and curriculum. In S.K. Biklen & D. Pollard (Eds.), *Gender and education* (pp. 43–63). Chicago: National Society for the Study of Education, University of Chicago Press.

Miller, J.L. (1993b). Solitary spaces: Women, curriculum, and teaching. In D. Wear (Ed.), *The center of the web: Women and solitude* (pp. 245–252). Albany: State University of New York Press.

Miller, J.L. (1994). "The surprise of a recognizable person" as troubling presence in educational research and writing. *Curriculum Inquiry, 24*(4), 503–512.

Miller, J.L. (1995). Women and education: In what ways does gender affect the educational process? In J.L. Kincheloe & S.R. Steinberg (Eds.), *Thirteen questions: Reframing education's conversation, 2nd Edition* (pp. 149–156). New York: Peter Lang.

Miller, J.L. (1996a). Curriculum and the reconceptualization: Another brief history. *JCT: An Interdisciplinary Journal of Curriculum Studies, 12*(1), 6–8.

Miller, J.L. (1996b). Hermeneutic portraits: The human histories. . . . *JCT: Journal of Curriculum Theorizing, 12*(4), 42–43.

Miller, J.L. (1996c). Teachers, researchers and situated school reform: Circulations of power. *Theory into Practice, 35*(2), 86–92.

Miller, J.L. (1997). Disruptions in the field: An academic's lived practice with classroom teachers. In T.R. Carson & D. Sumara (Eds.), *Action research as a living practice* (pp. 199–213). New York: Peter Lang.

Miller, J.L. (1998a). Autobiography and the necessary incompleteness of teachers' stories. In W.C. Ayers & J.L. Miller (Eds.), *A light in dark times: Maxine Greene and the unfinished conversation* (pp. 145–154). New York: Teachers College Press.

Miller, J.L. (1998b). Autobiography as a queer curriculum practice. In W.F. Pinar (Ed.), *Queer theory in education* (pp. 365–373). Mahwah, NJ: Lawrence Erlbaum, Publishers.

Miller, J.L. (1998c). Biography, education, and questions of the private voice. In C. Kridel (Ed.), *Writing educational biography: Explorations in qualitative research* (pp. 225–234). New York: Garland.

Miller, J.L. (1999a). Curriculum reconceptualized: A personal and partial history. In W.F. Pinar (Ed.), *Contemporary curriculum discourses: Twenty years of JCT* (pp. 498–508). New York: Peter Lang.

Miller, J.L. (1999b). Putting cultural studies to use: "Translating the curriculum." *Journal of Curriculum Studies*, 31(1), 107–110.

Miller, J.L. (2000). What's left in the field. . . . A curriculum memoir. *Journal of Curriculum Studies*, 32(2), 253–266.

Miller, J.L. (2000). English education in-the-making. *English Education*, 33(1), 34–50.

Miller, J.L. (2003). Biographical Entries: Henry C. Morrison, Jesse Newlon, and Joseph Rice. In J. Guthrie (Ed.), *The Macmillan Encyclopedia of Education* (pp. 1688–1690, Vol 5; pp. 1800–1801, Vol 5; pp. 2053–2055, Vol 6). New York: Macmillan.

Miller, J.L. (2004). A provisional biography: Methodological tangles. Paper presented at Annual Meeting of American Educational Research Association, April, San Diego.

Miller, J.L., & Martens, M.L. (1990). Hierarchy and imposition in collaborative inquiry: Teacher-researchers' reflections on recurrent dilemmas. *Educational Foundations*, 4(4), 41–59.

Miller, N. K. (1991). *Getting personal: Feminist occasions and other autobiographical acts*. New York: Routledge.

Mishler, E. (1979). Meaning in context: Is there any other kind? *Harvard Educational Review*, 49(1), 1–19.

Mitrano, B.S. (1981). Feminism and curriculum theory: Implications for teacher education. *JCT: Journal of Curriculum Theorizing*, 3, 5–85.

Moers, E. (1976). *Literary women*. Garden City, NY: Doubleday.

Moffett, J. (1994). On to the past: Wrong-headed school reform. *Phi Delta Kappan*, 76, 582–590.

Moraga, C., & Anzaldua, G. (Eds). (1981). *This bridge called my back: Writings by radical women of color*. New York: Kitchen Table Press.

Morgan, R. (Ed.). (1970). *Sisterhood is powerful: An anthology of writings from the women's liberation movement*. New York: Random House.

Morrison, T. (1990). The site of memory. In R. Ferguson, M. Gever, T. T. Minh-ha, & C. West (Eds.), *Out there: Marginalization and contemporary cultures* (pp. 299–305). Cambridge, MA: The MIT Press.

Morrison, T. (1992). *Playing in the dark: Whiteness and the literary imagination*. Cambridge: Harvard University Press.

Munro, P. (1998). *Subject to fiction: Women teachers' life history narratives and the cultural politics of resistance*. Philadelphia: Open University Press.

Myers, M. (1996). *Changing our minds: Negotiating English and literacy*. Urbana, IL: National Council of Teachers of English.

Nicholson, L.J. (1986). *Gender and history: The limits of social theory in the age of the family*. New York: Columbia University Press.

Nicholson, L.J. (1994). Feminism and the politics of postmodernism. In M. Ferguson & J. Wicke (Eds.), *Feminism and postmodernism* (pp. 69–85). Durham, NC: Duke University Press.

Nicholson, L.J. (Ed.). (1997). *The second wave: A reader in feminist theories.* NewYork: Routledge.

Oates, S.B. (Ed.). (1986). *Biography as high adventure.* Amherst: University of Massachusetts Press.

Oates, S.B. (1991). *Biography as history.* Waco, TX: Mankham Press Fund.

Olsen, T. (1978). *Silences.* New York: Delacorte Press/Seymour Lawrence.

Orner, M. (1992). Interrupting the calls for student voice in "liberatory" education: A feminist poststructuralist perspective. In C. Luke & J. Gore (Eds.), *Feminisms and critical pedagogy* (pp. 74–89). New York: Routledge.

Orner, M., Miller, J.L., & Ellsworth, E. (1996). Excessive moments and educational discourses that try to contain them. *Educational Theory,* 46(1), 71–91.

Pagano, J. (1988a). The claim of philia. In W.F. Pinar (Ed.), *Contemporary curriculum discourses* (pp. 514–530). Scottsdale, AZ: Gorsuch Scarisbrick.

Pagano, J. (1988b). Teaching women. *Educational Theory,* 38, 321–339.

Pagano, J. (1990). *Exiles and communities: Teaching in the patriarchal wilderness.* Albany: State University of New York Press.

Pagano, J. (1991). Moral fictions: The dilemma of theory and practice. In C. Witherell & N. Noddings (Eds.), *Stories lives tell: Narrative and dialogue in education* (pp. 193–206). New York: Teachers College Press.

Page, R. (2003, April). Invitation to curriculum. Vice Presidential Address, Division B (Curriculum Studies), Annual Meeting of the American Educational Research Association, Chicago.

Patterson, A. (1990). Changing the questions: The construction of alternative meanings in the English classroom. *English in Australia,* 94, 59–72.

Patterson, A. (1992). Individualism in English: From personal growth to discursive construction. *English Education,* 24(3), 131–146.

Patton, C. (1990). *Inventing AIDS.* New York: Routledge.

Pennycook, A. (1994). *The cultural politics of English as an international language.* New York: Longman.

Phelan, P. (1993). *Unmarked: The politics of performance.* New York: Routledge.

Pinar, W.F. (Ed.). (1974). *Heightened consciousness, cultural revolution and curriculum theory: The proceedings of the Rochester conference.* Berkeley, CA: McCutchan.

Pinar, W.F. (Ed.). (1975a). *Curriculum theorizing: The reconceptualists.* Berkeley, CA: McCutchan.

Pinar, W.F. (1975b). Search for a method. In W.F. Pinar, (Ed.), *Curriculum theorizing: The reconceptualists* (pp. 415–424). Berkeley, CA: McCutchan.

Pinar, W.F. (1978a). *Currere: A case study.* In G. Willis (Ed.), *Qualitative evaluation* (pp. 316–342). Berkeley, CA: McCutchan.

Pinar, W.F. (1978b). Notes on the curriculum field. *Educational Researcher,* 7(8), 5–12.

Pinar, W.F. (1979). "Announcing." *JCT: Journal of Curriculum Theorizing,* 1(1), 1.

Pinar, W.F. (1981). "Whole, bright, deep with understanding": Issues in qualitative research and autobiographical method. *Journal of Curriculum Studies,* 13(3), 173–188.

Pinar, W.F. (1982). Gender, sexuality and curriculum studies: The beginning of the debate. *McGill Journal of Education,* 2(3), 305–316.

Pinar, W.F. (1983). Curriculum as gender text: Notes on reproduction resistance, and male-male relations. *JCT: Journal of Curriculum Theorizing,* 5(1), 26–52.

Pinar, W.F. (Ed.). (1988). *Contemporary curriculum discourses.* Scottsdale, AZ: Gorsuch Scarisbrick Publishers.

Pinar, W.F. (1994). *Autobiography, politics and sexuality: Essays in curriculum theory 1972–1992.* New York: Peter Lang.

Pinar, W.F. (1999a). Response: Gracious submission. *Educational Researcher,* 28(1), 14–15.

Pinar, W.F. (Ed.). (1999b). *Contemporary curriculum discourses: Twenty years of JCT.* New York: Peter Lang.

Pinar, W.F. (2001). *The gender of racial politics and violence in America.* New York: Peter· Lang.

Pinar, W.F. (Ed.). (2003). *International handbook of curriculum research.* Mahwah, NJ: Lawrence Erlbaum Associates, Publishers.

Pinar, W.F. (2004). *What is curriculum theory?* Mahwah, NJ: Lawrence Erlbaum.

Pinar, W.F. (In press-a). The Synoptic Text Today. *JCT: Journal of Curriculum Theorizing.*

Pinar, W.F. (In press-b). The problem of the public. In R. Gaztambide-Fernandez & J.T. Sears (Eds.), *Curriculum work as public moral enterprise.* Landham, MD: Rowman & Littlefield.

Pinar, W.F., & Grumet, M.R. (1976). *Toward a poor curriculum.* Dubuque, IA: Kendall/Hunt.

Pinar, W.F., & Grumet, M.R. (1981). Theory and practice and the reconceptualization of curriculum studies. In M. Lawn & L. Barton (Eds.), *Rethinking curriculum studies: A radical approach* (pp. 20–42). London: Croom Helm.

Pinar, W.F., & Irwin, R.L. (Eds.). (In press). *Curriculum in a new key: The collected works of Ted T. Aoki.* Mahwah, NJ: Lawrence Erlbaum.

Pinar, W.F., & Miller, J.L. (1982). Feminist curriculum theory: Notes on the American field, 1982. *The Journal of Educational Thought,* 16(3), 217–224.

Pinar, W.F., & Reynolds, W.M. (Eds.). (1992). *Understanding curriculum as phenomenological and deconstructed text.* New York: Teachers College Press.

Pinar, W.F., Reynolds, W.M., Slattery, P., & Taubman, P.M. (1995). *Understanding curriculum: An introduction to the study of historical and contemporary curriculum discourses.* New York: Peter Lang.

Pitt, A.J. (2003). *The play of the personal: Psychoanalytic narratives of feminist education.* New York: Peter Lang.

Popkewitz, T.S., & Lind, K. (1989). Teacher incentives as reforms: Teachers' work and the changing control mechanism in education. *Teachers College Record,* 90(4), 575–594.

Pratt, M.B. (1991). *Rebellion: Essays 1980–1991.* Ithaca, NY: Firebrand Books.

Qualley, D. (1997). *Turns of thought: Teaching composition as reflexive inquiry.* Portsmouth, NH: Boynton/Cook Publishers, Heinemann.

Ramazanoglu, C., with Holland, J. (2002). *Feminist methodology: Challenges and choices.* London: Sage Publications.

Reiniger, M. (1988, Fall). Traces of misogyny in women's schooling: Autobiographical search for gyn/ecology. *JCT: Journal of Curriculum Theorizing,* 8, 7–89.

Reynolds, W.M. (2003). *Curriculum: A river runs through it.* New York: Peter Lang.

Rich, A. (1979). *On lies, secrets and silence.* New York: W.W. Norton and Company.

Richardson, L. (1997). *Fields of play: Constructing an academic life.* New Brunswick, NJ: Rutgers University Press.

Roberts, H. (Ed.). (1981). *Doing feminist research.* London: Routledge & Kegan Paul.

Roemer, M.G. (1991). What we talk about when we talk about school reform. *Harvard Educational Review,* 61(4), 434–448.

Roman, L.G., & Apple, M.W. (1990). Is naturalism a move away from positivism? Materialist and feminist approaches to subjectivity in ethnographic research. In E.W. Eisner & A. Peshkin (Eds.), *Qualitative inquiry in education: The continuing debate* (pp. 38–73). New York: Teachers College Press.

Roman, L., & Christian-Smith, L. (Eds.). (1988). *Feminism and the politics of popular culture.* London: Falmer.

Rose, P. (1984). *Parallel lives.* New York: Knopf.

Rosenau, P.M. (1992). *Post-modernism and the social sciences: Insights, inroads, and intrusions.* Princeton, NJ: Princeton University Press.

Rosenblatt, L.M. (1938). *Literature as exploration.* New York: Noble and Noble, Publishers, Inc.

Rosenblatt, L.M. (1978). *The reader, the text, the poem: The transactional theory of the literary work.* Carbondale: Southern Illinois University Press.

Rosenblatt, L.M. (1988). Writing and reading: The transactional theory. *Reader: Essays in reader-oriented theory, criticism, and pedagogy,* 20, 7–31.

Ross, V. (1991). Too close to home: Repressing biography, instituting authority. In W.H. Epstein (Ed.), *Contesting the subject: Essays in the postmodern theory and practice of biography and biographical criticism* (pp. 135–165). West Lafayette, IN: Purdue University Press.

Rubin, G. (1975). The traffic in women: Notes on the "political economy" of sex. In R. Reiter (Ed.), *Toward an anthropology of women* (pp. 157–210). New York: Monthly Review Press.

Said, E. (1983). *The world, the text, and the critic.* Cambridge, MA: Harvard University Press.

Salvio, P.M. (2001). Loss, memory and the work of learning: Lessons from the teaching life of Anne Sexton. In D.H. Holdstein & D. Bleich (Eds.), *Personal effects: The social character of scholarly writing* (pp. 93–117). Logan: Utah State University Press.

Sartre, J.-P. (1968). *Search for a method* (H.E. Barnes, Trans.). New York: Vintage Books. (Original work published 1960)

Schubert, W.H. (1986). *Curriculum: Perspective, paradigm, possibility.* New York: Macmillan.

Schubert, W.H., Schubert, A.L.L., Thomas, T., & Carroll, W. (2002). *Curriculum books: The first 100 years (2nd Edition).* New York: Peter Lang.

Schwab, J. (1970). *The practical: A language for curriculum.* Washington, D.C.: National Education Association.

Scott, J. (1991). The evidence of experience. *Critical Inquiry,* 178(3), 773–797.

Sedgwick, E.K. (1990). *Epistemology of the closet.* Berkeley: University of California Press.

Sedgwick, E.K. (1993). *Tendencies.* Durham, NC: Duke University Press.

Sedgwick, E.K. (2003). *Touching feeling: Affect, pedagogy, performativity.* Durham: Duke University Press.

Shields, C. (1993). *The stone diaries.* New York: Penguin Books.

Showalter, E. (1977). *A literature of their own: English women novelists from Bronte to Lessing.* Princeton: Princeton University Press.

Slattery, P. (1995). *Curriculum development in the postmodern era.* New York: Garland Publishing.

Slattery, P., & Rapp, D. (2002). *Ethics and the foundations of education: Teaching convictions in a postmodern world.* Boston: Allyn and Bacon.

Sleeter, C.E. (1992). Resisting racial awareness: How teachers understand the social order from their racial, gender, and social class locations. *Educational Foundations* (Spring), 7–32.

Smith, J. K. (1997). The stories educational researchers tell about themselves. *Educational Researcher,* 26(5), 4–11.

Smith, L.M. (1998). Biographical method. In N.K. Denzin & Y.S. Lincoln (Eds.), *Strategies of qualitative inquiry* (pp. 184–224). Thousand Oaks, CA: Sage Publications.

Smith, S. (1987). *A poetics of women's autobiography: Marginality and the fictions of self representation*. Bloomington: Indiana University Press.

Smith, S. (1993). Who's talking/who's talking back? The subject of personal narrative. *Signs: Journal of Women in Culture and Society*, 18(2), 392–407.

Smith, S., & Watson, J. (Eds.). (1998). *Women, autobiography, theory: A reader*. Madison: University of Wisconsin Press.

Smith, S. & Watson, J. (2001). The rumpled bed of autobiography: Extravagant lives, extravagant questions. *Biography: An Interdisciplinary Quarterly*, 24(1): 1–14.

Smith, S., & Watson, J. (Eds.). (2002). *Interfaces: Women/autobiography/image/performance*. Ann Arbor, MI: The University of Michigan Press.

Spacks, P.M. (1972). *The female imagination*. New York: Avon Books.

Spender, D. (Ed.) (1981). *Men's studies modified: The impact of feminism on the disciplines*. Oxford: Pergamon Press.

Spivak, G.C. (1988). Can the subaltern speak? In C. Nelson & L. Grossberg (Eds.), *Marxism and the interpretation of culture* (pp. 271–313). Urbana: University of Illinois Press.

Stanley, L., & Wise, S. (1983). *Breaking out: Feminist consciousness and feminist research*. London: Routledge & Kegan Paul.

Stimpson, C.R. (1981, March). "Women as knowers." Keynote Address, Southern Scholars on Women Conference, Georgia State University, Atlanta, GA.

Stone, L. (Ed.). (1994). *The education feminism reader*. New York: Routledge.

St. Pierre, E.A. (2004). Evidence after postmodernism. Paper presented at Annual Meeting of American Educational Research Association, April, San Diego.

St. Pierre, E.A., & Pillow, W.S. (Eds.). (2000). *Working the ruins: Feminist poststructuralist theory and methods in education*. New York: Routledge.

Sumara, D.J. (2002). *Why reading literature in school still matters: Imagination, interpretation, insight*. Mahwah, NJ: Lawrence Erlbaum Associates.

Tabakin, G., & Densmore, K. (1986). Teacher professionalization and gender analysis. *Teachers College Record*, 88(2), 257–279.

Tamboukou, M. (2003). *Women, education and the self: A Foucauldian perspective*. New York: Palgrave Macmillan.

Taubman, P. M. (1979). Gender and curriculum: Discourse and the politics of sexuality. Unpublished dissertation, University of Rochester, New York.

Tierney, W.G. (2000). Undaunted courage: Life history and the postmodern challenge. In N.K. Denzin and Y.S. Lincoln (Eds). *Handbook of qualitative research (Second Edition)*, (pp. 537–554). Thousand Oaks, CA: Sage Publications.

Tremmel, R. (2000). Still loading pig iron after all these years: Tribalism and English education in the global contact zone. *English Education*, 32, 194–225.

Trinh T. M-h. (1989). *Woman, native, other: Writing postcoloniality and feminism*. Bloomington: Indiana University Press.

Trinh T. M-h. (1991). *When the moon waxes red: Representation, gender and cultural politics*. New York: Routledge.

Trueit, D., Doll, W.E., Wang, H., & Pinar, W.F. (Eds.) (2003). *The internationalization of curriculum studies: Selected proceedings from the LSU Conference 2000*. New York: Peter Lang.

Van Maanen, J. (1988). *Tales of the field: On writing ethnography*. Chicago: University of Chicago Press.

Vinz, R. (1995). Opening moves: Reflections on the first year of teaching. *English Education*, 27, 158–207.

Vinz, R., & Schaafsma, D. (2000). A theory of crossed destinies. *English Education*, 32, 179–181.

Visweswaran, K. (1994). *Fictions of feminist ethnography*. Minneapolis: University of Minnesota Press.

Walker, A. (1989). On refusing to be humbled by second place in a contest you did not design: A tradition by now. In A. Walker (Ed.), *I love myself when I am laughing . . . and then again when I am looking mean and impressive: A Zora Neale Hurston Reader* (pp. 1–6). Boston: Feminist Press.

Walkerdine, V. (1990). *Schoolgirl fictions*. London: Verso.

Wallenstein, S. (1979a). Notes toward a feminist curriculum theory. *JCT: Journal of Curriculum Theorizing*, 1(1), 186–190.

Wallenstein, S. (1979b). *The reflexive method in curriculum theory: An autobiographical case study*. Unpublished doctoral dissertation, University of Rochester, Rochester, New York.

Wang, H. (2004). *The call from the stranger on a journey home: Curriculum in a third space*. New York: Peter Lang.

Wear, D. (Ed.). (1993). *The center of the web: Women and solitude*. Albany: State University of New York Press.

Weedon, C. (1987). *Feminist practice and poststructuralist theory*. New York: Basil Blackwell, Inc.

Weis, L. (Ed.). (1988). *Class, race and gender in American education*. Albany: State University of New York Press.

Weis, L., & Fine, M. (2000). *Speed bumps*. New York: Teachers College Press.

Weis, L., & Fine, M. (2004). *Working method: Research and social justice*. New York: Routledge.

Wexler, P. (1976). *The sociology of education: Beyond equality*. Indianapolis, IN: Bobbs, Merrill.

Williams, P.J. (1991). *The alchemy of race and rights: Diary of a law professor*. Cambridge, MA: Harvard University Press.

Willis, P. (1977/1981). *Learning to labour*. Hampshire, England: Gower. [1977 Edition published by Saxon House in Farnborough, England].

Willis, S. (1993). Multicultural teaching: Meeting the challenges that arise in practice. *Curriculum Update* (September), 1–6.

Winterson, J. (1995). *Art [Objects]: Essays on ecstasy and effrontery*. New York: Alfred Knopf.

Wood, G. (1983). Beyond educational cynicism. *Educational Theory*, 32(2), 55–71.

Wraga, W.G. (1999a). "Extracting sun-beams out of cucumbers": The retreat from practice in reconceptualized curriculum studies. *Educational Researcher*, 28(1), 4–13.

Wraga, W.G. (1999b). The continuing arrogation of the curriculum field: A rejoinder to Pinar. *Educational Researcher*, 28(1), 16.

Yalom, M. (1993). A review of *Social science and the self* and *Getting personal*. *Signs: Journal of Women in Culture and Society*, 18(2), 455–458.

Young, I.M. (1990). *Justice and the politics of difference*. Princeton, NJ: Princeton University Press.

Young, M. (2000). Preparing English teacher educators: Defining a process. *English Education*, 32, 226–236.

Ziarek, E.P. (2001). *An ethics of dissensus: Postmodernity, feminism, and the politics of radical democracy*. Stanford, CA: Stanford University Press.

INDEX

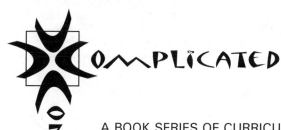

OMPLICATED

CONVERSATION

A BOOK SERIES OF CURRICULUM STUDIES

This series employs research completed in various disciplines to construct textbooks that will enable public school teachers to reoccupy a vacated public domain—not simply as "consumers" of knowledge, but as active participants in a "complicated conversation" that they themselves will lead. In drawing promiscuously but critically from various academic disciplines and from popular culture, this series will attempt to create a conceptual montage for the teacher who understands that positionality as aspiring to reconstruct a "public" space. *Complicated Conversation* works to resuscitate the progressive project—an educational project in which self-realization and democratization are inevitably intertwined; its task as the new century begins is nothing less than the intellectual formation of a public sphere in education.

The series editor is:

Dr. William F. Pinar
Department of Curriculum and Instruction
223 Peabody Hall
Louisiana State University
Baton Rouge, LA 70803-4728

To order other books in this series, please contact our Customer Service Department:

(800) 770-LANG (within the U.S.)
(212) 647-7706 (outside the U.S.)
(212) 647-7707 FAX

Or browse online by series:

www.peterlangusa.com

ABOUT THE AUTHOR

 Janet L. Miller is Professor and Coordinator for Programs in English Education in the Department of Arts and Humanities at Teachers College, Columbia University. She received her Ph.D. in curriculum theory and humanities education from The Ohio State University. Elected Vice-President of the American Educational Research Association for Division B-Curriculum Studies (1997–1999) and the first President of the American Association for the Advancement of Curriculum Studies (2001–2004), she also served as Managing Editor of *JCT: The Journal of Curriculum Theorizing* (1978–1998). In addition to numerous articles in edited books and professional journals, she is the author of *Creating Spaces and Finding Voices: Teachers Collaborating for Empowerment,* and co-editor of *A Light in Dark Times: Maxine Greene and the Unfinished Conversation.*